The Blue Rider in the Lenbachhaus, Munich

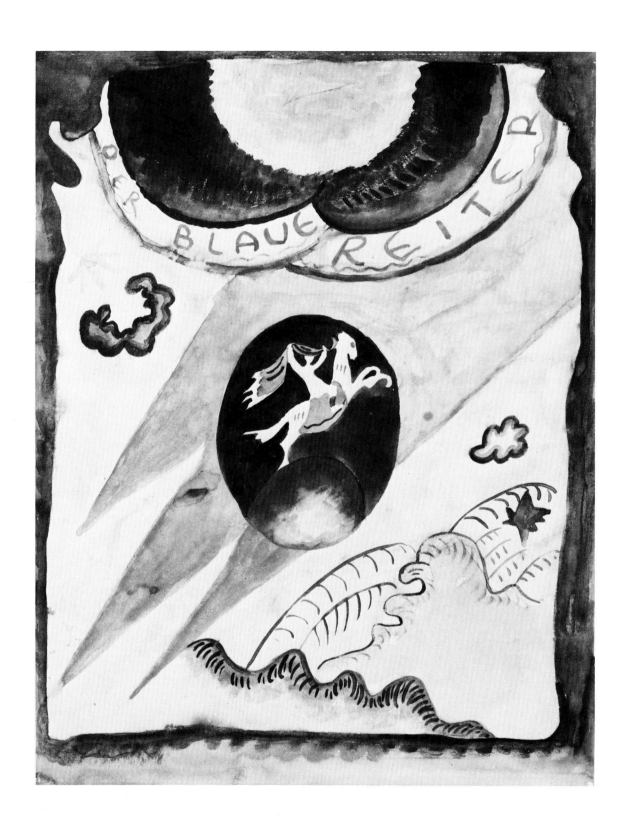

Armin Zweite

The Blue Rider
in the Lenbachhaus, Munich

Masterpieces by
Franz Marc · Vassily Kandinsky · Gabriele Münter
Alexei Jawlensky · August Macke · Paul Klee

Commentaries and biographies
by Annegret Hoberg

Prestel

Translated from the German by John Ormrod

Cover: Vassily Kandinsky, *Murnau with Church I*, 1910 (plate 31)

Frontispiece: Vassily Kandinsky, Design for the cover of *The Blue Rider* almanac, 1911.
Watercolor over pencil on paper, $10^7/8 \times 8^5/8''$ (27.7 × 21.8 cm).
Städtische Galerie im Lenbachhaus, Munich. (See also plate 52)

Prestel-Verlag
Mandlstrasse 26
D-8000 Munich 40
Federal Republic of Germany

Distributed in continental Europe and Japan by Prestel-Verlag, Verlegerdienst München
GmbH & Co KG, Gutenbergstrasse 1, D-8031 Gilching, Federal Republic of Germany

Distributed in the USA and Canada by te Neues Publishing Company, 15 East 76th Street,
New York, NY 10021, USA

Distributed in the United Kingdom, Ireland, and all other countries by Thames & Hudson
Limited, 30-34 Bloomsbury Street, London WC1B 3QP, England

Offset lithography by Repro Karl Dörfel GmbH, Munich
Composition, printing, and binding by Passavia GmbH, Passau

Printed in the Federal Republic of Germany

ISBN 3-7913-0850-0

Contents

Foreword

The name Blue Rider is closely associated with the Städtische Galerie im Lenbach-
haus, the museum which houses the largest collection of works by the group of
artists who came together in Munich in 1911/12 to promote the cause of Modernism.
Today we regard Vassily Kandinsky and Paul Klee, Alexei Jawlensky and Gabriele
Münter, August Macke, Franz Marc, and the other artists in the Blue Rider circle
as major innovators whose work paved the way for the emergence of a truly
modern art. However, it is important to remember that, at the time when they
were living and working in Munich, these artists were essentially outsiders: critics,
collectors, and the vast majority of other artists either ignored or categorically
rejected their pictures. The history of the subsequent reception accorded the Blue
Rider contrasts sharply with the relative lack of interest shown in the movement
by the contemporary Munich art world.

It is one of history's little ironies that the legacy of Modernism on which the
international reputation of the Städtische Galerie im Lenbachhaus is based should
be housed in the imposing mansion of a painter who, as one of the most influential
figures in the cultural life of Munich at the turn of the century, bitterly opposed
anything which even remotely appeared to herald the dawn of a new era in art (see
fig. 1, p. 11). Franz von Lenbach, one of the highest paid and most popular portrait
painters of his day, was still alive and active at the time when Kandinsky was laying
the foundations for the future. Some fifty years after Lenbach's death in 1904, the
house which he built in the center of Munich became the site of a bizarre encounter
between Historicism and early Modernism.

One of the main factors involved in this encounter was the generous donation
by Gabriele Münter, who had been Kandinsky's mistress and companion during
the time in Munich and had for many years cherished the hope that he would make
good his promise to marry her. This, however, was not to be. As a Russian citizen,
Kandinsky was forced to leave Germany when war broke out in the late summer
of 1914, taking with him only a few of his large-format paintings for exhibition
purposes and leaving behind an extensive collection of medium-sized and smaller
pictures, sketches, studies, books, and furniture, which was entrusted to the care of
Münter. Like so many of his contemporaries, Kandinsky believed that the war
would soon be over and that he would then be able to return to Munich and resume
his life and work, despite the fact that his relationship with Münter had recently
begun to show signs of deterioration. The couple met once more in Stockholm in
1916, but then decided to go their separate ways; shortly afterward, Kandinsky
married Nina Andreevskaya, a much younger woman, in Moscow. Münter, who
was bitterly disappointed, lived for several years in Scandinavia, but eventually
returned to the house in Murnau which she had bought in 1909 and which she had
shared for a time with Kandinsky. The Russian painter, on the other hand, remained
in Moscow until 1921, moving to Weimar the following year to take up a teaching
post at the Bauhaus. Immediately after he arrived back in Germany, Münter claimed
an entitlement to maintenance, but it was not until 1926 that the couple finally
signed a legal agreement dividing up their property. Kandinsky recovered his
books and furniture, together with a number of drawings, watercolors, and major
paintings; the remainder of the works which he had abandoned in Munich was left
to Münter. Until the 1950s few people were aware that she was in possession of
such a rich hoard of pictures.

Shortly after the appointment in 1956 of Hans Konrad Roethel as director of the Städtische Galerie, the museum and the city of Munich received one of the biggest donations of its kind ever made. On the occasion of her eightieth birthday on February 19, 1957, Münter presented Roethel with a collection of over ninety oil paintings by Kandinsky, some three hundred watercolors, tempera paintings, and drawings, twenty-nine sketchbooks with more than two-hundred-and-fifty sketches, twenty-four paintings on glass, a selection of applied art, and a large number of prints in varying states. The collection also included twenty-five of her own paintings, together with a variety of works by her friends from the period preceding World War I. In addition, Münter generously supported the efforts of the Städtische Galerie to purchase further works in order to augment this extraordinary donation, which determined the future direction of the museum's collecting policy. Since the original statutes of the Städtische Galerie, which had not been opened to the public until 1929, stipulated that it should limit its collecting activities to the work of local artists, the wisdom and circumspection of Gabriele Münter was instrumental in the building of its international reputation.

Roethel had not only been inordinately lucky in securing the donation for the city of Munich; he had also worked hard to convince the elderly painter in Murnau that he was the right person to look after this exciting collection of modern art. Münter, who had managed to preserve intact the works left to her by Kandinsky through the duration of the Nazi dictatorship, deliberately chose to donate her precious hoard to a museum which at that time was still relatively small and in which the paintings in her possession would stand out as major examples of early Modernism. She trusted Roethel implicitly as a committed advocate of modern art, and with good reason: his books and essays show that he felt a strong sense of empathy with the protagonists of the Blue Rider and saw himself as under an obligation to make their achievements a guideline for his own activities. From 1957 onward, he regarded it as his main duty to extend and study the collection of works by artists from the circle associated with Münter and Kandinsky.

A particularly important instrument for the achievement of this aim was the Gabriele Münter and Johannes Eichner Foundation, named for the artist and her later companion, which entered into effect in 1966. The Foundation was the sole legal heir of Münter's estate, which included pictures, documents, letters, real estate, and liquid assets. It has since supplied the means to purchase a number of works which are on permanent loan to the Städtische Galerie. The Foundation has also financed the setting-up of a museum in Münter's house in Murnau, which is now open to the public.

In 1965 the Städtische Galerie received a further donation in the shape of the Bernhard Koehler Collection. Bernhard Koehler senior was a Berlin industrialist with a number of factories making printing equipment and other related products. One of his nieces was the wife of August Macke, who introduced Koehler to modern art. Within the space of a few years the entrepreneur acquired a major collection of contemporary paintings, which included works by Paul Cézanne, Vincent Van Gogh, Pierre Bonnard, Paul Gauguin, Henri Matisse, Marc Chagall, Robert Delaunay, and Pablo Picasso, as well as by Marc, Kandinsky, Ferdinand Hodler, Edvard Munch, Emil Nolde, Ernst Ludwig Kirchner, Klee, Münter, and Jawlensky. In 1945 the major part of this exceptional collection was destroyed by an Allied bombing raid on Berlin. The remaining works, which had been put into store in southern Bavaria, were preserved by Bernhard Koehler junior, and in 1965 Elly Koehler presented the museum with a number of important paintings by Jawlensky, Macke, Marc, and Jean Bloé Niestlé.

The museum has since received a small number of further donations and has on occasion used its regular budget to augment the Blue Rider collection. In 1971 it also purchased the Kubin Archive of the Hamburg collector Dr. Kurt Otto, a friend of the artist, who for some fifty years had endeavored to buy every work by Alfred

Kubin that he could lay his hands on. Hence the Städtische Galerie now stands side by side with museums in Linz and Vienna as a major center for research into the work of Kubin, who can also be counted among the members of the Blue Rider circle.

This brief survey of the history of the Blue Rider collection should serve to guard against a possible misunderstanding. This volume does not claim to be a comprehensive history of the Blue Rider: it merely presents a selection of the works in the collection of the Städtische Galerie and attempts to trace some of the main ideas of the artists involved in the Blue Rider circle. The latter was a loose association of artists rather than a coherent group with a definite program. In the summer of 1911 Marc and Kandinsky had conceived the idea of publishing an almanac, which eventually appeared in May 1912 after a considerable delay caused by financial and other problems: titled *Der Blaue Reiter,* it was published by Reinhard Piper. The previous fall, after a rift had arisen in the Neue Künstler-Vereinigung München (New Artists' Association, Munich), a group of Munich artists to which both Kandinsky and Marc belonged, the two artists had decided, in their capacity as editors of the almanac, to organize an exhibition of modern painting, which was held at the Thannhauser gallery in December 1911. It was followed by a second exhibition, of drawings, watercolors, and etchings, at the Kunsthandlung Goltz from February to April of 1912. These two exhibitions and *The Blue Rider* almanac were essentially the work of two like-minded individuals, Kandinsky and Marc, whose endeavors have continued, right up to the present day, to exercise an exceptionally fruitful influence on artists. The reader may well detect a certain bias in the present volume toward the work of these two painters, especially that of Kandinsky. This is to some extent determined by the fact that their art is particularly well represented in the collection of the Lenbachhaus, but it also reflects the significance of their contribution to the Blue Rider.

The book also contains a number of works which were painted some time after the Blue Rider period. Since many of the ideas formulated in the years immediately preceding World War I continued to affect the development of modern art long after the Blue Rider itself had passed into history, it would seem entirely legitimate to include pictures from the 1930s and 1940s by Jawlensky, Kandinsky, and Klee.

I would like to take this opportunity of expressing my gratitude to all the people who have made the publication of this book possible. Particular thanks are due to Annegret Hoberg, for her knowledgeable and sensitive commentaries on the individual pictures, to John Ormrod, for his meticulous translation, and to the publishers, Prestel Verlag, who have taken infinite pains to ensure the highest possible standard of reproduction, book design, and printing.

Armin Zweite

The Blue Rider in Munich

I Munich in 1900

The Blue Rider is virtually synonymous with Munich. In the years immediately preceding World War I the Bavarian capital played a decisive part in the development of twentieth-century art: it was here, unnoticed by the general public, that the avant-garde came together to formulate what became the basis of Modernism. Of the artists associated with the Blue Rider, only one, Franz Marc, was actually born in Munich: Vassily Kandinsky came from Moscow, Marianne von Werefkin and Alexei Jawlensky from St. Petersburg, Paul Klee from Bern, August Macke from Bonn, and Gabriele Münter from Westphalia. In order to understand how this group of artists came into being, it is necessary to take into account the particular status of Munich at the end of the nineteenth century.

Since the reign of King Ludwig I of Bavaria (1825-48), whose ambition it had been to transform Munich into a new Athens, and especially since the International Exhibition of 1869, the city had become a major artistic center. The cultural climate of the 1890s was marked by a variety of conflicting movements. In both literature and art, Naturalism was on the decline: Neo-Idealism and a specifically German variety of Symbolism dominated the artistic scene, bringing to the fore painters such as Arnold Böcklin and Franz von Stuck. The year 1892 saw the emergence of the first Secession movement in the German-speaking world, when a group of Munich artists resigned from the conservative Künstlerverband (Artists' Union) and began to hold their own, independent exhibitions; dispensing with the usual jury, they sought to restore the criterion of artistic quality to its rightful position.

Fig. 1 The Lenbachhaus, Munich. Photograph, c. 1915

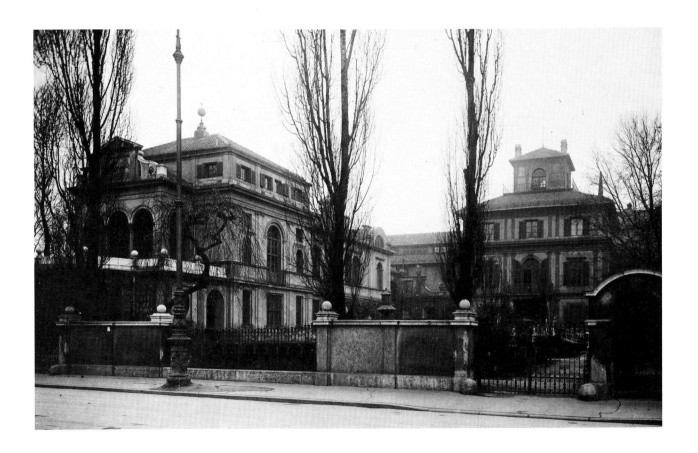

However, this group enjoyed only a short-lived success in its attempts to combat the influence of Historicism, whose leading representative, the immensely popular painter Franz von Lenbach, built himself a palatial town residence (fig. 1). The Secession soon found itself co-opted by the artistic and political establishment; progressive painters, such as Lovis Corinth, Max Slevogt, and Wilhelm Trübner, were denied a voice and left the group. From 1896 *Simplicissimus* was joined by another Munich magazine, *Jugend* (fig. 2), which gave its name to the German equivalent of Art Nouveau, *Jugendstil*. This new movement numbered such artists as August Endell, Hermann Obrist, Otto Eckmann, Richard Riemerschmid, and Bernhard Pankok among its protagonists. The first major showing of *Jugendstil* art, at the 1897 "Internationale Kunstausstellung" in the Munich Glaspalast, attracted a considerable amount of attention; however, the artists involved failed to gain the long-term support of the Munich public.

Despite the evidence of hopeful signs for the future, a number of critics detected symptoms of a degeneration of art in Munich. Toward the end of the century, Munich's status as the artistic capital of Germany was increasingly threatened by the more cosmopolitan city of Berlin, where major artists, writers, and musicians were congregating in growing numbers. As early as the 1880s, Bavaria was described as "the land of missed opportunities"; and around 1900 intellectuals began to think about ways of halting the cultural decline of the region. The village-like intimacy of Schwabing, the artists' quarter of Munich, was seen by many artists as a preferable alternative to the urban anonymity of Berlin. In his autobiography, *Jahrhundertwende* (*Turn of the Century*), the poet Max Halbe described the Bavarian capital as follows:

In 1895 Munich was, on the whole, a peaceful, leisurely place. Its population totalled around 400,000, about the same as Cologne, Leipzig, Dresden, and Breslau [Wroclaw], but it was nowhere near as lively or as busy as these cities. The broad Ludwigstrasse, with its monotonous classical architecture, the deserted Odeonsplatz, the quiet Residenzstrasse, and the sleepy Max-Josephs-Platz exuded the atmosphere of a medium-sized provincial town from a bygone era. Politically, Munich was living in the past, but it had an attractive human warmth, contenting itself with the quiet enjoyment of life's simpler pleasures.

The principal goal of the majority of artists who came to Munich was to acquire a solid grounding in artistic technique. In this respect, Munich was seen by many artists as a more attractive city than Paris, despite the latter's reputation as a center of innovation. The painter Leonid Pasternak compared the two cities: "Paris is a seething cauldron, and Munich a quiet, peaceful German city which some may have found boring. But as far as artistic training was concerned, it had a lot to offer: the people there knew how to paint, and that is the main thing, the paramount consideration." When artists headed west from St. Petersburg, Moscow, Prague, or Zagreb, they went either to Paris or to Munich; even Picasso toyed for a time with the idea of settling in Munich rather than Paris.

Hence there were good reasons for Jawlensky, Kandinsky, Werefkin, and others to head for Munich. On first acquaintance the city appeared far more attractive than it did to artists who had been living there for some time. A further factor which may have influenced their decision was the presence in Munich of a sizeable Russian community, composed largely of aristocrats and members of the wealthy bourgeoisie, but also including political exiles, such as Lenin, who lived in the city for several years.

The initial enthusiasm of most of the artists who came from outside Munich gradually gave way to a mood of disenchantment, which they sought to alleviate by banding together in small, close-knit groups of like-minded individuals. Although their attitude to the established visual culture of Munich was highly skeptical, they saw the city as offering a considerable range of opportunities for them to pursue their own interests. With its large international bohemian population, its galleries, museums, publishing houses, theaters, and orchestras, Munich had a cultural infrastructure which artists could exploit for their own purposes with less fear of

Fig. 2 Josef Rudolf Witzel, Cover for *Jugend*, vol. 1, no. 16 (April 18, 1896). Color lithograph, $10^5/_8 \times 7^5/_8''$ (27 × 19.3 cm). Städtische Galerie im Lenbach-haus, Munich

competition from other avant-garde movements than in the hothouse atmosphere of Paris. Romantic and idealistic as some of the artists associated with the Blue Rider may seem, their attitude to the realization of their aims was often characterized by hard-headed pragmatism. Kandinsky, in particular, was quick to recognize the mechanisms involved in the marketing of art. He realized from the outset, for example, that manifestos and aesthetic programs were just as important as works of art themselves. It was in accordance with this principle that the editors of the almanac *Der Blaue Reiter* (*The Blue Rider*) cited themselves as the official organizers of the exhibition at the Thannhauser gallery in 1911/12, although in fact the genesis of the exhibition owed more to accident than to design. We shall later be looking more closely at this central episode of the Blue Rider story. Let us turn first, however, to Kandinsky himself, the man whose theories and pictures played such a decisive part in the development of twentieth-century art.

Kandinsky was born in Moscow in 1866; five years later his family moved to Odessa, where he grew up. In 1886 he returned to Moscow to study economics, law, and ethnology. After finishing his studies, he worked for a time as the artistic director of a Moscow printing firm. In 1896 he was offered a teaching post at the University of Dorpat in Estonia, but he decided instead to go to Munich to study painting. In his autobiographical *Rückblicke* (*Reminiscences*) of 1913, Kandinsky spoke of the reasons for this decision to abandon a promising academic career in favor of art: "I loved all these sciences, and today I still think with gratitude of the enthusiasm and perhaps inspiration which they afforded me. Yet these hours paled into insignificance at my first contact with art, which alone had the power of transporting me beyond time and space. Never had scientific work given me such experiences, inner tensions, creative moments." Two events in particular influenced Kandinsky's change of direction: his first encounter with French Impressionism in the shape of one of Claude Monet's *Haystacks,* which he saw in an exhibition in Moscow, and the experience of seeing Richard Wagner's opera *Lohengrin.* Wagner's concept of the *Gesamtkunstwerk* (total work of art), fusing different forms of art to create a powerful total effect, led Kandinsky to realize that "art in general was far more powerful than I had thought, and ... that painting could develop just such powers as music possesses." And so, at the age of thirty, Kandinsky abandoned academic work, which he had come to regard as "forced labor," and traveled from Moscow to Munich, feeling, he later wrote, "as if I had been born again."

A number of other Russian artists came to Munich at about the same time as Kandinsky. In addition to such lesser-known figures as Mstislav Dobushinsky, Kuzma Petrov-Vodkin, Vladimir and David Burliuk, Vladimir Bechtejev, Alexander von Salzmann, Moissei Kogan, Alexander Mogilevski, and Alexander Sacharoff, this group of artists included Werefkin and Jawlensky, who subsequently played a prominent part in artistic developments in Munich. Unlike Kandinsky, Werefkin and Jawlensky had both received a thorough training in artistic technique. Werefkin, the daughter of the commandant of the Peter and Paul Fortress in St. Petersburg, had already acquired a certain reputation as a painter in the realist manner and had taken part in a number of exhibitions. She was highly educated, exceptionally well-read, and endowed with a keen intelligence; while still in Russia she had begun to reject both the philosophy of Positivism, which dominated Russian intellectual life at the time, and the Social Realist painting of the "Wanderer" school, headed by Ilya Repin, Jawlensky's and Werefkin's one-time teacher and friend. There can be no doubt that Werefkin, who took it upon herself to encourage Jawlensky's talent, was the dominant partner in the relationship. When her father died in 1896, she decided to move to Germany, taking Jawlensky with her; the couple was also accompanied by Igor Grabar and Dmitry Kardovsky, Werefkin's erstwhile colleagues at the Moscow Academy. As the unmarried daughter of a general, Werefkin was granted a pension which provided her and Jawlensky with a guaranteed income until payments ceased with the Revolution. Thus a Russian colony began to form

Fig. 3 Franz von Stuck, *Fighting
Amazon*, 1897. Oil and tempera on
wood, $19^5/_8 \times 17^3/_8''$ (50×44 cm).
Münchner Secessionsgalerie,
Munich

Fig. 4 Vassily Kandinsky,
English Garden in Munich, 1901.
Oil on canvasboard, $9^3/_8 \times 12^3/_4''$
(23.7×32.3 cm). Städtische Galerie
im Lenbachhaus, Munich

in Munich, congregating regularly in Werefkin's salon at No. 23 Giselastrasse in
Schwabing. Politics seems to have played very little part in the discussions of this
group, whose main energies were focused on the elaboration of a new visionary
world view influenced by Russian Symbolism. These meetings were dominated by
the lively, forceful personality of Werefkin, who was considerably older than most
of her Russian friends.

In leaving Russia and moving to the West, these artists and intellectuals were
following a long-established tradition among the nineteenth-century Russian intelli-
gentsia, many of whose members had either found themselves unable to pursue
their chosen career in their native country or had been forced to emigrate for
political reasons. The work of such painters as Kandinsky and Jawlensky has an
important place in the history of German Expressionism, but it also has a bearing
on the development of Russian art. The émigré artists in Munich continued to take
a lively interest in the Russian art scene, participating in exhibitions, contributing
to Russian periodicals, and traveling regularly to Moscow and St. Petersburg.

Like Jawlensky and a number of his fellow artists, Kandinsky initially attended
the private school of painting run by the Slovenian artist Anton Ažbe. Subsequently
he became a pupil of Stuck (see fig. 3), but he remained largely aloof from the
academic establishment. In his early years in Munich he worked extremely hard:

Days on which I did not work (rare though they were!) I considered wasted, and tormented
myself on their account. If the weather was at all decent, I would paint every day for an hour or
two, mostly in the old part of Schwabing, which was then slowly becoming a suburb of Munich.
At a time when I was disappointed with my studio work and the pictures painted from memory,
I painted large numbers of landscapes, which nevertheless gave me little satisfaction, so that later
there were very few of them I worked into pictures In my studies, I let myself go. I had little
thought of houses and trees, drawing colored lines and blobs on the canvas with my palette knife,
making them sing just as powerfully as I knew how. Within me sounded Moscow's evening hour,
but before my eyes was the brightly colored atmosphere of Munich, saturated with light, its scale
of values sounding thunderous depths in the shadows.

The free use of color described here is documeted in a number of early works,
dating from 1900 onward and painted mainly on small pieces of cardboard, which
allowed Kandinsky to dispense with an easel. An example of this phase in Kandin-
sky's creative development is *Englischer Garten in München* (*English Garden in Munich*;
fig. 4). Using pure colors applied with a palette knife, Kandinsky created a pointillist
effect reminiscent of Neo-Impressionism. Many commentators have also pointed
to Kandinsky's familiarity with Munich *Jugendstil* as a possible influence on the
direction of his work: his circle of acquaintances included some of the most promi-
nent *Jugendstil* artists, among them Hermann Obrist.

Although Kandinsky's work still remained largely unknown and unappreciated, he soon began to involve himself in a wide range of organizational and educational activities connected with art. He was the president and leading light of Phalanx, an association of Munich artists founded in 1901 whose exhibitions featured works by such artists as Monet, Alfred Kubin, and the French Neo-Impressionists (fig. 5). From the 1890s onward, the majority of the exhibitions of modern, innovative art held in Munich were organized by societies of this kind, following the example of the Munich Secession (fig. 6). Through his activities in connection with the Phalanx association Kandinsky exercised a stimulating influence on artistic life in Munich. At the same time he also began to devote a considerable part of his energies to the teaching of art, not for financial reasons but as a means of propagating his own ideas and principles.

In 1902, while teaching at the Phalanx school, Kandinsky made the acquaintance of Gabriele Münter, who was soon to become one of the most important German women artists of her time. At the turn of the century, women were still excluded from the Munich Academy of Fine Arts, and the only form of academic training open to them was at private art schools. Münter, who had grown up in Berlin and

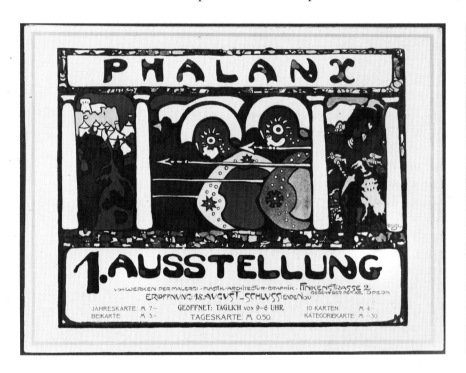

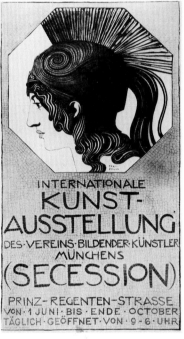

Fig. 5 Vassily Kandinsky, Poster for the first Phalanx exhibition, 1901. Color lithograph on paper, 18⅝ × 23¾″ (47.3 × 60.3 cm). Städtische Galerie im Lenbachhaus, Munich

Fig. 6 Franz von Stuck, Poster for the International Art Exhibition of the Munich Secession, 1893. Color lithograph on paper, 24¼ × 14⅛″ (61.5 × 36 cm). Stadtmuseum, Munich

Westphalia, had begun to study art with a private teacher in Düsseldorf in 1897, but soon grew bored with the lessons, which mainly involved drawing from plaster ornaments. Family reasons obliged her to spend two years in America, after which she decided to move to Munich. After trying out a number of teachers, she began attending the Phalanx school in 1901 and soon became an enthusiastic pupil of Kandinsky, who was a painstaking and sensitive instructor. In accordance with the common practice of the time, he frequently took his classes on outdoor painting expeditions, cycling out into the countryside to paint in the open air (figs. 7, 8). In the course of time Kandinsky and Münter became lovers. Since Kandinsky had married one of his cousins in 1892, the couple's relationship was problematical from the outset, but it nevertheless lasted until the outbreak of World War I. The Phalanx school closed down in 1904 as a result of financial difficulties.

Kandinsky's oeuvre up to 1904 is dominated by landscape and the human figure. Especially the woodcuts and the studies in tempera and crayon, with their strange,

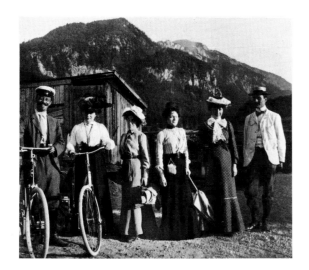

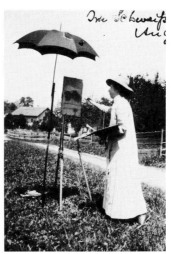

archaic settings, contain an exceptional wealth of narrative ideas. The horsemen, knights in armor, and couples in medieval costume in pictures such as *Altes Städtchen* (*Little Old Town*; fig. 9) point to Kandinsky's fondness for fairy tales and ancient legends, a penchant clearly documented by the woodcuts *Die Nacht* (*Night*; fig. 10) and *Der Abschied* (*The Farewell*; fig. 11), both of which date from 1903. The most remarkable feature of these and many comparable works is that they are not based directly on a literary model; instead, Kandinsky uses the figures and their surroundings to convey a general atmosphere, a fairy-tale mood composed of vague allusions and associations which bears a marked similarity to Symbolist art. Kandinsky's obvious points of reference include Wagner's operas and the poetry and plays of Maurice Maeterlinck, to whom Kandinsky repeatedly refers in his writings. In the field of painting there are affinities between the work of Kandinsky and that of Maurice Denis, Charles Guérin, and several Russian artists, such as Nikolai K. Rerich, Alexander Benois, Constantin Somoff, and Ivan Bilibin. Whether or not any of these artists influenced Kandinsky directly is difficult to prove, but there can be no doubt that the motifs of his early work follow a general

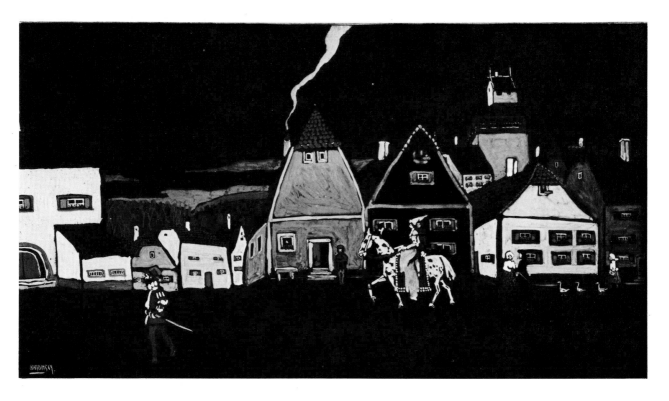

Fig. 10 Vassily Kandinsky, *Night (Large Version)*, 1903. Color woodcut on paper, 11³/₄ × 4⁷/₈″ (29.8 × 12.5 cm). Städtische Galerie im Lenbachhaus, Munich

Fig. 11 Vassily Kandinsky, *Farewell (Large Version)*, 1903. Color woodcut on paper, 12¹/₈ × 12″ (30.8 × 30.4 cm). Städtische Galerie im Lenbachhaus, Munich

European trend. The pictures from this period suggest an abandonment of the present in favor of a distant, dreamlike past; the gently oscillating *Jugendstil* lines and the contrast between brilliant colors and dark grounds indicate a high degree of formal awareness. Kandinsky's repertoire of archaic themes also includes motifs taken from the Rococo and Biedermeier periods. Although these pictures constitute a transitional phase in Kandinsky's development, one already detects, in their use of metaphor, the beginnings of a move away from representation and toward abstraction.

During the parallels between Kandinsky's work in this period and that of other European artists, his style and choice of subject matter displayed a considerable measure of inventiveness and originality. Münter and Jawlensky, on the other hand, were at this point still grappling with Impressionism and its avatars and, in Münter's case, also with large-scale figure painting (see fig. 12). For a time Jawlensky took Van Gogh as his artistic model. Werefkin had abandoned art altogether when she and Jawlensky moved to Munich: it was not until 1906, after a ten-year break, that she began once more to draw and paint.

During his early years in Munich, Kandinsky almost certainly came into contact with a large number of intellectuals and artists; however, there is no record of any particular friendships. In 1904 he was seized by a feeling of restlessness and began to travel extensively. He went with Münter to Holland in the summer of 1904 and to Tunis in the winter of 1904/05 (figs. 13, 14); the couple also stayed for brief periods in Innsbruck, Starnberg near Munich, and Dresden. At the end of 1905 he visited the Riviera and spent several months in Rapallo. From June 1906 to June 1907 Kandinsky and Münter lived in Sèvres, near Paris (fig. 15), subsequently traveling to Switzerland and South Tyrol. In September 1908 they returned to Munich and moved into an apartment in Schwabing. In the course of his travels Kandinsky made a large number of international contacts, while his work as a painter was finding growing recognition. Several exhibitions of his paintings and gouaches were held in Germany, and he also exhibited at the Paris Salon des Indépendents and Salon d'Automne. At the time when he was living near Paris the scandal surrounding the Fauves was still fresh in the memory of the public. It is likely that Kandinsky took a particular interest in the work of Henri Matisse, whom he repeatedly commended in his later writings as one of the most important painters of his time. The Fauves' use of color as an expressive value in its own right

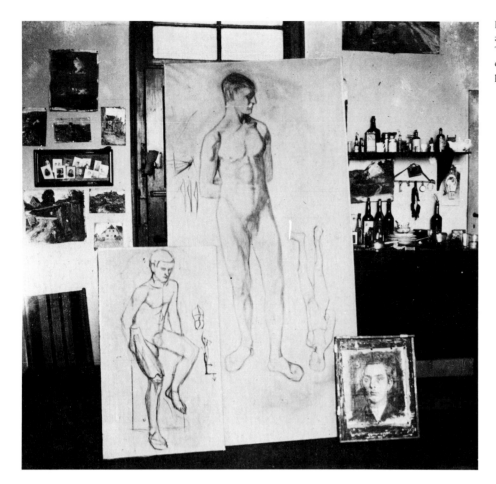

undoubtedly influenced Kandinsky in his decision to devote the major part of his energies to landscape painting, using this genre to experiment with new techniques.

During this period, Jawlensky's style, too, was progressing and evolving. To some extent, this may have been due to the ideas and suggestions of Werefkin, but the main stimulus to his creative development was the experience of seeing the originals of works by French painters. In 1903 he visited Normandy and Paris, but it was not until 1905, when he lived and worked for a time in Brittany, that the stylistic breakthrough occurred which was to determine the future course of his

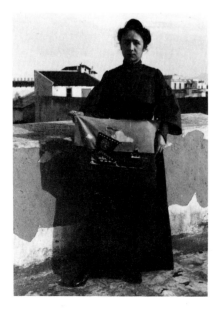

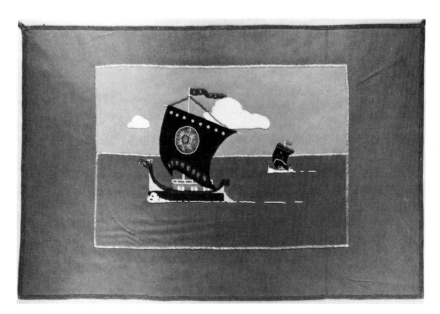

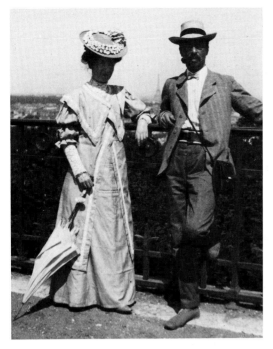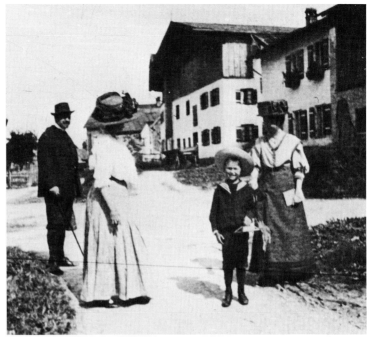

Fig. 15 Gabriele Münter and
Vassily Kandinsky. Sèvres, 1906

Fig. 16 From left to right:
Alexei Jawlensky, Marianne von
Werefkin, Jawlensky's son Andreas,
and Gabriele Münter. Murnau,
1908.

artistic development. In Brittany he painted a series of brightly colored landscapes and portraits (see plate 74) which exhibit a high degree of formal simplification. Of these works Jawlensky wrote: "The colors positively glowed, and I felt inwardly satisfied. Ten of the pictures were exhibited in September of that year in the Russian section of the Salon d'Automne." Shortly after this he made the acquaintance of Matisse in Paris and visited Ferdinand Hodler in Geneva. Jawlensky's friendship with the Benedictine monk and artist Willibrord Verkade, with whom he shared a studio for several months in 1907, also played a significant part in determining the direction of his work. Verkade, a pupil of Paul Gauguin, and Paul Sérusier, who spent the winter of 1907/08 in Munich, encouraged Jawlensky in his attempts to simplify the compositional structure of his pictures and to enhance the effect of their forms by using dark contours. The works from this period show the influence of Gauguin's *cloisonnisme* and the powerful style of Van Gogh: Jawlensky bought a Van Gogh landscape at a Munich exhibition in 1908. Matisse's ornamental configurations of color also left a deep impression on Jawlensky's approach to painting.

III Murnau, 1908

Münter, Werefkin, Kandinsky, and Jawlensky had already met on numerous occasions and knew each other well, but it was not until 1908 that the encounter took place which led them to embark on their highly fruitful exercise in artistic cooperation. In the spring of that year Münter and Kandinsky had paid a visit to the small market town of Murnau, some forty miles south of Munich in the Alpine foothills, and had been captivated by the town, with its brightly painted houses, and by the surrounding countryside. They communicated their enthusiasm to Werefkin and Jawlensky, who decided to spend that summer in Murnau. Soon after their arrival, Werefkin and Jawlensky wrote to Kandinsky and suggested that he and Münter should come and join them (fig. 16). After traveling for a while around southern Bavaria and the Salzkammergut in northern Austria, Kandinsky and Münter arrived in Murnau in mid-August and took rooms for six weeks at the Gasthof Griesbräu. In 1911 Münter described the summer in Murnau as follows:

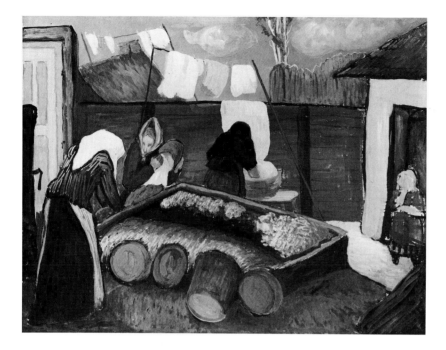

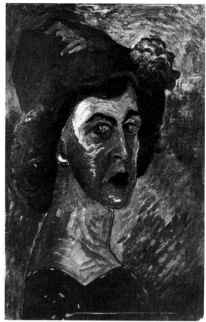

After a short period of agony I took a great leap forward, from copying nature – in a more or less Impressionist style – to abstraction, feeling the content, the essence of things. It was an interesting, cheerful time; we had lots of conversations about art with the enthusiastic "Giselists" [the nickname for Werefkin and Jawlensky, who lived on Munich's Giselastrasse]. I particularly enjoyed showing my work to Jawlensky, who praised it lavishly and also explained a number of things to me: he gave me the benefit of his wide experience and talked about "synthesis." He is a good colleague. All four of us were keenly ambitious, and each of us made progress We all worked very hard. Since then, Kandinsky's work has progressed miraculously.

The accuracy of this account is confirmed by the pictures which the four artists painted in Murnau. Münter's *Jawlensky and Werefkin* (plate 58) documents her striving for artistic originality, in which she was particularly encouraged by Jawlensky. The latter's *Murnau Landscape* (plate 79) relies on a limited number of strong colors; the street, the trees, the telegraph poles, and the mountains are framed by dark contours which heighten their expressiveness. Jawlensky borrowed this stylistic device from the Pont-Aven painters, especially Gauguin and Emile Bernard. Werefkin's paintings from this period (see figs. 17, 18) are more subdued, and continue to use color in a strictly representational manner rather than adopting the freer approach of her fellow artists: one detects obvious echoes of Symbolism in her work.

Fig. 17 Marianne von Werefkin, *Washerwomen*, c. 1909. Tempera on cardboard, $19^7/_8 \times 25^1/_4''$ (50.5 × 64 cm). Städtische Galerie im Lenbachhaus, Munich

Fig. 18 Marianne von Werefkin, *Self-Portrait I*, c. 1910. Oil on cardboard, $20^1/_8 \times 13^3/_8''$ (51 × 34 cm). Städtische Galerie im Lenbachhaus, Munich

Fig. 19 Gabriele Münter painting. Kochel, 1909. *Tombstones in Kochel* (plate 61) is on the easel. Photograph by Vassily Kandinsky

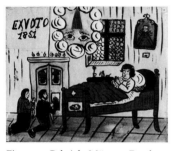

Fig. 20 Gabriele Münter, *Death of a Saint*, c. 1909. Painting on glass, 10⁷/8 × 7¹/2″ (27.5 × 19 cm). Copy of an early nineteenth-century Bavarian mirror painting which was illustrated in *The Blue Rider* almanac. Gabriele Münter and Johannes Eichner Foundation, Munich

Fig. 21 Gabriele Münter, *Ex voto 1851*, c. 1909. Painting on glass, 8 × 4⁷/8″ (20.4 × 12.5 cm). Copy of a painting on glass by the Bavarian folk artist Heinrich Rambold. Gabriele Münter and Johannes Eichner Foundation, Munich

Kandinsky was content for a time to follow the lead of Jawlensky, whose position in the summer of 1908 was the most advanced in the group. However, in his remarkable landscape studies, Kandinsky soon began to dissolve the surface appearance of reality, liberating color almost entirely from any representational function and thus going way beyond the intentions of Jawlensky, whose idea of "synthesis" meant, above all, simplification. Whereas Kandinsky's Murnau landscapes represent an important step on the road toward total abstraction, the work of Jawlensky from the period 1908/09 continued in a representational vein, while encompassing a greater degree of stylization.

Kandinsky's preference for bright, glowing colors is exemplified by *Nature Study from Murnau III* and *Before the City* (plates 24, 20). In the latter work the color is applied in such a way that the surface of the picture appears to vibrate, and the individual motifs blend into one another: the group of figures in the foreground is partially camouflaged by the surrounding foliage.

In the first instance it was Jawlensky who supplied the innovative impetus behind the group. His ideas had a genuinely liberating effect on Münter (fig. 19) and also encouraged Kandinsky to change tack and begin experimenting with techniques which were to take him a stage further than his Russian compatriot. The avant-garde tendencies of the group were counterbalanced by a further element which exercised a particular influence on the work of Kandinsky. It was Münter who drew the attention of her friends to Bavarian folk art and suggested that they should study traditional methods of painting (see figs. 20, 21). The subject failed to interest Jawlensky, and Werefkin restricted herself to a few half-hearted exercises in the use of folk-art techniques. For Kandinsky, however, a whole new world opened up, the discovery of which was to have far-reaching formal and iconographical consequences for his own work. In view of the importance of this discovery it would seem appropriate to offer a few brief comments on the subject.

Before World War I the tradition of *Hinterglasmalerei* (painting on glass) was still very much alive in Murnau, although its originality had suffered through the encroachments of tourism. Especially in Munich, folk art was becoming the object of serious attention on the part of writers and museums. Kandinsky's *Reminiscences* contains an account of his expedition in 1889 to the province of Vologda in northern Russia, where, for the first time, he encountered examples of folk art which impressed him just as deeply as the pictures of Rembrandt or Monet: "I made many sketches – these tables and various ornaments. They were never petty, and so strongly painted that the object within them became dissolved." Precisely this phenomenon – the dissolution of the concrete and the superimposition of different

Fig. 22 *House*, children's drawing. Crayon and pencil on paper, 9³/8 × 7³/4″ (23.9 × 19.8 cm). Gabriele Münter and Johannes Eichner Foundation, Munich

Fig. 23 Gabriele Münter, *House*, 1914. Oil on cardboard, 16 × 12³/4″ (40.5 × 32.5 cm). Gabriele Münter and Johannes Eichner Foundation, Munich

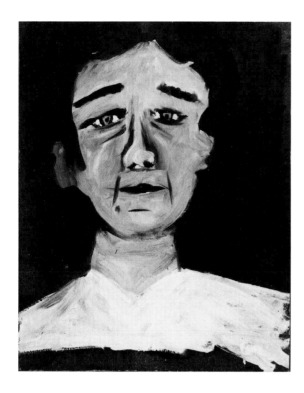

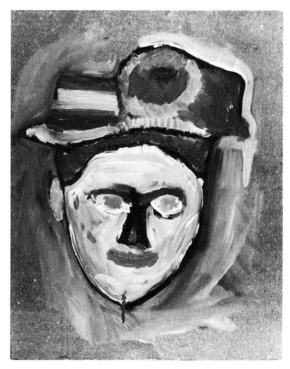

layers of reality – was the problem with which Kandinsky was grappling in his own painting at this time; hence it is understandable that he should have been interested in Bavarian folk art.

This interest has to be seen in the general context of European avant-garde art at the turn of the century. In their search for an immediate form of expression untainted by civilization, painters and sculptors were increasingly looking to "primitive" and naive art, to the art of children and the mentally ill, as a source of fresh ideas. The Cubists, for example, drew part of their inspiration from African sculptures and masks. The members of the Brücke group were interested in Polynesian cult objects and customs. Following the trend of the time, Jawlensky owned a

Fig. 24 Amateur painter, *Portrait of Gabriele Münter*, c. 1909. Oil on cardboard, 16 × 12³/₄″ (40.5 × 32.5 cm). Gabriele Münter and Johannes Eichner Foundation, Munich. The portrait, by Münter's sister Emmy, was illustrated in *The Blue Rider* almanac

Fig. 25 Anonymous, *Portrait of a Woman*, 1909. Oil on cardboard, 16 × 12³/₄″ (40.5 × 32.5 cm). Gabriele Münter and Johannes Eichner Foundation, Munich. This work by an amateur American painter was illustrated in *The Blue Rider* almanac

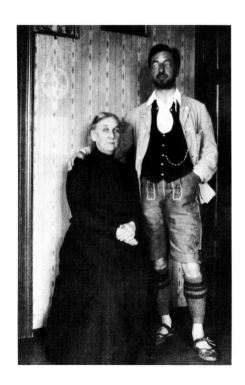

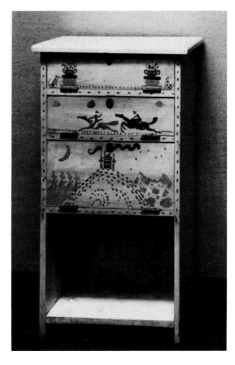

Fig. 26 Vassily Kandinsky, in Bavarian costume, with his mother. Murnau, c. 1910/11

Fig. 27 Wooden cupboard, 39³/₈ × 22 × 12¹/₄″ (100 × 56 × 31 cm). Painted by Kandinsky, c. 1910/11. Gabriele Münter and Johannes Eichner Foundation, Munich

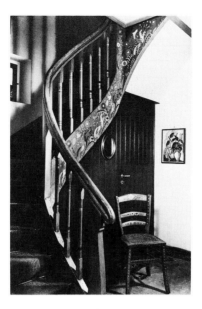

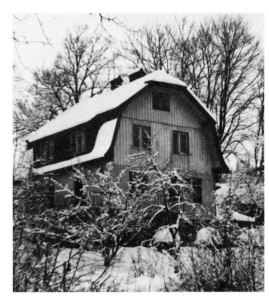

Fig. 28 Staircase and chair in Kandinsky's and Münter's house in Murnau. Painted by Kandinsky, c. 1910/11

Fig. 29 Kandinsky's and Münter's house in Murnau, nicknamed the "Russians' House" by the local inhabitants

Fig. 30 The dining room of Kandinsky's and Münter's house in Murnau, c. 1913. Paintings on glass by Kandinsky can be seen on the wall

Fig. 31 Gabriele Münter, *Interior*, c. 1910. Oil on cardboard, $28 \times 20^7/_8''$ (71 × 53 cm). Gabriele Münter and Johannes Eichner Foundation, Munich. The painting depicts rooms on the top floor of Kandinsky's and Münter's house in Murnau; Kandinsky can be seen in bed through the open door

number of Japanese woodcuts, while Münter and Kandinsky began to assemble a collection of children's drawings which still exists today (see figs. 22-25). Throughout western Europe, in Paris, Dresden, and Munich, the formal vocabulary of exotic and "primitive" art was regarded as a means of sabotaging outdated academic traditions and injecting new life into painting and sculpture. The extent of Kandinsky's primitivist interests can be gauged from his work and activities in the period up to 1914. He copied the customs of the Bavarian peasantry, wearing traditional Bavarian costume when he was staying in Murnau and painting folk-art designs on the furniture in the small house which Münter bought at the edge of the town (figs. 26-31). Activities of this kind corresponded to the attempts of Kandinsky and other artists to set a new tone in the cultural life of Munich.

Münter condensed her own innovative endeavors and those of her friends into the simple formula "abstraction, feeling the content, the essence of things" in place of the "Impressionist copying of nature." These popular slogans of the time are also to be found in the circular distributed by the Neue Künstler-Vereinigung München at the time of its foundation.

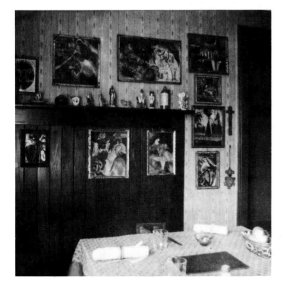

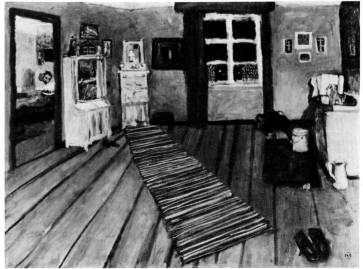

IV The Neue Künstler-Vereinigung München

Although there is no firm documentary evidence to this effect, it seems reasonable to suppose that while in Murnau the four artists conceived the idea of exhibiting the fruits of their labors and of joining forces to propagate their views. Although Jawlensky had been living in Munich for over ten years, his work was still unknown outside a small circle of connoisseurs and had been consistently ignored by the official institutions of the art world. Werefkin had only recently resumed her artistic activities, while Münter and Kandinsky, who had been away from Munich for several years, were somewhat out of touch with the gallery and exhibition scene. The only one of the four who had any experience of organizing exhibitions was Kandinsky: between 1901 and 1904 he had mounted several exhibitions in connection with the Phalanx school, featuring pictures by *Jugendstil* artists and painters, such as Corinth, Trübner, Axel Gallen-Kallela and Albert Weisgerber, and works by Monet, Kubin, Paul Signac, and Henri Toulouse-Lautrec. It is not known precisely who took the lead in founding the Neue Künstler-Vereinigung München (New Artists' Association, Munich), a union of like-minded artists bent on securing greater public recognition for their work. The new association was almost certainly modeled on the Secession movements, which in the past had played an important part in promoting new art in the face of opposition from the academic establishment. Initially, the leading light of the association was Jawlensky: Werefkin and his friends Alexander Kanoldt and Adolf Erbslöh (see fig. 32) pleaded with him to accept the chairmanship. However, when the Neue Künstler-Vereinigung München was entered in the official city register of clubs and associations on January 22, 1909, the chairman was named as Kandinsky: as Münter later wrote, "nobody else could do the job." In addition to Kandinsky, Münter, Jawlensky, and Werefkin, the members of the association included committed lovers of art, such as Oskar Wittenstein and Heinz Schnabel. In the course of the following year they were joined by, among

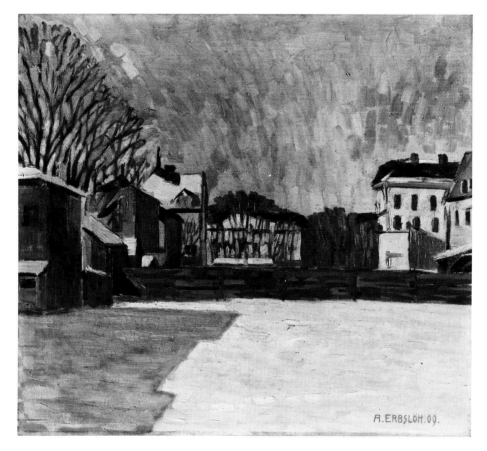

Fig. 32 Adolf Erbslöh, *March Sun*, 1909. Oil on canvas, $18^{1}/_{2} \times 20^{1}/_{2}''$ (47 × 52 cm). On permanent loan to the Städtische Galerie im Lenbachhaus, Munich. The painting was shown at the first exhibition of the Neue Künstler-Vereinigung München

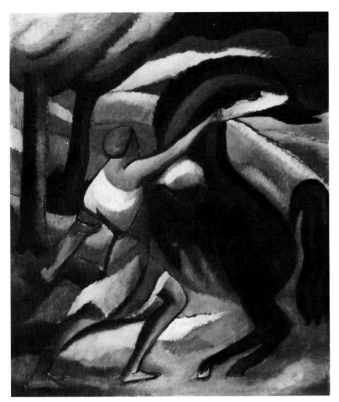 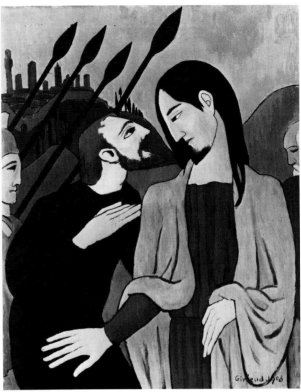

Fig. 33 Vladimir von Bechtejev, *Horse Tamer*, c. 1912. Oil on canvas, 43¹/₄ × 37″ (110 × 94 cm). Städtische Galerie im Lenbachhaus, Munich

Fig. 34 Pierre Girieud, *Judas*, 1908. Oil on canvas, 36³/₈ × 28³/₄″ (92.3 × 73 cm). Gabriele Münter and Johannes Eichner Foundation, Munich. The painting was shown at the first exhibition of the Neue Künstler-Vereinigung München

others, Bechtejev, Kogan, Paul Baum, Pierre Girieud, Karl Hofer, and Erma Bossi (see figs. 33-35). The composition of the association was heterogeneous in the extreme: alongside Neo-Impressionists, such as Baum, there was Girieud, who practiced an etiolated form of Symbolism. In terms of both theory and practice, the most radical members of the group were Jawlensky and Kandinsky, notwithstanding the parallels which can be detected between their work at this time and that of Erbslöh and Kanoldt. It was unquestionably the Russian artists whose voice carried the most weight, and it was they who formulated the founding manifesto, which contains the following general statement of their aims: "Our point of departure is the belief that the artist, apart from those impressions which he receives from the world of external appearances, continually accumulates experiences within his own inner world. We seek artistic forms that express the reciprocal permeation of all these experiences – forms that must be freed from everything incidental, in order to pronounce powerfully only that which is necessary – in short, artistic synthesis. This seems to us a solution that is once again uniting in spirit an increasing number of artists."

Modernism arrived in Munich in a series of waves: before the Blue Rider, it was the Neue Künstler-Vereinigung which provided a forum for avant-garde ideas. Jawlensky's pet notion of "synthesis" became the main slogan of the group. This term was one of the most overworked aesthetic catchphrases of the day, and its meanings are legion: it served as a general byword for artistic unity, harmonious composition, the coherence of forms and colors, and suchlike desiderata. The popularity of the term dates back to the Paris exhibition of the Groupe Impressioniste et Synthésiste in 1890, following which Gauguin adopted the motto "Vive la sintaize!" As used by Jawlensky, "synthesis" denoted a general aim which had been embraced by a number of French artists: the aim of blending external impressions with inner experience, using forms which break loose from nature, which are free of extraneous detail, and "pronounce powerfully only that which is necessary."

The Neue Künstler-Vereinigung was founded in January 1909, but its first exhibition did not take place until the end of the year. In an article published in the Russian art journal *Apollon* on October 3, 1909, Kandinsky outlined the problems

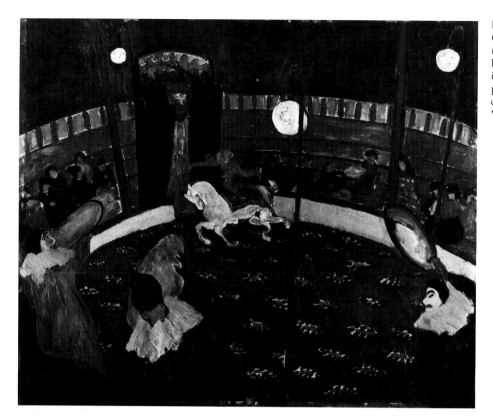

facing the association: "When I returned to Munich a year ago, I found everything still in the same old place. And I thought: this really is that fairy kingdom in which pictures sleep on the walls, the custodians in their corners, the public with their catalogues in their hands, the Munich artists with their same broad Munich brushstrokes, the critics with their pens between their teeth. And the buyer, who in former times went indefatigably with his money into the secretary's office – he too, as in the story, has been overcome by sleep on the way, and left rooted to the spot."

Refusing to be discouraged by the inertia of the Munich art world, Kandinsky endeavored to enlist the support of Hugo von Tschudi, the newly appointed director of the Bavarian state art collection whose strong interest in modern art had caused him to be dismissed from his previous post at the Nationalgalerie in Berlin. Tschudi in turn drew the Neue Künstler-Vereinigung to the attention of the art dealer Franz Joseph Brakl. However, it was not Brakl but the well-known dealer Heinrich Thannhauser who staged the first exhibition of works by members of the Neue Künstler-Vereinigung at his Moderne Galerie in the Palais Arco on Theatinerstrasse, one of Munich's most prestigious shopping streets. The exhibition opened on December 1, 1909, and ran for two weeks (see figs. 36, 37); in the following year it went on tour to Brünn (Brno), Elberfeld-Barmen, Hamburg, Düsseldorf, Wiesbaden, Schwerin, and Frankfurt, where it was shown in both private galleries and public museums. Despite the largely negative and, in some instances, positively venomous reactions of the press, the exhibition was a remarkable success.

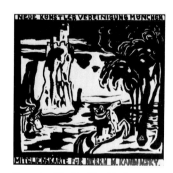

Whereas participation in this first project had been limited to artists living in Munich, the second exhibition of the Neue Künstler-Vereinigung, held at the Thannhauser gallery from September 1 to 14, 1910 also featured works by a number of artists of international repute, including Georges Braque, André Derain, Kees van Dongen, Henri Le Fauconnier, Picasso, Georges Rouault, Maurice Vlaminck, and David and Vladimir Burliuk (see fig. 38). The pictures of Erbslöh, Jawlensky, Kandinsky, Kanoldt, Kubin, Münter, and Werefkin thus had to prove their worth in the face of stiff competition. Kandinsky, as the chairman of the association, had taken charge of making the necessary contacts and had persuaded Le Fauconnier,

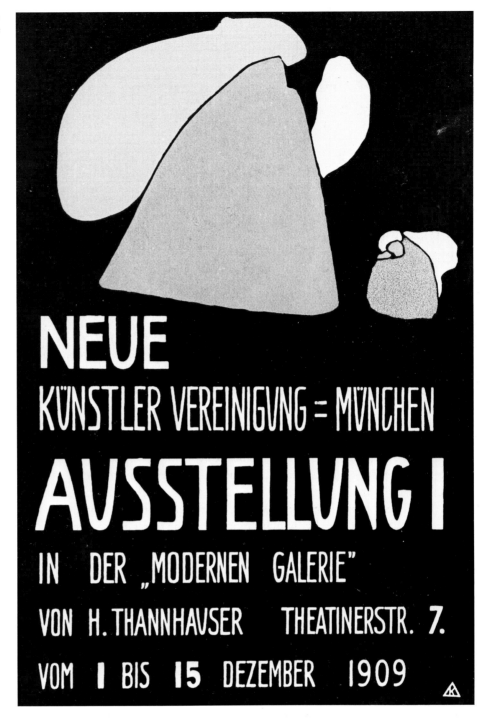

the Burliuk brothers, Odilon Redon, and Rouault to contribute essays which
appeared alongside his own text in the catalogue. This publication thus attracted a
good deal of attention in Paris, as well as Munich, and took on the character of a
manifesto. To Kandinsky and Jawlensky, the exhibition represented a consummation
of everything which they and their friends had hoped for. In the catalogue Le
Fauconnier called for "the highest degree of economy in the use of artistic means,
for the sake of the highest goals"; the contribution of the Burliuk brothers, an
apologia for French painting, insisted once more on the importance of "synthesis,"
meaning, in effect, little more than simplification. Kandinsky's essay is particularly
interesting, in that it clearly reveals the widening rift between his ideas and those
of his Munich colleagues. Unlike Jawlensky, who argued that the goal of painting
was to reconcile the opposition between objective sense-impressions and subjective

emotion, Kandinsky had come to see this opposition in terms of an absolute conflict between the material and the spiritual, decreeing painting to be "the speaking of the hidden by means of the hidden." This enigmatic phrase indicates that the Symbolist undercurrent in Kandinsky's thinking had resurfaced, alienating him not only from Jawlensky but also from the majority of the other members of the Neue Künstler-Vereinigung. Erbslöh and Kanoldt seem to have taken a particularly skeptical view of Kandinsky's gradual abandonment of figurative motifs (see plates 28, 30).

The second exhibition of the Neue Künstler-Vereinigung, which traveled to Karlsruhe, Mannheim, Hagen, Berlin, and Dresden, marked the climax of the group's activities; shortly afterward, the association began to disintegrate. Given the differences between their respective artistic aims, it was hardly surprising that its members and guest exhibitors felt no sense of adherence to a common program. The exhibitions of the group met with a correspondingly mixed reaction. On September 10, 1910, the art critic of one of Munich's main dailies, the *Münchner Neueste Nachrichten,* wrote:

There are only two possible explanations for this absurd exhibition. Either the majority of the members and guests are hopelessly deranged, or they are shamelessly bluffing, pandering to the thirst for sensation which characterizes the modern age and exploiting a particular current of fashion. For my own part, I incline toward the latter assumption, despite all the solemn assurances to the contrary [Synthesis], one of the catchwords of this Munich assembly of East Europeans, has been put into practice with a vengeance. Taken as a whole, their exhibition is sheer nonsense, but one also finds in it a synthesis of the shortcomings and futile mannerisms of the art of every known people and region, from primitive cannibals to Parisian neo-decadents.

However, there were also positive reactions, such as that of Franz Marc. After visiting the exhibition, Marc wrote an enthusiastic review and sent the manuscript to Erbslöh, the secretary of the Neue Künstler-Vereinigung. The essay was published in a pamphlet, side by side with the devastating critique which had appeared in the *Münchner Neueste Nachrichten.* Marc prefaced his sympathetic discussion of the work of Kandinsky, Bechtejev, Erbslöh, Girieud, and Le Fauconnier with a series of introductory remarks concerning the general aims of the Neue Künstler-Vereinigung, with which he found himself in full agreement:

Completely spiritualized and dematerialized inwardness of feeling is a problem in painting which our fathers, the artists of the nineteenth century, never so much as attempted to tackle. This bold attempt to spiritualize the material reality to which Impressionism clings with such dogged obstinacy is a necessary reaction which began with Gauguin in Pont-Aven and has already given rise to innumerable experiments. The reason why this latest experiment by the Neue Künstler-Vereinigung seems to us so promising is that, in addition to their highly spiritualized meaning, the pictures of the group offer highly valuable examples of rhythm, composition, and color theory.

The idea of the spiritualization and dematerialization of feeling echoed Marc's own concerns, and it was only to be expected that he should ally himself with the painters who were striving to put this idea into practice. He saw the second exhibition of the Neue Künstler-Vereinigung as an endorsement of his own endeavors, and this may well have had a liberating influence on his work.

Marc, the son of the painter Wilhelm Marc, was born in Munich in 1880. After vacillating between art and theology as possible courses of study, he opted for the former and began attending the Munich Academy in the fall of 1900. His early work was unspectacular, exemplifying the restrained version of Modernism favored by his teachers, Gabriel Hackl and Wilhelm von Diez. In 1903, when he undertook the first of several trips to Paris, Marc began to question this traditional approach to painting. It was at this point that the themes emerged which were to form the focal point of his oeuvre. He was particularly interested in the depiction of animals, in which he saw the incarnation of natural innocence and purity. This view of animals is apparent, for example, in his 1909 painting *Rehe in der Dämmerung* (*Deer at Dusk*; fig. 39). The brown tones echo the manner of his early work, but there are obvious signs of an Impressionist influence. *Deer in the Snow* (plate 2), painted in 1911, uses the same motif; the style, however, is quite different: the deep blue and green contours of the winter landscape are reminiscent of *Jugendstil*. Step by step, Marc was moving away from illusionism and embracing the radical view, first formulated by Maurice Denis some twenty years previously, that "a painting ... is essentially a flat surface covered with colors arranged in a certain order," a dictum which accords with Marc's statement that "the picture is a cosmos governed by a different set of laws from those of nature." Marc also became interested in Cubism and adopted, albeit in a somewhat superficial fashion, the stylistic principles of Futurism, blurring the demarcation between figure and ground and using pure, brilliant colors in a way which corresponded to their compositional significance

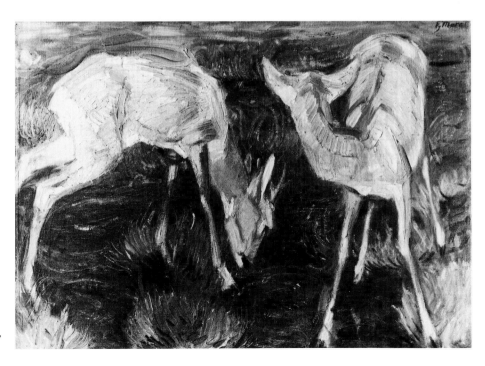

Fig. 39 Franz Marc, *Deer at Dusk*, 1909. Oil on canvas, 27³/₄ × 39⁵/₈″ (70.5 × 100.5 cm). Städtische Galerie im Lenbachhaus, Munich

and psychological effect. His pictures bore increasingly eloquent witness to his search for a principle of unity in nature and life as a whole. Marc's thinking combined a critical view of modern civilization with a Romantic longing to restore the lost harmony of spirit and matter.

Marc, who rarely managed to sell any of his paintings and was obliged to work for a time as an art teacher, knew a number of artists in Munich, but had not yet succeeded in finding anybody with artistic interests similar to his own. This lack was finally remedied at the beginning of 1910. In the course of a visit to Munich, August and Helmuth Macke, accompanied by the son of the Berlin collector Bernhard Koehler, discovered a number of lithographs by Marc in Brakl's gallery and were so taken with the pictures that they decided on the spot to go and visit this unknown artist at his studio on Schellingstrasse. Marc and August Macke soon struck up a close friendship. Macke had begun attending the Düsseldorf Academy in 1904 and studied there for two years, but his main interest had been in French, rather than German, painting, and he had been to Paris several times. In 1909/10 he lived for a time by the Tegernsee lake near Munich, making occasional trips to the city: it was during one of these visits that he encountered Marc. The meeting marked something of a turning point in Marc's career, not least because Koehler, on the advice of Macke, bought two of his paintings. By the end of January 1910 – shortly after their first encounter and some weeks after the end of the first exhibition of the Neue Künstler-Vereinigung, which apparently neither Marc nor Macke visited – the two artists had already hatched a plan to persuade Brakl, who staged Marc's first one-man show in February 1910 (see fig. 40), to organize an exhibition of new avant-garde art. However, the scheme failed to get off the ground: Marc and Macke did not possess contacts with artists of a caliber sufficient to ensure the success of such an exhibition. It is thus easy to see why the Neue Künstler-Vereinigung should have taken on such importance, especially for Marc.

V The Blue Rider

It was at the beginning of January 1911 that Marc first met the other members of what was to become the Blue Rider circle. In an enthusiastic letter to his wife Maria, he described his new friends thus:

I am in something of a hurry, since there is a Schoenberg concert this evening, at which we shall of course be meeting the whole Vereinigung: like me, they are all looking forward to it. Yesterday evening I went with Helmuth [Macke] to Jawlensky's apartment and spent the whole time talking

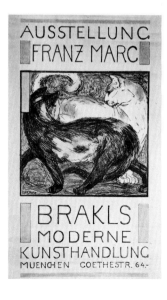
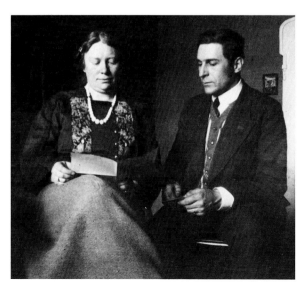

Fig. 40 Franz Marc, Poster for the artist's exhibition at the Brakl gallery, Munich, 1910. Color lithograph on paper, $36^{1}/_{8} \times 24^{7}/_{8}''$ (91.9 × 63.3 cm). Städtische Galerie im Lenbachhaus, Munich

Fig. 41 Maria and Franz Marc in Kandinsky's and Münter's home at Ainmillerstrasse 36, Munich, 1911

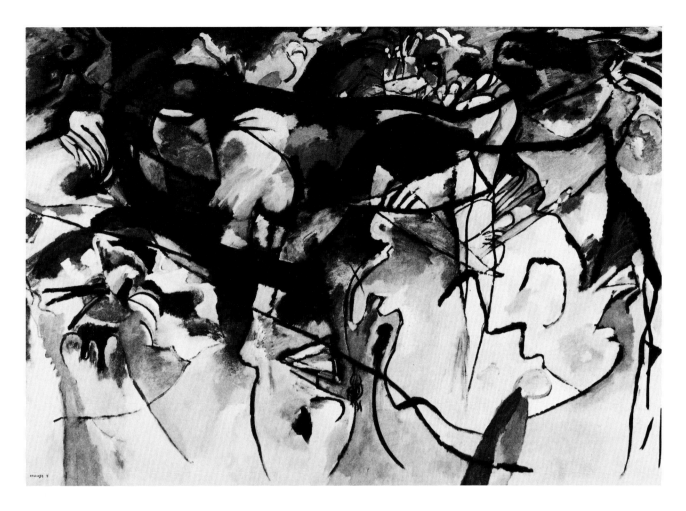

to Kandinsky and Münter, who are wonderful people. Kandinsky is the most charming of them all, even more so than Jawlensky. I was completely captivated by his refinement and distinction: altogether a splendid fellow. I can well understand why Münter, whom I liked *very* much, is madly in love with him. They all want to come and visit me and Helmuth in Sindelsdorf [where Marc was living], and we in turn are going to visit Kandinsky and Münter in Murnau. I look forward immensely to introducing you to all these people. I'm sure you'll feel instantly at home with all of them, including Münter.

Marc (fig. 41) very soon realized that of all the members of this new circle of acquaintances, Kandinsky was the one with the most interesting ideas. Meanwhile, Kandinsky himself had grown dissatisfied with the Neue Künstler-Vereinigung: he felt misunderstood by a number of its members, and at the end of 1910, after the second exhibition, he had even considered resigning. On January 10, 1911, shortly after he had befriended Marc, he gave up his post as chairman and wrote a formal letter of resignation to Jawlensky, stating the reasons for his decision. When Marc showed his latest pictures to Jawlensky in February, he was surprised by his enthusiastic reaction, having expected that Jawlensky "would sense the mild note of opposition to the aims of the Vereinigung." In the summer of that year the situation became increasingly critical. In a letter to Macke, written with the aim of persuading his friend to join the Neue Künstler-Vereinigung and thereby strengthen his own position, Marc spoke of the problems facing the group: "It is obvious to Kandinsky and myself that the next time the jury meets (in the late fall) there will be the most terrible altercation. Sooner or later there will be a split in the group, and either the one faction or the other will resign; the question will be which of them remains. We don't *want* to give up the Vereinigung, but the incompetent members will have to go." Just as Marc had predicted, the next meeting of the jury, on December 1-2, 1911, did indeed result in an open quarrel, when the members voted against the inclusion of Kandinsky's *Composition V* (fig. 42) in the group's next exhibition.

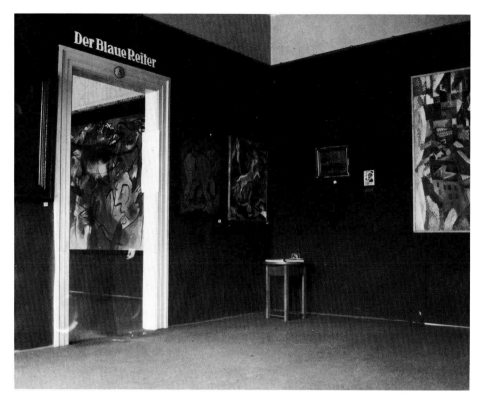

Fig. 43 First Blue Rider exhibition, Thannhauser gallery, Munich, 1911/12. Room 1 (from left to right): Gabriele Münter, *Dark Still Life* (cropped; plate 66); Vassily Kandinsky, *Composition V* (in the adjacent room; fig. 42); Albert Bloch, *Three Pierrots*; Heinrich Campendonk, *Leaping Horse*; Henri Rousseau, *Chicken Farm*; Franz Marc, *Portrait of Henri Rousseau* (fig. 51); Robert Delaunay, *The Town No. 2 (2nd Version)* (cropped). Photograph by Gabriele Münter

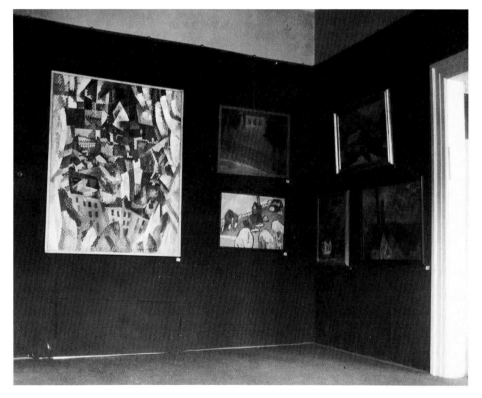

Fig. 44 First Blue Rider exhibition. Room 1 (from left to right): Robert Delaunay, *The Town No. 2 (2nd Version)*; Arnold Schoenberg, *Nocturnal Landscape* (above); Gabriele Münter, *Frost Landscape* (below); August Macke, *Still Life – Vase of Flowers with Agave*; Münter, *Evening* (above); Albert Bloch, *Houses and Chimneys*. Photograph by Gabriele Münter

It is difficult to ascertain the precise nature of the role played by Werefkin and Jawlensky in this dispute. Both of them declared their solidarity with Kandinsky's artistic intentions, and Werefkin seems to have used every means at her disposal to prevent a split in the Neue Künstler-Vereinigung. With his wide range of international contacts, Kandinsky was too important a figure to lose: his resignation would undermine the very foundations of the association. Kandinsky's main antagonists were Kanoldt and, above all, Erbslöh: it was they who finally engineered the split in the group. It is far from clear why Werefkin and Jawlensky did not join

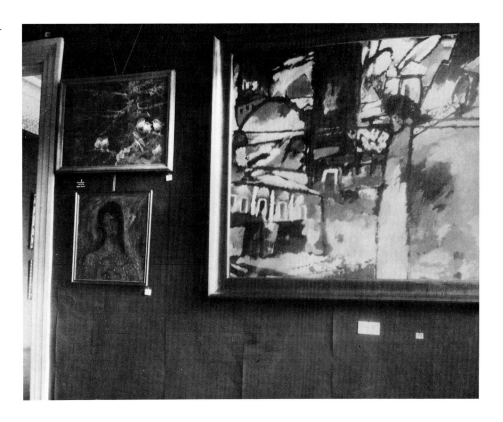

Kandinsky, Marc, and Münter in resigning from the Neue Künstler-Vereinigung immediately after the jury had declared its decision. Marc's wife, Maria, hinted in a letter to August Macke that there were "personal" grounds for their failure to resign: "grounds of a fully understandable nature, which we respect." Their decision may also have been influenced by both aesthetic and material considerations.

In the history of late nineteenth and early twentieth-century art, dissensions and schisms of this kind are everyday occurrences. As spectators, rather than participants, Werefkin and Jawlensky had already witnessed similar forms of infighting in the artistic *cénacles* of St. Petersburg. However, the conflict within the Neue Künstler-Vereinigung is endowed with special historical significance: Kandinsky's name is inextricably linked with the birth of abstract art, and it seems likely that this was the root cause of the crisis. Despite their close personal links with Kandinsky, it is entirely possible that Jawlensky and Werefkin disapproved of his intentions and inwardly dissociated themselves from him.

One of the reasons why Jawlensky and Werefkin may have objected to the path which Kandinsky had begun to tread is that the concept "synthesis," on which they had hitherto based their work, ruled out the total elimination of representational elements. At this point, in 1911, Kandinsky had not yet rejected representation altogether, but the degree of abstraction in his depiction of nature (see plates 33, 38-43) was sufficient to confound his fellow artists, who compared the highly controversial *Composition V* with the completely different style of his Murnau landscape studies. Ultimately, though, it was the cosmological aspect of Kandinsky's and Marc's ideas, their notions about the spiritual transcendence of reality, which alienated Werefkin and Jawlensky. Looking back at the history of the Neue Künstler-Vereinigung, Marc spoke of the latent conflict of ideas within the group:

A characteristic feature of the Vereinigung was its heavy emphasis on the *program*; the members learned from each other's example, and there was a general competition to see who had the best grasp of the ideas. The word "synthesis" was heard rather too often. The young French and Russian guest exhibitors exercised a liberating influence. They gave one food for thought, and people began to understand that art is concerned with the most profound matters, that innovation is not a question of form but of intellectual renewal. There was a reawakening of the *mystical*, of age-old elements which are vital to art.

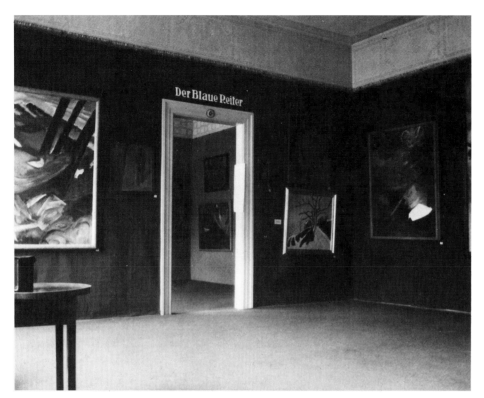

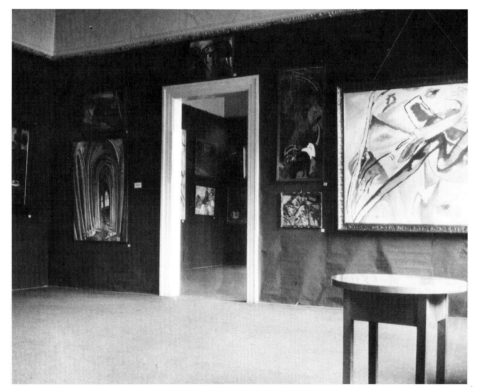

Thus Marc indirectly accused the artists who had remained in the Neue Künstler-Vereinigung of fetishizing formal innovation and lacking a sense of intellectual direction: a charge which was patently unfair to both Werefkin and Jawlensky. Further interesting light is thrown on the conflict by a contemporary publication titled *Das neue Bild* (*The New Picture*), by Otto Fischer. Launching an all-out polemical assault on abstract art, Fischer, himself a member of the association, clearly stated the reasons for the schism in the Neue Künstler-Vereinigung. "A picture," he wrote, "is not only expression but also representation. It does not lend

Fig. 48 First Blue Rider exhibition. Room 3 (from left to right): Franz Marc, *Landscape (Stony Path)*; Robert Delaunay, *The Tower*; Elisabeth Epstein, *Portrait* (above); Heinrich Campendonk, *Woman and Animal* (below). Photograph by Gabriele Münter

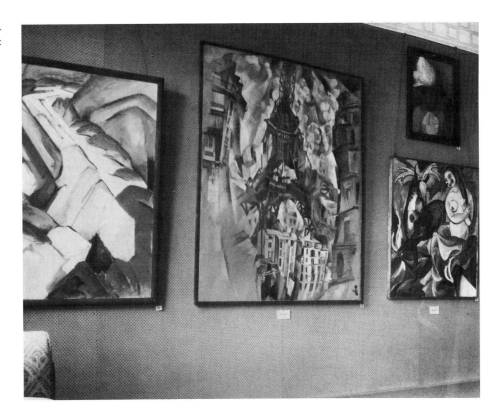

immediate expression to the soul; it expresses the soul within the object. A picture without an object is meaningless. Half object and half soul is sheer madness. The empty-headed dreamers and charlatans are on the wrong track. The muddleheads talk of the spiritual – the spirit does not muddle our thinking, but clarifies it." This is an obvious reference to Kandinsky, whose *Über das Geistige in der Kunst* (*On the Spiritual in Art*) had recently been published. Kandinsky could hardly have been expected to continue associating with artists whose views differed so radically from his own. Jawlensky and Werefkin were quick to dissociate themselves from Fischer's position, and they too resigned from the Neue Künstler-Vereinigung in 1912; shortly afterward, the group's activities came to an end. The Neue Künstler-Vereinigung München had played an undeniably important role in promoting the cause of Modernism in Munich; now, however, the time had arrived for the group to hand on the baton to its successor, the Blue Rider.

When the schism occurred in the Neue Künstler-Vereinigung in December 1911, Marc and Kandinsky had quickly organized an exhibition of their own at the Thannhauser gallery, under the auspices of *The Blue Rider* almanac (figs. 43-48). The show, which ran concurrently with the exhibition of the Neue Künstler-Vereinigung, included works by the following artists: Henri Rousseau, Albert Bloch, David and Vladimir Burliuk, Heinrich Campendonk, Robert Delaunay, Elisabeth Epstein, Eugen von Kahler, Kandinsky, Macke, Marc, Münter, Jean Bloé Niestlé, and Arnold Schoenberg. These artists did not in any sense form a coherent group (see figs. 49, 50). The catalogue offered the following explanation for this apparent lack of a unifying idea: "This little exhibition does not seek to propagate a specific form; our purpose is rather to show, through a variety of different forms, the multiplicity of ways in which the inner wishes of the artist take shape."

In several respects the exhibition was a remarkable event. The participants included a number of artists who were virtually unknown in Germany. For the "Douanier" Rousseau, whose work Kandinsky admired as an example of "great realism," a kind of shrine was created: a wreath of laurel leaves with a black crape band was hung under his painting *Chicken Farm* and, next to it, a painting on glass by Marc modeled on one of Rousseau's self-portraits (fig. 51). Marc gave this work

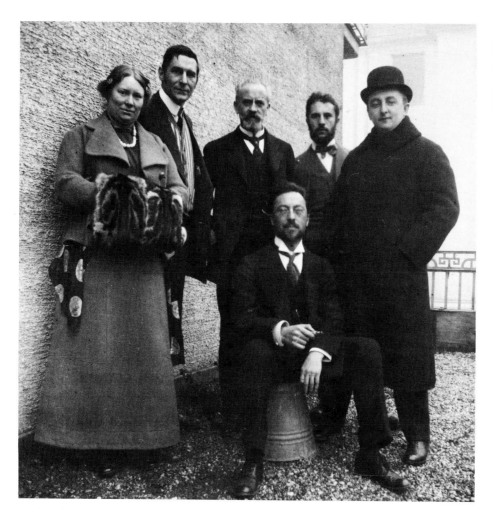

to Kandinsky as a Christmas present that year. While living in Paris in 1906/07
Kandinsky had paid little attention to the work of the "Douanier": his interest in
Rousseau had only recently been aroused by a monograph on the great naive painter
by Wilhelm Uhde, published in Paris in 1911, which had been sent to him by the
publisher Reinhard Piper. Delaunay, who had known Rousseau personally, had
helped to arrange the loan of a number of pictures for the exhibition at the
Thannhauser gallery, which also included several of his own major paintings. As a
result, Delaunay's work became known in Germany, where it exercised a consider-
able influence on Macke, Marc, and Klee and on numerous other painters in
Berlin and the Rhineland. Delaunay's Cubism (christened "Orphism" by Guillaume
Apollinaire), with its technique of transforming the formal basis of a picture into a
transparent, luminous structure of color (see fig. 52), was seen by many artists as
having an exemplary significance, as was his preference for urban subjects, as seen
in the pictures *La tour* (*The Tower*), *Saint-Séverin,* and *La ville* (*The Town*), which
were shown in the first Blue Rider exhibition. From a historical point of view, the
participation of Delaunay was one of the most significant features of the exhibition.

Long before the exhibition Kandinsky had contacted Delaunay and asked him to
contribute to the almanac. He also approached Schoenberg, whose main theoretical
work, the *Harmonielehre* (*Theory of Harmony*) was published in 1911. Schoenberg
was not only known for his music: the first exhibition of his paintings had been
held the previous year. After attending a Schoenberg concert in January 1911,
Kandinsky wrote a letter to the composer which initiated a lively exchange of ideas
(see fig. 53). Hence Schoenberg too found himself among the exhibitors at the
Thannhauser gallery. Kandinsky admired Schoenberg's pictures for their simplicity
and economy of technique (see fig. 54). "As a rule," he wrote, "Schoenberg ... has

no regard for any decorative or delicate effects, and the 'poorest' form becomes in his hands the richest. Here lie the roots of the new great realism. The complete and exclusively simple rendering of the external shell of things constitutes the divorce of the object from any practical purpose, hence permitting the inner element to sound forth." Kandinsky's estimation of Schoenberg, whom he placed on a par with Rousseau, was not necessarily shared by his fellow artists: Macke, for example, scoffed at Schoenberg's paintings.

The seemingly random selection of works for the first Blue Rider exhibition embodied an intended contrast between, on the one hand, what Kandinsky called "great abstraction," exemplified by the pictures of Marc and Delaunay and especially by his own work, and, on the other, the "great realism" of artists such as Rousseau,

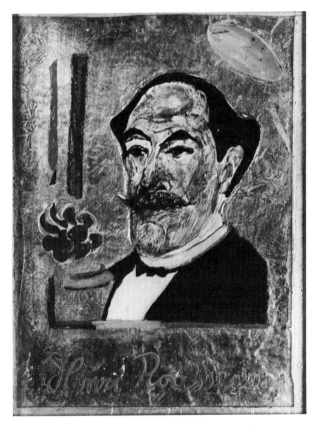

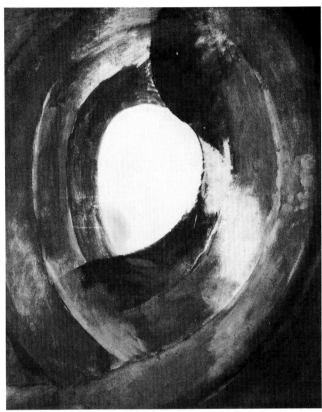

Fig. 51 Franz Marc, *Portrait of Henri Rousseau*, 1911. Painting on glass, 6¼ × 4½″ (15.3 × 11.4 cm). Städtische Galerie im Lenbachhaus, Munich

Fig. 52 Robert Delaunay, *Circular Forms (Moon No. 1)*, 1913. Oil on canvas, 25⅝ × 21¼″ (65 × 54 cm). Städtische Galerie im Lenbachhaus, Munich, and Gabriele Münter and Johannes Eichner Foundation, Munich

Schoenberg, and Niestlé. In the exhibition itself this contrast failed to stand out: the large-format works by Marc, Delaunay, and Kandinsky dominated the show, visually dwarfing the pictures of the other, "realist" artists. This was so much the case that Niestlé withdrew his picture before the end of the show, and Schoenberg, who had been invited to take part in a group exhibition in Budapest, was initially reluctant to allow his work to go on tour with the rest of the Blue Rider exhibition.

A further exhibition, comprising over three hundred watercolors, drawings, woodcuts, and etchings, was held at the Kunsthandlung Hans Goltz in February 1912 (see fig. 55). Again, the list of contributors had a strong international flavor, but it also included a number of artists from the Brücke group, Germany's other main avant-garde movement. The work of Erich Heckel, Ernst Ludwig Kirchner, Otto Mueller, Emil Nolde, and Max Pechstein was well represented, forming a striking contrast with the pictures by Braque, Picasso, Vlaminck, Natalia Goncharova, Mikhail Larionov, and Kasimir Malevich. The exhibition also included a set of Russian folk-art prints owned by Kandinsky, for whom these works had special importance as examples of "great realism." Unlike the first exhibition, this second show did not go on tour to other cities.

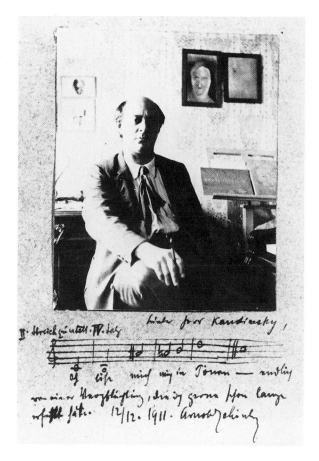

The two Blue Rider exhibitions bore the personal stamp of two like-minded individuals: Franz Marc and Vassily Kandinsky. However, it was in the almanac, rather than the exhibitions, that their ideas were most accurately reflected. The first exhibition, in particular, was a hastily arranged affair, designed to put in the shade the works by members of the Neue Künstler-Vereinigung that were on show at the same time in the adjacent rooms of the Thannhauser gallery. The publication of the almanac, on the other hand, was planned with considerable care.

VI The Blue Rider Almanac

The extent to which Kandinsky and Marc dominated the activities of the Blue Rider is clearly apparent from the early history of the group. In the early summer of 1911 Kandinsky had conceived the plan of publishing an almanac, and he outlined the idea in a letter to Marc, dated June 19, 1911. The letter is, as it were, the birth certificate of the Blue Rider. It proved impossible to put the plan into action straight away, and the almanac did not appear until mid-May the following year, after the two spectacular exhibitions. In an article published in 1930 in the magazine *Kunstblatt,* Kandinsky explained how the title originated: "We made up the name 'The Blue Rider' over coffee in the leafy garden at Sindelsdorf. Both of us loved blue, Marc – horses, I – riders." Horses and riders, symbolizing both a nostalgia for the past and a yearning for new adventure, play a central part in Kandinsky's Romantic pictures. Blue was for him "the typical color of heaven," the color which awakens mankind's longing for spiritual purity, transcending the limits of the material world. It is possible that the name also alludes to the *Blaue Blume* (blue flower) motif of German Romanticism. The Blue Rider became a symbol of the revolution in

Fig. 53 Arnold Schoenberg. Photograph inscribed: "2nd string quartet, 4th movement. Dear Herr Kandinsky, I am observing – in music as well – an obligation that I would like to have fulfilled long ago. 12.12.1911. Arnold Schoenberg." Musée National d'Art Moderne, Fonds Kandinsky, Paris

Fig. 54 Arnold Schoenberg, *The Red Gaze*, 1910. Oil on cardboard, $12^5/_8 \times 9^5/_8''$ (32.2 × 24.6 cm). On permanent loan to the Städtische Galerie im Lenbachhaus, Munich

Fig. 55 Cover of the catalogue of the second Blue Rider exhibition, 1912

modern art, as exemplified by Kandinsky's cover illustration for the almanac (see plate 52), which features a horseman who is clearly reminiscent of St. George, together with a number of other characteristic Kandinsky motifs.

The exhibition and the almanac are both part of the same enterprise. Their special significance derives from the fact that, in addition to avant-garde works, they included examples of Egyptian and Oriental art, folk art, and the art of children and amateurs, with the aim of bringing together the widest possible variety of genres, styles, and periods in a grand synthesis (see fig. 56). Kandinsky also planned to bring out a second volume of the almanac with examples of advertising, kitsch, and detail photography. He had contrived to lend the publication a strong international flavor: the list of contributors included David Burliuk, August Macke, Schoenberg, Thomas von Hartmann, and Roger Allard, in addition to Marc and himself. Among his own major contributions were the essays "Über die Formfrage" ("On the Question of Form") and "Über Bühnenkomposition" ("On Stage Composition"), and the dramatic scenario *Der gelbe Klang* (*Yellow Sound*).

One of the most striking themes of the essays published in *The Blue Rider* almanac is the idea of the need for a synthesis of the arts, following on from the German Romantic notion of the *Gesamtkunstwerk*. Marc, for example, characterized the aims of the Blue Rider thus: "Both of them [Cézanne and El Greco] sensed in the image of the world the inner mystical construction which is the main problem of the present generation." Kandinsky argued that "the external effect [of a work of art] can be different from the internal effect, which is produced by the inner sound, which is one of the most powerful and profound means of expression in every composition." Discussing the principle governing the selection of the illustrations for the almanac, Kandinsky declared, "of prime importance in the question of form is whether or not form has arisen out of inner necessity." This idea of inner necessity was central to the thinking of Marc and Kandinsky; it also occurs in the theories of Klee.

The almanac included no less than three contributions by Marc. His programmatic introductory essay, titled "Geistige Güter" ("Spiritual Goods"), ends with the stirring words "Der Geist bricht Burgen" (The spirit breaks down castle walls), a motto which neatly encapsulates the quintessential ideas of this major artist, whose popularity in Germany grew to outstrip that of any other twentieth-century painter, with the possible exception of August Macke. Paintings such as *Blue Horse, Deer in the Forest,* and *The Tiger* (plates 3, 4, 6) have appeared in countless reproductions. Marc's pictures, essays, and letters testify to his deep sense of affinity with the traditions of German Idealism. Like so many other members of his generation, the offspring of the late nineteenth century, he categorically rejected materialism in favor of an abstract concept of spirituality which, seen in retrospect, appears to embody both a strong Modernist impulse and a certain element of escapism. At the time when he first came into contact with Kandinsky and the other members of the Neue Künstler-Vereinigung, he was engaged in the search for an alternative reality beyond the surface appearance of everyday life, which he found insufferably banal. Notwithstanding the formal power and innovative significance of his pictures, their content raises a number of problems. Taking up the notion of spirituality propagated by Kandinsky, Marc devised an abstract pictorial language which expressed reality in symbolic terms. The *leitmotiv* of his thinking was an insistence of the need to purge and purify the soul of the dross of worldly concerns, an attitude which is reflected in his gradual rejection of landscape and the human figure in favor of the animal themes that feature so prominently in his mature work. Using a revolutionary formal vocabulary and drawing on the symbolic resources of color, he strove to express the idea that animals have their own specific place within the cosmos. The aim of modern art, in his view, was to create "symbols for our time which belong on the altars of the spiritual religion of the future and whose technical creator vanishes into anonymity." In the early years of the twentieth century, when

der seine Priester Krankes beschwören. Für die grotesken Zierate der Maske finden wir
Analogien in den Baudenkmälern der Gotik, in den fast unbekannten Bauten und In-
schriften im Urwalde von Mexiko. Was für das Porträt des europäischen Arztes die welken
Blumen sind, das sind für die Maske des Krankheitsbeschwörers die welken Leichen. Die
Bronzegüsse der Neger von Benin in Westafrika (im Jahre 1889 entdeckt), die Idole von
den Osterinseln aus dem äussersten Stillen Ozean, der Häuptlingskragen aus Alaska und
die Holzmaske aus Neukaledonien reden dieselbe starke Sprache wie die Schimären von
Notre-Dame und der Grabstein im Frankfurter Dom.

 Wie zum Hohn europäischer Aesthetik reden überall Formen erhabene Sprache.
Schon im Spiel der Kinder, im Hut der Kokotte, in der Freude über einen sonnigen Tag
materialisieren sich leise unsichtbare Ideen.

 Die Freuden, die Leiden des Menschen, der Völker stehen hinter den Inschriften,
den Bildern, den Tempeln, den Domen und Masken, hinter den musikalischen Werken,
den Schaustücken und Tänzen. Wo sie nicht dahinter stehen, wo Formen leer, grundlos
gemacht werden, da ist auch nicht Kunst.

KINDERZEICHNUNG ARABER

ALASKA

life was becoming increasingly mechanized and traditional social bonds and values
were collapsing under the pressure of industrialization, Marc's notion of a binding
and universally valid art appeared highly attractive. In his and Kandinsky's view,
it was necessary to make a clean break with the practice of contemporary art, with
the jaded formal repertoire and obsolete themes of Naturalism and Impressionism.
According to Marc, the fundamental aim of art was to satisfy man's hunger for a
"wholeness of being" and to free him from "the delusions of the senses in our
ephemeral world."

 The precise nature of the coming radical revolution in art remained uncertain:
Marc declared it impossible to decipher the "signs of the times" and to determine
"what the future holds in store." He saw the almanac as a temporary beacon in the
darkness, "until the coming of the dawn whose natural light will disperse the
ghostly aura which surrounds these works today." The confrontation between "our
work, which looks to the future and has yet to prove itself" and the art of "ancient
cultures which have stood the test of time" supplies the justification for ushering in
the revolution. These and similar assertions must be seen in the context of Kandin-
sky's emphasis on the necessity of replacing material with spiritual values.

 The ideas of August Macke followed a similar path. In his essay "Die Masken"
("The Masks"), Macke wrote: "The pictures which we hang on the wall are similar
in principle to the carved and painted poles in a negro's hut. To the negro, his idol
is the tangible form of an intangible idea, the personification of an abstract concept.
To us, a picture is the tangible form of an intangible idea of someone who has died,
of an animal or a plant, of the whole magic of nature, of rhythm." For Macke, as
for Kandinsky, the essential question which, consciously or unconsciously, informs
all artistic activity is whether, and if so in what way, form is "the expression of
mysterious forces." The function of art is not to represent reality, nor should the
artist indulge in purely academic formal exercises; his aim, instead, should be to

Fig. 56 *The Blue Rider* almanac.
Double-page spread showing a
chief's collar from Alaska and a
children's drawing of 1908

create a kind of fetish, a crystallization of spiritual, even mystical forces. Hence Macke, like Marc, was moving in the same general direction as Kandinsky and Münter, albeit with the difference that the Russian painter was even more determined than his fellow artists to sever all links with tradition.

Kandinsky was also intent on providing his ideas with a scientific backing. His *On the Spiritual in Art,* written in 1910, first appeared in print at the end of 1911 (see figs. 57, 58); several further editions were published in the following years. Its main theses were aired and discussed at the 1911 Pan-Russian Congress of Artists in St. Petersburg. *On the Spiritual in Art* contains a wealth of insights which considerably enhance one's understanding of the pictures Kandinsky was painting at the time and demonstrate the breadth of his intellectual horizons. Emphasizing the need for a liberation of painting from naturalistic, figurative content, Kandinsky called on the artist to base his work on universal spiritual themes and to exercise a correspondingly greater inventiveness in the use of forms and colors. With its open hostility to materialism and marked stress on the spiritual, the book clearly reflects the prevailing irrationalist mood of the time. There are particularly striking parallels between the ideas of Kandinsky and those of theosophy: although Kandinsky was by no means an uncritical admirer of Rudolf Steiner, he undoubtedly found a number of Steiner's theories attractive. Like many artists of his time, including Piet Mondrian, he frequently cited both Steiner and Madame Blavatsky as intellectual authorities. As early as 1917 G. F. Hartlaub pointed out this connection between art and theosophy. Despite what he called the "monstrous intellectual atavism" of theosophy, Hartlaub saw the ideas of Steiner as offering a possibility of rediscovering a holistic way of thinking which could have a revitalizing effect in overcoming the excessive specialization of contemporary thought. Henry Van de Velde's *Kunstgewerbliche Laienpredigten* (*Lay Sermons on Arts and Crafts,* 1902) and Wilhelm Worringer's *Abstraktion und Einfühlung* (*Abstraction and Empathy,* 1908) have also been cited as influences on the ideas of Kandinsky. Certainly, both these books helped to prepare the ground for the reception of Kandinsky's conception of art, which he summarized as follows in an address given at the opening of an exhibition on January 30, 1914: "The birth of a work of art is of cosmic character. The originator of the work is thus the spirit."

Kandinsky's painting and graphics from this period still contain figurative motifs, such as horsemen, castles, mountains, and trees. *Improvisation 6* (plate 29), for example, features brightly colored figures with burnouses and turbans; the landscape in the background is clearly recognizable, as is the wall which delimits the composition.

Kandinsky made frequent reference in his writings to the problem which arises in these works of combining figurative motifs with abstract elements. Between representation and total abstraction "lie the infinite number of forms in which both elements are present, and where either the material or the abstract predominates. These forms are at present the store from which the artist borrows all the individual elements of his creations. Today, the artist cannot manage exclusively with purely abstract forms. These forms are too imprecise for him. To limit oneself exclusively to the imprecise is to deprive oneself of possibilities, to exclude the purely human and thus impoverish one's means of expression." Here, Kandinsky describes the constitutive tension in his prewar paintings, some of which are completely abstract while others still retain a narrative core. Hence it is clear that the creation of abstract pictures is not the result of a purely formal process of reduction, but of an attempt to evoke the spiritual and psychological essence of reality while eliminating its material substratum. At the time when he was moving toward abstraction, Kandinsky was particularly interested in religious themes of a mainly eschatological nature. As Rose-Carol Washton-Long has pointed out, "a careful analysis reveals that the more vaguely titled paintings of the period still contain veiled religious motifs that were characteristic of the four thematically titled groups: Resurrection and Last

Judgment, Deluge, Paradise and Garden of Love, and the Improvisations with the themes of battle and storm." It would seem that the themes of the Flood and especially the Last Judgment played a major part in the development of the studies for *Composition VII.* The details to the right of center in the second study for the painting (plate 46) can be interpreted as human figures of the kind seen in the artist's All Saints pictures (see plate 37). However, rather than merely alluding to biblical and historical events for their own sake, Kandinsky used these motifs in his finished pictures to evoke in visual terms the general problem of the tragedy of existence, buried deep in the collective unconscious.

Kandinsky's thinking in the years preceding World War I was largely modeled on linguistic phenomena, on literary methods and techniques, and especially on musical theory; its focal point was the relationship between reality and abstraction, representation and free form. These concerns are clearly reflected in his paintings

and watercolors and in his works for the theater, such as *Yellow Sound,* which was first published in the almanac. There are a number of striking resemblances between this stage composition and Schoenberg's music drama *Die glückliche Hand (The Lucky Hand),* on which the composer had been working since 1909, using some of the scenes as the basis for a series of small oil paintings. Kandinsky's attempts to create a synthesis of the concrete and the imaginary, word and image, sound and appearance, are also in evidence in his book *Klänge (Sounds),* a collection of thirty-eight prose poems and fifty-six woodcuts, twelve of them colored and the rest black-and-white, which was finally published, after a long period of preparation, by Piper in the fall of 1912 (see figs. 59, 60). The problem of combining different genres is also addressed in the essay "On the Question of Form." Here, Kandinsky did not simply call on the artist to do away with realistic motifs: characterizing modern art as "anarchistic," he saw the storehouse of artistic material as offering a number of quite different formal options between the two extremes of "great abstraction" and "great realism," which he viewed as equally legitimate principles.

Fig. 57 Vassily Kandinsky, Cover design for *On the Spiritual in Art,* c. 1910. Pen and ink, and gouache, over pencil on paper, 6⁷/₈ × 5³/₈″ (17.5 × 13.5 cm). Städtische Galerie im Lenbachhaus, Munich

Fig. 58 Cover of Vassily Kandinsky's *On the Spiritual in Art,* with motif by the artist, published in 1911/12 by R. Piper & Co. Verlag, Munich

Fig. 59 Vassily Kandinsky in his home at Ainmillerstrasse 36, Munich, June 24, 1911. He is studying his watercolor design for *Three Riders in Red, Blue, and Black*, a woodcut that appeared in his book *Sounds*. Photograph by Gabriele Münter

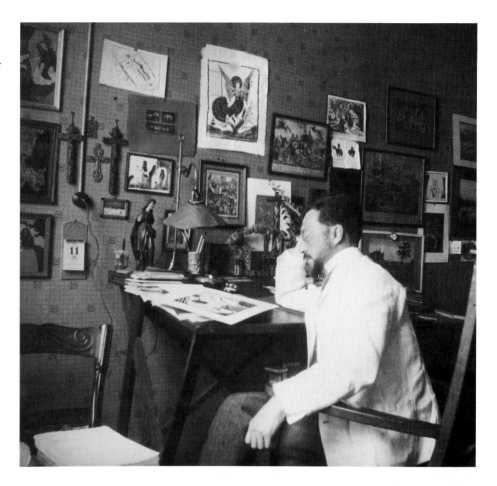

Citing the work of Rousseau as a paramount example of "great realism," Kandinsky defined the latter as "a desire to exclude from the picture the externally artistic element and to embody the content of the work of art by means of the simple, 'inartistic' rendering of the simple, hard object By reducing the 'artistic' element to a minimum, the soul of the object sounds forth most strongly from within this outer shell, because external, palatable beauty can no longer distract us." And, he emphasizes, "that artistic element which has been reduced to a minimum must be recognized as the most powerfully affective abstract element." In a footnote Kandinsky adds: "The quantitative diminution of the abstract thus equals the qualitative augmentation of the abstract." The paradox enshrined in this statement stems from a deliberate conflation of terms: in the first part of the proposition "abstract" refers to form, but in the second it refers to the inner "sound" of things.

Unlike realism, abstraction tends "to exclude completely the objective (real) element and to embody the content of the work in 'nonmaterial' forms." The inner sound of the picture is amplified by the elimination of the real; the "external, supporting object" has a dampening effect on the inner sound. In abstract pictures it must become possible "to hear the whole world just as it is, without objective interpretation That 'objective' element which has been reduced to a minimum must, in the case of abstraction, be recognized as the most powerfully affective real element." Here too, Kandinsky's terminology is ambiguous: whereas we normally take the "object" or the "real" to mean concrete reality, with its specific physical attributes, Kandinsky again seems to be referring to the inner sound of objects.

This example illustrates the difficulty of approaching Kandinsky's pictures through his writings. His ambiguous metaphors and confusing terminology present considerable problems of comprehension, as does the synaesthetic component in his thinking: in discussing pictures he often uses a nonvisual vocabulary, talking about the sound, the feel, or even the taste of a painting. Leaving aside this aspect of his

Fig. 60 Vassily Kandinsky,
Double-page spread from *Sounds*,
published in 1912 by R. Piper &
Co. Verlag, Munich

ideas, which harks back to the Symbolist conception of art, the main point which
emerges from his aesthetic writings is that he sees "great realism" and "great
abstraction" as pursuing the common aim of revealing the inner sound of an object
or a picture. "The greatest external dissimilarity becomes the greatest internal
similarity." This statement can be read as a justification for the visual appearance
of *The Blue Rider* almanac, which elevated heterogeneity to the status of a guiding
principle.

Kandinsky saw his revolutionary art, which exploded the traditional European
concept of the picture, as anticipating the advent of a new spiritual cosmos. Litera-
ture, music, and art, in his view, are "the first and most sensitive realms where this
spiritual change becomes noticeable in real form. These spheres immediately reflect
the murky present; they provide an intimation of that greatness which first becomes
noticeable only to a few, as just a tiny point, and which for the masses does not
exist at all." Kandinsky's theory of art combines a romantic Utopianism with
elements of antimaterialism and hostility to science which are reminiscent of
Symbolism and, in some respects, of German Romanticism.

Kandinsky's move toward abstraction met with a highly mixed reception. Few
people were in a position to grasp the full implications of his radically new approach
to art. Collectors turned their backs on him, and critics who had taken a relatively
charitable view of his earlier work now began to pour scorn on him, describing his
painting as "idiotic." There were also those, however, who protested against this
debasement of the tone of art criticism and took up the cudgels in Kandinsky's
defence. One of his partisans was Klee, who lived in the same neighborhood as
Kandinsky and soon found himself accepted into the latter's circle of friends. In a
Swiss journal Klee characterized Kandinsky thus: "In his case, the rigor of the mind
takes on productive forms Museums do not illuminate him, he illuminates
them, and even the greatest of those found there cannot diminish the value of his
own intellectual world."

In retrospect, the almanac and the two Blue Rider exhibitions would seem to
demonstrate that, for a brief period at least, Munich was indeed a center of the
European avant-garde. The first exhibition in particular, which was seen in so many
other cities, had a resounding effect. Even more important was the almanac, which
set out the theoretical principles on which the new art was based. Together with
Kandinsky's *On the Spiritual in Art,* the almanac is the most significant programmatic
document in the history of twentieth-century German art; it has influenced succes-
sive generations of artists up to the present day. There can be no doubt that
Kandinsky's visionary commitment was the principal impetus behind the exhibi-

tions and the almanac. While Marc took care of the practical issues, it was Kandinsky who supplied the main ideas. Without wishing to detract from the achievements of the other Blue Rider artists, it must be emphasized that, in both intellectual and aesthetic terms, Kandinsky, whom Hugo Ball called "the prophet of rebirth," was the boldest member of the group.

VII Agreement and Dissent

This survey of the work and ideas of Marc, Macke, and Kandinsky has so far ignored another artist from the Blue Rider circle: Paul Klee (fig. 61), who contributed no less than seventeen drawings to the second exhibition at the Goltz gallery in February 1912 and who also had a number of works reproduced in the almanac. Although the major works by Klee in the collection of the Lenbachhaus date from a later period, his role in the history of the Blue Rider is sufficiently important to warrant a brief digression.

Klee was born and bred in Bern, Switzerland. He came to Munich in 1898 and began to attend Heinrich Knirr's private school of drawing, after which he went on to study at the Academy, where he was a pupil of Franz von Stuck. From 1902 to 1906 he lived in his parents' house in Bern, and it was there, in the summer of 1903, that he began work on the ten-part cycle of etchings titled *Inventionen* (*Inventions*), which was first shown at the 1906 international exhibition of the Munich Secession. During the following years Klee experimented with a number of different techniques (see fig. 62), but finding color difficult to handle, he concentrated mainly on etching and drawing (see fig. 63).

Klee's work attracted the attention of Kubin, who bought several of his drawings. This was an important sign of recognition for Klee, since at this point Kubin was a highly successful artist with a far wider reputation than Marc or Kandinsky. His fantasy novel *Die andere Seite* (*The Other Side*) had been published in 1909, and it seems probable that Klee had read the book. In the same year Kubin joined the Neue Künstler-Vereinigung; he took part in the association's first two exhibitions and took up the cudgels for Kandinsky during the dispute at the beginning of December 1911. A number of his visionary drawings were included in the second Blue Rider exhibition. The almanac also featured several reproductions of works by Kubin, whom Kandinsky classed, along with Schoenberg and Rousseau, among the representatives of that "great realism" which he saw as the "antipode" of his own work. Discussing the bizarre, chaotic motifs of Kubin's art (see figs. 64, 65), Klee wrote: "He [Kubin] fled from the world because he could not bear it physically. He found himself stuck half way, longing for the crystalline but unable to free himself from the glutinous mud of the world of appearances. His art grasps the world as poison, as collapse."

Klee met Kubin for the first time in January 1911; the following September he was introduced to Macke by Louis Moilliet, and shortly afterward he met and befriended Kandinsky. He also became a close friend of Marc. Klee was fascinated by the aims of the Blue Rider: he reviewed the first exhibition at the Thannhauser gallery in the Swiss periodical *Die Alpen* and took part in the second. In the diary which he kept from 1898 to 1918 he wrote: "The Blue Rider, that's the name of the thing. The intrepid 'editors' Kandinsky and Marc have mounted a second exhibition this winter, an exhibition of graphics on the upper floor of the Goltz art bookshop. Munich's 'number one' dealer has taken the risk of exhibiting Cubist art in his shopwindow. The passersby who stop and stare say that it's typical 'Schwabing' art. Picasso, Derain, and Braque as members of the Schwabing coterie – what a charming idea! The Schwabing artists' work gave me the idea that it would be nice to go and have another look round in Paris."

Fig. 61 Paul Klee. Munich, 1911

Fig. 62 Paul Klee, *Beast*, 1906. Painting on glass, $6^{1}/_{4} \times 9^{1}/_{4}''$ (16×23.5 cm). Städtische Galerie im Lenbachhaus, Munich

In April of that year Klee did indeed travel to Paris, where he visited the studio of Delaunay, whose work strongly influenced his ideas on the use of color. In January 1913 he translated Delaunay's essay "On Light," which was published shortly afterward in the Expressionist magazine *Der Sturm*.

The experience of meeting Kandinsky, Marc, Macke, and Delaunay undoubtedly led to a change of direction in Klee's work, although in some respects the ideas which he had been pursuing closely resembled those of the other members of the Blue Rider circle. His interest in children's drawings and in the art of the mentally ill was shared by Marc and Kandinsky, whose theory of art especially prized the qualities of naivety and originality which such forms of art exemplified. In his diary Klee noted: "All this ['primitive' art, children's drawings, etc.] has to be taken very seriously, more seriously than all the museums of the world, if there is to be a

Fig. 63 Paul Klee, *Four Figures at Two Tables*, 1912. Pen and ink on paper, $2^{5}/_{8} \times 4^{1}/_{8}''$ (6.8×10.5 cm). Städtische Galerie im Lenbachhaus, Munich

reform of art. It is my belief that all yesterday's traditions have petered out and that, seen in the light of history, all the so-called innovators, those liberal gentlemen, with their seemingly fresh and healthy expressions, are jaded and tired. If this is so, then a great moment has arrived, and I salute those who are working to bring about the coming Reformation. The boldest of them here is Kandinsky, who also tries to act through the written word."

Despite the encouragement offered him by his new friends, Klee was far too original and independent an artist to be in any danger of imitating someone else's style. It was not until the spring of 1914 that the theoretical ideas which had emerged from his study of Kandinsky's and Delaunay's aesthetic notions began to bear fruit, enabling him to come into his own as a painter, rather than devoting the major part of his energies to drawing and etching. Klee traveled to Tunisia in April 1914 with Moilliet and Macke. The culture and atmosphere of the country supplied the inspiration for a series of magnificent watercolors which fired his enthusiasm and led to an insight that was crucial to his future work. His diary entry for April 16

reads as follows: "I'm going to stop working now. There's a sense of deep calm, and I feel so sure of myself, without exertion. Color has got me. I no longer need to chase after it. It has got me for ever, I know it. That is the meaning of this happy hour: color and I are one. I am a painter."

Meanwhile, dissensions had begun to undermine the euphoric sense of common purpose within the Blue Rider circle. The latent conflicts between the different generations, and differences of opinion within the circle, emerged into the open when the demands of group solidarity began to clash with the interests of individual members. As in the case of the rift which had arisen in the Neue Künstler-Vereinigung, the main bone of contention was the position of Kandinsky, which alienated younger artists, such as Macke.

Marc and Kandinsky saw themselves in the first instance as painters; right from the outset they regarded color as their main medium of expression. Unlike Klee, whose conversion to color did not take place until well after the two exhibitions in 1911 and 1912, Macke was quick to adopt the ideas of the two main protagonists of the Blue Rider. However, his views on painting had also been influenced by his two trips to Paris in 1907 and 1908. His boundless admiration for the work of Matisse and Delaunay, which had a demonstrable effect on his own use of color, instilled in him a critical attitude to German art. In a letter dated April 26, 1910, to his wife's uncle Bernhard Koehler, a prominent collector of modern art and patron of the Blue Rider, Macke wrote: "In Germany we take care to ensure that great talents are nipped in the bud. In France, where there is a tradition of risk-taking, the boldest experiments of young painters have success on their side. Our experiments are failures, carried out by muddleheaded people who can't speak the language properly."

Given this critical viewpoint, it is hardly surprising to find Macke commenting on the Blue Rider exhibition: "There are a lot of good things there, but also a lot of things which do not warrant the grossly exaggerated propaganda." Writing to Koehler on January 22, 1912, Macke praised the work of Rousseau, Kandinsky, and Delaunay but sharply criticized Marc and Münter. In the course of the year he dissociated himself more and more from his Munich friends. This almost certainly had to do with the petty jealousies and misunderstandings that arose in connection with the participation of Blue Rider artists in a number of major exhibitions, such as that of the Sonderbund held in Cologne in the summer of 1912. In addition, however, Macke was developing a more skeptical view of the work of Kandinsky, which he had once admired so much. In 1913, for example, he produced a caricature poking good-humored fun at the Blue Rider circle (fig. 66). In the midst of a mass of colored splotches and swirling shapes à la Kandinsky one sees a horse-drawn carriage driven by Marc, with Kandinsky and Münter in the back seat and Herwarth Walden, editor of the magazine *Der Sturm* and owner of the Berlin gallery of the same name, issuing directions. Walden appears again on the right, towering over the diminutive figure of Macke himself, whose peripheral place in the picture betokens a sense of dissociation from the rest of the group. In a letter to Koehler Macke wrote: "As far as my painting is concerned, Kandinsky has quietly faded away. Delaunay had set up shop next door, and there you could see *living* color as opposed to that incredibly complicated but utterly *insipid* color-*patch* composition. One's hopes have been betrayed: it's enough to make one cry. But Delaunay started out with the Eiffel Tower and Kandinsky with gingerbread. There is more mysticism in a tabletop than in all his pictures put together. They no longer have any resonance for me." Although remarks of this kind, made in the context of a private letter to a relative, need to be taken with a pinch of salt, they nevertheless bear witness to Macke's growing disenchantment with Kandinsky's art and ideas.

Kandinsky's relationship with Marc, his friend and comrade-in-arms, had also begun to turn somewhat sour. At the time when the two of them were working on *The Blue Rider* almanac, Kandinsky had begun to collect ideas for a second

Fig. 66 August Macke, *Satire on the Blue Rider*, 1913. Watercolor, pencil, and black chalk on paper, $9^5/_8 \times 13^5/_8''$ (24.6 × 34.5 cm). Städtische Galerie im Lenbachhaus, Munich

volume: their original intention had been to publish a kind of yearbook. However, it proved impossible to put this plan into practice. Instead, a marginally revised edition of the almanac appeared in the late spring of 1914, this time with separate prefaces, dated March 1914, by the two editors. Reviewing the progress of the Blue Rider, Kandinsky and Marc expressed a certain satisfaction with the achievements of the group, but also struck a note of doubt and disappointment. Kandinsky wrote that the Blue Rider had failed to achieve its main aim, because the public, "contrary to the spiritual striving of our time, continues to look at, to analyze, to systematize the formal element alone. Hence it may be that the time is not yet ripe for 'hearing' and 'seeing'." In a letter to Marc, dated March 10, 1914, he ventured the opinion that the energies of the Blue Rider were exhausted: "There is not enough artistic material. We can join in the other things, but we can't do them ourselves. It would hardly be conscientious, and it would be a pity for the cause. So let us wait a while with the second book." Marc's reply took a more defiant line: "I definitely feel that we have to say something *now,* precisely because of the lack of material." However, in his preface to the second edition of the almanac, Marc acknowledged his disappointment at the failure of his hopes: "the common herd," as he put it, "is unable to follow us; the path is too steep and is as yet untrodden." He opined that it would be impossible to embark on the task of putting together a second volume of the almanac "until we are alone again, and until modernity has stopped trying to industrialize the virgin forest of new ideas."

The general tenor of the above comments indicates that the plan to publish a second volume of the almanac was doomed to failure, and that a parting of the ways was imminent, despite the personal and intellectual sympathies which united the two artists. Hence it is hardly surprising that a further project failed to come to fruition. In the spring of 1913 Marc, Kandinsky, Kubin, Klee, Heckel, and Ko-

koschka discussed the possibility of producing an illustrated edition of the Bible. A number of sketches were done, but the publication of the work, which was to be called the Blue Rider Edition, was foiled by the outbreak of war, which rendered further cooperation impossible. Kubin's contribution appeared in 1918 under the title *Der Prophet Daniel: Eine Folge von 12 Zeichnungen* (*The Prophet Daniel: A Series of 12 Drawings*).

There is little point in speculating about what might have happened if Macke and Marc had not been killed in World War I and if the Russians had not been forced to leave Munich. However, from the available evidence it seems highly unlikely that Marc and Kandinsky would have continued to work together: by the summer of 1914 it had become impossible for them to agree on a common platform for future activities. Nevertheless, their friendship remained intact, and in retrospect it is apparent that their respective ideas on art tallied with each other more closely than with those of any other artists associated with the Blue Rider. Despite their differences of opinion and artistic approach, their work was inspired by a common motive which poses a number of as yet unanswered questions.

Looking at the numerous programmatic statements by Marc and especially Kandinsky, one cannot fail to be struck by the extent to which their thinking revolves around certain recurrent concepts that are global rather than specifically aesthetic in reference. One of the most significant of these concepts is the notion of the "spiritual," which occurs time and time again in the manifestos of the Blue Rider. At the turn of the century, *Geist* (spirit) was a popular intellectual slogan: in the magazine *Blätter für die Kunst,* for example, the poet Stefan George, who also lived and worked in Munich, had argued in favor of a "spiritual" art, as an alternative to Naturalism, which he deemed "an inferior school, a spent force, stemming from a false notion of reality." In 1899 the philosopher Ludwig Klages detected an increasing tendency among artists to resite their work in the realm of the spirit and the dream. The year 1910 saw the publication of Wilhelm Dilthey's *Der Aufbau der geschichtlichen Welt in den Geisteswissenschaften* (*The Construction of the World in the Humanities*); its central notion of the hermeneutic circle soon became one of Kandinsky's catchwords. Friedrich Gundolf and Friedrich Wolters, both members of the George circle, edited a publication entitled *Jahrbuch für die geistige Bewegung* (*Yearbook of the Spiritual Movement*), the first volume of which appeared in 1910. From an empiriocritical standpoint, the biologist Jakob von Uexküll attacked the materialism of Ernst Haeckel and argued in favor of a "subjective" biology, looking forward to the day when "matter will collapse into nothingness and the spirit will reign supreme." In his book *Le Sablier,* which was avidly read by the Blue Rider artists, Maurice Maeterlinck proclaimed: "L'univers est esprit." These thinkers, and many others like them, rejected the analytical intellect in favor of a form of reason allied with that "intuition" which Henri Bergson had deemed to be the prime motive force in human thinking and action. Rather than to the everyday experience of reality, artists looked for inspiration to "the unknown in the world beyond." The only channel of communication with this numinous realm was the imagination, which Maeterlinck called "the mystical summit of our reason." There are numerous parallels between the ideas of Kandinsky and those of the various prophets of the "spiritual" who were living in Munich at the time. In his excellent book *The Sounding Cosmos: A Study in the Spiritualism of Kandinsky and the Genesis of Abstract Painting* (1970), Sixten Ringbom has convincingly shown that the theosophy and anthroposophy of Rudolf Steiner played a major part in shaping Kandinsky's thought. Although he did not attend Steiner's lectures in person, Kandinsky is known to have read and studied the transcripts made by one of his pupils. Münter's library, which has been preserved intact, also testifies to the influence of Steiner on the artists in the Blue Rider circle.

The antimaterialism of Kandinsky and others did not go entirely unopposed. In his essay "Geist und Tat" ("Spirit and Deed"), published at the beginning of 1911,

Heinrich Mann, elder brother of the novelist Thomas Mann, launched a widely regarded polemical attack on everything that artists like Kandinsky and Marc stood for and argued in favor of a politically committed art. Mann accused his contemporaries of ignoring reality, "whitewashing the demonic," and supplying "sophistical justifications for injustice, for the mortal enemy of the intellectual – power." "In Germany," he wrote, "we go further in our thinking than anyone else, up to the limits of reason, to nothingness; and meanwhile the country is ruled by the grace of God and the law of the jungle."

Although there is little to be gained from playing off the writer Mann against the artist Kandinsky, it has to be acknowledged that the version of Idealism propagated by Kandinsky and, in a modified form, by Marc did indeed result in a distorted perception of reality. This became glaringly obvious after the outbreak of World War I, which Marc, like many of his contemporaries, saw as confirming his chiliastic beliefs. On October 24, 1914, he wrote to Kandinsky: "I myself am living in the midst of this war. I see it as a salutary, if cruel, means of achieving our aims; rather than setting people back, it will cleanse Europe and prepare it." Kandinsky, who was living in exile in Switzerland, took a more skeptical view: "I thought that the clearing of the ground for the future would take a different form. The price for this kind of cleansing is terrible." "Nevertheless," he added, "I firmly believe in the future, in the time of the spirit which has brought us all together." To which Marc replied: "I am not angry at this war; I am grateful for it, from the bottom of my heart. There was no other avenue to the time of the spirit; it was the only way of cleansing the Augean stables of the old Europe. Or is there a single person who wishes that this war had not happened?"

Ideas of this kind, which today seem incomprehensible, had a wide currency during the first months of the war, and Marc was only one of a large number of intellectuals who enthusiastically welcomed the outbreak of war and rushed to volunteer for military service. August Macke was killed in the first weeks of the war. The shock of Macke's death, together with his own experience of the gruesomeness of trench warfare, caused Marc to change his attitude, before he too was killed in 1916. With the benefit of hindsight it becomes possible to recognize that his initial misjudgment of the war was to some extent the product of an ideology which he shared with Kandinsky and which formed a part of the theoretical foundations of abstraction.

VIII Conclusion

The name "The Blue Rider" is connected with a mere handful of events: the two exhibitions at the Thannhauser and Goltz galleries at the end of 1911 and the beginning of 1912, and the publication of the almanac edited by Kandinsky and Marc. Thus, the Blue Rider was very far from being a broad-based artistic movement, although it must be remembered that various selections of the paintings from the first exhibition were shown in numerous cities throughout Europe, including Cologne, Berlin, Frankfurt, Hamburg, Rotterdam, Amsterdam, Vienna, Prague, Budapest, Oslo, Stockholm, and Göteborg. Together with the almanac, a minimally revised edition of which appeared in the late spring of 1914, the traveling exhibition helped to propagate the ideas of the group. Kandinsky's *On the Spiritual in Art* also played an important part in drawing public attention to the activities of the Blue Rider.

However, by the time World War I broke out, the movement had effectively fallen apart. Differences of opinion had arisen between the individual artists, and the projected second volume of the almanac had failed to materialize. Macke and Marc died in the trenches in France; Werefkin, Jawlensky, and Kandinsky, being

Russian citizens, were forced to leave Germany. Only Klee remained in Munich, but in the summer of 1914 he had become one of the founding members of the Neue Münchener Secession (New Munich Secession), a less radical association of artists who did not embrace the ideas of Marc and Kandinsky. Klee was appointed to a teaching post at the Bauhaus in 1920 and moved to Weimar the following year. By this point Munich had long ceased to be a focus of the avant-garde. In an essay published in 1930 Kandinsky looked back nostalgically to the prewar years in the Bavarian capital, reflecting on the fact that the innovative seed of the Blue Rider had fallen on barren gound:

Today – after so many years – the spiritual atmosphere of beautiful Munich, a city that despite everything remains dear to me, has altered fundamentally. Schwabing, in those days so loud and bustling, has become silent – not a sound is to be heard from there. A pity for Munich, and even more of a pity for funny, somewhat eccentric, and self-confident Schwabing, in whose streets a person – whether man or woman – not carrying a palette, a canvas, or at the very least a portfolio was immediately conspicuous. Like an "intruder" in a "nest." Everybody painted … or wrote poetry, or played music, or learned to dance. In every house, one could find under the eaves at least two studios, in many of which not so much painting went on as constant discussion, debate, philosophizing, and a good measure of drinking (which depended not so much on one's moral state as upon one's pocket).

Hence the Blue Rider had no lasting influence in Munich, where conservative tendencies were increasingly coming to the fore, in both the cultural and the political sphere. It was here that Hitler staged his first, abortive putsch in 1923; and after the Nazis came to power, Munich artists and administrators helped to stage the 1937 exhibition of "degenerate" art which held the avant-garde up to public ridicule and contempt. Thousands of works by modern artists, including Jawlensky, Kandinsky, Klee, Macke, and Marc, were removed from German museums and either sold abroad or destroyed. Nevertheless, the ideas of the Blue Rider circle continued to influence the development of art, both before and after the Nazi period.

A considerable part of the credit for the success of the Blue Rider in attracting the attention of the art world must go to Kandinsky and Marc, the leaders of the group. However, it must also be emphasized that they were helped and supported by a number of individuals who were not themselves artists. We have already mentioned the collector Bernhard Koehler, who not only bought a number of works by painters from the Blue Rider circle but also put up the money both for the publication of the almanac and for the organization of the Erster Deutscher Herbstsalon (First German Salon d'Automne) which was held in Berlin in 1913. A further important figure was Herwarth Walden, the owner of the Berlin gallery Der Sturm and editor of the magazine of the same name. A number of museum directors, among them Hugo von Tschudi, took a benevolent interest in the activities of the Blue Rider. Reinhard Piper, the publisher of the almanac and of Kandinsky's *On the Spiritual in Art,* proved that he was willing to take considerable risks. Various other gallery owners, such as Thannhauser and Goltz, and a number of critics and collectors were quick to recognize the revolutionary potential of the Blue Rider artists and to grasp the full import of their intentions, which went far beyond the specific field of painting. Commercial considerations were by no means alien to the members of the circle, who invested a considerable amount of energy in propaganda; convinced as they were of the rightness of their mission to reform not only art but society as well, they used every means at their disposal to publicize their ideas: exhibitions, lectures, books, and magazine articles. They had realized that artistic innovation itself – the production of paintings, drawings, stage compositions, music, poetry, and prose which broke with the aesthetic conventions of the time – was not enough: the artist had to go into the marketplace and advertise his wares. Marc and Kandinsky in particular had a clear understanding of the mechanisms governing the success or failure of new art, and they set out to turn these mechanisms to their own advantage. In Munich their activities were largely confined to a small circle of newcomers from elsewhere. Hence it is perhaps hardly surprising that the main influence of the group should have been felt outside of Munich itself.

Fig. 67 Vassily Kandinsky, Page from *Point and Line to Plane*, published in 1926. The page shows a photograph and diagram of a leap by the dancer Palucca

It is impossible here to trace in full the later iconographical and stylistic development of all the artists associated with the Blue Rider. However, it would seem appropriate to offer a few brief comments on the subject. Gabriele Münter remained faithful to the aims of the circle as formulated before 1914, but the quality of her work seldom equalled that of her earlier achievements (see plates 71-73). The same is true of Marianne von Werefkin, who, committed as she was to a basically Symbolist conception of art, never wholly accepted the idea that form and color should follow their own autonomous logic. Alexei Jawlensky continued along the path which he had begun to follow at the time of the foundation of the Neue Künstler-Vereinigung, eventually reducing his art to a single motif to which he returned time and time again in his *Meditations* (plates 85, 86, 88, 89). In respect of their spiritual aura, the icons which Jawlensky painted in the latter part of his career are clearly influenced by the religious impulse underlying the activities of the Blue Rider. The work of Klee and Kandinsky, on the other hand, underwent a radical thematic and stylistic change (see plates 50, 51, 113-21). In the early 1920s the two artists were invited by Walter Gropius to join the teaching staff of the Bauhaus, where some of the main ideas of the Blue Rider, albeit in a modified form, continued to influence the development of modern art and design.

While still in Munich, Kandinsky had emphasized the importance of *seelische Vibration* (vibration in the soul) as the basis of all true art. Defining form as "the material expression of abstract content," he saw painting as "a spiritual organism that, like every other organism, consists of many individual parts." According to his concept of art, the picture arises from "the planned and purposeful juxtaposition" of the individual parts belonging to "linear" and "painterly" form, on the basis of "inner necessity." Following his appointment in March 1920 as director of the newly founded Soviet Institute of Artistic Culture, better known by its abbreviated name Inkhuk, he devoted himself to the task of devising a set of objective criteria for determining artistic values. His ideas failed to impress his colleagues: the attitude of such Constructivist artists as Alexander Rodchenko to Kandinsky's notion of the "great spiritual" was at best skeptical and at worst downright hostile. His vision of a new epoch of the "great utopia" was out of touch with the reality of the Revolution and the changes it instigated. Kandinsky found himself under increasing pressure to justify his position and to explain the principles on which his painting was based.

In his *Punkt und Linie zur Fläche: Ein Beitrag zur Bildelementenanalyse* (*Point and Line to Plane: A Contribution to the Analysis of Pictorial Elements*), which was published in 1926 as volume 9 in the series Bauhaus Books (fig. 67), Kandinsky discussed the psychological effects of various basic elements in abstract painting. His arguments have a conspicuously "scientific" tone. Having failed in his attempts to ground abstraction in the utopia of the "great spiritual," he sought an alternative mode of

justification which would still allow him to situate art in a higher realm of its own, beyond the confines of the material world (see fig. 68). While retaining his basic antimaterialist convictions, he drew on the theories of the exact sciences and of engineering in order to support his contention that there was a fundamental morphological similarity between art and nature. This idea, which occurs repeatedly in Kandinsky's theoretical statements from the 1920s, is set out in the following passage:

Abstract art, despite its emancipation, is subject ... to "natural laws," and is obliged to proceed in the same way that nature did previously, when it started in a modest way with protoplasms and cells, progressing very gradually to increasingly complex organisms. Today, abstract art also creates primary or less primary art-organisms, whose further development the artist can predict only in uncertain outline, and which entice, excite him, but also calm him when he stares into the prospect of the future that faces him. Let me observe here that those who doubt the future of abstract art are, to choose an example, as if reckoning with the stage of development reached by amphibians, which are far removed from fully developed vertebrates and represent not the final result of creation, but rather the "beginning."

Elsewhere, Kandinsky decrees that a knowledge of the laws of nature is "indispensable" to the artist, and speaks of the "deep and intimate correspondence" between art and nature. In 1928 he wrote: "Like art, nature also 'works' by its own means (the primary element in nature is also the point), and even today one can admit with certainty that the deep root of the laws of composition is identical for art and nature. The connection between art and nature ... does not lie in the fact that painting will never be able to avoid the representation of nature or the object. But both 'realms' carry out their works according to a similar or identical mode." The guarantor of this relationship is abstract art. From the fact that the exact sciences are concerned with the investigation of nature and that the theory of painting has taken a scientific turn, Kandinsky draws the conclusion that there is no fundamental difference between art and technology. This, however, looks suspiciously like a gesture of obeisance, on the part of an incurable idealist, to the ideology of the Bauhaus, insofar as the latter emphasized the importance of the practical application of the arts. What Kandinsky had in mind was not the specialization of art, which he saw as a symptom of base materialism, but the synthesis of all areas of life, the union of spirit and matter. In his view, this union could not be achieved under the auspices of architecture, as the Bauhaus manifesto claimed, but only under the tutelage of painting, which alone could be entrusted with the task of "fructifying all the arts and guiding their development along the right lines." Although, when teaching at the Bauhaus, Kandinsky spoke of the need to develop a vocabulary and a grammar of painting, he was convinced that his own investigations in this field were mere experiments, laying down a provisional set of foundations for the future. He saw art as something which could not be taught – a view shared by Gropius, who had explicitly stated it in his manifesto. When he moved to Paris in 1933, Kandinsky returned to the conception of art which he had favored during his years in Munich. His style of argument was less emphatic but no less categorical; in 1938, for example, we find him proclaiming, "art is subordinate to cosmic laws revealed by the intuition of the artist."

Kandinsky never relinquished this fundamentally ahistorical position, although he did make two definite attempts to reconcile the ideals which he saw as eternal and unchanging with the demands of everyday artistic practice. Both in the Soviet Union and at the Bauhaus he endeavored to place his concept of art on what he saw as a scientific footing which would be transferable to arts other than painting. Conflicts were inevitable. In Moscow Kandinsky faced stiff opposition from a younger generation of artists who rejected his idealistic notions. At the Bauhaus, whose intellectual foundations blended Expressionism with theosophy, social Utopianism, and Eastern mysticism, the situation was different. Above all, Kandinsky was no longer alone. There are obvious similarities, for example, between his ideas and those of Klee, who also saw an analogy between art and nature (see fig. 69). In

his 1924 lecture at the Kunstverein (Art Association) in Jena, for example, Klee spoke of the "mission" of those artists "who have penetrated into the proximity of that secret sphere where the primeval law governs developments." At the end of this remarkable address, a statement of his artistic beliefs, Klee talked about the motives behind his work at the Bauhaus. Speaking of the need for a synthesis of pure *Weltanschauung* and the pure practice of art, he said: "We have found parts of this synthesis, but not the whole. We do not yet have the necessary power, for we are not supported by a people. But we are seeking a people; we have begun to do so at the Bauhaus. We have started there with a community to which we sacrifice everything we have. More than this we cannot do." Like Kandinsky, Klee was an idealist who tended to think in organic metaphors and had a sense of missionary commitment. At the Bauhaus, these elements in the thinking of Klee and Kandinsky, which had evolved during their Munich years, were subjected to a measure of rational control, without which it would have been impossible for the two artists to put their ideas across to their students.

Klee's complaint that "we are not supported by a people" was soon to be confirmed by historical events. In April 1933 Klee was summarily dismissed from the teaching post which he had held since 1930 at the Düsseldorf Academy, and at the end of the year he was forced to leave Germany and return to Switzerland, a traumatic experience that found expression in such works as *Überstandener Sturm* (*Weathered Storm*; fig. 70). Kandinsky, who was fundamentally apolitical, remained at the Bauhaus until it was finally closed by the Nazis. He then thought for a time that Fascist Italy might provide a home for his artistic activities; eventually, however, he emigrated to Paris, where he died in 1944.

To sum up, one can say that Kandinsky, whose ideas were heavily influenced by the intellectual atmosphere of the *fin de siècle,* was a messianic visionary with a

marked predilection for arcane holistic theories. Like Klee, he worked in the 1920s at an institution with a Utopian mission to build a better society, which was bitterly opposed by conservatives and the extreme Right. The Bauhaus was more than just an art school; it was a cooperative society committed, in the wake of the November Revolution of 1918, to a program of radical democratic renewal, to an aesthetic philosophy which sought to reconcile art and industry and to reintegrate the artistic imagination into everyday life. The Bauhaus followed in the footsteps of the Arts and Crafts movement and the Werkbund, which had also combined the cause of aesthetic reform with that of social and political change. As Jürgen Habermas has remarked, such movements exemplify the permanent contradiction "between the democratic demand for universal cultural participation and the fact that, under industrial capitalism, there is an ever-increasing tendency to remove whole areas of life from the control of the preeminent cultural forces." This contradiction is clearly apparent in the activities of the Bauhaus and in the work of Kandinsky, who continued to adhere to the basic ideas of the Blue Rider but was forced to realize that, in the context of an increasingly complex world, his attempts to justify abstract painting in scientific terms were insufficient to uphold the claim of art to the status of total arbiter.

Although the artistic ideas of Klee and Kandinsky were to some extent discredited by the changed circumstances of the 1920s and 1930s, the quality of their pictures is not in doubt. The works in the collection of the Lenbachhaus alone would suffice to demonstrate the exceptional nature of their achievement. However, the theoretical foundations of their artistic approach no longer appear as unproblematical as at the time when their program was formulated, and even then dissenting voices were raised in some quarters. After World War II their writings found a wide audience and were read with a degree of interest which would have amazed the two artists. Today, though, one is forced to acknowledge that the erstwhile innova-

Fig. 69 Paul Klee, Page from the artist's notes for his first series of lectures at the Bauhaus, Weimar, in 1921/22

tive thrust of their work and ideas has largely been dissipated. What was once a revolutionary approach to art has been assimilated and canonized, thereby sharing the universal fate of the avant-garde movements of this century. Whether or not the reception of the Blue Rider has done justice to its original intentions is an open question.

Whereas in Germany the ideas of the Blue Rider were disseminated via the activities of Kandinsky and Klee at the Bauhaus in Weimar and Dessau, there was a considerable delay before their work began to influence artists outside this particular sphere. A specific example of an attempt to follow directly in the footsteps of the Blue Rider can be seen in the case of a group of Danish artists, including Asger Jorn, Carl Henning Pedersen, and Egill Jacobsen, who took up the ideas of the almanac at the time of the Nazi occupation of Denmark and became enthusiastic devotees of kitsch, primitive and folk art, the art of the mentally ill, children's drawings, and graffiti: the same forms of innocent creativity which had inspired the Blue Rider artists. Shortly afterward, the Dutch Experimental Group adopted the same ideas, arguing in favor of a wholly intuitive form of art governed solely by the norm of spontaneous expression. Immediately after the end of World War II a group of artists in Copenhagen, Brussels, and Amsterdam joined together to form the Cobra movement – the name was taken from the initial letters of the three cities – whose aim was to fill the cultural vacuum left by Fascism in Europe. Their aesthetic program had a Communist political slant, of a kind by no means uncommon in the immediate postwar period. By contrast, the members of the Blue Rider circle – with the exception of Klee, who supported the Bavarian Soviet Republic of 1919 – had always been apolitical idealists.

Cobra and the movements which followed in its wake, or which emerged at the same time in the USA, embraced a form of painting which had not yet advanced toward abstraction. The masks and chimeras, grotesque mythical beasts, and strange goblin-like figures which populate the garishly colored pictures of the Cobra artists follow the dictum of Constant Nieuwenhuys that "a picture is not a building composed of forms and lines, but an animal, a night, a cry, a person, or all these things together." The manifest influence of the Blue Rider on Cobra and its predecessors testifies to the vitality of the ideas of Kandinsky and his fellow theorists,

ideas which had first been formulated some thirty years previously. Cobra, in turn, has continued to influence the development of modern art up to the present day, as can be seen, for example, in the Neo-Expressionist movement which emerged in the early 1980s. And the attempts of the Blue Rider artists to combine different genres, as in Kandinsky's stage composition *Yellow Sound* and the theatrical activities of the Bauhaus, have been a source of inspiration to many artists working in the area of performance and experimental theater.

Notwithstanding the fructifying influence of the Blue Rider in this particular field, it has to be admitted that the subversive power of the painted subject now sometimes seems to have exhausted itself; the work of Marc, Macke, Jawlensky, Münter, Kandinsky, and Klee, and of their various contemporaries and successors, graces the walls of museums and has become an object of consumption. This is especially true of the abstract paintings in the tradition of Kandinsky. As Meyer Shapiro remarks in his book *The Spiritual in Art,* first published in 1957:

> The successful work of painting ... is a unique commodity of high market value. Paintings are perhaps the most costly man-made objects in the world. The enormous importance given to a work of art as a precious object which is advertised and known in connection with its price is bound to affect the consciousness of our culture. It stamps the painting as an object of speculation, confusing the values of art. The fact that the work of art has such a status means that the approach to it is rarely innocent enough; one is much too concerned with the future of the work, its value as an investment, its capacity to survive in the market and to symbolize the social quality of its owner.

This statement, made over thirty years ago, has lost nothing of its relevance; on the contrary, its lasting truth is borne out by the astronomical prices paid today for works by classic modern artists. We have seen that the Blue Rider artists were vehemently opposed to materialism. However, their pictures, the concrete manifestations of their ideals, have long since been overtaken by it, and the question thus inevitably arises whether, and if so to what extent, the "spiritual" impulse behind their work had any sort of capacity to resist cooption by the market. But rather than indulging in idle speculation, we must content ourselves with keeping alive the memory of one of the momentous revolutions in the history of art. The Blue Rider was a movement whose utopian notions of aesthetic synthesis and spiritual renewal exceeded its ability to put these ideas into practice. Precisely this discrepancy between program and practice may well be the reason why the Blue Rider has continued to function as a source of stimulation to successive generations of artists. To this end, the collection of the Städtische Galerie im Lenbachhaus contains a wealth of fascinating illustrative material, which is presented here in a representative selection.

Plates

Franz Marc
b. 1880 in Munich – d. 1916 at Verdun

Marc originally intended to study theology, but changed his mind and turned to painting. Until 1903 he attended the Munich Academy; in the course of the following years he made several trips to Paris, where he came into contact with all the latest developments in modern art. It was only in 1909, however, that these influences began to make themselves felt in his work. In 1910 he met and befriended Macke, who taught him the importance of pure color and helped him to find his own personal style. He also made the acquaintance of Kandinsky, who became his closest artistic collaborator. Marc and Kandinsky were the joint editors of the almanac *Der Blaue Reiter* (*The Blue Rider*), which featured contributions from a wide range of artists and reproductions of works from different periods and genres: the aim of the publication was to show that each work of art had its own expressive core, its own distinct "inner sound." Between 1911 and 1914 Marc concentrated almost exclusively on the depiction of animals: he saw them as embodying a particular quality of innocence which corresponded to his own quasi-religious striving for spiritual purity. His artistic approach was considerably influenced by the rhythmic compositional techniques of Futurism and by the "Orphic" Cubism of Robert Delaunay, whom he visited with Macke in 1912. In 1914 he began experimenting with abstraction. He was killed in action in World War I.

Franz Marc

1 NUDE WITH CAT (*Akt mit Katze*), 1910
Oil on doubled canvas, 34⁵/₈ × 32¹/₄″ (88 × 82 cm)
G 12762

The year 1910 saw a decisive change in the direction of Marc's
work. From 1900 to 1903 he had studied at the Munich
Academy; ever since, he had been struggling to free himself
from the bonds of Naturalism and to develop an artistic vo-
cabulary of his own. He had been deeply impressed by his first
encounter with the work of Van Gogh during a trip to Paris
in 1903, and promptly left the Academy to continue painting
on his own. The principal subjects of these early pictures were
people and, in particular, animals, which he regarded as a
vehicle for piercing the veil of appearances and delving down
to the core of reality: a lofty theoretical aim which the pictures
themselves initially failed to realize. Looking at the experi-
ments of early Modernism, Marc recognized that color would
have to be used as an expressive medium in its own right if he
were to break with traditional conventions of representation,
but he found himself unable to translate this insight into con-
vincing pictorial practice.

The event which provided Marc with the impetus to de-
velop his own distinctive style was his encounter with Macke.
In 1910 Macke discovered a set of lithographs by Marc in
a Munich gallery and was so taken by the pictures that he
immediately set out to find the artist, calling on him that same
day. This meeting with Macke put an end to Marc's isolation
and freed him from the material worries which had previously
beset him: in Macke's wealthy uncle, Bernhard Koehler (see
plate 91), he found a willing and generous patron. That same
month the two artists visited an exhibition of pictures by Henri
Matisse at the Thannhauser gallery in Munich, which Macke
in particular found highly stimulating. Marc's *Nude with Cat*
exhibits a freer use of color which also appears to be influenced
by the Fauvism of Matisse. The red-haired woman squats on
a cushion in the center of the almost square picture; her body
is powerfully modeled with vermilion, yellow, and green con-
tours. Green shadows play on her arms and face as she bends
forward to give the small yellow kitten its milk. The diagonal
stripes of the brightly colored carpet integrate the figure into
the colored surface of the background. The only remnant of
Marc's academic style is to be seen in the deliberate, harmoni-
ous drawing of the outline of the body, while the pose is
reminiscent of a nude study of a crouching woman which
Marc had painted in 1909. In a letter written in 1907 to his
future wife, Maria Franck, Marc spoke of his wish "to depict
the human species, the 'animal' Man." Yet the human figure
was soon to disappear from his pictures. In his opinion, only
animals embodied that special quality of purity and innocence
which would enable the artist to uncover the spiritual principle
underlying the material world of appearances – a view which
allied Marc with Kandinsky as one of the main protagonists
of the Blue Rider.

Franz Marc

2 DEER IN THE SNOW (*Rehe im Schnee*), 1911

Oil on canvas, 33³/₈ × 33¹/₄″ (84.7 × 84.5 cm)
Presented in 1971 by Frau Elly Koehler to Hans Konrad Roethel in
recognition of his services to the Blue Rider
G 14641

Deer in the Snow is one of the first works in which Marc
succeeded in freeing himself from the Naturalism of his early
animal pictures and in jettisoning realist conventions in the
depiction of nature. Whereas *Rehe in der Dämmerung* (*Deer at
Dusk*; fig. 39, p. 29), painted two years previously, uses late
Impressionist techniques of individual characterization, the
delicate brown arabesques of the two animals in *Deer in the
Snow* are inscribed in the closed, abstract world of a winter
landscape. The lines of their bodies, the curving back of the
deer on the left, and the arched neck of its companion on the
right are echoed by the deep blue and green shadows in the
pyramid of snow behind them. In this picture and others like
it, the objects are transformed into pure, semiabstract blocks
of color. Writing to Macke, Marc described a similar procedure
in a picture which he painted of his dog Russi: "As the color
grew purer, the outlines of the dog gradually disappeared, until
a pure relationship of color finally established itself between
the yellow, the cold white, and the blue of the snow."

 Deer in the Snow is the first picture in which Marc manages
to bring together the rhythms of animals and landscape in a
coherent composition based on a set of carefully interwoven
formal relationships, thereby evoking the sense of a specific,
harmonious order within nature. Here, we find Marc moving
toward a conception of painting centered on expression rather
than representation. On February 22, 1911, at about the time
he was working on *Deer in the Snow,* Marc wrote to his fiancée
Maria: "I am working very hard and striving for form and
expression. There are no 'objects' and no 'colors' in art, only
expression.... That, in the final analysis, is what really counts.
I already knew that, but in my work I was always distracted
by other things, such as 'probabilities,' the melodious sound
of the colors, so-called harmony, etc.... But we should seek
nothing but expression in pictures. The picture is a cosmos
governed by a different set of laws from those of nature."
There is, it must be admitted, something of a contradiction
between this last statement and Marc's conviction that the
"animalized" forms of his art would enable him to capture
"the symbolism, the pathos, and the mystery of nature."

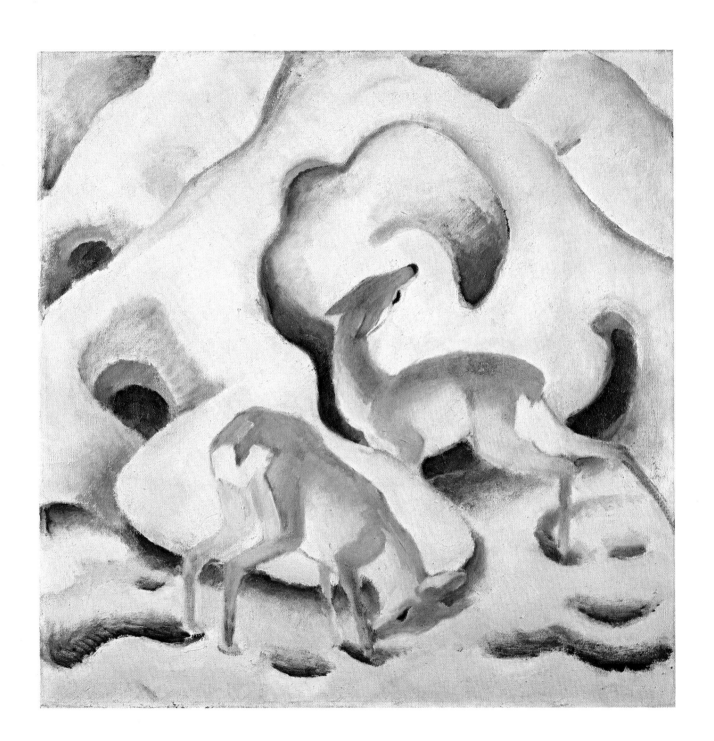

Franz Marc

3　BLUE HORSE I (*Blaues Pferd I*), 1911

Oil on canvas, 44 × 33¹/₄″ (112 × 84.5 cm)
Bernhard Koehler Donation, 1965
G 13 324

Blue Horse I, one of Marc's best known pictures, has an exceptional symbolic power. The blue foal, its limbs still gangling and awkward, stands with its head cocked slightly to one side, as if lost in thought. Its angular body is tinged with white, but its mane and hooves are deep navy blue. The proliferation of contrasts between complementary colors – from vermilion and green at the bottom of the picture, via carmine and yellow, to violet, blue, and orange at the top – illustrates with rare clarity the color theory which underlies much of Marc's mature work. In a famous letter to Macke, written in December 1910, Marc explained: "*Blue* is the *male* principle, austere and spiritual. *Yellow* is the female principle, gentle, bright, and sensual. *Red* is *matter,* brutal and heavy, the color which the other two have to fight against and overcome! For example, if you mix the serious, spiritual blue with red, you intensify the blue to the color of an unbearable sadness, and the conciliatory yellow, which is complementary to violet, becomes *indispensable.* (The woman as comforter, not as lover!) If you mix red and yellow to make orange, you give the passive, feminine yellow a 'shrewish' sensual power, so that the cool, spiritual blue becomes indispensable – the blue of the man, which immediately and automatically aligns itself with orange: the two colors love each other. Blue and orange, a thoroughly festive sound. If you then mix blue and yellow to make green, you bring red, matter, the 'earth,' to life, but as a painter I always sense a difference here: with green you can never quite suppress the eternal brute materiality of red Blue (the sky) and yellow (the sun) have to come to the aid of green in order to *silence matter.*" Thus Marc sets out his theory of the symbolic significance of blue as the "spiritual" color *par excellence.*

In *Blue Horse I* he finally abandons "natural" colors in favor of what Klaus Lankheit has termed "essential color." The horse, a traditional symbol of nobility, acquires an additional connotation: it symbolizes the same spiritual striving as the rider in Kandinsky's cover illustration for *The Blue Rider* almanac (see plate 52 and frontispiece). Its particular expressive pathos derives not only from its "spiritual" color, but also from its form. The pensively lowered head conveys the impression of a sentient being, with human thoughts and feelings. Johannes Langner has convincingly shown that Marc modeled many of his animal pictures on traditional images – for example, that of the lone, contemplative individual in the pictures of Caspar David Friedrich – thereby endowing the animals with a human aspect. The sense of a spiritual presence evoked by *Blue Horse I* finds its most complex and formally convincing expression in *Turm der Blauen Pferde* (*Tower of the Blue Horses*), a picture of four horses whose fragmented bodies form a cathedral of the spirit. Unfortunately, this work, which is Marc's most famous painting, was lost during World War II.

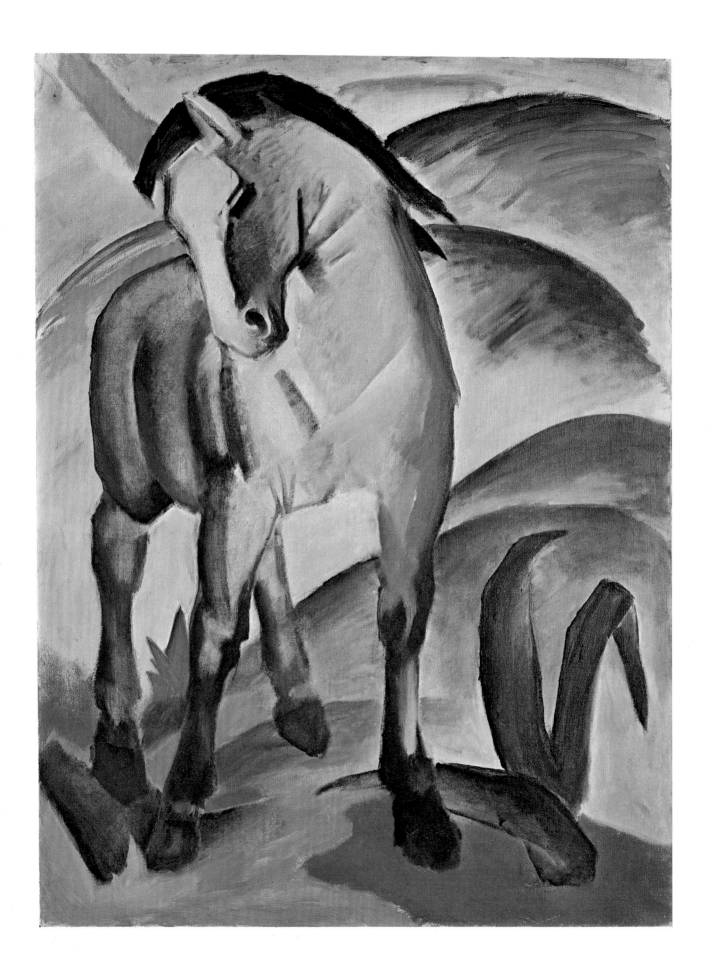

Franz Marc

4 DEER IN THE FOREST II (*Rehe im Wald II*), 1912

Oil on canvas, 43^1/$_4$ × 31^7/$_8$″ (110 × 81 cm)
Inscribed "Marc" (lower right)
Bernhard Koehler Donation, 1965
G 13 321

In April 1910 Marc had moved to Sindelsdorf in southern
Bavaria, where he was to devote himself almost exclusively to
the painting of animals. The first version of *Deer in the Forest*
was painted in the summer of the following year, after Marc
had returned from his honeymoon in London via Bonn, where
he visited Macke. *Deer in the Forest I* was included in the first
Blue Rider exhibition in December 1911 (see fig. 46, p. 34). In
1912 Marc painted this second version, in which the individual
forms are more clearly delineated and the black trunk of a tree
falls diagonally across the picture. A sleeping deer, its head
tucked into the curve of its body, lies in a hollow on the floor
of a fairy-tale forest, whose colors have a dull nocturnal glow.
Enclosed in the interlinking colored surfaces of the incline
which rises up behind it, the deer appears at once protected
and vulnerable. The top section of the picture is dominated by
the deep blue of the night sky, interrupted by the white twigs
hanging down in the foreground. The black diagonals of the
tree trunk and the branch on the right are inclined toward the
sleeping animal. This has been interpreted by Frederick S.
Lewine, who studied the covert apocalyptic symbolism of
Marc's pictures, as signifying an implicit threat.

Formally, the picture owes something to Cubism, which
helped Marc to integrate the animal into its surroundings: the
forest is seen, as it were, through the eyes of the deer itself.
Marc himself commented on this shift of perspective in dealing
with nature, the aim of which was to attain an experience of
a previously unknown form of transcendence: "What can be
more mysterious to the artist than the idea of how nature is
mirrored in the eyes of an animal? How does a horse see the
world, or an eagle, a deer, a dog? How impoverished and
soulless our convention is of placing animals in a landscape
which belongs to our eyes, instead of empathizing with the
soul of the animal in order to understand its view of the
world." The gentle figure of the yellow deer in the rhythmic
forms of the nocturnal forest does indeed convey a certain
sense of how the world must appear when seen from the
perspective of an animal.

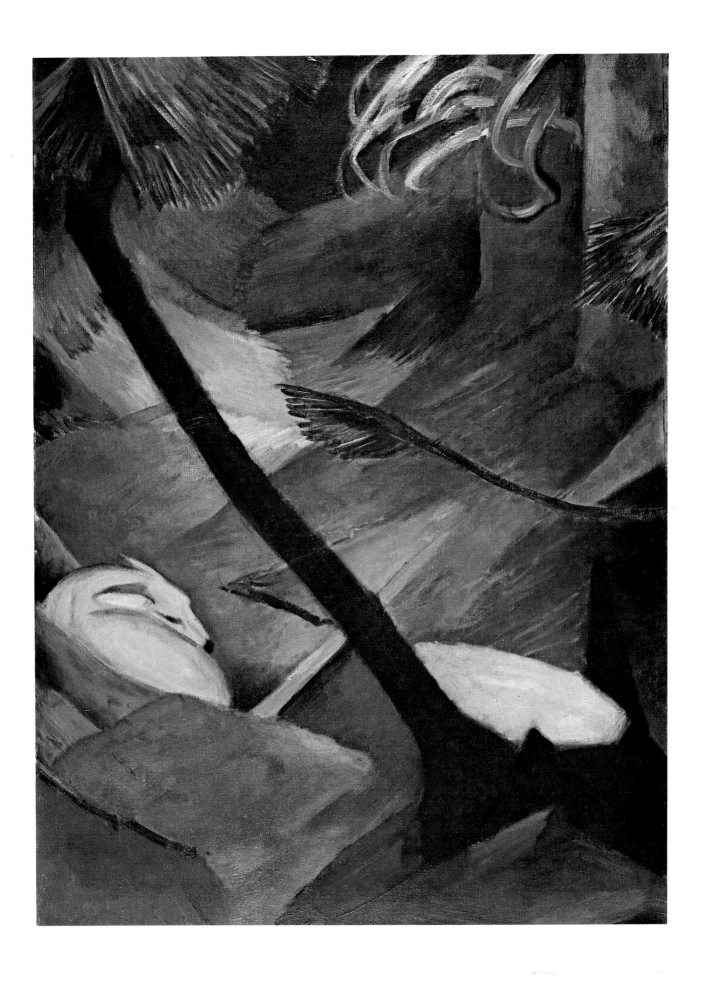

Franz Marc

5 RED AND BLUE HORSE (*Rotes und blaues Pferd*), 1912

Tempera on paper, $10^3/8 \times 13^1/2''$ (26.3 × 34.3 cm)
Inscribed "Fz. Marc" (lower left)
GMS 706

In the course of 1912 Marc increasingly used splintered, crystal-
line forms which remove the animals in his pictures from their
natural surroundings and transpose them onto a higher plane
of being. The landscape in *Red and Blue Horse* has a petrified
appearance, with yawning gaps that suggest an infinite abyss.
The lowered heads of the horses and the confrontation between
the "material" red and the "spiritual" blue convey an impres-
sion of both resignation and contemplation. Klaus Lankheit
has emphasized that the forms of the animals in Marc's pictures
are the product, not of an abstract stylization, but rather of an
attempt to grasp the essence of the species – in this case, of the
horse. The modernization of artistic form results from Marc's
aim of "animalizing" art. In his first published essay, a contribu-
tion to a book published by Reinhard Piper with the title *Das
Tier in der Kunst* (*The Animal in Art*), Marc explained his
ambitious artistic program: "My concern is not with animal
painting as such. I am looking for a good, pure, and clear style
which can fully accommodate at least a part of what we
modern painters have to say. I seek to strengthen my feeling
for the organic *rhythm* of things in general, to identify pantheis-
tically with the trembling and the flow of blood in nature, in
the trees, in animals, in the air – to make that into a picture
with new movements and with colors that pour scorn on our
old easel painting I can think of no better means than the
animal picture for achieving what I would call the '*animaliza-
tion*' of art. That is why I have taken to painting animals. In
the pictures of a Van Gogh or a Signac everything is animal,
the air, even the rowing boat which floats on the water, and
especially painting itself. These works bear no resemblance
whatever to what used to be called 'pictures.'"

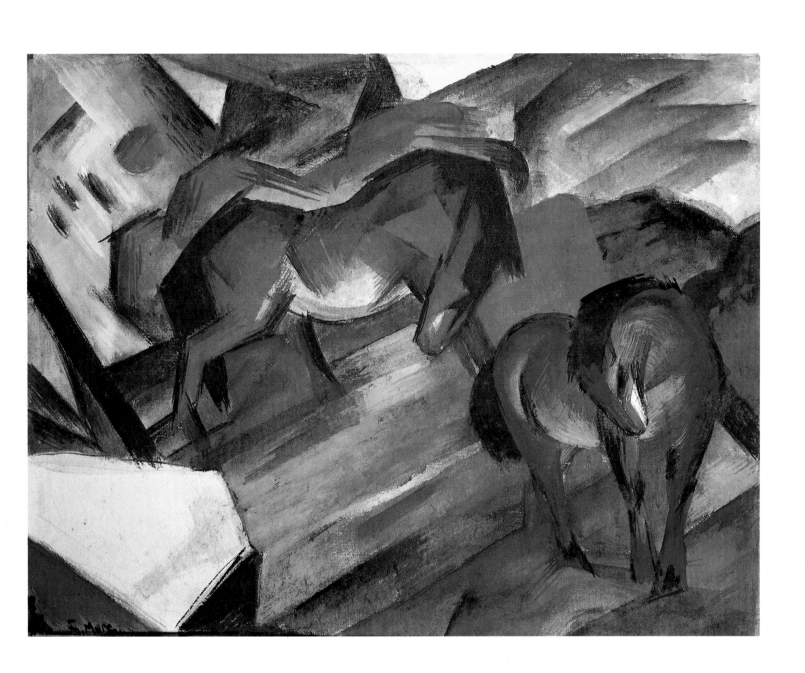

Franz Marc

6 THE TIGER (*Der Tiger*), 1912

Oil on canvas, 43³/₄ × 43⁷/₈″ (111 × 111.5 cm)
Inscribed "Fz. Marc/12" (reverse)
Bernhard Koehler Donation, 1965
G 13 320

The Tiger is one of Marc's finest works from the period before
the end of 1912, when his style began to evolve in a new
direction, influenced by the *simultanéisme* of Robert Delaunay
and evincing more abstract, interwoven forms and rhythmi-
cally arranged blocks of color. The almost square picture is
dominated by the powerful, angular form of the tiger, with
his beautifully formed head. The yellow of his body merges
with the transparent, Cubist forms of his surroundings: Marc
deliberately obscures the distinction between organic and inor-
ganic matter. Despite the semiabstract style of the picture, the
essential nature of the animal – its temporarily suppressed,
explosive energy, its power and litheness – is captured with
exceptional precision in a tightly organized network of formal
relationships. *The Tiger* is the fruit of Marc's attempts over
several years to synthesize the typical attitudes and movements
of animals, to grasp the secret of their essential form. The
details of this mature work are anticipated in the small bronze
sculpture of a panther, also in the Lenbachhaus, which Marc
made in 1908 and which, despite the artist's lack of experience
in this medium, demonstrates an astonishing formal virtuosity.
Hence the formal vocabulary of Cubism, which Marc had
encountered in the works by Picasso and Braque shown in the
second exhibition of the Neue Künstler-Vereinigung München
and in the 1912 Sonderbund exhibition in Cologne, is used
only as an additional expressive element in the painting of a
figure that Marc had already conceived some years previously:
his reception of Cubism is an expressive reworking of its
techniques. In his famous essay "Die Wilden Deutschlands"
("The Fauves of Germany"), published in *The Blue Rider* alma-
nac, Marc correspondingly emphasized the priority of "spiri-
tual" values over mere formal innovation in art: "The most
beautiful prismatic colors and the famous school of Cubism
have ceased to hold a meaning for these 'wild' painters. Their
thinking has a different goal: to create symbols for our time
which belong on the altars of the spiritual religion of the future
and whose technical creator vanishes into anonymity."

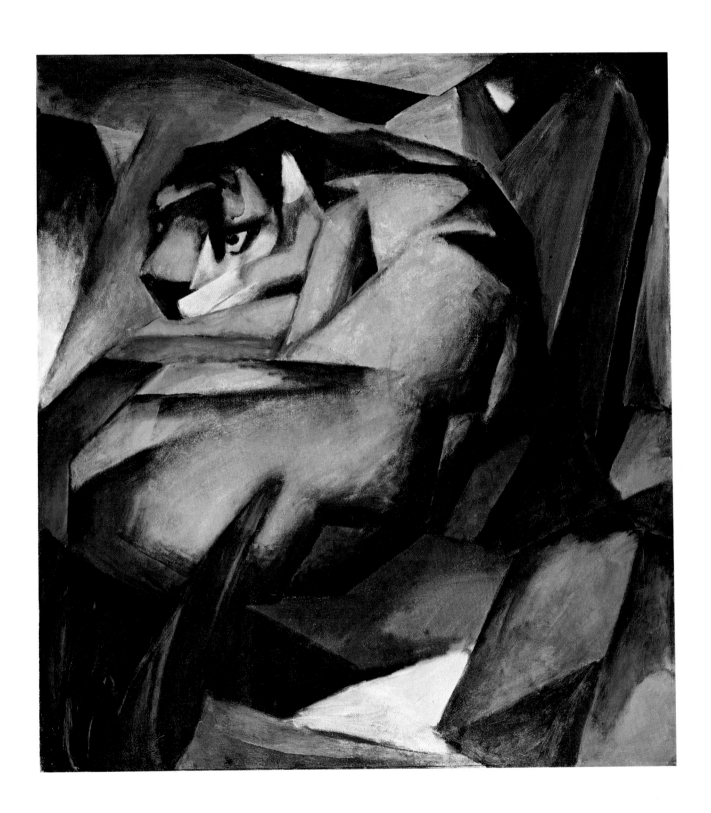

Franz Marc

7 COWS, YELLOW-RED-GREEN (*Kühe, gelb-rot-grün*), 1912

Oil on canvas, 24³/₈ × 34¹/₂″ (62 × 87.5 cm)
Inscribed "Marc" (lower right), "Sindelsdorf MARC" (on the stretcher)
Donated by Gabriele Münter, 1961
G 13 140

There are two previous versions of this picture. One of them, *Die Gelbe Kuh* (*The Yellow Cow*; Solomon R. Guggenheim Museum, New York), was received with a mixture of disapproval and incomprehension by Marc's former colleagues from the Neue Künstler-Vereinigung München when it was shown in the first Blue Rider exhibition in December 1911 (see fig. 46, p. 34). Alexander Kanoldt, for example, deemed it "an altogether deplorable work." However, the bizarre image of a leaping cow was greeted with enthusiasm by an avant-garde minority of Expressionist artists and, in particular, poets, such as Theodor Däubler, who spoke of the "drop of sunshine in the soul of the cow," and Walter Mehring, who praised the "bellowing cow-yellow." It would be hard to find a more apt commentary on the picture than Kandinsky's remarks on the color yellow in *On the Spiritual in Art,* published at the time of the first Blue Rider exhibition. According to Kandinsky, yellow, orange, and red generate "ideas of joy"; yellow is "the typical earthly color," which "affects us like the sound of a trumpet being played louder and louder"; it is "eccentric ... leaping over its boundaries and dissipating its strength upon its surroundings." Däubler poetically describes the consequences of this choice of color for the rest of the picture: "The cow sees the world in blue."

Color symbolism also plays a constitutive part in the later *Cows, Yellow-Red-Green.* Here, the yellow cow is joined by a red calf and a green bull, and the landscape replaced by nocturnal darkness, with vague lines of orange, blue, and carmine in the foreground. As in so many of Marc's animal pictures, the formal structure of the work follows the rhythm of the creatures' stylized bodies. Marc concluded his letter of February 22, 1911, to his fiancée (see plate 2) with the following remark: "Nature is lawless because it is infinite, an infinite coexistence and sequence. Our spirit gives itself strict, rigid laws which enable it to depict the infinity of nature." In the irrational picture of a leaping yellow cow Marc once again breaks with the traditional conventions of animal painting.

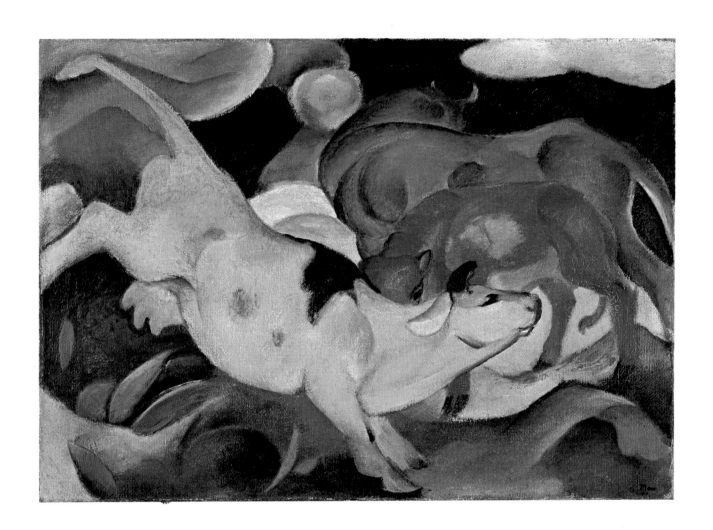

Franz Marc

8 THE MONKEY (*Das Äffchen*), 1912

Oil on canvas, $27^3/4 \times 37^3/8''$ (70.4 × 100 cm)
Inscribed "Marc" (lower left), "Marc Sindelsdorf" (reverse)
Bernhard Koehler Donation, 1965
G 14 664

The Monkey offers a further demonstration of the remarkable
speed with which Marc progressed from the subdued Natural-
ism of his studies of deer and horses, which he was still painting
in 1910, to the experimental style of this and similar pictures.
In his later pictures, as in his earlier work, he took his motifs
from nature but enriched them through his own imagination.
In the center of the picture a small gray monkey with a long
curling tail is depicted in profile perching on the diagonal
branch of a tree. Behind him, the jagged forms of jungle
vegetation form a kaleidoscope of coruscating colors. In con-
trast to *Mandrill* (Bayerische Staatsgemäldesammlungen, Mu-
nich), painted the following year, the monkey stands out from
its surroundings, in a manner reminiscent of the earlier *Affen-
fries* (*Ape Frieze*, 1911; Kunsthalle, Hamburg). Its softly
rounded head and its expression of shy vigilance lend it an
almost human appearance. The flowers amidst the dark green
vegetation constitute one of those references to the work of
Paul Gauguin that occasionally occur in Marc's pictures; here,
they have the effect of precious, exotic mannerisms.

Adolf Behne, one of the few critics who unreservedly praised
Marc's 1913 one-man exhibition at the Galerie Der Sturm in
Berlin, wrote: "Marc's pictures are deeply and intimately
rooted in nature. Indeed, I must confess that I would be hard
put to name another contemporary painter with such an ability
to move us and to lead us into the innermost depths of nature.
The innermost depths – that is precisely the point! The out-
ward appearance, the outward form, the outward correctness
of nature – they mean nothing to him. What concerns him is
the hidden presentiment, the inner life, the soul, the pulse of
nature! In terms of the intensity of feeling which his magnifi-
cent pictures evoke, Franz Marc is a worker of miracles!"
However, statements of this kind, which echo the words of
Marc himself, should not lead us to overlook the anthropo-
morphism of Marc's pictures, the tendency to confer human
features on animals, which stems from a deeply felt desire
for harmony and from a nostalgic urge to escape from the
materialism of the modern world.

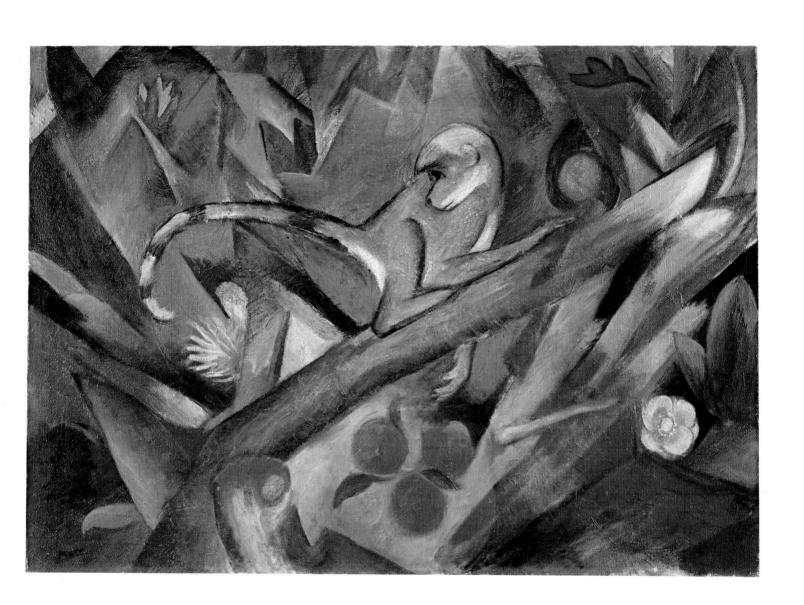

Franz Marc

9 DEER IN A MONASTERY GARDEN (*Reh im Kloster-garten*), 1912

Oil on canvas, 29³/₄ × 39³/₄″ (75.7 × 101 cm)
Inscribed "Marc" (lower right), "Marc Sindelsdorf" (reverse)
Bernhard Koehler Donation, 1965
G 13 323

It is possible that Marc hit on the motif for *Deer in a Monastery Garden* while taking an evening stroll in the garden of the monastery at Benediktbeuren, where he might suddenly have glimpsed the outlines of a deer in the moonlight. Compared with the artist's other pictures from 1912, its style is exceptionally advanced. To an even greater extent than in *The Tiger* (plate 6), the individual elements of the picture are broken up into narrow, opposing facets and reassembled to create a new reality. The rudimentary forms of nature play a mysterious role in generating the bundles and grids of intersecting lines, semicircles, and triangles which structure the composition. The deer in the center of the picture, enclosed in one of the abstract angular forms and yet retaining its physical integrity, stands with its raised head pointing toward the dull sphere of the moon, which, bounded by subdued orange and blue tones, is the calmest element in the agitated nocturnal landscape.

Unlike Kandinsky, Marc was receptive to parallel movements in modern art. Thus, *Deer in a Monastery Garden* is clearly influenced by the Futurist pictures which Marc first saw in the catalogue of the 1912 exhibition at the Galerie Der Sturm in Berlin. He takes up the techniques used by the Futurists to convey a sense of dynamic movement and adapts them to his own purposes. A further, possibly more important influence on his mature work of 1913 and 1914 was his encounter with the art of Robert Delaunay. In a letter to Kandinsky from Bonn, Marc gave an enthusiastic account of Delaunay's series of "window" pictures: "He [Delaunay] is working toward truly constructive pictures, eliminating representation altogether: pure fugues of sound, one might say." Even if Klaus Lankheit is correct in his contention that *Deer in a Monastery Garden* was painted before Marc and Macke visited Delaunay in Paris in October 1912, it is certain that Marc was already familiar with a number of Delaunay's pictures, including a painting of the Eiffel Tower which had been shown in the first Blue Rider exhibition (see fig. 48, p. 35) and a work from the *La ville* series which had been reproduced, alongside an essay on the artist, in *The Blue Rider* almanac. However, whereas in Delaunay's transparent prisms, the formal energy, intervals, and contrasts of color constitute the actual subject of a painting, Marc uses these formal effects to mirror the inner being of nature: his stated aim of "seeing the world through the eyes of the animal" is no more than a paraphrase for an artistic viewpoint whose aim is to attain an experience of transcendence.

In *Deer in a Monastery Garden* the light comes not only from the moon, but also from a number of other, concealed sources. In this, Frederick S. Lewine detects a new sense of hidden menace, and indeed, the works that Marc painted in the last two years before the outbreak of World War I do evince an atmosphere of impending doom.

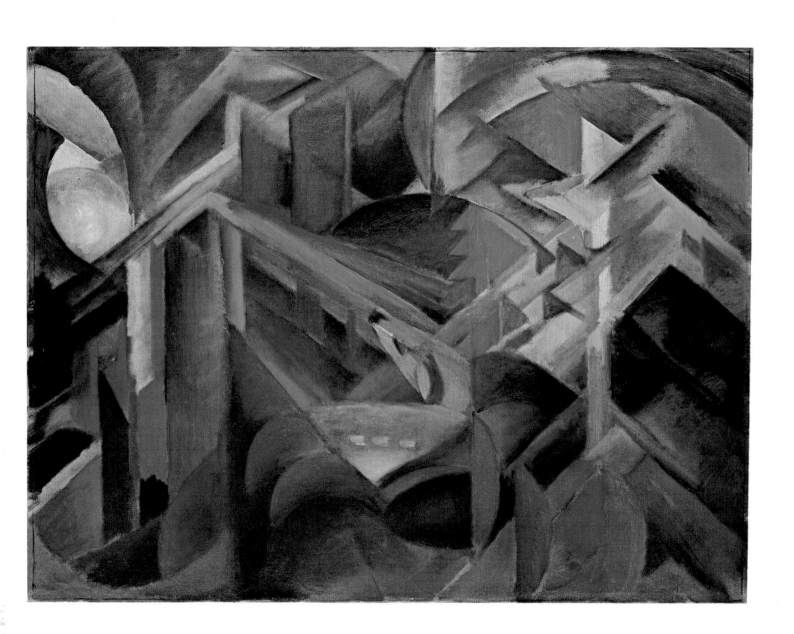

Franz Marc

10 IN THE RAIN (*Im Regen*), 1912

Oil on canvas, 31⁷/₈ × 41¹/₂″ (81 × 105.5 cm)
Inscribed "F.M." (top right)
Bernhard Koehler Donation, 1965
G 13 322

In terms of both form and content *In the Rain* stands out from
the rest of Marc's mature work. Through the diagonal grid of
falling raindrops one sees the broken outlines of a human
couple, dressed in the style of the period, with a large white
dog running ahead of them. From 1910 onward, Marc had
devoted himself almost entirely to painting animals; in this
work, however, he depicts himself and his wife Maria, caught
in a heavy rainstorm with their dog Russi. The picture, which
powerfully conveys the experience of battling against the ele-
ments, betrays particularly strong Futurist influence. The
clearly recognizable clothes and faces of the couple strike an
unusually "modern" note. Marc's first exposure to Futurist
painting was through the catalogue of an exhibition at Her-
warth Walden's Galerie Der Sturm in Berlin; he later saw the
pictures themselves at the Gereons-Club in Cologne, where he
helped Macke to hang them, and at the Thannhauser gallery
in Munich in November 1912. After seeing the reproductions
in the Berlin catalogue, he wrote to Kandinsky: "I cannot get
over the strange conflict between my estimation of their ideas,
most of which I find brilliant and *fruitful,* and my view of
their pictures, which strike me as, without a doubt, utterly
mediocre." Yet when he had seen the originals, he also waxed
enthusiastic about the formal qualities of the pictures. When
they were shown in Munich, he wrote to Macke: "The effect
is magnificent, far, far more impressive than in Cologne."
Though his animal pictures, painted in the rural isolation of
Sindelsdorf in southern Bavaria, may seem highly idiosyn-
cratic, even quirky, Marc was in fact very receptive to the
latest developments in modern art, as his essays in *The Blue
Rider* almanac clearly demonstrate. He also possessed consider-
able organizational skills, helping to arrange the Blue Rider
exhibitions, the Sonderbund exhibition in Cologne, and the
Erster Deutscher Herbstsalon (First German Salon d'Automne)
in Berlin in 1913. In addition, he was a member of the Sonder-
bund and the Berlin Secession. Such were the contradictions
of Marc's artistic personality, which expressed themselves in
the conflict between modern forms and Romantic ideas that
runs through his entire work.

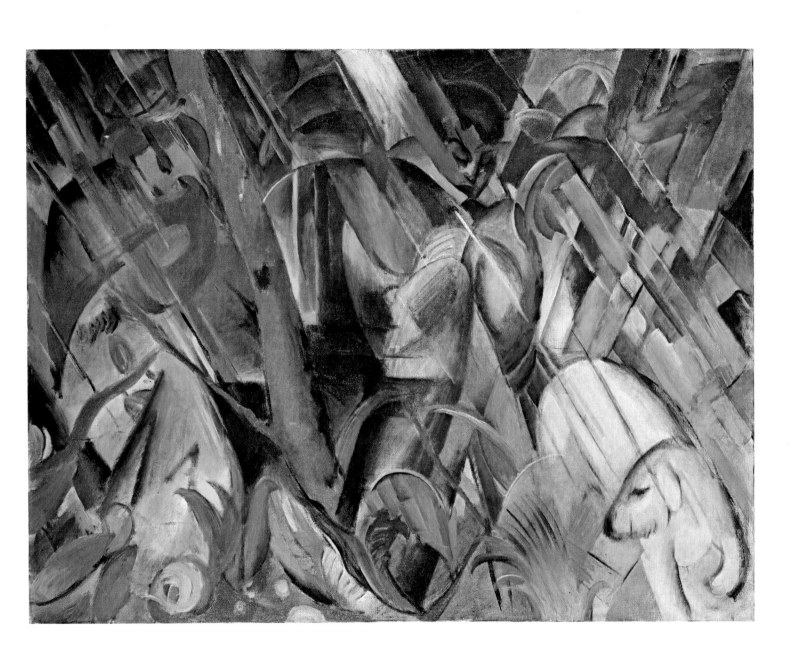

Franz Marc

11 THE BIRDS (*Die Vögel*), 1914

Oil on canvas, $42^7/8 \times 39^3/8''$ (109 × 100 cm)
Inscribed "M" (lower right)
FH 335

The Birds is one of the most important pictures which Marc painted in the period immediately before the outbreak of World War I. The brightly colored, angular forms of the picture evoke the fluttering, whirring movement of the three birds and, at the same time, convey a magical sense of stillness and calm, suggesting the presence of a larger bird slowly spreading its wings. Both forms and colors testify to Marc's interest in Futurism and the art of Robert Delaunay.

In the pictures which he painted toward the end of his career, Marc increasingly tended to use abstract forms. This was a logical consequence of the striving for artistic purity which had led him to concentrate exclusively on animals, the incarnation of natural innocence. Eventually, however, he came to see even animals as unsuitable subjects for a genuinely "pure" art. He explained this shift of attitude in a wartime letter, written from the Western Front to his wife in 1915: "Very early on I saw human beings as 'ugly'; animals seemed to me purer, more beautiful, but even in them I found so much that was ugly and contrary to feeling that, following an inner compulsion, my pictures instinctively grew more schematic and abstract, until I suddenly became aware of the ugliness, the *impurity* of nature. Perhaps our European eyes have poisoned and distorted the world; that is why I dream of a new Europe." Marc's last pictures are indeed entirely abstract; in *The Birds,* he makes a final attempt to reconcile animal forms with the urge for purity. As the reception subsequently accorded his work shows, his mature pictures have a specifically modern formal quality which has outlasted their content. Marc himself implicitly recognized this in his essay "Zur Kritik der Vergangenheit" ("Notes for a Critique of the Past"). "How is it possible," he asked, "that people who do not seem to be surprised by Dürer's arabesques or the folds of a Gothic garment are enraged by the triangles, disks, and tubular forms of our pictures? Surely they must be full of wires and tensions, of the wonderful effects of modern light, of the spirit of chemical analysis which decomposes energy and reassembles it in its own way. All this is the outer sensuous form of our pictures."

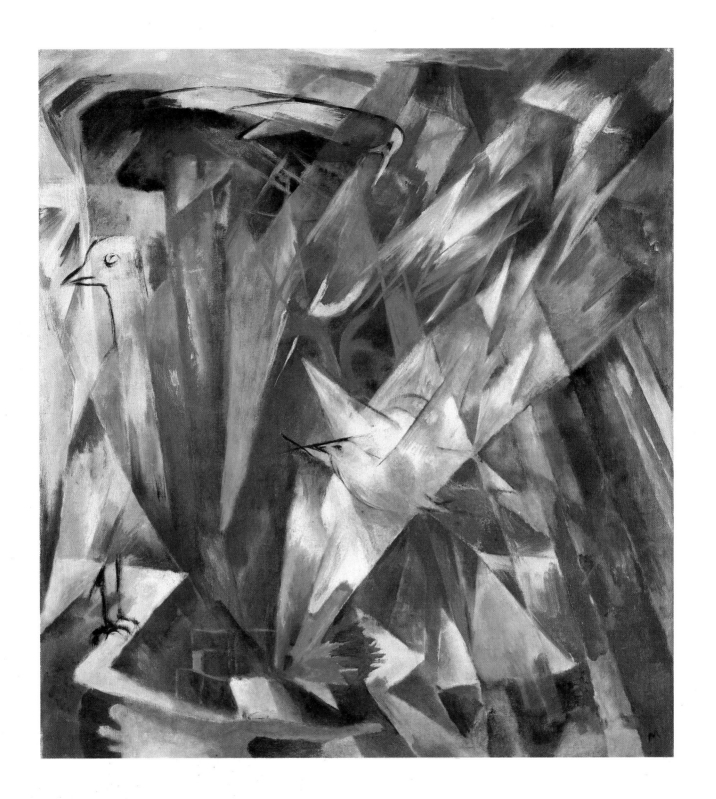

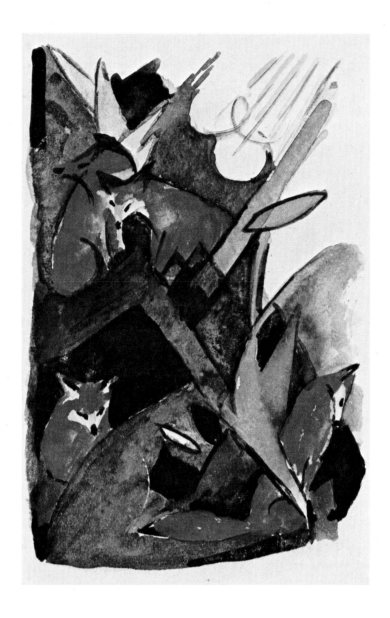

Franz Marc

12 FOUR FOXES (*Vier Füchse*), 1913
Watercolor on paper, 5^1/$_2$ × 3^1/$_2$″ (14 × 9 cm)
Postcard to Kandinsky, February 4, 1913
GMS 746

Among the many manuscript sources relating to the work of Marc is his extensive correspondence with a wide variety of artists, writers, collectors, and art dealers, among them, Macke, Kandinsky, Münter, Klee, Alfred Kubin, Robert Delaunay, Lyonel Feininger, Else Lasker-Schüler, Bernhard Koehler, and Reinhard Piper. While the letters he wrote to these and other individuals are invaluable historical documents, the postcards which he began to send to his friends in 1912 contain in miniature the very essence of his art. The majority of the cards date from 1913, Marc sometimes sending as many as two or three in a single day. With their singular poetic charm, these

small pictures are veritable jewels of early modern art. The illustrations on the cards, apart from those sent to Lasker-Schüler, often bear no relation to the text, which is generally concerned with practical matters. The text on the reverse of *Four Foxes* reads as follows: "Dear Kandinsky, Your book is wonderful, the text in particular is closer to me than I had felt it to be when I heard it read aloud; I am absolutely thrilled. Once again, many thanks for the book and the watercolor, and kindest regards in the [here Marc drew a square, a circle, and a cross]. F. Marc." The book which Marc mentions may well be Kandinsky's poetry album *Sounds*, which was published by Reinhard Piper in Munich in 1913. The front of the card shows for young foxes sitting at the entrance to their lair; the mixture of shyness and playfulness with which they sniff the air and inspect their surroundings is depicted with characteristic economy.

Franz Marc

13 VERMILION GREETING (*Zinnobergruss*), 1913

Tempera on paper, 5^1/2 × 3^1/2″ (14 × 9 cm)
Postcard to Kandinsky, April 9, 1913
GMS 726

On the front of this postcard two red and blue animals can be seen grazing in the midst of a landscape whose colors – yellow and dark orange – are almost garish. In the dark sky above their heads the following message to Kandinsky is painted in vermilion letters: "Dear K., Hartley is coming on Monday; I have arranged to meet him at the Goltz Gallery, where he has some pictures. Why don't the two of you come along as well: maybe we can all go and eat somewhere. We are traveling back on Wednesday evening. Vermilion greetings. F. Marc." With the single word *Zinnobergruss* (vermilion greetings), which contains a multiplicity of sensual and mental associations, Marc establishes a relationship between the text and the magical world of the animals below, one of which is colored in the same brownish red as the salutation. In addition, the "vermilion greeting" testifies to the closeness of the relationship between Marc and Kandinsky, each of whom trusted the other to understand his work intuitively.

Franz Marc

14 LANDSCAPE WITH RED ANIMAL (*Landschaft mit rotem Tier*), 1913

Tempera on paper, $3^1/_2 \times 5^1/_2''$ (9 × 14 cm)
Postcard to Alfred Kubin, March 18, 1913
Kub. No. 1

This charming miniature landscape was sent to the artist Alfred Kubin, who regularly corresponded with Marc and numerous other artistic and literary figures. There is a singular lack of documentary material relating to Kubin's membership of the Blue Rider circle, although he is known to have enjoyed close contacts with Marc, and with Klee, Kandinsky, and Münter until well into the 1920s: he and the other members of the circle frequently exchanged pictures and opinions. Together with Marc and Münter, Kubin had been one of the first artists to side with Kandinsky at the time of the controversy which led to the founding of the Blue Rider, when the Russian painter's *Composition V* (fig. 42, p. 31) was rejected by the Neue Künstler-Vereinigung München in 1911.

The text of the card reads as follows: "Dear Herr Kubin, I am extremely pleased that you are joining in. Kokoschka's acceptance is still outstanding. How right you are about him. It is all to the good if some of the people involved have 'tough' views – Kandinsky and I are somewhat pathologically inclined. We can talk about the further details when we meet. Of course,

there's no question of rushing anybody. Kind regards, F. Marc." The message refers to the illustrated edition of the Bible which Marc planned to publish. The previous week he had written to Kubin to ask him whether he would be interested in participating in the project: "How would you like to illustrate the Bible, a large-format edition in separate volumes? Kandinsky is doing the Apocalypse, I am going to do Genesis." The other contributors were to be Erich Heckel, Klee, who chose to illustrate the Psalms, and Oskar Kokoschka, who opted for the Book of Job. Kubin took on the Book of Daniel and, in fact, was the only one of the six artists to produce a finished set of illustrations, in the spring of 1914. These pictures were published as a separate volume in 1918.

In the last two years of his artistic career Marc turned to the subject of the Creation, which forms the theme of a number of his later woodcuts and drawings. In his *Skizzenbuch aus dem Felde* (*Sketchbook from the Field*) he noted several "inspirations" for the Bible illustrations. *Landscape with Red Animal* hints at the magic of this new beginning. In the background, standing out against the "spiritual" blue of the sky, a solitary red deer grazes on the brow of a hill. The foreground is dominated by three black, almost bare trees whose stylized trunks are twisted and bent. The depiction of the surrounding countryside, which lacks all sense of spatial definition, reminds one of a miniature in a medieval manuscript.

Franz Marc

15 TWO ANIMALS (*Zwei Tiere*), 1913

Watercolor on paper, $3^1/2 \times 5^1/2''$ (9 × 14 cm)
Postcard to Kandinsky, February 15, 1913
GMS 747

With their heavy, blurred bodies and heads, the two animals on this postcard merge into an almost abstract unity. The colors – red, blue, and the dull green of the bull's head – enable the viewer to distinguish between the animals but they continue beyond the outlines of the bodies. As so often, the text of the postcard relates to the day-to-day exchange of ideas between the two artists and to the arrangement of one of their frequent meetings: "Dear Kandinsky, Under separate cover I am sending you a copy of PAN, with an article by one Anton Meyer, incredibly stupid and bad, from a book published by our patron Cassirer! What has Herr Einstein got to say about it? We are coming to town on Sunday evening; may we come round and see you at around half-past seven? Then we can have a nice cozy chat. I hope this is convenient. Kindest regards from both of us to both of you. Fz. Marc."

Franz Marc

16 TWO BLUE HORSES IN FRONT OF A RED ROCK
(*Zwei blaue Pferde vor rotem Felsen*), 1913

Tempera on paper, varnished, 5^1/$_2$ × 3^1/$_2$″ (14 × 9 cm)
Postcard to Kandinsky, May 21, 1913
GMS 742

Two Blue Horses in front of a Red Rock is a singularly pure evocation of the imaginative world of Franz Marc. Two blue foals are depicted lying on a patch of grass in front of a red rock which has a semitransparent, crystalline appearance. Their pose and expression connote a mixture of happiness in the here and now and soulful longing for a paradise which lies beyond the confines of earthly existence – a longing for what Marc called the "indivisibility of being."

The text of the card refers to more prosaic matters: "Dear K. Why don't the two of you come with us to see Sacharoff [see plate 76]? There is no question of us attending the theatrical supper afterward, so the four of us can go off and have dinner somewhere. If you decide to go, then get tickets for us and send us a note: we can meet at the box office. If you don't go then we shall get tickets for the Friday and come round to see you on Saturday afternoon at about 4 o'clock. Is this all right with you? We have a prior engagement in the evening. Kind regards 2 × 2, Fz. Marc."

Franz Marc

17 RED AND BLUE HORSE (*Rotes und blaues Pferd*), 1913
Watercolor on paper, 3¹/2 × 5¹/2″ (9 × 14 cm)
Postcard to Kandinsky, April 5, 1913
GMS 743

With their sinuous pale red and blue outlines, the two leaping horses on this postcard convey a sense of dynamic movement which is unusual in Marc's animal pictures. In 1913 Marc was inspired by the example of Delacroix' pictures of horses and beasts of prey to make a number of studies of animals in motion, including the woodcut *Löwenjagd nach Delacroix* (*Lion Hunt After Delacroix*). The elongated horse on the left of *Red and Blue Horse* is based on a fresco which Marc discovered in a medieval church in South Tyrol. The same motif recurs several times in his work – for instance, in the postcard *Das Schlachtpferd des Prinzen Jussuf* (*The War Horse of Prince Jussuf*, 1913; Bayerische Staatsgemäldesammlungen, Munich).

The text of the postcard begins on the front: "Dear K., I am ill, have strained a muscle in my back. I shall send a telegram to Walden; perhaps he will come out here. Otherwise Campendonk will come in my stead," and continues on the back: "into town, so that you will not be left with all the work. At least Campendonk will bring me the news, etc. The Sonderbund: I have handed in my resignation, without giving a reason; they can work it out for themselves. As far as the Bible business is concerned, we should stick to six people. Kindest regards 2 × 2 Fz. Marc." Marc had joined the Sonderbund, an association of Rhineland artists, in 1912, but left the group a year later on the grounds that its members failed to take sufficient account of the interests of the Blue Rider artists. The "Bible business" refers to the projected publication of an edition of the Bible with illustrations by Marc himself, Kandinsky, Klee, Erich Heckel, Oskar Kokoschka, and Alfred Kubin (see plate 14).

Vassily Kandinsky

b. 1866 in Moscow – d. 1944 in Neuilly-sur-Seine, France

At the age of thirty Kandinsky gave up his promising university career as a lecturer in law and moved to Munich in order to take up painting. After studying for a while at a private school of painting and at the Academy, where he was a pupil of Franz von Stuck, he founded his own Phalanx art school in 1901. One of his first pupils, Gabriele Münter, was his mistress for many years. From 1904 to 1909 the couple traveled extensively. When they returned to Munich and Murnau in 1909, Kandinsky became one of the founding members of the progressive Neue Künstler-Vereinigung München (New Artists' Association, Munich). Only two years later a rift arose between Kandinsky and the more moderate members of the group. Together with Marc, Münter, and Alfred Kubin, Kandinsky left the Neue Künstler-Vereinigung to form the Blue Rider circle, the Munich equivalent of the revolutionary Brücke group in Berlin and Dresden. The year 1912 saw the publication of the famous almanac *Der Blaue Reiter* (*The Blue Rider*) and of Kandinsky's *Über das Geistige in der Kunst* (*On the Spiritual in Art*), whose common message was that inner, spiritual experience should take precedence over the representation of reality. For Kandinsky, this meant moving systematically toward abstraction.

At the beginning of World War I Kandinsky returned to Moscow, where he played a leading role in the debate on the politics of art which followed the Revolution. In 1922 he was appointed to a teaching post at the Bauhaus in Weimar. After the Nazi seizure of power in 1933 he left Germany and moved to Neuilly-sur-Seine, where he remained for the rest of his life, painting the late pictures of the "Paris years."

Vassily Kandinsky

18 RIDING COUPLE (*Reitendes Paar*), 1906/07

Oil on canvas, 21^5/$_8$ × 19^7/$_8$″ (55 × 50.5 cm)
Inscribed "KANDINSKY" (lower right), "KANDINSKY – (esquisse)"
(reverse), "REITENDES PAAR" (reverse of frame)
GMS 26

Riding Couple is one of a large group of early works, done
before 1907, in which Kandinsky conjures up a world of poetic,
fairy-tale images. Set in a long-vanished past, the pictures are
surrounded by an air of mystery and unreality. They feature
groups of nineteenth-century figures, medieval knights in an-
cient German streets, and, above all, motifs from Russian
history, which play a particularly prominent part in Kandin-
sky's early work and also provide the key to many of the ideas
and associations in his later pictures.

Riding Couple was painted in the winter of 1906/07 while
Kandinsky was staying in Sèvres, near Paris. The final version
was preceded by a tempera study and a number of pencil
sketches. Using small, delicate particles of color, the artist
depicts a young couple on horseback, dressed in Russian cos-
tume and locked in a tender embrace; the stylized birch trees
above their heads are covered with a net of golden leaves. In
the middle distance a calmly flowing river winds through the
picture; the water is a mosaic of varied colors in which it is
just possible to discern the white sails of two Viking ships,
reminders of a remote historical past. On the far side of the
river the brightly colored domes and towers of an old Russian
city stand out like a shining vision on the horizon.

One detects a number of different influences in this picture,
as in other early works by Kandinsky. The poetic character of
Riding Couple owes an obvious debt to the aesthetics of Art
Nouveau and to Symbolism, with its emphasis on the abstract,
spiritual content of art and the necessity of dematerializing
physical reality. The style also echoes that of contemporary
Russian fairy tale illustrations, which in turn were influenced
by the highly artificial forms of Art Nouveau and Symbolism.
In addition, Kandinsky profited from the innovations of Neo-
Impressionism, whose exponents had invented Pointillism, a
technique of breaking up colors into a multitude of elements.

Kandinsky uses color as a means of disguising the content
of the picture. This is one of the major features of his aesthetic
approach; in one of his early notes for the publication *On the
Spiritual in Art* he wrote: "The rich coloring of the picture
must exercise an irresistible fascination on the viewer and at
the same time obscure the underlying content." The individual
motifs of *Riding Couple* – the horse's bridle and decorative
apparel, the clothes of the young couple, the forms of the earth
and the sky – are fragmented into myriad particles of color, in
which the external contours of reality dissolve and merge.

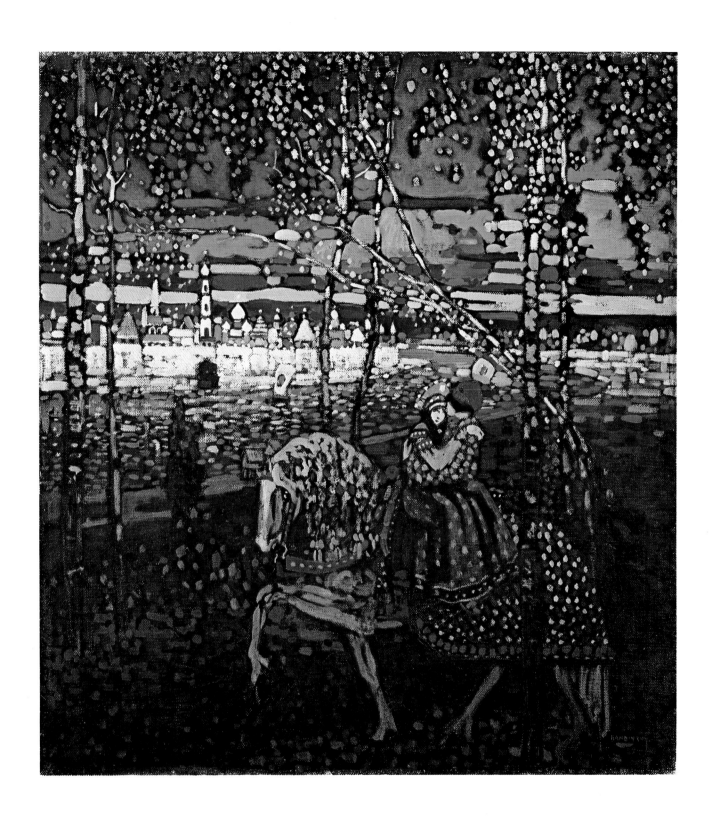

Vassily Kandinsky

19 MOTLEY LIFE (*Das bunte Leben*), 1907

Tempera on canvas, 51¹/₄ × 63″ (130 × 162.5 cm)
Inscribed "KANDINSKY 1907" (lower right), "La vie mélangée No. 46."
(on the stretcher)
On permanent loan from the Bayerische Landesbank
FH 225

With its teeming variety of human figures, the large tempera
painting *Motley Life*, executed in Sèvres at the beginning of
1907, is the last of Kandinsky's early cycle of poetic pictures;
its format and general ambitiousness make it the main work
in this series. Depicting a broad panorama of different human
situations, Kandinsky draws once more on the nostalgic, fantas-
tic motifs of his early work. The picture is an enamel-like,
glowing mosaic composed of individual particles of color, in
which the human figures appear as symbols of birth and death,
belief and struggle, love and separation, against a black back-
ground that conveys a sense of spatial uncertainty. In the dis-
tance a Russian city stands out on a dark, humplike hill on the
other side of the river.

A number of the archetypal Russian figures in the picture
appear in earlier paintings and woodcuts, such as *Bewegtes Leben*
(*Bustling Life*, 1903). In his autobiographical *Reminiscences*,
Kandinsky himself speaks of the resemblances between *Motley
Life*, the tempera painting *Ankunft der Kaufleute* (*Arrival of the
Merchants*, 1905; private collection, London), and the later
Composition 2 (destroyed); according to the artist, all three
works lend expression, in different ways, to an early, feverish
vision which exercised an initially unconscious influence on
his painting. While *Arrival of the Merchants* shows a similarly
varied group of Russian figures, albeit with a lesser degree of
narrative definition than in *Motley Life*, the link between the
latter picture and the virtually abstract *Composition 2* may seem
somewhat surprising. But this picture too is dominated by
conflicting images of happiness and impending doom, of life's
contradictions, evoked by scantily outlined figurative symbols.
Motley Life is evidently a step on the road toward the discovery
of new means of formal expression. Kandinsky later wrote:
"In *Motley Life*, where the task which charmed me most was
that of creating a confusion of masses, patches, lines, I used a
'bird's-eye view' to place the figures one above the other.
To arrange the dividing-up of areas and application of the
brushstrokes as I wished, on each occasion I had to find a
perspective pretext or excuse." This proves that, when work-
ing on the richly varied colors of tempera paintings such as
this, Kandinsky was experimenting with new, semiabstract
ways of seeing. The dreamlike disparity and isolation of the
figures also contributes to the dissolution of traditional notions
of form and content. However, it is important to realize that
in the work of Kandinsky, dissolution of form is accompanied
by a symbolic complexity which is evident in both his early
and his later pictures. A number of the motifs found in his
early work – the horseman, the boat, the Russian city, and
the mysterious encounter, for example – recur in his abstract
pictures, transformed into cryptic signs which imbue these
meticulously composed and highly suggestive works with an
aura of mystery and wonder.

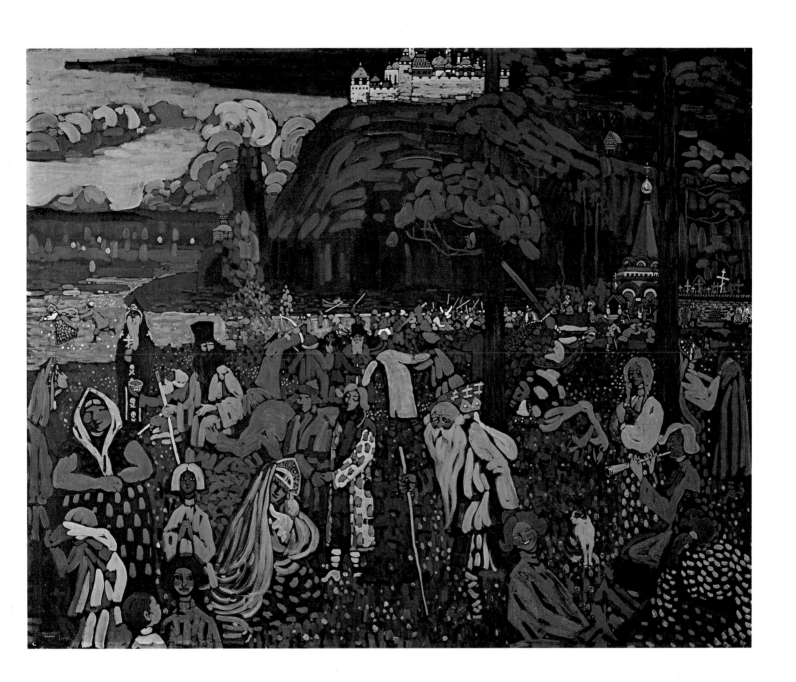

Vassily Kandinsky

20 BEFORE THE CITY (*Vor der Stadt*), 1908

Oil on cardboard, $27^1/_8 \times 19^1/_4''$ (68.8 × 49 cm)
Inscribed "KANDINSKY 1908" (lower left)
GMS 35

After several years of traveling around from one country to the next, Kandinsky and Münter returned to Bavaria in 1908. In August of that year they stayed for the first time in the small town of Murnau in the foothills of the Bavarian Alps, where they were joined by Jawlensky and Marianne von Werefkin. For Kandinsky and Münter in particular, working in Murnau meant the end of a long period of experimentation and the beginning of a decisive breakthrough in the discovery of new means of artistic expression. Shortly afterward, the couple settled in Munich and rented an apartment together in Schwabing, the artists' quarter of the city.

Before the City was one of the first pictures to emerge from this new phase in Kandinsky's creative development. Painted in strong, almost explosive colors which betoken a highly individual artistic approach, the work is a view of Kandinsky's new surroundings on the outskirts of the old city. The viewer's eye moves upward from the wavy lines of royal blue, green, yellow, and red in the lower section to the glowing deep blue of the sky and the brightly colored architecture, which is in turn offset by the darker tones at the bottom of the picture. The reckless, carefree manner in which Kandinsky applies the paint evidently owes a good deal to the influence of Fauvism, which he had heard all about from Jawlensky after the latter's visit to Henri Matisse's studio. The Fauvist preference for strong, pure colors, applied in flat, unbroken lines and patches, was fully compatible with Kandinsky's aim of exploiting the intrinsically expressive attributes of artistic materials, sealing off the surface of the picture and eliminating all sense of atmospheric illusion.

In the small *plein air* oil studies which he had been doing for several years in addition to his lyrical colored drawings, Kandinsky had already allowed himself the maximum possible degree of freedom in the use of color. He later wrote: "In my studies, I let myself go. I had little thought for houses and trees, drawing colored lines and blobs on the canvas with my palette knife, making them sing just as powerfully as I knew how." However, these early works, up to 1907, were painted with small strokes of the palette knife in a late Impressionist style that offered no possibilities for further development. Kandinsky's first stay in Murnau, and the pictures which followed, brought him closer to the fulfillment of his artistic aims. More than any of its predecessors, this picture conveys a sense of what Kandinsky referred to as "the brightly colored atmosphere of Munich, saturated with light, its scale of values sounding thunderous depths in the shadows."

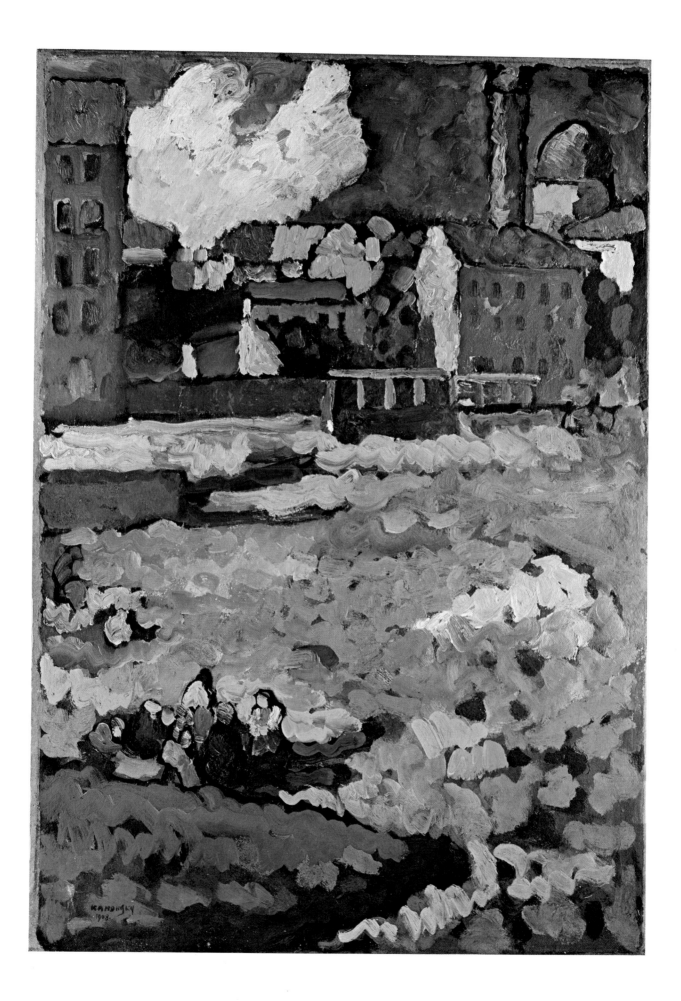

Vassily Kandinsky

21 KOCHEL – GRAVEYARD AND RECTORY
(*Friedhof und Pfarrhaus in Kochel*), 1909
Oil on cardboard, $17^1/_2 \times 12^7/_8''$ (44.4 × 32.7)
Inscribed "KANDINSKY" (lower right)
GMS 43

Following their first period of residence in Murnau in 1908, Kandinsky and Münter entered a phase of exceptional productivity and rapid creative development. Up to the outbreak of World War I in 1914, the two artists made a habit of spending the summer in Murnau and of retreating there for occasional weeks during the rest of the year. Especially in the years 1908 to 1910, but also later, until 1913, Kandinsky painted a large number of landscapes in Murnau which document the way in which he was advancing toward a new way of seeing and toward the discovery of new forms.

Kochel – Graveyard and Rectory was painted in February 1909, during a visit to the small, nearby town of Kochel. What strikes one in particular is the fascinating interplay of color between the brilliant yellow facades of the houses, the bold, if thinly applied, blue of the sky, the bluish-tinged snow, and the hues of the bushes in the foreground. Modifying and experimenting with colors and forms of the various winter motifs, Kandinsky was moving away, step by step, from realism and representational conceptions of painting.

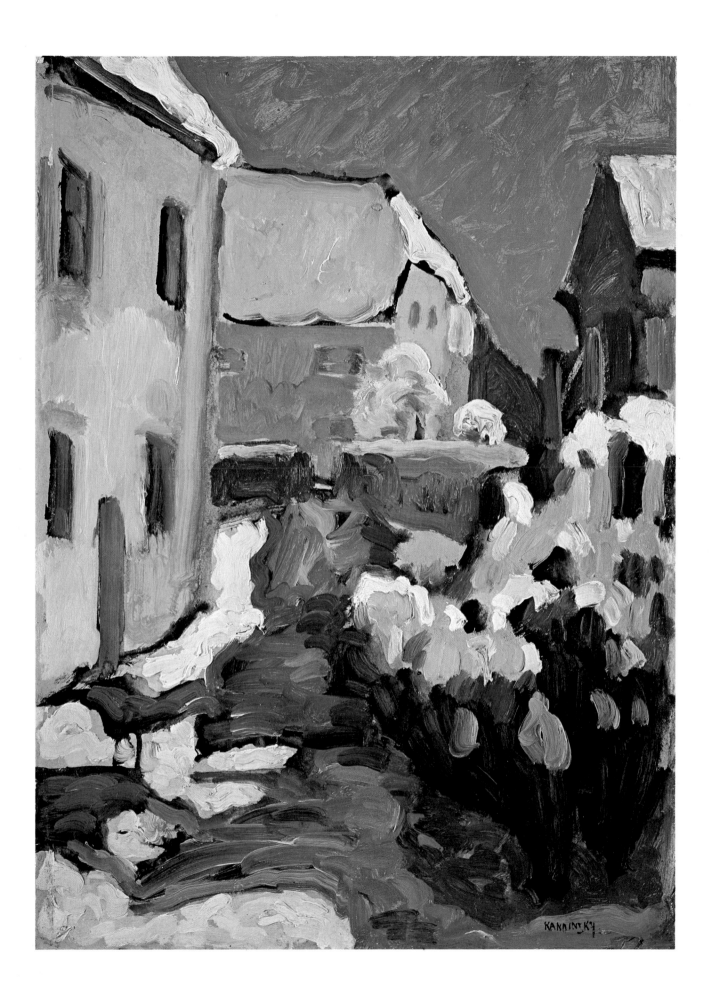

Vassily Kandinsky

22 RAILROAD AT MURNAU (*Eisenbahn bei Murnau*), 1909

Oil on cardboard, 14¹/₄ × 19¹/₄″ (36 × 49 cm)
Inscribed in Münter's hand" KANDINSKY", in another hand "1909"
(both reverse)
GMS 49

In the late summer of 1909, at Kandinsky's prompting, Münter bought a house in Murnau which soon became known among the locals as the *Russen-Haus* (Russians' house; fig. 29, p. 23). Here the couple spent their most productive months together, paying frequent visits to Marc in the nearby village of Sindelsdorf. It was in Murnau that Marc and Kandinsky edited *The Blue Rider* almanac in 1911. The Munich–Garmisch railroad ran right past the end of the garden, and the occupants of the house saw trains steaming by every day. Together with *Landschaft bei Murnau mit Lokomotive* (*Landscape near Murnau with Locomotive*; Solomon R. Guggenheim Museum, New York), *Railroad at Murnau* is one of the few pictures by Kandinsky with a technological or industrial theme. Unlike the North German Expressionists or the French Impressionists, whose work he knew well, Kandinsky depicts the train as a kind of toy, propelled by some supernatural force: the picture strikes a naive, almost comical note. The train resembles a huge black snake; its dark silhouette stands out clearly against the surrounding fields of color. The flickering red of the sunlight under the wheels of the train, the white steam, and the handkerchief of the waving girl create an impression of dynamic movement which extends to the two stylized telegraph masts.

In this picture one detects the subliminal influence of primitive art and the Bavarian folk art of painting on glass. Primitivism and the antidescriptive conception of images in popular art were an important stimulus to the imagination of Kandinsky, Münter, and the other members of the Blue Rider circle. Kandinsky did not see the realistic intentions of popular art as conflicting with his own aim of reducing the materiality of the object. In his essay "On the Question of Form" in *The Blue Rider* almanac, he argued that "the truly artistic" could be either realist or abstract; citing the naive painter Henri Rousseau as an example of what he called "great realism," he put the latter approach to art on a par with "great abstraction." Looking at pictures such as *Railroad at Murnau*, it becomes easier to understand this equation of two apparently opposed stylistic positions.

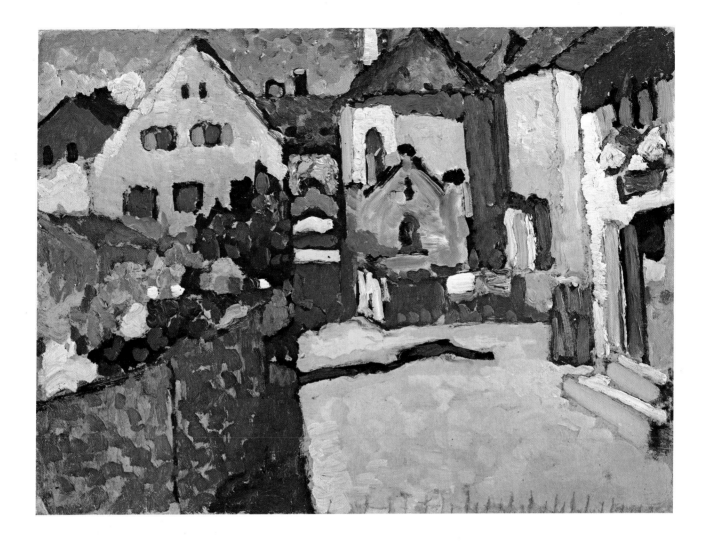

Vassily Kandinsky

23 MURNAU – GRÜNGASSE (*Grüngasse in Murnau*), 1909

Oil on cardboard, 13 × 17¹/₂″ (33 × 44.6 cm)
Inscribed in Münter's hand "KANDINSKY" (reverse)
GMS 42

Kandinsky painted *Murnau – Grüngasse* in the summer of 1909. The brilliant, deliberately artificial colors appear at first glance to correspond naturalistically to the sun-soaked stillness and the deep shadows of the street. However, the use of color has a deeper significance: the strong, triumphantly glowing, yet subtle contrasts of variegated yellows, blue, and warm, straw-berry red structure the image of the street in such a way as to lend the picture an exceptional formal presence. As in so many of Kandinsky's landscapes from 1908 onward, the main elements of the picture are thinly edged in black, so that their contours are clearly recognizable. But here too we find Kandinsky playing visual games with the forms constructed by color, such as the blue shadows on the ground and the colored shadows on the walls of the houses. The hedge in the foreground and the arrangement of the houses lend the picture a certain sense of spatial depth, but the laws of perspective and three-dimensional perception are suspended in favor of a carefully structured, homogeneous treatment of all the parts.

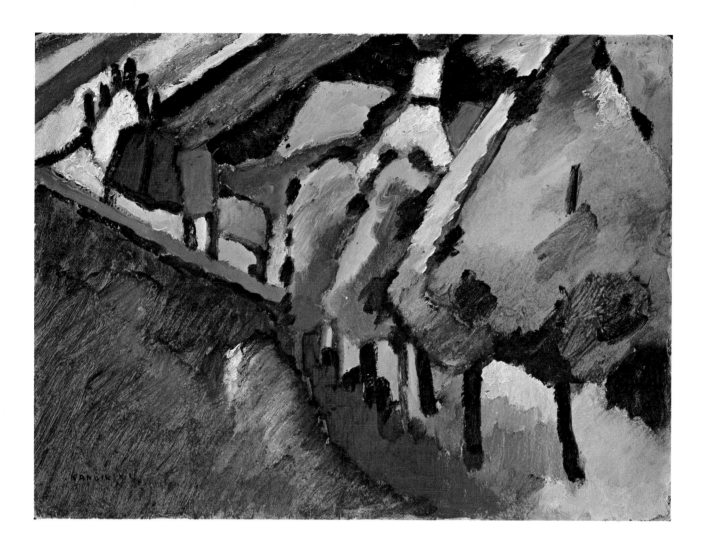

Vassily Kandinsky

24 NATURE STUDY FROM MURNAU III

(*Naturstudie aus Murnau III*), 1909

Oil on cardboard, $12^3/8 \times 17^5/8''$ (31.5 × 44.7 cm)
Inscribed "KANDINSKY" (lower left), in the artist's hand "Studie Murnau", in Münter's hand "Naturstudie Murnau 1909 oder 1908" (both reverse)
GMS 40

Kandinsky painted numerous pictures of Murnau, with its church, medieval castle, and brightly colored houses, as seen from the window of the house where he lived with Münter. As in *Murnau with Church I* (plate 31), which was painted the following year, the avenue of trees in the foreground opens up the space of the picture and makes its forms intelligible. The most striking feature of *Nature Study from Murnau III* is the power of the colors, the mixture of dark and bright, warm and cold, pure and mixed tones in the autumn landscape. By cutting off the horizon at the top of the picture, in a manner that is reminiscent of his earlier small-format studies in oil, Kandinsky deliberately weakens the sense of perspective and reduces the element of representational illusion. The effect and the expressive dimension of the landscape are evoked solely by the spontaneous brushwork and the resonance of the colors.

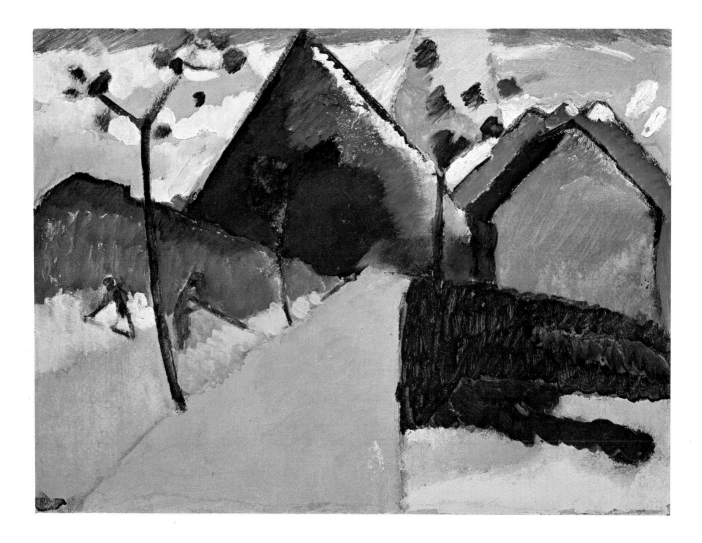

Vassily Kandinsky

25 NATURE STUDY FROM MURNAU I
(Naturstudie aus Murnau I), 1909

Oil on cardboard, 13 × 17¹/₂″ (32.9 × 44.6 cm)
Inscribed in Münter's hand "Kandinsky Naturstudie Murnau 1909"
(reverse)
GMS 45

Nature Study from Murnau I exhibits a greater degree of formalization than any of Kandinsky's previous pictures. A light blue road leads straight through the middle of the picture toward a dark blue triangular mountain, whose sharp-peaked outline is echoed by the silhouettes of a number of further mountains, painted in royal blue and a complementary yellow. The forms of the landscape are reduced to a set of basic geometric structures.

The resemblances between the work of Kandinsky and that of Münter and Jawlensky are closer in the Murnau pictures than at any other point in the three artists' development. Their landscape studies in particular were influenced by Jawlensky's notion of "synthesis," a principle of formal and stylistic economy whose aim was to render what Münter called the "extract" of things. *Nature Study from Murnau I* can be compared with Jawlensky's *Murnau Landscape* (plate 79), which was painted in the same year, and Münter's *Gerade Strasse (Straight Road*; private collection), painted in 1910. In all three pictures dark lines are used to emphasize the contour of the motifs; however, Kandinsky takes this technique a stage further by using similar lines as graphic abbreviations for the trees along the road and the two laborers working in the field. This double function of line as descriptive contour and independent figure anticipates Kandinsky's later reversal of its role in the pictorial process. In the free application of color, which subverts the rigid organization of the forms, there is a certain element of irrationality which distinguishes Kandinsky's landscape studies from those of his friends. The proximity of his landscapes to his more cryptic, abstract works is demonstrated by the main motif which dominates the painting: the blue mountain rearing up in the distance, with its slightly asymmetrical shape and the tip of its peak cut off at the edge of the picture. The same motif is found in a similarly dominant form and position in a number of further Murnau landscape studies, as well as in the enigmatic painting *Mountain* (plate 28) and the famous *Impression V – Park* (Musée National d'Art Moderne, Paris), painted in 1911.

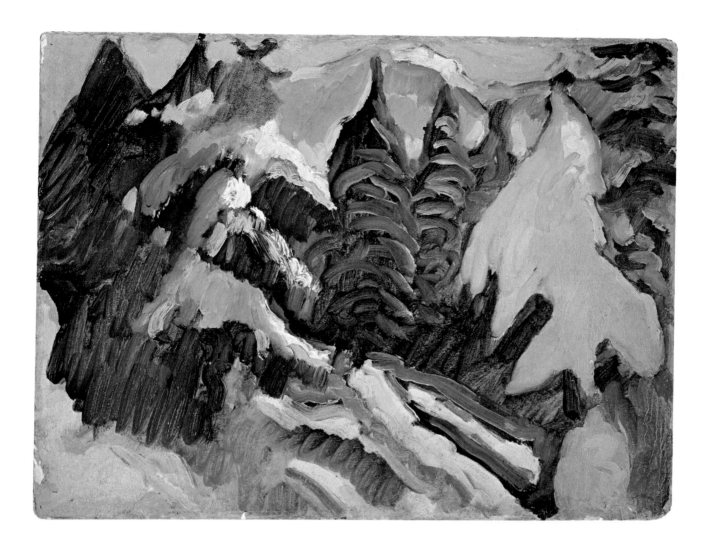

Vassily Kandinsky

26 KOCHEL – SNOW-LADEN TREES (*Verschneite Bäume in Kochel*), 1909

Oil on cardboard, 12⁷/₈ × 17¹/₂″ (32.8 × 44.5 cm)
Inscribed in Münter's hand "Kandinsky Naturstudie Kochel Februar 1909" (reverse)
GMS 38

Like *Kochel – Graveyard and Rectory* (plate 21), *Kochel – Snow-Laden Trees* was painted while Kandinsky and Münter were staying with the composer Thomas von Hartmann in February 1909. The semiabstract style of the small picture, with its intermingling colors – rust, brown, violet, yellow, blue, and white – anticipates the subsequent direction of Kandinsky's work. To an even greater extent than in *Kochel – Graveyard and Rectory*, Kandinsky is inspired by the winter landscape to liberate painting from its motif and blend natural forms with other, mysterious shapes. Rosel Gollek describes the picture as follows: "The pine trees, whose outlines are obscured by a blanket of snow, have become strangely unrecognizable; nature has lost its familiar appearance, taking on a new, magic form. The colors also strike an uncanny note. It seems as if Kandinsky has contrived to note down on his palette the exotic effects of color which brilliant sunlight often creates, in order to capture the fascinating essence of a fleeting instant." In his landscape studies Kandinsky allowed himself a free hand to pursue his own artistic goals, abbreviating the outward appearance of nature in order to convey its fundamental organic vitality. This reinterpretation of landscape is part of the process which culminates in the large paintings combining figure and landscape in a new "spiritual" manner.

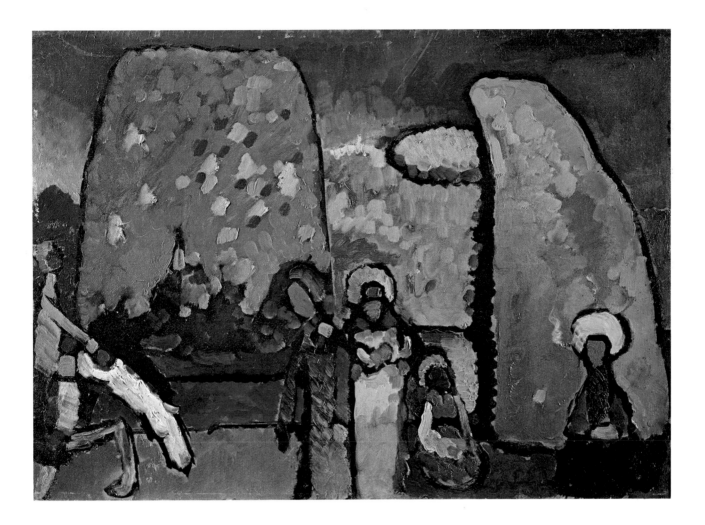

Vassily Kandinsky

27 STUDY FOR IMPROVISATION 2 (FUNERAL
MARCH) (*Studie zu Improvisation 2 [Trauermarsch]*), 1909
Oil on cardboard, $19^5/8 \times 27^3/8''$ (50 × 69.5 cm)
GMS 50

From 1909 onward, Kandinsky began to divide his more
important new works into three categories: "impressions,"
"improvisations," and "compositions." He explained this dis-
tinction in *On the Spiritual in Art*. "Impressions," in Kandin-
sky's terminology, are "direct impressions of 'external'
nature"; "compositions" are pictures in which "reason, the
conscious, the deliberate, and the purposeful play a preponder-
ant role" (see plates 45, 46); and "improvisations" are "chiefly
unconscious, for the most part suddenly arising expressions of
events of an inner character, hence impressions of 'internal'
nature." *Study for Improvisation 2 (Funeral March)*, the finished
version of which is in the Moderna Museet, Stockholm, is one
of the first of a series of improvisations which Kandinsky
created in the period from 1909 to 1913.

The scene, which incorporates elements of landscape, has an
unreal quality. Three women of vaguely Russian appearance
are seated in the center of the foreground, with a fourth woman
in the bottom right-hand corner; a rider on a white horse
enters the picture from the left. One detects a certain Symbolist

influence. As in several of the later "improvisations," Kandin-
sky uses Russian folk-art motifs, whose form is modified but
which nevertheless determine the entire character of this
"impression of inner nature." The subtitle *Funeral March* indi-
cates a general mood rather than a specific action. The subdued
tone of the painting, which is fraught with significance, is
echoed in *Bild mit Kahn* (*Painting with Skiff*; private collection,
Sweden), also dating from 1909, and the earlier *Mit drei Frauen*
(*With Three Women*; lost). The composition and some of the
motifs of these two works provide a number of clues to an
understanding of *Improvisation 2*.

Referring to *Painting with Skiff* and *With Three Women*, it
is possible to identify the deep blue band which separates the
figures from the background as a stream or river; the large
blocks of color behind them are mountains, with a white cloud
floating between the twin peaks. However, these two blocks
of color, especially the orange one to the right, with its light
blue "back," also have an organic appearance: the carefully
differentiated use of color fills them with restless life. The
schematic female figures are cowed and static; three of them
directly face the viewer, while the fourth turns to welcome the
approaching rider. The latter is one of Kandinsky's favorite
symbolic figures: it frequently appears in the "improvisations,"
anticipating the "blue rider" on the cover of the almanac.

Vassily Kandinsky

28 MOUNTAIN (*Berg*), 1909

Oil on canvas, $42^7/8 \times 42^7/8''$ (109×109 cm)
Inscribed "KANDINSKY" (lower left), "KANDINSKY – Berg (1909)"
(reverse)
GMS 54

In 1909 Kandinsky painted this astonishing picture, whose hallucinatory, emotionally charged, and near-abstract form appears to anticipate his tempestuous "experimental" phase shortly before the outbreak of World War I. It is only with some difficulty that the viewer recognizes the deliberately blurred outlines of two figures in front of a cone-shaped mountain, the main body of which is green, inlaid with white, and framed by a dominant strip of blue, which in turn is surrounded by a red zone of energy. On closer inspection, one realizes that the enigmatic figures allude to symbols familiar from other works by Kandinsky. A rider on a white horse is approaching a second figure, whose identity is uncertain; the two figures are attended, or threatened, by a sharply pointed zigzag shape on the extreme left of the picture and by a dark, inclining form on the far right. The form integrated into the mountain at the top of the picture echoes the familiar motif of the Russian city.

In this case, as in many others, one's understanding of the picture may be enhanced by comparing it with other works by Kandinsky, in particular with *Der Blaue Berg* (*The Blue Mountain*, 1908/09; Solomon R. Guggenheim Museum, New York). In this work, the mountain occupies a similarly central position, towering over, and visually dominating, the three riders on white horses in the center. Two figures stand at each edge of the picture: the one on the right leans slightly to the left like the dark form in *Mountain*. The coloring of *Mountain* is also echoed in the New York picture.

Although the figures are more clearly recognizable, the theme of *The Blue Mountain* is just as enigmatic as that of *Mountain*. All one can definitely say about the latter is that the landscape and the rider are endowed with an intense spiritual quality, to an even greater degree than in Kandinsky's previous work. This is to some extent a function of the colors. Kandinsky regarded blue as the color of infinity, the "typical heavenly color," which arouses a longing for purity and transcendence. Red is a warm, mature color full of power and purposive energy. White, on the other hand, which dominates the figures in *Mountain,* is the color of absolute silence. However, Kandinsky writes, when we have "looked beyond the wall," we find that white is full of unsuspected possibilities.

The mountain initially appears to be a highly formalized depiction of a real landscape: it is interesting to compare its form with the hierarchical, almost symmetrical shape of the mountain in *Nature Study from Murnau I* (plate 25) and *Herbstlandschaft* (*Autumn Landscape*, 1911; private collection, Chicago). However, it is important to realize that in this picture, the landscape and the figures merge into one another and are unified in a new way. Two formerly separate areas of Kandinsky's painting – the *plein air* landscape studies in oil and the enigmatic depictions of the human figure in other techniques – are brought together for the first time and integrated in a large-format work. Kandinsky had finally succeeded in liberating his technique from the traditional constraints with which he had long since broken in theory, but not as yet in practice.

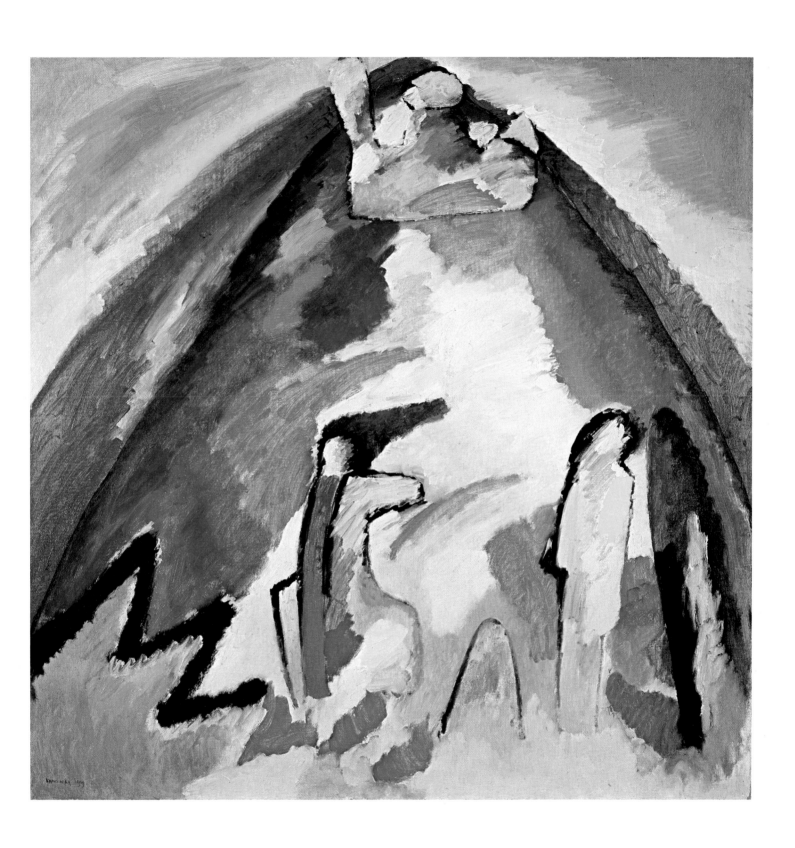

Vassily Kandinsky

29 IMPROVISATION 6 (AFRICAN) (*Improvisation 6
[Afrikanisches]*), 1909

Oil on canvas, $42^1/_8 \times 37^5/_8''$ (107×95.5 cm)
Inscribed "KANDINSKY 1909" (in blue, lower left), "N 96" (on the
stretcher)
GMS 56

Improvisation 6 differs from the other "improvisations" dating
from the same period in respect of its clearer composition and
the greater definition of its motifs. Its theme almost certainly
derives from the impressions which remained in Kandinsky's
mind after his visit to Tunis with Münter in 1905. Two figures
with turbans and voluminous caftan-like robes stand in the
foreground; to the left, one sees a white, rectangular shape
resembling the wall of a North African house. The robes, with
their narrow black borders, create an ornamental play of lines.
Kandinsky uses a variety of glowing colors – reds, yellows,
greens, and blues – which contrast with the dull white in the
left-hand section of the picture.

As in *Improvisation 2* (see plate 27), the foreground vaguely
echoes the atmosphere of Symbolist painting: Kandinsky him-
self referred to the Symbolists, in particular to Arnold Böcklin
and Giovanni Segantini, as "seekers of the spiritual in the
material." His stylized use of line in this painting is also reminis-
cent of Munich *Jugendstil*. The background, however, is quite
different. Here, the forms become increasingly blurred; the
colors merge into one another and cease to have any representa-
tional function. The two bowed forms behind the central
figures also appear to be human, but the seemingly organic
colored shapes in the background are entirely enigmatic.

In this "improvisation," which is admittedly less abstract
than some of the others, it would seem that Kandinsky was
nevertheless trying partially to hide the objects, in order to
allow the viewer to discover their inner "resonance" for him-
self. As he later wrote, "I dissolved objects to a greater or lesser
extent within the same picture, so that they might not all be
recognized at once and so that these emotional overtones might
thus be experienced gradually by the spectator, one after the
other."

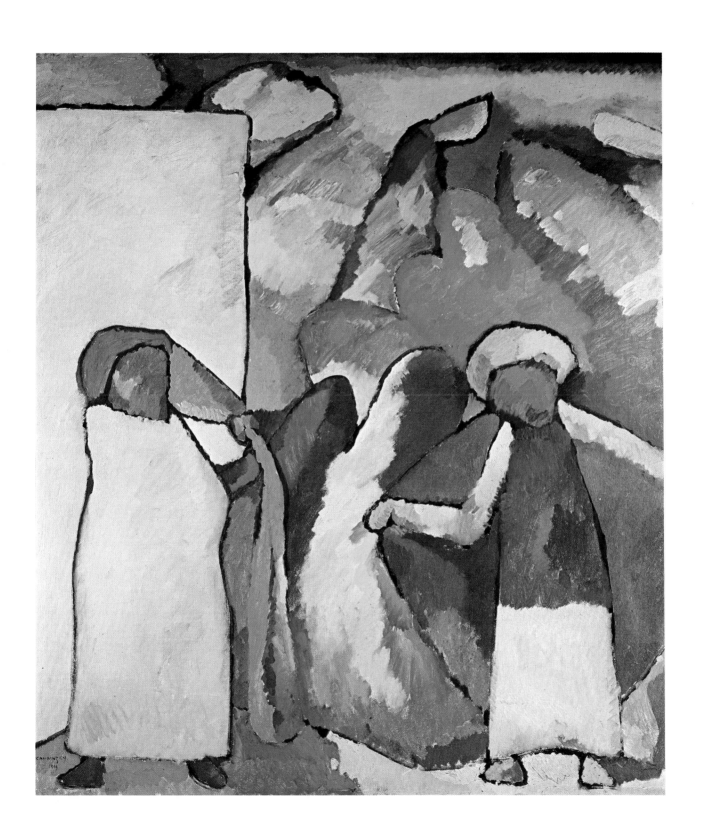

Vassily Kandinsky

30 ORIENTAL (*Orientalisches*), 1909

Oil on cardboard, $27^3/8 \times 38''$ (69.5 × 96.5 cm)
Inscribed in Münter's hand "Kandinsky Orientalisches" (reverse)
GMS 55

In painting *Oriental* Kandinsky drew on the same set of memories as in *Improvisation 6* (plate 29): the inspiration for the picture, with its exotic colors, was supplied by his visit to Tunisia in 1905. To an even greater extent than in *Improvisation 6* the dominant color is a powerful, sensuous red, combined with yellow and blue; green, however, is absent. Kandinsky also uses white to provide additional highlights, which stand out like jewels on the surface of a work whose broad format lends it a frieze-like quality. The crouching and moving figures are linked together by their long, awkward, intertwining limbs. In the background, behind the two white minarets, we see four cone-shaped mountains, crowned by Russian castles of the kind so frequently seen in Kandinsky's work. Thus, impressions of the Orient are fused with Russian motifs, via the intense experience of color of which Kandinsky so often spoke in connection with his native country. The same set of motifs is also used in a color woodcut, in which the distribution between figure and ground is deliberately blurred, thereby transforming the picture into a vibrant, near-abstract pattern.

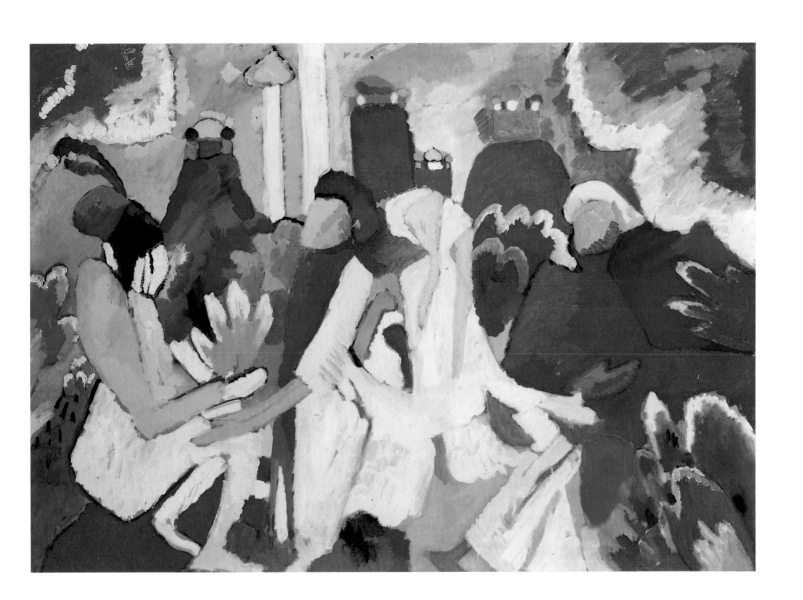

Vassily Kandinsky

31 MURNAU WITH CHURCH I (*Murnau mit Kirche I*), 1910

Oil on cardboard, 25¹/₂ × 19³/₄″ (64.7 × 50.2 cm)
Inscribed in Münter's hand "Kandinsky Kirche" (reverse)
GMS 59

Murnau with Church I is one of the best known views which Kandinsky painted of the small market town in southern Bavaria. It stands out from the rest of the Murnau landscapes painted in the period up to and including 1910: while remaining faithful to the motifs and the genre of landscape, Kandinsky follows a less naturalistic approach and uses color in the freer, more spontaneous manner with which he was experimenting in his "fantasy" paintings. It is just possible to recognize individual pictorial signals which distinguish the objects in the flow of color: the tall white church steeple, for example, and the vague outlines of a cluster of houses to the left. Kandinsky painted a number of similar pictures, such as *Murnau with Church II* (Stedelijk Van Abbemuseum, Eindhoven), in which the view is outlined more clearly and the dark silhouette of the mountains behind the church steeple lends the landscape a sense of spatial definition. In *Murnau with Church I* the only sense of depth is provided by the conglomeration of colors in the center of the picture. The color is freely and spontaneously applied: here and there, the bare surface of the cardboard shows through. This use of paint, together with the dynamic tilt of the steeple and the houses, creates an effect of movement and energy. Despite its apparent immediacy, *Murnau with Church I* is composed with meticulous care: this is evident in the balanced distribution of blue and white in the picture.

It may have been this picture, or a similar one, which occasioned an experience described by Kandinsky in his autobiographical *Reminiscences*. One evening in his studio, shortly after dusk, he suddenly saw "an indescribably beautiful picture, pervaded by an inner glow. At first I stopped short and then quickly approached this mysterious picture, on which I could discern only forms and colors and whose content was incomprehensible. At once, I discovered the key to the puzzle: it was a picture I had painted, standing on its side against the wall." He sensed that the impression generated by this picture was closely akin to his idea of "true" abstraction, but realized that he still had a long way to go before achieving his goal of devising purely abstract pictorial forms by eliminating perspective, introducing graphic elements into oil painting, and liberating color from any descriptive function.

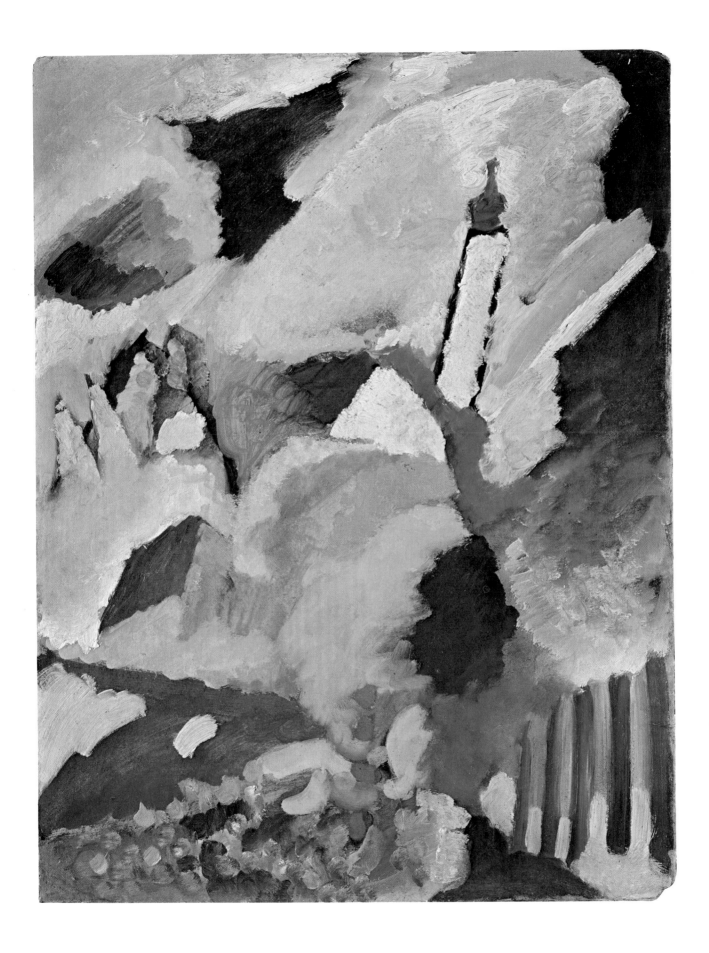

Vassily Kandinsky

32 THE COW (*Die Kuh*), 1910

Oil on canvas, 37³/4 × 41³/8″ (95.5 × 105 cm)
Inscribed "KANDINSKY 1910" (lower left), "KANDINSKY Die Kuh
(1910)" (reverse, in the artist's hand)
GMS 58

In painting *The Cow,* Kandinsky employed dissolved structures
of the kind seen in *Murnau with Church I* (plate 31), with the
difference that in *The Cow* these structures are used as a means
of deliberately blurring the image, thereby producing an effect
of alienation. In the foreground a large white-and-yellow cow,
facing to the right, is being milked by a young peasant girl.
The outlines of the cow are obscured by the white and yellow
of the surrounding area. One is particularly struck by the white
mountain, which seems to follow and extend the line of the
cow's back. The pointed conical shape of the mountain, framed
by a strip of blue, is typical of the Murnau mountain form
which occurs in so many of Kandinsky's pictures in the period
up to 1913. Its peak is crowned by a white wall, which may
be a reference to the city wall of Murnau, although behind it
one sees a number of Greek Orthodox onion-shaped domes.
Once again, we find Kandinsky painting a vision inspired by
a specifically Russian quality of feeling, but set in the country-
side of southern Bavaria, whose churches and chapels aroused
in him, as he later wrote, a similar resonance to that evoked
by Russian church architecture.

Like the form of the cow, these walls and towers are inte-
grated into the colors of their surroundings. In this picture
Kandinsky was evidently more concerned with creating struc-
tural analogies and dissolving the contours of the motifs than
with concealing some deeper meaning.

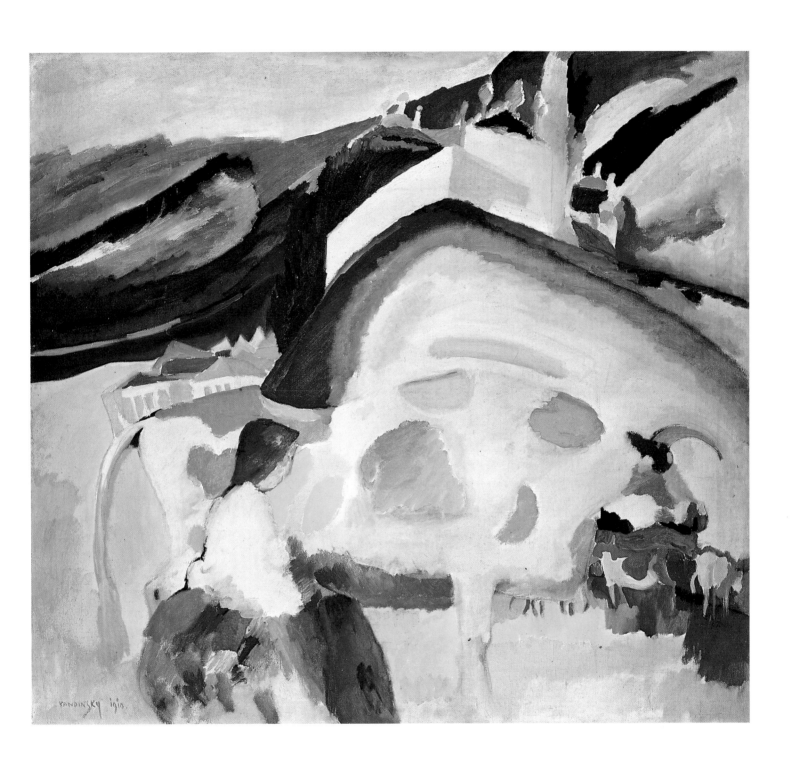

Vassily Kandinsky

33 IMPRESSION III – CONCERT (*Impression III
[Konzert]*), 1911

Oil on canvas, 30^1/$_2$ × 39^3/$_8$″ (77.5 × 100 cm)
Inscribed "KANDINSKY 1911" (lower right), "Impression Concert 1911
No. 116" (reverse)
GMS 78

Impression III – Concert was painted shortly after a concert of
music by Arnold Schoenberg which Kandinsky attended on
January 2, 1911, together with Marc and several other members
of the Neue Künstler-Vereinigung München. Kandinsky was
deeply impressed by Schoenberg's boldly innovative use of the
twelve-tone scale and began to correspond with the composer,
who took part in the Blue Rider exhibition at the end of the
year.

Kandinsky numbered this fascinating picture among his
"impressions," whose aim was to convey "a direct impression
of 'external nature'." By this, he meant not only visual impres-
sions but sense impressions of all kinds, which he attempted to
translate into visual terms in a nonrepresentational manner.
Impression III – Concert is based on an acoustic experience, for
which Kandinsky found a highly complex pictorial equivalent.

Yellow and black, accentuated by white, are the dominant
colors in the picture. Under the dynamic area of black in the
top section, the yellow unfolds with a broad, sweeping gesture.
It seems to flood back and forth across the picture, almost
engulfing the brightly colored patches and the linear arabesques
on the left. On closer inspection, one sees that the picture
conveys the essence of a musical experience, blending acoustic
and visual impressions in a revolutionary way. The black area
is a highly schematic representation of a grand piano; the
colored shapes edged in black are concertgoers listening in-
tently to the music. Two preparatory pencil sketches, now in
the Centre Pompidou in Paris, clearly depict the listeners sitting
at the front of the auditorium and standing by the left-hand
wall; in both painting and sketches, the piano is bisected by a
vertical white column which, in the painting, seems to meta-
morphose into a white pillar of sound.

The main impression, however, is of a yellow "sound,"
which fills the concert hall and makes the picture itself into an
almost symphonic experience. In Kandinsky's imagination the
color yellow had a specifically musical connotation: as early
as 1909 he wrote a stage composition entitled *Yellow Sound,*
which was subsequently published in *The Blue Rider* almanac.

Impression III – Concert is a particularly striking exploration
of the phenomenon of synaesthesia, the analogy between music
and painting, which played a major role in early twentieth-
century art. Critics have repeatedly pointed to Kandinsky's
interest in synaesthesia, as evidenced by his book *On the Spiri-
tual in Art,* in which he discussed the correspondences between
colors and particular instruments and tones. However, Kandin-
sky emphasized that painting and music each have their own
specific resources. Only to the extent that it is inherently
abstract, emancipated from nature, can music serve as a model
for the new painting of the coming era of the "great spiritual."
"In this respect," Kandinsky writes, "painting has caught up
with music, and both assume an ever-increasing tendency to
create 'absolute' works, i.e. completely 'objective' works that,
like works of nature, come into existence 'of their own accord,'
as the product of natural laws, as independent beings."

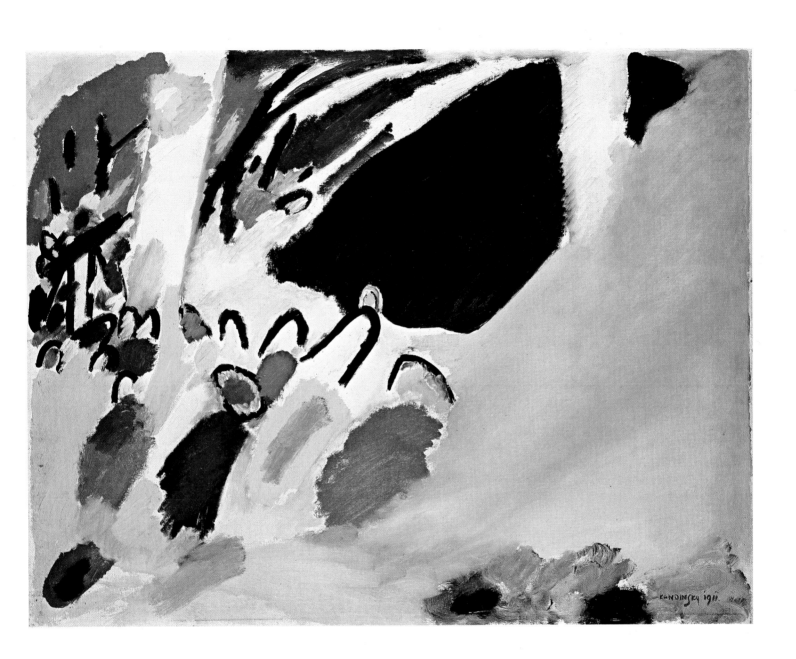

Vassily Kandinsky

34 IMPRESSION IV – GENDARME (*Impression IV [Gendarme]*), 1911

Oil on canvas, 37³/₈ × 42¹/₄″ (95 × 107 cm)
Inscribed "Kandinsky" (reverse)
GMS 85

Like *Impression III – Concert* (plate 33), *Impression IV – Gendarme* belongs in the category of "direct impressions of 'external nature'." Altogether, Kandinsky painted six of these "impressions," all of them in 1911, two years after the first "improvisations" and a year after beginning work on the "compositions." This shows that the distinction between "impression," "improvisation," and "composition" does not imply any kind of value judgment: Kandinsky did not regard the depiction of "external" nature as inherently inferior to the abstract, spiritualized form of the "compositions." Some of the impressions, such as *Concert* and *Impression V – Park* (Musée National d'Art Moderne, Paris), themselves tend toward the abstract. As Johannes Langner has indicated, the salient point about the distinction between the three groups of works is the fact that Kandinsky categorized his pictures in a new way, according to the manner and circumstances of their genesis rather than to their content. This practice constituted a radical departure from traditional concepts of iconography and genre. In this respect, as in so many others, Kandinsky was a truly revolutionary artist.

The six impressions are subtitled *Gendarme, Fountain, Moscow, Concert, Park,* and *Sunday,* titles which point to a world of bourgeois leisure and civilized, genteel amusement. In the foreground of *Impression IV – Gendarme,* which at one time was mistakenly titled *Impression III – Fackelzug (Torchlight Procession),* one sees the powerful black contours of a huge horse facing from right to left and the black outline of a rider. The two diagonal lines on the left and right extend the structures of the horse over the plane of the picture. On the left, next to the horse's head, two passersby dressed in black are doffing their hats. In the right-hand section of the picture one recognizes the blurred outlines of a crowd of people; above their heads a mass of brightly colored lanterns is framed by energetic strokes of dark color. In the center, behind the rider, there is a kind of portal with three pillars, the outlines of which are also boldly painted. It would seem to be part of a pseudo-classical building in a public place in which a crowd, controlled by mounted gendarmes, has gathered on some form of official occasion.

It is thought that *Impression IV* was inspired by a procession to the Königsplatz in Munich to mark the 90th birthday of the Bavarian Prince Regent on March 12, 1911. The participants in the procession carried lanterns, and tall pylons with torches were erected in the square: one of these pylons can be seen at the top of the picture, to the right of the rider's head.

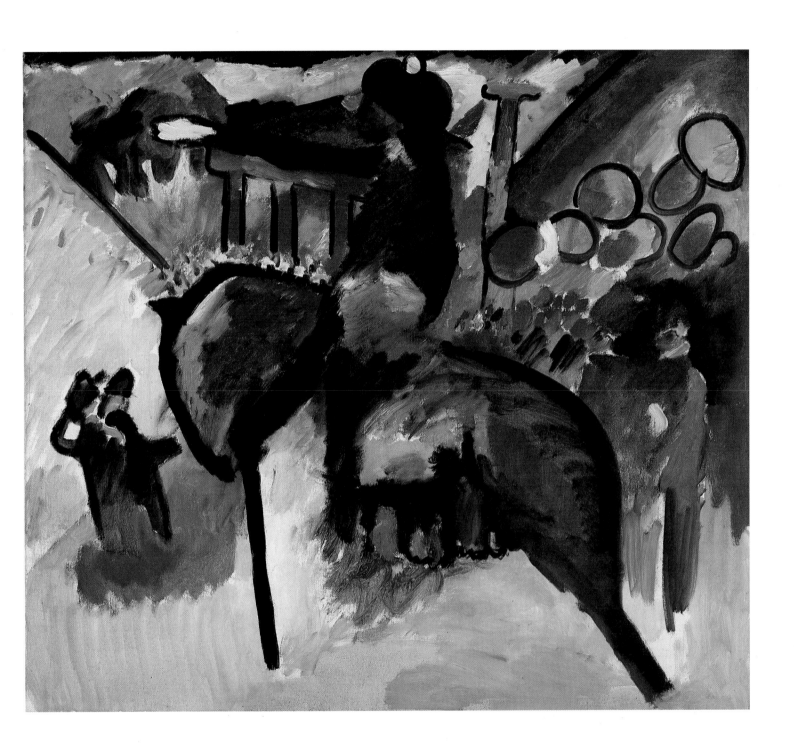

Vassily Kandinsky

35 IMPRESSION VI – SUNDAY (*Impression VI [Sonntag]*), 1911

Oil on canvas, 42³/₈ × 37³/₈″ (107.5 × 95 cm)
Inscribed in the artist's hand "KANDINSKY Impression (Sonntag)"
(reverse)
GMS 57

To an even greater extent than the fourth impression, *Gendarme* (plate 34), the motifs of *Impression VI – Sunday* belong to the world of middle-class leisure. A couple dressed in their Sunday best, the man in a dark suit with a round, bowler-type hat, the woman in a long dress with a cinched waist, walks toward the viewer. A small white dog gambols in front of them; in the background one sees a brightly colored park scene with what appears to be a child on a swing. The whole exudes French chic and elegance.

The couple's clothes, although seen only in outline, hark back to the Belle Epoque, the last decade of the nineteenth century. Right from the beginning of Kandinsky's development as a painter, this period, together with the so-called Second Empire, was one of his major sources of themes in painting the human figure. Motifs of this kind can be seen in some of his earliest oil and tempera paintings, such as *Helle Luft* (*Bright Air,* 1901; Musée National d'Art Moderne, Paris), with its promenading ladies in crinoline skirts, and *Im Park* (*In the Park,* c. 1902; Lenbachhaus), which features a lady dressed in the fashion of the Belle Epoque and accompanied by a small dog. Similar scenes are depicted in a number of Kandinsky's early woodcuts.

One of the most striking general features of the "impressions" is the way in which Kandinsky reduces the figures to a set of more or less bold, black outlines. Deprived of their materiality, they take on a transparent quality: the color appears to pass through them. In this way they merge with their surroundings, while at the same time retaining their identity. They function as graphic ciphers of the kind which played an increasingly important part in Kandinsky's pictures from 1911 onward.

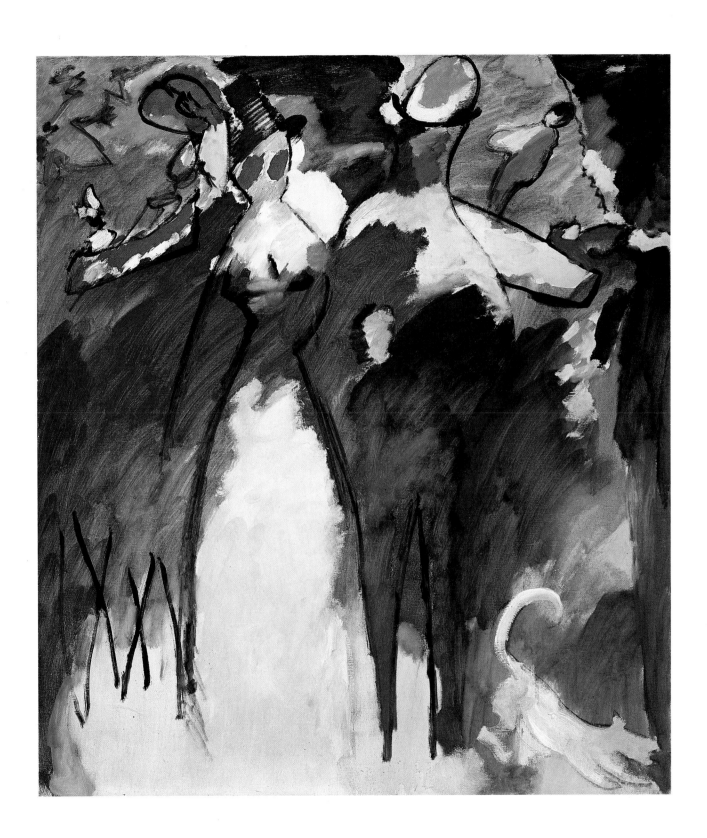

Vassily Kandinsky

36 ALL SAINTS I (*Allerheiligen I*), c. 1911

Oil on cardboard, 19⁵/₈ × 25³/₈″ (50 × 64.5 cm)
Inscribed "K", enclosed in a triangle (lower left), "KANDINSKY"
(reverse, in the artist's hand)
GMS 71

From 1910 onward, Kandinsky increasingly turned his attention to Christian motifs, such as the figure of St. George (see plates 39, 56) and the eschatological themes which played an important part in a number of his major pictures from the pre-1914 period, including *Composition* (private collection, Switzerland), painted in the fall of 1911, and the two subsequent "compositions," VI and VII (see plates 45, 46). These motifs are not only central to the meaning of the pictures themselves, they also offer a key to the understanding of Kandinsky's work as a whole and of the Blue Rider movement, with its message that a new, "spiritual" age was dawning.

One of the earliest pictures based on biblical themes is *Jüngstes Gericht* (*Last Judgment*, 1910; private collection, New York), whose motifs include the kneeling figure of a resurrected soul with severed head, an angel blowing a trumpet, and the crumbling towers of a city on a hill. *Last Judgment* was followed in 1911 by a similar painting, this time on glass (Lenbachhaus), on which Kandinsky painted the Russian word for "resurrection." In a further painting on glass titled *Grosse Auferstehung* (*Great Resurrection*; Lenbachhaus), Kandinsky introduced a number of additional motifs, including a boat with a triangular sail and a group of Christian believers bearing lighted candles. These features also appear in a colored woodcut with the same title.

All Saints I, too, was based on a painting on glass (plate 57). It modifies and partly disguises the theme, which the "naive" painting on glass presents in a more direct fashion. By comparing the two works it becomes possible to recognize the figures of two saints embracing each other in the center; they are surrounded by a group of smaller figures, which includes a female saint in a yellow habit sitting in the foreground with one arm outstretched. To the left of the two central figures one sees a knight in armor on a white horse; in front of them, there is a small boat with a blue sail and, at the top of the picture, a city on a hill, with collapsing towers. The picture is dominated by the figures of two angels with golden trumpets; the angel on the left with long yellow hair is especially prominent. This motif is particularly significant: it serves to combine the theme of All Saints with that of the Last Judgment, thereby adding an apocalyptic connotation – Kandinsky's alternative title for the picture was *Day of Judgment*. It is possible that Kandinsky's intention in partially disguising the theme was to lend an additional emphasis to the "ultimate truth" of the work.

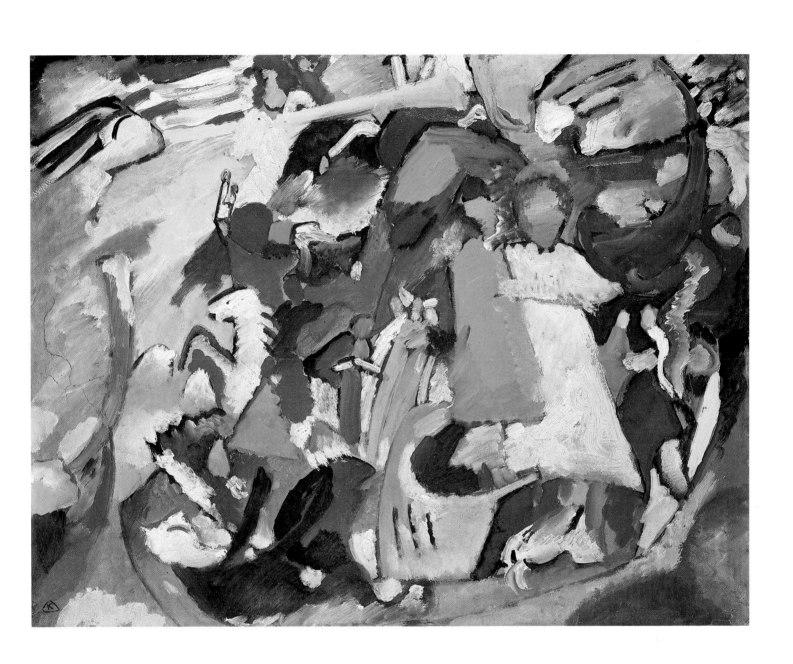

Vassily Kandinsky

37 ALL SAINTS II (*Allerheiligen II*), 1911

Oil on canvas, 33⁷/₈ × 39″ (86 × 99 cm)
Inscribed in an unknown hand "…ligen. Kandinsky" (reverse)
GMS 62

In 1911 Kandinsky created a large number of paintings, water-
colors, and woodcuts based on eschatological themes. In these
pictures, religious figures are combined with images from the
artist's earlier symbolic vocabulary – for instance, the images
of the rider and the city on the hill (see, for example, plate 19)
– to create an iconographical repertoire which is unique in
modern art. *All Saints II*, which is closely related to *All Saints
I* (plate 36), explores the possibilities of this new stock of
images. With their black outlines, the figures in the picture
have a simplicity which reminds one of Kandinsky's paintings
on glass (see plate 57), but they are drawn in a freer, more
expressive manner. The three saints in the center gesturing
toward the right have been identified as St. Basil, St. Gregory,
and St. John Chrisostom. The female figure in front of them
is said to be St. Walburga, the patron saint of Bavaria.
St. Vladimir, the patron saint of Russia, stands with out-
stretched arms above the group of candle-bearing believers,
the sailing boat, and the whale – a reference to the story of
Jonah. At the top of the picture, the prophet Elijah is ascending
to heaven in a fiery chariot drawn by three golden horses. This
image, known as the *troika* motif, often recurs in Kandinsky's
abstract pictures, where the outlines of the horses are suggested
by three wavy lines. On the right, St. John the Evangelist, the
chronicler of the Apocalypse, stands next to a resurrected soul
with severed head, looking up at one of the trumpet-bearing
angels floating high above the scene. In the center, we reen-
counter the familiar motifs of the rider and the collapsing city
on the hill. This image of the rider and the crumbling tower,
which Kandinsky used in the frontispiece for his book *On the
Spiritual in Art,* is a kind of symbolic shorthand for the idea of
the coming apocalypse and the dawning of a new, "spiritual"
age.

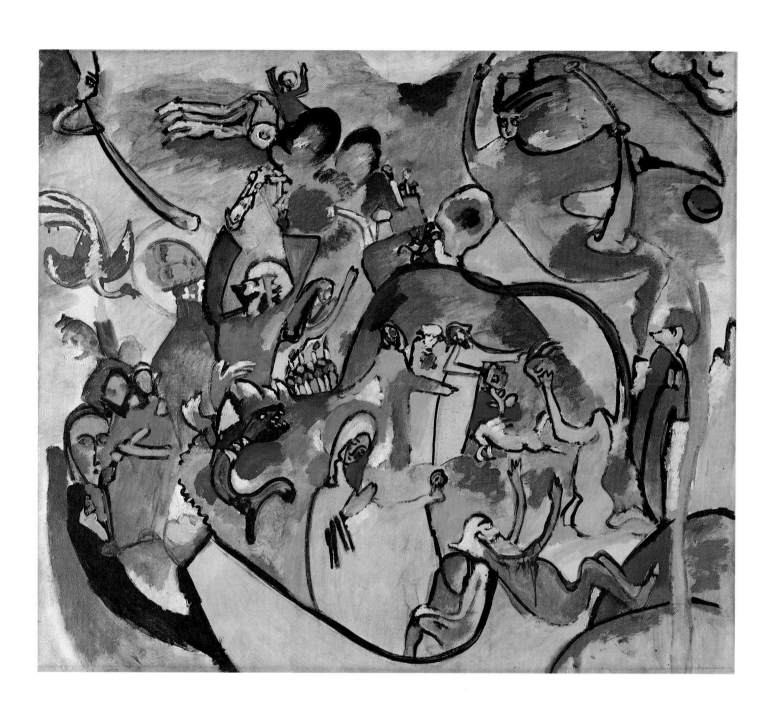

Vassily Kandinsky

38 ROMANTIC LANDSCAPE (*Romantische Landschaft*),
1911

Oil on canvas, 37^1/4 × 50^3/4″ (94.3 × 129 cm)
Inscribed "KANDINSKY 1911" (lower right)
GMS 83

Romantic Landscape stands in a class of its own: it is neither an "impression" nor an "improvisation," nor is it a true landscape. The form of the picture is breathtakingly open and spontaneous, casting a kind of hermetic spell. An impression of immediacy is generated by the three horsemen emerging from a zone of dense color and galloping downhill from right to left. The blue slant of the hill, the blood-red sun, and the two forms rearing up in the foreground are hastily sketched in bare outline. The blobs of color in the top right-hand corner evoke the dynamic power of the landscape; their almost untamed, disparate energy is collected and concentrated in the elongated forms of the three horses with their violet-colored riders. The color of the front two horses is echoed by the blue-green contours of the yellow one at the rear, which emphasize the power and speed of the group. Their rushing, downhill movement is highlighted by the diagonal brushstrokes in the rest of the picture, which impart a sense of kinetic urgency to the surrounding landscape. The steep, light-brown hill toward which the riders are galloping seems to pose a kind of threat, which is counterbalanced by the dark form from which the group has escaped. This form is in turn offset by the openness of the white into which the elements of the landscape are nonchalantly strewn, by the graphic economy of the work, and by the harmony of the colors.

Some twenty years later, in a letter written in 1930, Kandinsky commented once more on the picture: "In 1910 I painted a *Romantic Landscape* which had nothing to do with earlier Romanticism. I intend to use a title of this kind again Where is the dividing line between the lyrical and the Romantic? The coming Romanticism is indeed deep and rich in content; it is a lump of ice in which a flame burns. If people only see the ice and not the flame, then so much the worse for them." In *Romantic Landscape,* which was in fact painted in 1911, Kandinsky transposed the flickering puzzles of the "improvisations," based on inner impressions of nature, into the spacious realm of lyrical freedom.

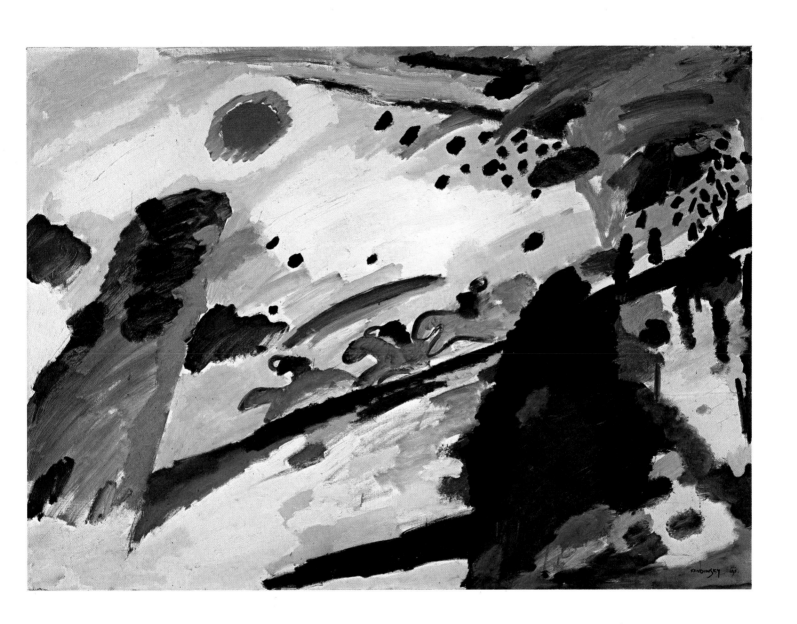

Vassily Kandinsky

39 ST. GEORGE NO. 3 (*St. Georg Nr. 3*), 1911

Oil on canvas, 38³/₈ × 32³/₈″ (97.5 × 107.5 cm)
Inscribed "KANDINSKY 1911" (lower left), "Kandinsky St. Georg
No. 3" (reverse)
GMS 81

From 1911 onward, the Christian motifs of All Saints and
the Last Judgment occupied a central position in Kandinsky's
symbolic vocabulary. At about the same time, the figure of
St. George, the dragon-killer and vanquisher of evil, took on
a particular significance for the artist. For a discussion of the
symbolism of the saint – a close relative of the figure of the
rider, which had always been one of Kandinsky's favorite
motifs – the reader should refer to plates 52 and 56. In addition
to three paintings on glass, one of which is almost identical
with the woodcut on the cover of *The Blue Rider* almanac,
Kandinsky made three oil paintings depicting St. George, in
which this Christian theme is varied in a number of ways. The
pictures have an almost hallucinatory quality. *St. George No. 1,*
owned by a Swiss collector, shows a schematic figure envel-
oped by white, amorphous clouds, stabbing his lance into the
dragon beneath him. *St. George No. 2* (Hermitage, Leningrad)
is an almost abstract representation of the horse and the rider
behind the expressive diagonal of the sacred lance. In *St. George
No. 3* the knight, on the extreme left of the picture, is scarcely
recognizable. He thrusts his lance vertically into the maw of
the dragon at his feet. The dragon's light-colored body, with
its lashing tail, seems to dissolve into its surroundings. The
image is deliberately obscured by the prolific use of the color
white: St. George himself, the dragon, and the background are
mainly white, which is relieved only by the weapon, the pink
and yellow section of the dragon's body, and the dark lines
distributed through the picture.

Here, as in a number of Kandinsky's other major works, the
formal makeup of the picture takes on a meaning of its own,
which is almost more important than the motif. According to
Kandinsky, white is a color which does not occur in nature
and which the artist only uses to translate nature into an "inner
impression." In *St. George No. 3* there seems to be some form
of secret relationship between the dominant zone of white and
the picture's aura of struggle, death, and salvation. In *On the
Spiritual in Art* Kandinsky wrote: "As a closer definition, *white,*
which is often regarded as a noncolor … is like the symbol of
a world where all colors, as material qualities and substances,
have disappeared. This world is so far above us that no sound
from it can reach our ears. We hear only a great silence, that,
represented in material terms, appears to us like an insurmount-
able, cold, indestructible wall, stretching away to infinity. For
this reason, white also affects our psyche like a great silence,
which for us is absolute …. It is a silence that is not dead, but
full of possibilities. White has the sound as of a silence that
suddenly becomes comprehensible." The schematic image of
St. George recurs once more in one of Kandinsky's major
abstract pictures, *Bild mit weissem Rand* (*Picture with White
Border*; Solomon R. Guggenheim Museum, New York),
painted in 1912.

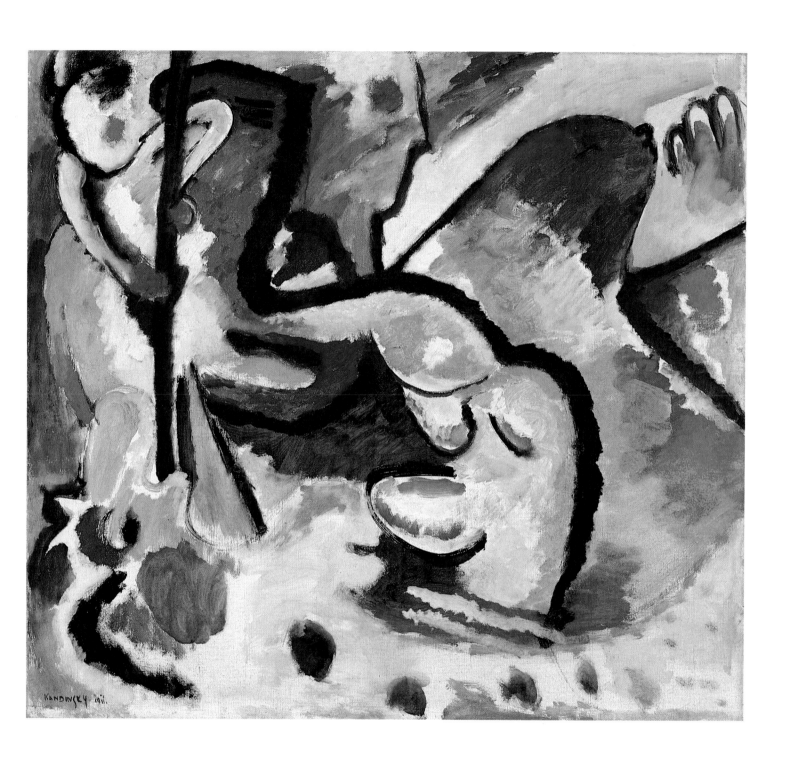

Vassily Kandinsky

40 IMPROVISATION 18 – WITH TOMBSTONE
(*Improvisation 18 [mit Grabstein]*), 1911
Oil on canvas, 55^1/$_2$ × 47^1/$_4$″ (141 × 120 cm)
Inscribed "KANDINSKY" (lower right)
GMS 77

The "improvisations" offered Kandinsky a further field for
experimenting with the blurring of images, which for him was
an important means of exploring the possibilities of abstraction.
Rather than adopting the more obvious course of painting in
a geometrical or ornamental style, Kandinsky moved toward
abstraction through a complicated process of dissolving the
object. Even pictures such as *Improvisation 18* retain a certain
figurative element, although the motifs are divested of their
meaning and external form and rendered almost unrecogniz-
able. Only their "inner sound" remains – as a kind of absurd
echo, as if a single word were being repeated over and over
again – and fills the picture with a wealth of barely perceptible
but nevertheless highly intriguing implications.

The picture contains a disturbing jumble of vague forms
piled up on top of each other in diagonal layers; the pale, empty
zones between the forms appear to represent the rudiments of
a landscape. The three tombstones, barely discernible in a dirty
patch of gray in the bottom right-hand corner, are echoed by
the three bowed figures at the top of the picture. A further
group of figures stands huddled together in the center. One is
reminded of the medieval topos of the Meeting of the Three
Living and the Three Dead, with which Kandinsky was un-
doubtedly familiar. What is important, however, is not the
iconographical content of the picture, but the way in which
the statement that it makes is modified by the obscuring of
form. A year later, Kandinsky wrote: "My personal qualities
consist in the ability to make the inner element sound forth
more strongly by limiting the external. Conciseness is my
favorite device. For this reason I do not carry even purely
pictorial means to the highest level. Conciseness demands the
imprecise (that is, no pictorial form – whether drawing or
painting – that produces too strong an effect)." In many of the
"improvisations" and "compositions" which he painted during
this phase of his development, Kandinsky successfully em-
ployed this technique of reduction, deliberately blurring motifs
and even allowing the effects of different colors to cancel each
other out.

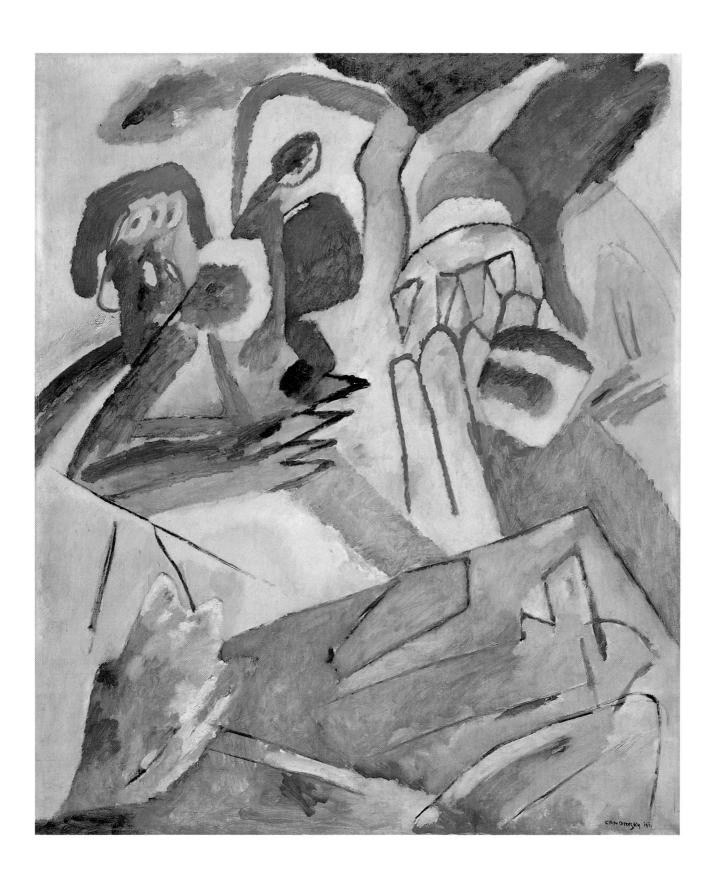

Vassily Kandinsky

41 IMPROVISATION 19, 1911

Oil on canvas, $47^1/4 \times 55^3/4''$ (120 × 141.5 cm)
Inscribed "Kandinsky – Improvisation No 19" (reverse)
GMS 79

To a greater extent than any of the other pictures included here, *Improvisation 19* points to a further important aspect of Kandinsky's liberation of painting from traditional notions of representation. Sixten Ringbom and other scholars have shown that in the period before World War I Kandinsky took a marked interest in theosophy and spiritualism. It is known that he was familiar with the ideas of the anthroposophical thinker Rudolf Steiner and that he had connections with the Munich circle of the poet Stefan George; his library contained a number of theosophical treatises featuring illustrations of occult manifestations and parapsychological phenomena. The revolutionary discoveries of psychology in the early years of the century also opened up new avenues of thought which tied in with Kandinsky's search for a means of conveying inner experience. The influence of these various areas of thought can be detected in his secret language of abstract forms.

Improvisation 19 depicts two groups of figures whose attention appears to be focused on some unknown event. The figures huddled together on the left seem to be advancing toward the front edge of the picture. The colors of the background shine through their flat, hollow bodies. Behind them one sees the vague outlines of a further group of figures, edged in white: the color of hidden, as yet uncertain possibilities.

The central section of the painting is dominated by a variety of vivid blues, illuminating the figures on the right, which seem to be moving toward some goal at the edge of the picture. These larger figures, in an attitude of spellbound concentration, appear to be closer to the moment of being "chosen" than the group advancing from the background on the right. Between the two groups an elongated form with rounded contours enters the picture from the top: its diaphanous play of colors is bordered by a thick black line.

Hans Konrad Roethel has drawn an enlightening comparison between *Improvisation 19* and the woodcut version of *Improvisation I*, the whereabouts of which are unknown. In the latter work, a similar group of figures advances on the left toward the front of the picture; a massive shape, which may be a Russian church or a gate, stands in the center; and on the right one figure is leading another away. Roethel also discusses the woodcut which Kandinsky made of *Improvisation 19*, in which the group of figures on the right and the elongated form in the center are strongly emphasized. However, the transparent colors of the painting reveal a new level in this mysterious picture. They evidently represent a form of aura, the visible emanation of a particular mode of thought and feeling; and the round form at the top of the picture can be seen as a kind of occult manifestation. Whereas the figures on the left are characterized by "earthly" colors, the blue is the color of a higher, spiritual realm; the violet heads of the "initiated" convey the idea of transition to a higher plane of consciousness. In *Improvisation 19* Kandinsky attempted to translate spiritual phenomena into pictorial terms, a task to which he saw semiabstract forms as well-suited. The mysterious ritual of the picture lends expression to an almost Messianic hope of salvation, which Kandinsky connected with art and which was one of the main factors in the dawning of that "epoch of the great spiritual" of which he spoke in *On the Spiritual in Art*.

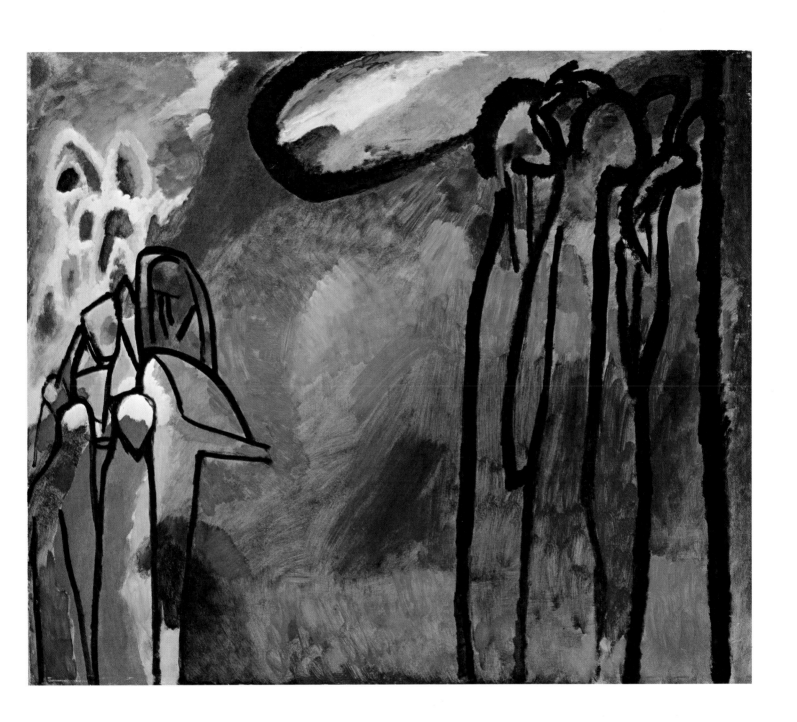

Vassily Kandinsky

42 IMPROVISATION 19a, 1911

Oil on canvas, $38^{1}/_{4} \times 41^{3}/_{4}''$ (97 × 106 cm)
Inscribed "Improvisation 19a No. 128a" (reverse, in the artist's hand)
GMS 84

Improvisation 19a is a further demonstration of the extent to which Kandinsky's painting had succeeded in freeing itself from the external appearance of nature in order to construct its own pictorial system. In the bold but indeterminate movement of the colors the elements between body and space are impossible to pin down. Despite the variety of bright colors, the overall tone of the picture is dark and brooding, conveying an atmosphere of struggle that is underlined by the conflict between the different color effects. Kandinsky had finally succeeded in developing a technique adequate to the task of expressing the transcendental spirit of nature, thereby overcoming his previous doubts about his ability to solve this problem. In *Reminiscences* he wrote: "Years had to elapse before I arrived, by intuition and reflection, at the simple solution that the aims (and hence the resources too) of art and nature were fundamentally, organically, and by the very nature of the world different – and equally great, which also means equally powerful."

However, what Rose-Carol Washton-Long calls the "hidden imaginary" still continues to play an important part in this process of transmission. It gives the almost abstract picture its "inner vibration" and lends it a suggestive charm. The overall structure of *Improvisation 19a,* with the sharp peaks of the "mountains" in the background and the division of the "hills," may be based on a recollection of the landscape in Murnau. Two stooping figures can be seen on the edge of the "hill" in the top right-hand corner; below them, two further figures seem to be passing something from hand to hand. The most striking feature of the picture is the dark yellow, domed form in the foreground, which appears to shoot up and then cascade down like a mountain stream; the black aperture also allows it to be read as a conical body turned toward the right.

Comparisons with other works by Kandinsky, such as *Improvisation 7* (Tretiakov Gallery, Moscow), in which the movements follow a similar direction, are of only limited use. The motifs would seem to evoke an animated landscape in which people are wandering aimlessly, driven by fate. The salient features of the picture, however, are the overall impression of disorder and the deliberate distortion of the image, which is elevated onto another, more universal plane. The nexus of meaning is broken up by the indeterminacy of the individual forms and the chaotic manner in which they are juxtaposed, in accordance with a principle of planned disorder which can already be seen in Kandinsky's early work. Johannes Langner has aptly characterized the development of Kandinsky's work toward the open, abstract picture as follows: "In a concatenation of motifs which is no longer founded in action or verifiable fact, but only in meaning and mood, free association replaces causal connection."

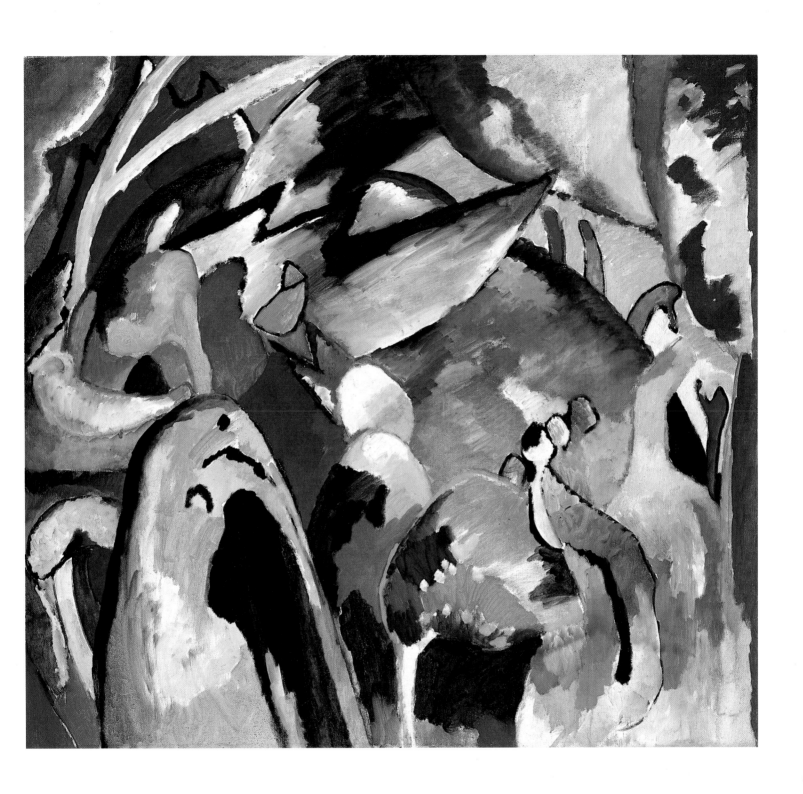

Vassily Kandinsky

43 IMPROVISATION 21a, 1911

Oil on canvas, 37³/₄ × 41³/₈″ (96 × 105 cm)
Inscribed "KANDINSKY 1911" (lower left), "Kandinsky Improvisation
No. 21a" (reverse, in the artist's hand)
GMS 82

Improvisation 21a was inspired by the small painting on glass
With Sun (plate 55). It is closely related to the picture *Kleine
Freuden* (*Simple Pleasures*; Solomon R. Guggenheim Museum,
New York), which Kandinsky painted some eighteen months
later, in the summer of 1913. Kandinsky himself described how
the delicate colors of *With Sun* gave him the idea of painting
a larger picture on the same theme. In *With Sun* the individual
pictorial elements are more clearly identifiable than in *Improvi-
sation 21a* or *Simple Pleasures*. At the top, one sees the sun and,
in the center, two hills crowned by the familiar onion-shaped
domes of a Russian church; on the left there is a pair of figures
leaning backward at a sharp angle; above them, three riders
are racing up a hill. On the right there are two large curved
forms: a boat with three oars and a dark cloud in the sky
above. In *Improvisation 21a,* on the other hand, the motifs are
to some extent blurred; the bright, glowing colors of the
painting on glass are suppressed and overlaid with a whitish
gray.

Nevertheless, the picture makes a bold general statement
whose intensity is heightened by the multiplicity of associations
to which it gives rise. Many Kandinsky scholars, especially
Rose-Carol Washton-Long, emphasize the importance of the
dramatic contrast between the two halves of the painting, the
confrontation between the sun and the dark, menacing cloud
above the boat in the storm-tossed lake. Comparing the sym-
bolic vocabulary of *Improvisation 21a* with that of such pictures
as *All Saints II* (plate 37), the various paintings on glass of the
Last Judgment, and *Composition VI – Sintflut* (*Deluge*; Hermi-
tage, Leningrad), Washton-Long and Sixten Ringbom see the
work as embodying an apocalyptic vision of despair and hope,
destruction and renewal.

However, in his account of the genesis of *Simple Pleasures,*
which draws on a similiar set of motifs, Kandinsky makes no
mention of such visions, concentrating instead on the formal
properties of the picture, its "balance" of heterogeneous ele-
ments. Describing the basis of the work as "spiritual," he
writes: "My aim ... was to let myself go and pour a quantity
of simple pleasures over the canvas." The dark cloud struck a
more serious note, in the form of a "subtle inner simmering,"
an "overflowing." However, this melancholy note remains in
the background, as a muted "vibration": as Kandinsky says,
"it all remains in the area of simple pleasures and does not
take on a painful overtone." Once more, one is surprised by
Kandinsky's complex mode of thinking, which deals with
individual elements of pictures in a new and contradictory
manner and renders them inaccessible to closer analysis.

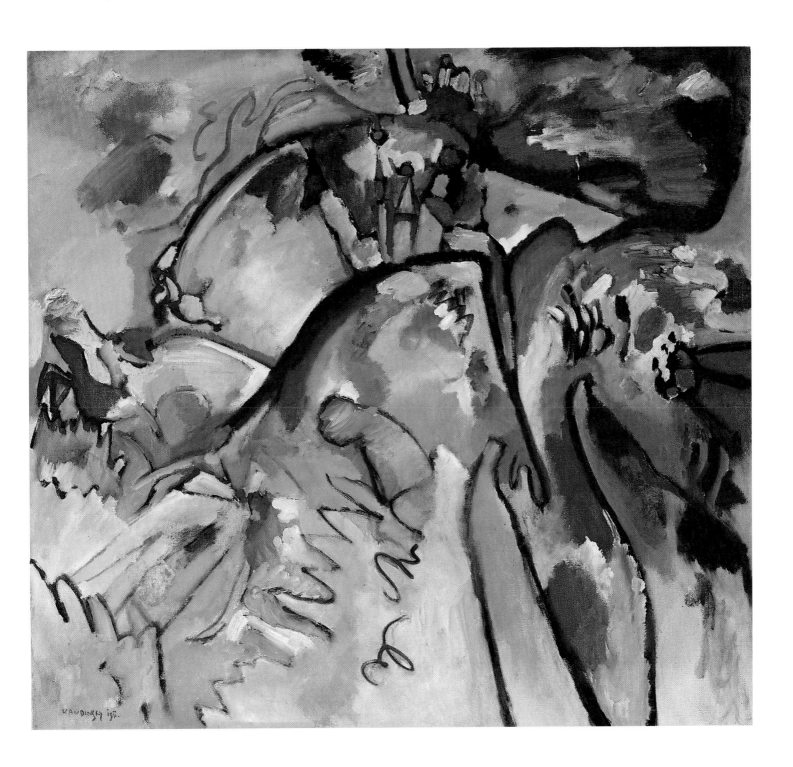

Vassily Kandinsky

44 IMPROVISATION 26 – ROWING (*Improvisation 26 [Ruder]*), 1912

Oil on canvas, 38^1/$_4$ × 42^3/$_8$″ (97 × 107.5 cm)
Inscribed "KANDINSKY 1912" (lower left), "KANDINSKY – Improvisation No. 26" (reverse, in the artist's hand)
GMS 66

The subtitle *Rowing* indicates the motif of this intriguing picture. The viewer who is familiar with the visual ambiguities of Kandinsky's painting recognizes the outlines of a boat with laid-out oars, gliding weightlessly over the iridescent surface of the work. The motif of the boat is an integral part of Kandinsky's figurative cosmos; it appears, in a variety of contexts, in some of his earliest works, such as *Motley Life* (plate 19). As Armin Zweite has pointed out, its connotations change from one picture to another: in some instances it can be taken to mean farewell and the anticipation of new pastures, in others it is a metaphor of liberation or of an apocalyptic vision of doom.

It may well be possible to discover connotations of this kind in *Improvisation 26 – Rowing,* which is unusual in respect of its single motif: Kandinsky's pictures frequently combine several forms in a complex whole. Perhaps the most interesting feature of the picture, however, is its formal appearance, which places it among the true masterpieces of this revolutionary period in Kandinsky's work. Line and the spread of color have separated in order to form a new unity. The open curve of the rounded boat is painted in the same shade of madder as the undulating line in the upper section of the picture, which can be identified, by reference to one of Kandinsky's watercolors, as a chain of hills. The powerful black diagonals of the oars and the bent backs of the rowers convey a sense of disembodied psychic energy. Some scholars have interpreted the black lines at the top as trees or birds, but they can also be read as a collision between swift, conflicting movements.

In this picture Kandinsky succeeds in evoking a dreamlike, floating sense of space between plane and depth, which is based entirely on the choice and juxtaposition of the colors. In *On the Spiritual in Art* he discusses the experiments of the Cubists in abandoning traditional perspective and constituting the picture on a new, ideal plane. He points out that there are alternative possibilities to those envisaged by the Cubists, "possibilities offered by the correct use of color, which can recede or advance, strive forward or backward, and turn the picture into a hovering in mid-air, which signifies the same as the pictorial extension of space." In this way, although the colors are laid side by side with no fixed borders, Kandinsky creates an impression of depth, of an independent pictorial space. He discussed this technique, which often involves a calculated use of contradictory effects, in his 1914 "Cologne Lecture": "The colors which I employed later lie as if upon one and the same plane, while their inner weights are different. Thus the collaboration of different spheres entered into my pictures of its own accord This difference between the inner planes gave my pictures a depth that more than compensated for the earlier, perspective depth. I distributed my weights so that they revealed no architectonic center I would treat the individual color-tones likewise, cooling the warmer tones, warming the cold, so that even one single color was raised to the level of a composition."

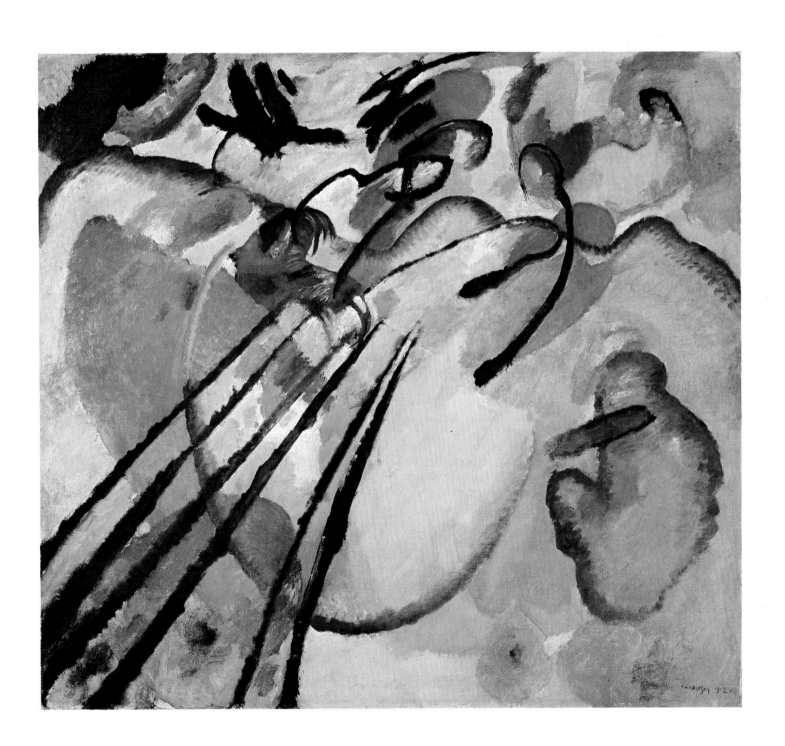

Vassily Kandinsky

45 IMPROVISATION DELUGE (*Improvisation Sintflut*), 1913

Oil on canvas, 37³/₈ × 59″ (95 × 150 cm)
Inscribed "Kandinsky 1913 Sintflut Improvisation" (reverse, in the artist's hand)
GMS 76

Improvisation Deluge is one of several preparatory studies for *Composition VI* (Hermitage, Leningrad), which is also based on the theme of the Deluge. Kandinsky describes the genesis of the latter picture in some detail. His starting point was a painting on glass "that I had done more for my own satisfaction. Here are to be found various objective forms, which are in part amusing (I enjoyed mingling serious forms with amusing external expressions): nudes, the Ark, animals, palm trees, lightning, rain, etc." However, some eighteen months elapsed before the artist was able to detach himself from the concrete image of the Deluge and find a form which would convey the "inner sound" of the theme, rather than its "external impression." In the major paintings from the year 1913 Kandinsky at last fully achieves his aim of dissolving the object and transforming the individual elements of the picture into a complex system of internal contradictions.

Improvisation Deluge is a raging whirlpool of colors. White rays of light shoot down from the top into the center of the picture. The work evokes an impression of drama and catastrophe, although there is no immediate figurative basis for such an interpretation. Here, as in the finished version of *Composition VI,* there are two centers, which Kandinsky describes thus: "1. on the left the delicate, rosy, somewhat blurred center, with weak, indefinite lines in the middle; 2. on the right (somewhat higher than the left) the crude, red-blue, rather discordant area, with sharp, rather evil, strong, very precise lines."

Nevertheless, there are a number of major differences between *Improvisation Deluge* and *Composition VI.* The paint in the "composition" is thinner and the dominant color is green, in various shades. A number of graphic signs, some of which are easily decipherable, continue the drama on a second level. On the left a large round boat with three laid-out oars floats in space; above it, one sees an angel blowing the Last Trumpet and, in the center, the body of a fish. The sharp diagonal lines in the center, which are now black instead of white, can be interpreted as representing either rain or the sound of the trumpet. These elements point once more to the themes of the Apocalypse and the Last Judgment, which occur frequently in Kandinsky's pictures from 1911 onward.

However, according to Kandinsky, "nothing could be more misleading than to dub this picture the representation of an event." In his estimation, the most important new element in *Improvisation Deluge* was the third center in the middle, which is missing in *Composition VI.* In the words of the artist, the "hovering" appearance of this center, its "feeling of 'somewhere ... determines the 'inner sound' of the whole picture." The work is deliberately obscure: the objects are dissolved but nevertheless retain a subliminal presence, and Kandinsky uses a variety of contradictory formal devices in order to clothe "the greatest disturbance ... in the greatest tranquility." It embodies an element of irrationality which, according to Wilhelm Worringer, contradicts "the rationalism of seeing that educated Europeans regard as the natural form of seeing."

Vassily Kandinsky

46 STUDY FOR COMPOSITION VII (VERSION 2)
(*Studie zu Komposition VII [Entwurf 2]*, 1913

Oil on canvas, $39^3/8 \times 55^1/8''$ (100 × 140 cm)
Inscribed "KANDINSKY" – zu Komposition 7 (Entwurf 2) 1913 No.
182" (reverse, in the artist's hand)
GMS 64

Composition VII is one of Kandinsky's most important paintings
from the pre-1914 period: it marks the culmination of his
attempts to stimulate "the capacity to experience the spiritual
in material and abstract things" by creating a new art based on
revolutionary principles of construction. In the course of his
entire career Kandinsky painted only ten pictures with the
grand title *Composition*. In *On the Spiritual in Art* Kandinsky
defined the "composition" as the expression "of feelings which
have been forming within me ... over a very long period of
time, which, after the first preliminary sketches, I have slowly
and pedantically examined and worked out Here, reason,
the conscious, the deliberate, and the purposeful play a prepon-
derant role. Except that I always decide in favor of feeling
rather than calculation." These highly complex works are
indeed the result of a synthesis of reason and creative intuition.
The detailed planning which went into the pictures is demon-
strated by the numerous sketches and studies for the 78-by-
118-inch final version of *Composition VII*, which is now in the
Tretiakov Gallery in Moscow. In addition to some twenty
drawings and watercolors, Kandinsky made six oil studies; the
final work was produced in four days, from November 25 to
28, 1913.

The present work is one of the preparatory oil studies. Like
Improvisation Deluge (plate 45), it seems at first sight to be a
turbulent chaos of colors and forms, lacking any intelligible
structure. Hence, one is surprised to learn that eschatological
motifs play a significant part in the conception of the painting.
Kandinsky deliberately obscures and breaks up the semantic
content of the work, whose entirely abstract form is neverthe-
less pregnant with meaning.

In the numerous sketches and studies for *Composition VII*,
the concentric circle of colors in the middle, traversed by two
black lines, was established right from the outset. A striking
feature of the present study is the vague emptiness at the
bottom edge. In the final version, the dynamic force of the
vortex in which the colors float above the chaos beneath is
more sharply emphasized, and one clearly sees a large rowing
boat in the left-hand bottom corner – an obvious piece of
apocalyptic symbolism.

Composition VII has often been interpreted as a dramatic
vision of impending doom and of the dawning of a new age.
There can be no doubt that eschatological ideas of this kind
were uppermost in Kandinsky's mind when he was painting
this and other works from the pre-1914 period; however,
rather than expressing these ideas in figurative terms, he trans-
lated them into a revolutionary form of pictorial thinking.
"Painting," Kandinsky wrote in 1913, "is like a thundering
collision of different worlds that are destined, in and through
conflict, to create that new world called the work. Technically,
every work of art comes into being in the same way as the
cosmos – by means of catastrophes, which ultimately create
out of the cacophony of the various instruments that symphony
we call the music of the spheres. The creation of the work of
art is the creation of the world."

Vassily Kandinsky

47 LARGE STUDY FOR A MURAL FOR EDWIN R.
CAMPBELL NO. 3 (SUMMER) (*Grosse Studie zu einem
Wandbild für Edwin R. Campbell Nr. 3 [Sommer]*), 1914

Oil on canvas, 39 × 23³/₈″ (99 × 59.5 cm)
Inscribed "Kandinsky" (reverse, in the artist's hand)
GMS 75

In 1914 Kandinsky was commissioned by Edwin R. Campbell, the founder of the Chevrolet Motor Company, to produce a series of murals for the entrance hall of his New York apartment. The commission was negotiated by the art dealer Arthur J. Eddy. In a letter to Kandinsky, Campbell described the proportions of the hall, which was almost round, with three doors leading off it. In Murnau in the spring of 1914, the artist created four paintings in the shape of a tall rectangle, two of which were relatively narrow, while the others had a broader format. The outbreak of World War I initially made it impossible to deliver the pictures; eventually, however, they left Europe via Stockholm in 1916 and were hung in Campbell's apartment on Park Avenue. All four works are now in the Museum of Modern Art, New York.

Since the publication of Kenneth C. Lindsay's seminal article on the Campbell series in 1956, the four pictures have been given the subtitles *Spring, Summer, Fall,* and *Winter* and been seen as a cycle depicting the seasons. It must be emphasized that these subtitles were not used by Kandinsky himself: their sole function is to differentiate between the four puzzlingly abstract works, which cannot be interpreted by reference to traditional categories. Within the series, however, it is possible to detect certain principles of order. *Fall* and *Winter,* the two broader works, are the scene of a drama of dynamic colors, while *Spring* and *Summer* are characterized by a fine structure of lines; their floating surfaces of color are larger but less obtrusive, and the individual elements more clearly isolated.

The picture under discussion here is a study for *Summer.* The long white tubular forms reach upward like tentacles; the sprinkling of colors ("an inner seething in an unclear shape") fills the center form with additional, subtle life. The other colors in the painting are yellow, red, and blue; near the top of the picture one sees a black patch with a white aperture. This patch recalls the structures of meaning in Kandinsky's *Bild mit schwarzem Bogen (Picture with a Black Arch,* 1912; Musée National d'Art Moderne, Paris), in which red and blue stand in an antithetical relationship and traces of black lines dominate the work. The study for *Summer* in the Campbell series is full of overlapping graphic signs, all of which appear to be dim reflections of something else. The streaky black patch in the center of the picture brings to mind the angel blowing the Last Trumpet; the steep upward curve of the lines in the top left-hand corner refers to the fiery chariot of the prophet Elijah; and the strange blue angular shape at the bottom right with the "eye" in the center possibly alludes to the face of St. John on the island of Patmos. Paradoxically, the important thing about these references is the fact that the remaining fragments of lines have taken on an expressive value in their own right. Although the delicate black structures of *Summer* embody the tense quality of erstwhile graphic abbreviations, they have liberated themselves entirely from any representational function. Thus the picture constitutes an important step on the road toward an autonomous form of painting.

Vassily Kandinsky

48 IMPROVISATION GORGE (*Improvisation Klamm*),
1914

Oil on canvas, $43^1/_4 \times 43^1/_4''$ (110×110 cm)
Inscribed "Kandinsky 1914" (reverse, in the artist's hand)
GMS 74

Like many of Kandinsky's pictures from 1913/14, *Improvisation
Gorge* conveys the impression of a tumultuous conglomeration
of natural phenomena. Looking more closely at its jumble of
forms, one sees a variety of meticulously executed figurative
elements, drawn with a degree of realism which one would
scarcely expect to encounter at this stage of Kandinsky's
creative development. Hans Konrad Roethel characterizes the
remnants of figurative motifs in the work as follows: "In
deciphering the images, it is helpful to know that Kandinsky
painted the picture immediately after an excursion with Gab-
riele Münter to the Höllental gorge near Garmisch-Partenkir-
chen on July 3, 1914. In the foreground one clearly recognizes
a man and a woman dressed in Bavarian costume, standing on
a landing-stage, beneath which two canoes are passing, with
their oars jutting up into the air. From the landing-stage and
the canoes the eye is drawn upward to the lake occupying the
center of the composition. The surface of the water is defined
by fine brushstrokes, like little waves; in the middle of the lake
there is a yacht with a red sail. The lake is set in the majestic
landscape of a mountain valley. A chain of mountain peaks,
the sky, and streaks of cloud mark the upper limit of the
picture." The form on the far right is a waterfall; "to the right
of the center, on what would appear to be the shore of the
lake, there is a red house with black windows. To the left of
the house one sees a railroad line. On the left-hand side of the
picture the motif of the Russian chapel seems to have merged
with that of the church in Murnau, which can be recognized
by the three domed towers." In the top left-hand corner a
dark green fir tree bends in the wind. All these figurative
elements, which lack any sense of proportion or perspective,
seem to be caught up in a whirlwind whose vortex is marked
by the structure resembling a rope ladder in the upper section
of the picture. Roethel contributes a further clue to the inter-
pretation of the work by pointing to the outlines of the white
horse on the left, with the clearly visible set of beam scales
above its head. This motif recurs, together with the couple on
the landing-stage, the boats, and the waterfall, in a pencil sketch
by Kandinsky dated June 22, 1914, on which he wrote the
Russian word for "sunset." The visit to the Höllental gorge
would appear to have supplied the impetus to execute the
painting. Seen as a "sunset" and in relation to images of the
Four Horsemen of the Apocalypse, the work echoes the fanta-
sies of doom and destruction found in many of Kandinsky's
prewar pictures.

Vassily Kandinsky

49 UNTITLED IMPROVISATION (*Unbenannte Improvisation*), 1914

Oil on canvas, $48^{7}/_{8} \times 28^{7}/_{8}''$ (124.3×73.5 cm)
Inscribed in Münter's hand "Kandinsky 1914", in another hand
"Unbenannte Improvisation" (both reverse)
GMS 69

In 1913/14 Kandinsky painted a series of pictures, including
Untitled Improvisation and *Schwarze Striche* (*Black Lines*; Solo-
mon R. Guggenheim Museum, New York), in which fine
calligraphic lines, mostly black but in some instances colored,
take on a puzzling life of their own against a blurred back-
ground of color. In *Untitled Improvisation* one also sees transpar-
ent hermaphrodite shapes which document the living, organic
quality of Kandinsky's abstract forms with exceptional clarity.
A transparent, amoebalike form, which appears to have sur-
faced from the black, centrifugal depths, floats in the center of
the picture. The small, light-colored waves above it and the
curving, dark-blue edge on the right recall, like a distant
memory in the hidden recesses of the mind, the shore of a lake,
an impression which is reinforced by the storm-tossed zone in
the foreground. However, the revolutionary perspective of the
work is wholly oriented toward that "impression of inner
nature" which Kandinsky had sought to convey in his "impro-
visations." The colors, which have a milky, translucent quality,
retreat from the edge of the picture in a manner characteristic
of Kandinsky's work during the war years. The concentration
of the picture's action in the center, which in many of the
paintings from this period is surrounded by a light-colored
border, eventually leads to the reinforcement of the individual
elements. A calmer, more restrained mood replaces the seething
chaos of colors in Kandinsky's "classic" abstract phase up to
1914. In the 1920s the artist carried on painting in an abstract
manner, using a quite different vocabulary.

Vassily Kandinsky

50 RED SPOT II (*Roter Fleck II*), 1921

Oil on canvas, 51⁵/₈ × 71¹/₄″ (131 × 181 cm)
Inscribed "K 21" (lower left), "K No. 234 1921" (reverse), "Tache
rouge No. 2" (on the stretcher)
FH 233

When World War I broke out, Kandinsky left Germany and
returned to Russia via Switzerland. During the years of the
war and the Revolution he painted very little and devoted the
major part of his energies to the politics of culture. *Red Spot II*
is listed in Kandinsky's personal catalogue as his first painting
of the year 1921, in which he created a mere eight pictures.
The technique is quite different from that of his earlier work
and marks the beginning of a new phase in his creative develop-
ment. The influence of such Constructivist artists as Kasimir
Malevich, Vladimir Tatlin, and Liubov Popova, with whom
Kandinsky taught for a time in Moscow, is clearly evident in
the clarity and precision of the work, the geometrical arrange-
ment of the individual elements, and the smoothness of the
surface. The expressive vehemence of the prewar pictures has
given way to a more detached, seemingly rational mode of
composition, using pure, simple forms.

However, despite the apparent influence of Constructivism
on his work, Kandinsky was strongly critical of the new Rus-
sian art. In an article published in 1935 in the French journal
Cahiers d'Art, he characterized the Constructivists as mere
"mechanics," rather than abstract artists in the proper sense of
the term, and it is indeed possible to detect certain differences
between pictures such as *Red Spot II* and the work of the
Revolutionary artists. Although Kandinsky uses geometrical
forms, such as triangles, circles, and arcs, they are juxtaposed
in an irregular, nongeometrical manner and used as elements
in a more complex composition. The picture lacks the logical
structure of Constructivist art. Behind the red patch, with its
painterly texture, two arcs collide with a collection of smaller
forms; at the edge of the white central zone one sees a number
of colored circles of varying sizes. During the time when he
was working at the Bauhaus the circle became a crucial element
in Kandinsky's formal vocabulary. In 1929 he described his fasci-
nation with the "inner force" of the circle, declaring, "I love
circles today in the same way that previously I loved, e.g.,
horses." Kandinsky evidently took a positive decision to follow
the trend of the time in using geometrical forms, thereby con-
tinuing his quest for pure forms with no distracting associations.

Vassily Kandinsky

51 PARTIES DIVERSES, 1940

Oil on canvas, $35 \times 45^5/_8''$ (89×116 cm)
Inscribed "VK 40" (lower left)
On permanent loan from the Gabriele Münter and Johannes Eichner
Foundation
FH 208

Parties diverses is characteristic of the works which Kandinsky painted in Paris, where he lived from 1933, after the Bauhaus was finally closed down by the Nazis, until his death in 1944. Once again, his formal vocabulary underwent a decisive change. Numerous commentators have described the amoeba-like, semiorganic microorganisms and miniature structures which began to populate his pictures after the constructive, geometrical Bauhaus phase. These forms are seen with a certain detachment and inserted in an artificial, floating frame of reference, using equally artificial, "Asiatic" colors. *Parties diverses* is

divided up into a number of differently colored geometrical fields whose structure is ultimately symmetrical. In a somewhat muted form, the work once more invokes the principle of dualism, the sense of opposition and contradiction which had been one of the most prominent features of Kandinsky's art ever since his pre-1914 abstract-expressive phase. The oppositions in pictures such as *Parties diverses* and *Wechselseitiger Gleichklang* (*Mutual Harmony,* 1942; Musée National d'Art Moderne, Paris) are anticipated by the "constructive" structures of, for example, *Entwicklung in Braun* (*Development in Brown,* 1933; Musée National d'Art Moderne, Paris). As Serge Vonboult has pointed out, "Kandinsky's art can be defined, as a whole, as the synthesis of divided, conflicting forces." This conflict is shaped not only by archetypal, microcosmic forms and colors that convey "something of the spirit of the East," but also by the artificial colors and decorative forms of modern industry and the contemporary world.

Vassily Kandinsky

52 FINAL DESIGN FOR THE COVER OF THE BLUE
RIDER ALMANAC (*Endgültiger Entwurf für den Umschlag des
Almanachs Der Blaue Reiter*), 1911

Ink and watercolor over pencil tracing on paper, 11 × 8⁵/₈″
(27.9 × 21.9 cm)
Inscribed "K", enclosed in a triangle (lower right)
GMS 608

In 1911 Kandinsky and Marc, whose status in the Neue
Künstler-Vereinigung München was growing increasingly
precarious, conceived a plan to publish an almanac with the
title *Der Blaue Reiter*. The publication, whose aim was to
formulate the goals of a new art, featured contributions by
painters, writers, and musicians from Germany and elsewhere.
With its fourteen major articles and wealth of illustrations, the
almanac endeavored, in a highly modern fashion, to break
down the barriers between different periods and genres, in
order to prove, as Kandinsky put it, that "the truly artistic is
not a question of form, but of artistic content." Classical reliefs
stood side by side with children's drawings, Chinese prints
with the naive paintings of Henri Rousseau, folk art with
Picasso, El Greco with Robert Delaunay (see fig. 56, p. 40).

Kandinsky made, in quick succession, a total of eleven
sketches for the cover illustration of the almanac, ten of which
are in the collection of the Lenbachhaus (see frontispiece).
Almost all of them show a triumphant rider holding up a
fluttering banner in his outstretched hands, symbolizing the
victory of the spirit. For the final version, however, Kandinsky
discarded the sketches and made a woodcut whose striking,
eloquent symbolism neatly encapsulates the statement which
the almanac intended to make. The rider in the final sketch,
illustrated here, recalls the figure of St. George, the dragon-
killer and conqueror of evil. Wearing a somewhat strange form
of headdress and carrying a shield, the knight is mounted on
a rampant horse. The dragon writhes on the ground beneath
him; its scaly tail lashes upward, following the line of his back.
On the right, in the foreground, one sees the diminutive figure
of the captive princess turning to greet her liberator.

The form of the image is clearly influenced by the tradition
of Bavarian painting on glass, whose naive, antinaturalistic
style was an important source of inspiration to Kandinsky
and his fellow members of the avant-garde. This influence is
documented by a painting on glass by Kandinsky which is
almost identical with the sketch for the cover illustration of
the almanac and which is also in the collection of the Lenbach-
haus. In the cover illustration itself, the figure of St. George,
which appears in a number of Kandinsky's pictures from 1911/
12 (see plates 39, 56), is drawn in a manner which largely
conforms to traditional iconographical models; at the same
time, however, the picture succeeds in conveying a universal
meaning by dint of its original stylization and "spiritual" color-
ing. The figure of the Blue Rider becomes a symbol of a
movement of spiritual renewal, struggling to purify the world
and to rescue it from the dead forces of materialism. This
message of salvation, proclaiming the dawning of a new spiri-
tual epoch in which art and culture will play a major part, is
one of the central themes of *The Blue Rider* almanac. The title
Blue Rider became the name of the movement associated with
Kandinsky and Marc when, at the end of 1911, the two artists
organized the first exhibition of the group.

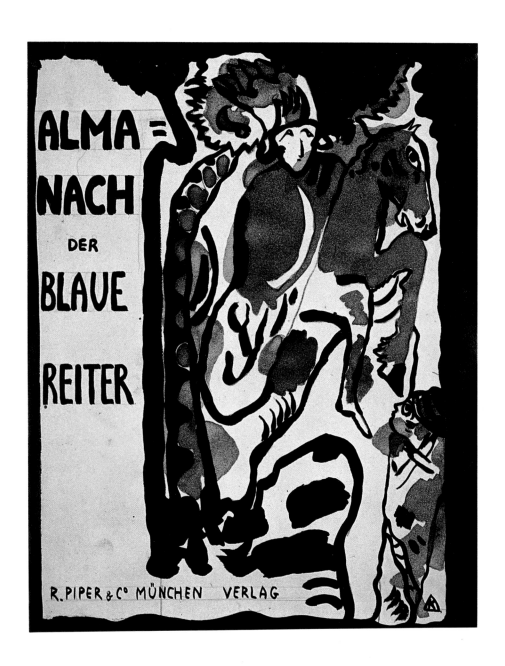

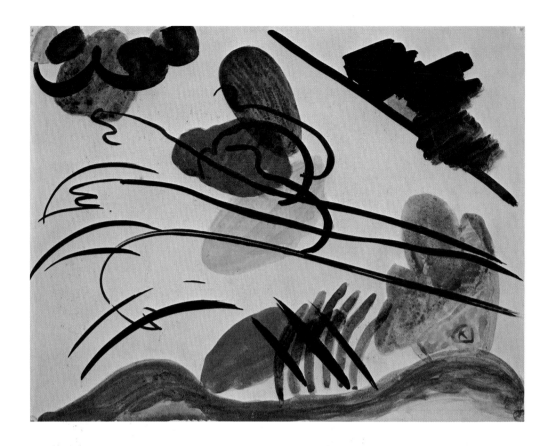

Vassily Kandinsky
53 WITH THREE RIDERS (*Mit drei Reitern*), 1911
Ink and watercolor on paper, $9^7/8 \times 12^5/8''$ (25 × 32 cm)
Inscribed "K" (lower right)
GMS 153

This famous watercolor once again uses the motif of the rider, which, after its adoption by Kandinsky, became one of the key symbols of modern art. The six bold lines of the galloping horses and their riders evoke a sense of concentrated movement and energy. Kandinsky draws the elongated lines of the horses' backs with smooth, powerful brushstrokes; the impression of speed is heightened by the bowed figures of the riders. The black ink lines are superimposed on the economically distributed colors, which, as in Kandinsky's major compositions, merely hint at specific forms and bodies: the three patches of color – blue, red, and yellow – behind the three riders can be seen as an echo of their aura.

There are obvious parallels between *With Three Riders* and several other pictures by Kandinsky, including *Romantic Landscape* (plate 38), which was painted in the same year. Here again, three riders are depicted galloping from right to left. Kandinsky was especially intrigued by movement in this direction, which he saw as conveying a particular sense of intensity and dynamism, whereas movement from left to right, as he wrote in his book *Point and Line to Plane* (1926), induces a feeling of calmness or even tiredness. He included a woodcut based on *With Three Riders* in his poetry album *Sounds,* published in 1913. The watercolor has a fleeting charm of its own: rarely in Kandinsky's work does the line incorporate such a degree of autonomous psychological power, while at the same time fulfilling a representational function.

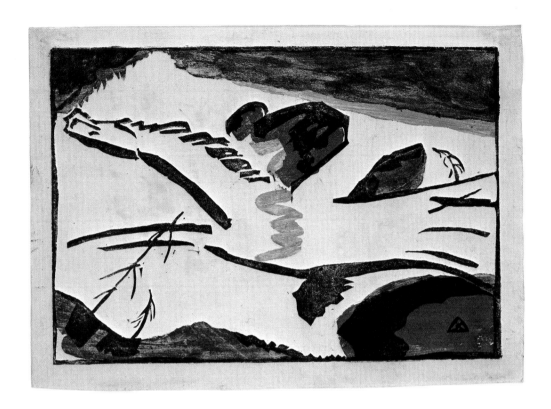

Vassily Kandinsky

54 LYRICAL (*Lyrisches*), 1911

Color woodcut on paper, $5^3/4 \times 8^1/2''$ (15.5 × 21.7 cm)
Inscribed "K", enclosed in a triangle (lower right)
GMS 303

Lyrical belongs to the same group of stylized and powerful "rider" pictures as *With Three Riders* (plate 53). Kandinsky also produced an oil painting with the same title, which is in the Boymans-van Beuningen Museum, Rotterdam. In both works the motif of the rider is sketched with brief, economical lines; the woodcut, however, is more powerful and compact than the painting. The contours of the horse and the rider bending low over its neck merge into an organic unity which vividly conveys the idea of swift forward motion. Whereas in the painting the colors in the vicinity of the finely drawn trees vaguely suggest the outlines of a landscape, the trees in the woodcut have vanished into the substratum of two-dimensional colored patches. A crucial feature of the woodcut is the white patch surrounding the rider, which lends his movement a sense of continuity.

The woodcut and painting illustrate yet again the extent to which Kandinsky regarded these two media as equally valid, mutually fructifying genres which facilitated his experiments in the reduction of form. In some instances, the woodcut, with its innate tendency toward stylistic exaggeration, precedes the painting.

Vassily Kandinsky

55 WITH SUN (*Mit Sonne*), 1911

Painting on glass, 12 × 15⁷/₈″ (30.6 × 40.3 cm)
Inscribed in Münter's hand "Kandinsky. Glasbild mit Sonne" (reverse)
Frame painted by the artist
GMS 120

With Sun is the model for *Improvisation 21a* (plate 43) and the later picture *Kleine Freuden* (*Simple Pleasures*; Solomon R. Guggenheim Museum, New York). It employs the same set of motifs, but uses the stylized, almost naive language of painting on glass. In the center of the picture one sees a group of overlapping hills, two of which are crowned by the silhouettes of a Russian city; on the left, three brightly colored riders are galloping up the hills. A menacing black cloud hangs over the right-hand section; beneath it, a purple boat with three occupants is tossing in the dark waves of a lake; in the foreground, two semiorganic forms project into the picture. The glowing colors of the figures – red, blue, and yellow – are muted by the grubby whitish tones of the hills and the landscape.

The attempts to interpret these images in terms of an apocalyptic vision have already been mentioned in connection with *Improvisation 21a*. Angelica Zander Rudenstine writes: "Ringbom too places the work in the context of Kandinsky's notion of the Apocalypse, announcing a new spiritual era. Although he does not discuss the imagery of the painting as a whole, he sees the ubiquitous hill with the 'onion dome towers' – also used on the cover of *On the Spiritual in Art* [fig. 58, p. 42] – as a direct reflection of that passage in the book where 'a large city, solidly built according to the rules of architecture and mathematics, [is] suddenly shaken by an immense force,' the towers crumble and fall, the sun glows dark, and one searches in vain for the power with which to battle the darkness This central image of the collapsing or threatened city is, Ringbom argues, a metaphor for a shattered material world on the eve of spiritual regeneration."

However, Kandinsky's later comments on the picture *Simple Pleasures* have a quite different, ironic tenor; they are guided by the aura of the various pictorial elements, which are evidently divorced from the object, in terms of both form and ideas, and loosely distributed through the work.

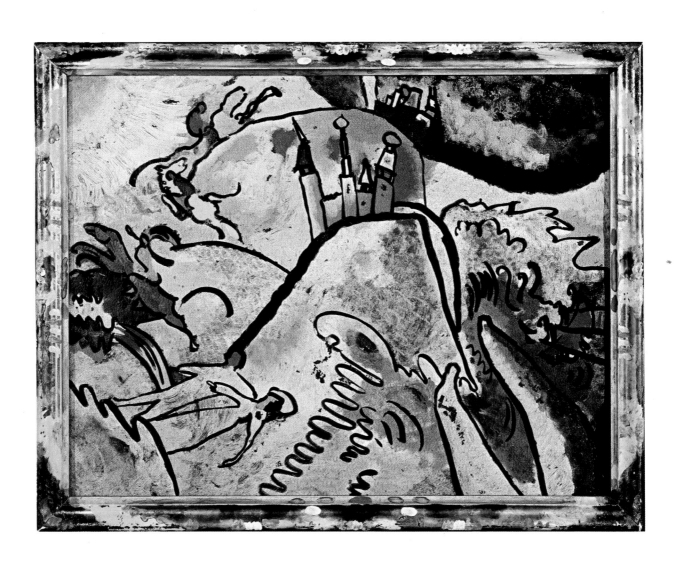

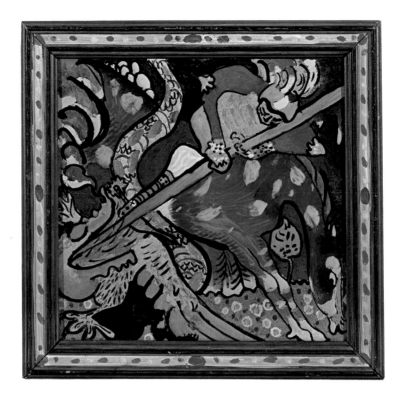

Vassily Kandinsky

56 ST. GEORGE I (*Heiliger Georg I*), 1911

Painting on glass, 7^1/$_2$ × 7^5/$_8$″ (19 × 19.5 cm)
Inscribed "Kandinsky / gemalt im Juni 1911 in Murnau" (reverse)
Frame painted by the artist
GMS 105

St. George I is one of Kandinsky's best known paintings on glass. Influenced by the style of folk art, the figure of the saintly knight is an early version of the more abstract figure which was to become the herald of the Blue Rider (see plate 52). The brightly glowing painting is dominated by the diagonally slanting forms of the horse and rider. The saint bends down from his shying horse to thrust his massive lance into the dragon's body on the ground. Behind the horse, which is colored in a deep, "spiritual" shade of blue with gold flecks that echo the color of the knight's armor, one sees a dark red sky and the round form of a tree, which often appears in Kandinsky's pictures in connection with the rider motif. The picture is a drama of struggle and victory in a confined space.

Through his choice of colors for the picture and the frame Kandinsky further emphasizes the innate antinaturalism of Bavarian folk art, whose "primitive" character – its simplicity and directness, its boldly contrasting colors, and its genuine emotional fervor – was a continuing source of inspiration to Kandinsky and several of his contemporaries. During the summer that they spent in Murnau in 1908 he and Münter had discovered the charms of Bavarian folk art and, in particular, of its paintings on glass, a technique which they copied and adapted for their own purposes (see figs. 20 and 21, p. 21). Kandinsky, Marc, and Münter attributed an almost magical power to these folk-art pictures, a dozen of which were included among the illustrations reproduced in *The Blue Rider* almanac.

With the figure of St. George, a saint particularly revered in Bavaria, Kandinsky added a new dimension of meaning to the figure of the rider, which plays such a central part in his oeuvre. The personal metaphor of the rider, which evokes a sense of the quest for a new art and a new spiritual awakening, acquires a religious connotation: St. George symbolizes the victory of good over evil. Kandinsky's particular interest in this theme is documented by three oil paintings of St. George (see plate 39), in addition to which he made two further paintings on glass and a number of watercolors and woodcuts.

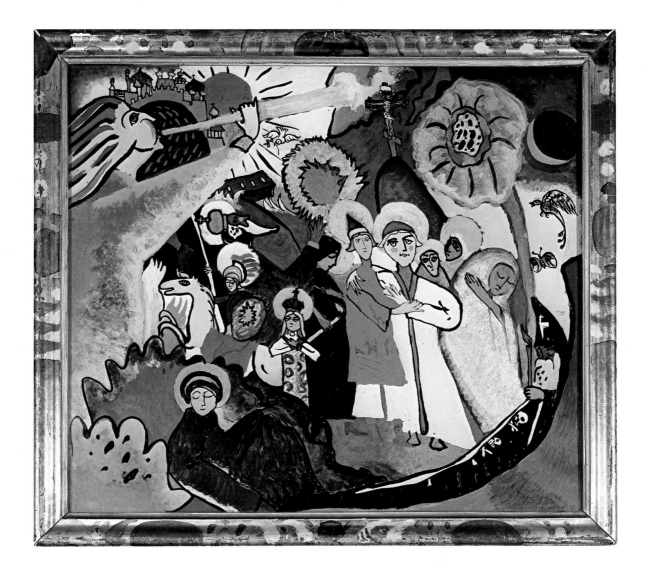

Vassily Kandinsky

57 ALL SAINTS I (*Allerheiligen I*), 1911

Painting on glass, 13³/₈ × 16″ (34.5 × 40.5 cm)
Inscribed in Münter's hand "Kandinsky. Allerheiligen, in Murnau,
unverkäuflich" (reverse)
Frame painted by the artist
GMS 107

The painting on glass *All Saints I*, which formed the basis of
the paintings *All Saints I* and *All Saints II* (plates 36, 37),
features a wide variety of religious motifs that played a prominent part
in Kandinsky's pre-1914 pictures. These motifs were drawn
partly from Bavarian and Russian folk art and partly from
early German Bible illustrations, whose naive expressive power
was a source of inspiration to Kandinsky. Using simple forms
and bright colors, and ignoring questions of proportion or
logical connection, the artist assembles the figures under the
yellow trumpet of the giant angel. The figures include
St. George, with shield and lance, mounted on a white horse;
St. Vladimir; a female saint bearing a lighted candle; and two
saints piously embracing each other, whose identity is un-

certain: it is possible that they are meant to represent either
St. Boris and St. Gleb, the first two martyrs of the Russian
Orthodox Church, or St. Cosmas and St. Damian, two saints
who are particularly revered in Bavaria. To their right, three
mourners stand over the flat, curving figure of a dead monk,
at whose feet a haloed figure sits in the foreground. The group
is overshadowed by an opposition between light and dark,
salvation and damnation, which is clearly expressed by the
contrast between the two halves of the picture. Whereas the
Russian city on the hill in the top left-hand corner is lit up by
the rays of the red sun, the upper right-hand section of the
picture is dominated by the black moon and the darkness
against which the figure of Christ on the cross stands out like
a beacon.

This opposition between light and dark, which also plays
an important part in such pictures as *Improvisation 21a, Improvi-
sation Deluge,* and *With Sun* (plates 43, 45, 55), implies the idea
of a possible salvation. In *All Saints I* the dove fluttering above
Noah's Ark, the butterfly, and the phoenix symbolize the hope
that the drama of the Apocalypse will be followed by an era
of salvation and renewal.

Gabriele Münter

b. 1877 in Berlin – d. 1962 in Murnau (Bavaria)

Münter moved to Munich in 1901; a year later she began attending Kandinsky's newly founded Phalanx school of art. From 1903 until the beginning of World War I she and Kandinsky lived and worked together. From 1904 on, the couple traveled extensively; in 1906 they moved to Sèvres, near Paris, and stayed there for nearly a year. After their return to Germany in 1908, they discovered the small town of Murnau in southern Bavaria, where Münter bought a house; during the following years she and Kandinsky spent much of their time in Murnau, often inviting other members of the Blue Rider circle to come and stay with them. In 1909 Münter and Kandinsky joined the Neue Künstler-Vereinigung München (New Artists' Association, Munich), whose other members included Jawlensky, Marianne von Werefkin, Adolf Erbslöh, Alexander Kanoldt, and Albert Bloch; Marc joined the group in 1910. Münter painted in a free, original style, using simple but bold structures; her work is quite distinct from that of the other Blue Rider artists. In 1911 she followed Kandinsky's lead in breaking with the Neue Künstler-Vereinigung. She took part in the first Blue Rider exhibition in the winter of 1911/12 and in all the further exhibitions of the group. Münter's last meeting with Kandinsky was in Stockholm in 1916. She then abandoned painting for nearly twenty years, not taking it up again until the 1930s, when she settled in Murnau.

Gabriele Münter

58 JAWLENSKY AND WEREFKIN (*Jawlensky und Werefkin*), 1908/09

Oil on cardboard, $12^7/8 \times 17^1/2''$ (32.7 × 44.5 cm)
Inscribed in Johannes Eichner's (?) hand "Marianne v. Werefkin und Jawlens. um 1908/09 (unverkäuflich)" (reverse)
GMS 655

For Münter, as for her friend and colleague Kandinsky, the discovery of the area around Murnau in southern Bavaria was a major event which marked the beginning of a new departure in the development of her artistic approach. In the fall of 1908 the couple had returned to Munich after spending several years abroad and moved into a shared apartment on Ainmillerstrasse in Schwabing. The previous spring they had visited Murnau for the first time and were so taken with the small country town that they returned there in the summer to spend an extended painting holiday with Jawlensky and Marianne von Werefkin. In her diary Münter enthusiastically described the sense of liberation which she felt in Murnau: "We had seen the town in the course of an excursion into the countryside and recommended it to Jawlensky and Werefkin, who told us to come and join them there. We stayed at the Griesbräu, and the place appealed to us. After a short period of agony I took a great leap forward, from copying nature – in a more or less Impressionist style – to abstraction, feeling the content, the essence of things."

The picture of Jawlensky and Werefkin, which shows the couple reclining in a meadow, documents Münter's abrupt abandonment of Impressionism in favor of an uncompromisingly modern style of her own making. Radically simplifying the forms of nature and the human figure, she uses boldly contrasting, luminous colors. The almost faceless figures of her two friends are seen in outline only, standing out against the homogeneous green of the meadow and the blue of the sky and the mountains. Münter uses the *cloisonniste* technique which Jawlensky had copied from Gauguin, outlining all the important elements of the picture in black. Her work, with its direct, uncluttered view of reality, was particularly influenced at this point by Jawlensky's notion of "synthesis," that is, the reduction of the picture to a small number of characteristic forms. During her stay in Murnau in 1908 she painted a considerable number of major pictures which formed the basis for her contribution to the subsequent Blue Rider exhibitions. In her diary she wrote: "It was an interesting, cheerful time. We had lots of conversations about art with the enthusiastic 'Giselists' [Jawlensky and Werefkin, who lived on Munich's Giselastrasse]. I particularly enjoyed showing my work to Jawlensky, who praised it lavishly and also explained a number of things to me: he gave me the benefit of his wide experience and talked about 'synthesis.' He is a good colleague. All four of us were keenly ambitious, and each of us made progress. There were days when I painted as many as five studies; often it was three, and the days were rare when I didn't paint at all. We all worked very hard."

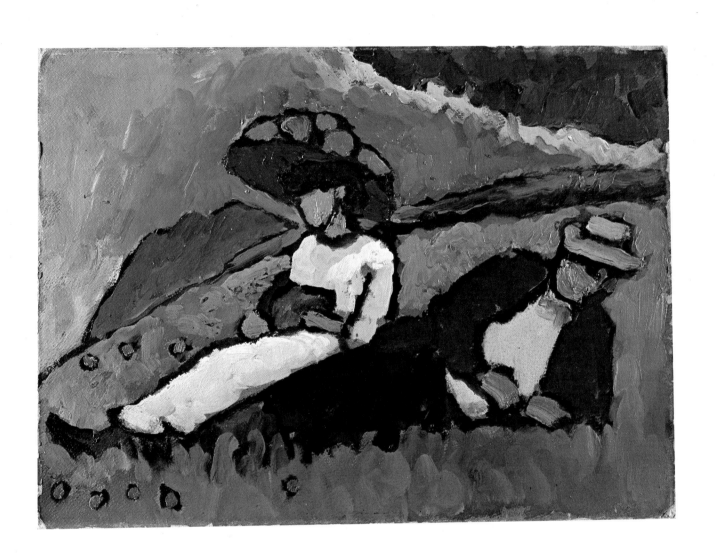

Gabriele Münter

59 MURNAU LANDSCAPE (*Blick aufs Murnauer Moos*),
1908

Oil on cardboard, 12⁷/₈ × 16″ (32.7 × 40.5 cm)
Inscribed "M 08" (lower right), "Münter 1908 Blick aufs Moos"
(reverse, in the artist's hand)
GMS 654

Murnau Landscape, a view of meadows and mountains near the
Staffelsee, is one of the first of a series of landscapes which
Münter painted in the Murnau area. The distinction between
foreground and background is blurred by the additive
technique; the colors of the landscape are sketched in with
quick, confident brushstrokes which leave patches of the card-
board bare. With its economical but bold mixture of blues and
greens, this evening scene realizes, in an exemplary fashion,
the programmatic aims of Münter, Kandinsky, and Jawlensky:
the reduction of form, the liberation of color from representa-
tional functions, the abandonment of perspective, and the sim-
plification of objects in order to heighten their expressive value.
The importance of this program of formal renewal in the
development of modern German art cannot be emphasized too
strongly: the only parallel to it is to be found in the landscapes
of the North German Expressionists Ernst Ludwig Kirchner,
Erich Heckel, and Karl Schmidt-Rottluff.

The experience of being exposed to the Alpine landscape
and its intriguing light effects almost certainly contributed to
the liberation of Münter's visual imagination: in the foothills
of the Alps, the colors of the landscape often take on an
unreal quality, and the viewer's sense of perspective becomes
distorted. Hence it seems likely that the coloring of the picture,
its seemingly arbitrary combination of violet, blue, and green,
corresponds to an actual impression of nature, from which
Münter extracted the basic essence. In Murnau, her main artis-
tic strengths – her intensity of vision and her ability to simplify
the physical appearance of reality – came into their own. Her
friends greatly admired her pictures and regarded her technique
as having exemplary significance for their own work.

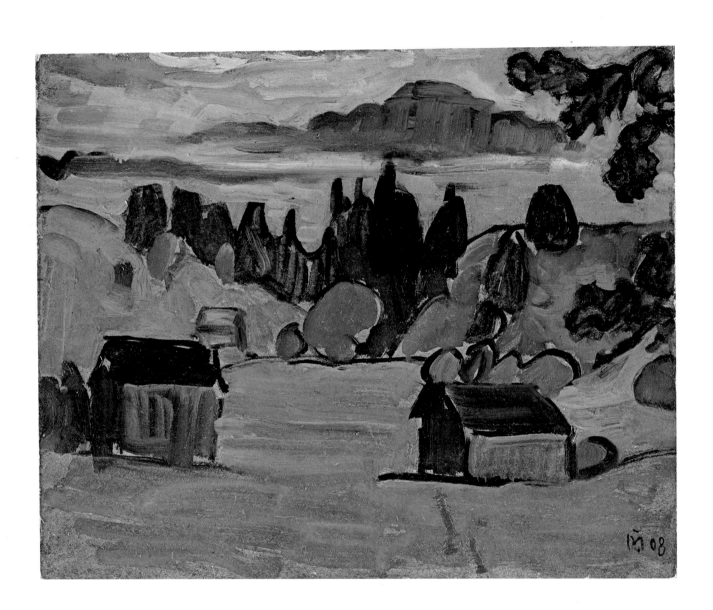

Gabriele Münter

60 PORTRAIT OF MARIANNE VON WEREFKIN
(Bildnis Marianne von Werefkin), 1909

Oil on cardboard, $31^7/_8 \times 21^5/_8''$ (81×55 cm)
Inscribed "Münter" (lower right), "Gabriele Münter. Bildnis Marianne
von Werefkin. Wahrscheinlich 1909" (reverse, in the artist's hand)
GMS 656

Münter painted this portrait of her friend and fellow artist
Marianne von Werefkin in 1909, at the time when Kandinsky,
Jawlensky, Münter, and Werefkin were working closely
together: with a number of other artists, they had founded the
Neue Künstler-Vereinigung München on January 22, 1909.
Jawlensky and Werefkin's apartment on Giselastrasse was a
meeting place for large numbers of artists, writers, actors, and
other members of the Munich avant-garde. Werefkin, the
daughter of a Russian general, had studied painting with Ilya
Repin in St. Petersburg. She had met Jawlensky in 1891 and
moved to Munich with him in 1896, where she devoted the
major part of her energies to nurturing his talent and largely
neglected her own work. Nevertheless, she was a central figure
in the circle of artists from which the Blue Rider movement
emerged.

This exceptionally vital and powerful portrait conveys a
sense of Werefkin's fascinating personality. Standing in front
of a vividly structured, yellow background, and wearing a
huge hat decorated with brightly colored flowers, she looks at
the viewer over her right shoulder. The solid plinth of her
body, seen in profile, is framed by her broad violet scarf and
painted with energetic brushstrokes similar to those seen in the
background. Violet shadows play around her eyes, hair, nose,
and slightly open lips, which, together with her wide-awake
expression, testify to her vivacious personality and lively intel-
lect. Only rarely did Münter, under the temporary influence
of Jawlensky, come as close to emulating the technique of the
French Fauves as in this picture.

Portrait of Marianne von Werefkin is one of the most significant
portraits painted by any of the Blue Rider artists, who in
general rejected representational portraiture. In Münter's view,
however, the human face was something which could not be
dissolved or replaced by purely symbolic, "spiritual" images.
Obliquely referring to Kandinsky, she wrote: "The personality
is rooted in the spiritual and emerges from an invisible realm.
The visible physical appearance of the person is the natural
symbol of this invisible element." In Münter's work, the visible
symbol is in turn objectified and given an experimental value
by the laws of the image.

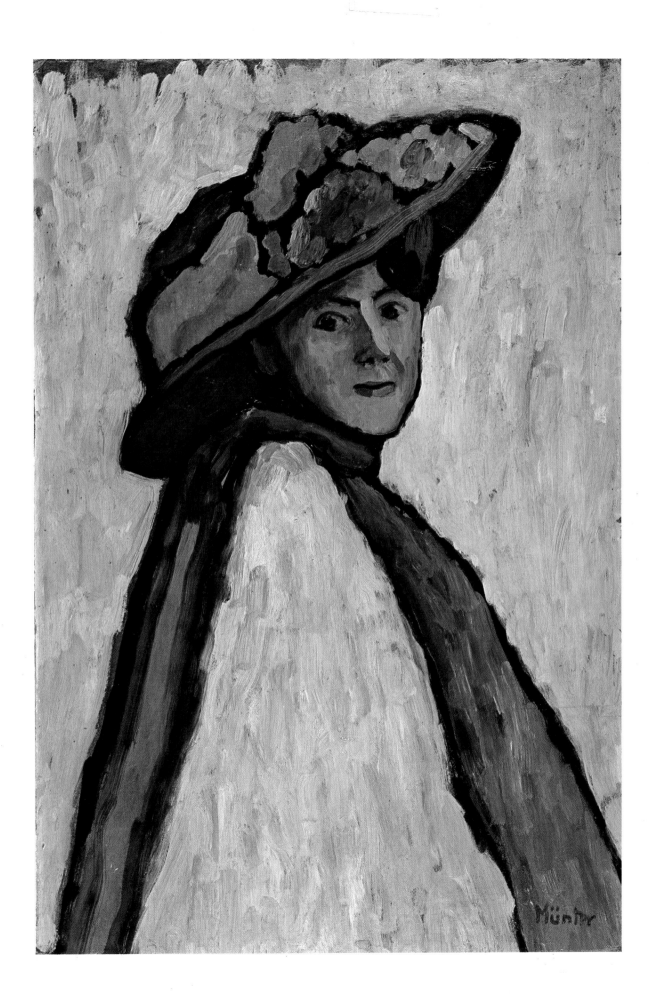

Gabriele Münter

61 TOMBSTONES IN KOCHEL (*Grabkreuze in Kochel*), 1909

Oil on cardboard, 16 × 12⁷/₈″ (40.5 × 32.8 cm)
Inscribed "Mü" (lower left), "Grabkreuze in Kochel 1909" (reverse, in the artist's hand)
GMS 658

Tombstones in Kochel was painted while Münter and Kandinsky were staying with the composer Thomas von Hartmann in February 1909, at the same time as Kandinsky painted *Kochel – Graveyard and Rectory* (plate 21) and a number of other winter pictures. The similarities between the landscape studies of Münter and Kandinsky at this point are greater than at any other time in their respective careers. Many critics have emphasized the importance of the pupil-teacher relationship between the two artists and have noted that, for a time at least, it was far from easy to tell their pictures apart. Up to 1911, and especially during the Murnau years, they did indeed work closely together, exchanging ideas on form and technique, and it seems certain that Kandinsky exerted a considerable influence on Münter's artistic approach. As she later wrote, "he loved, understood, protected, and nurtured my talent."

Kandinsky took a photograph of Münter in a winter coat working on this picture in the graveyard at Kochel (fig. 19, p. 20). At the time when he was teaching at the Phalanx school of art, Kandinsky had placed great emphasis on the importance of *plein air* painting as a means of liberating art from academic restrictions, and he and Münter continued to paint outdoors when they were working together in Murnau. However, despite the similarities between the Kochel pictures, they also exhibit certain differences. Münter's choice of motif betokens her interest in the visual play of objects themselves, which is clearly apparent in her later still lifes. She stylizes the crosses in a way that lends them added drama, which is enhanced by those blue shadows in the snow that so fascinated Kandinsky. Münter's colors do not have the separated, glowing quality of those used by Kandinsky: the wintry yellow is mixed into the white, thereby binding the picture together into a unified whole. Looking at Kandinsky's Kochel pictures, it seems possible that he to some extent copied Münter's natural, flowing brushstroke.

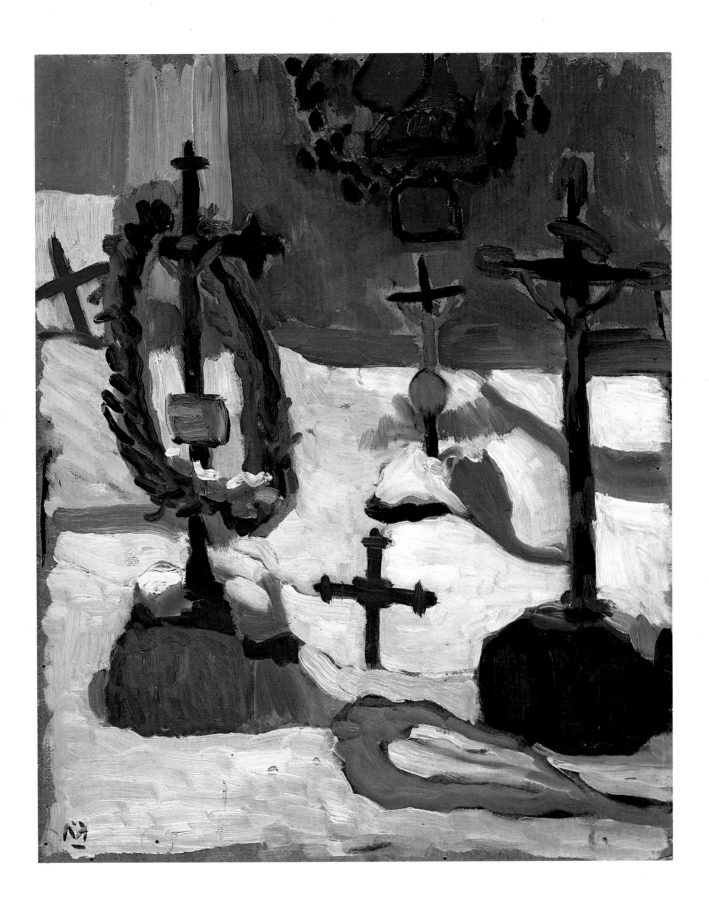

Gabriele Münter

62 LISTENING (PORTRAIT OF JAWLENSKY)
(*Zuhören [Bildnis Jawlensky]*), 1909

Oil on cardboard, 19⁵/₈ × 26″ (49.7 × 66.2 cm)
Inscribed "Münter" (upper left), "G. Münter Zuhören 1909" (reverse, in the artist's hand)
GMS 657

Münter gives the following account of the genesis of this painting: "All three of them [Kandinsky, Klee, and Jawlensky] talked incessantly about art, and initially each of them had his own views and his own style. Jawlensky was less intellectual, or less intelligent, than Kandinsky and Klee, and he often found their theories confusing. On one occasion I painted a portrait which I called *Listening* and which showed Jawlensky with an expression of surprise on his chubby face, listening to Kandinsky explaining his latest theories of art." In portraying her friends, Münter often took a characteristic situation as her point of departure, rather than the physiognomic peculiarities of the individual subject. Here she employs a deliberately naive technique to capture Jawlensky's expression of bewilderment. The Russian artist sits on the right at a table indicated by a horizontal black line. The curving line of his pink shirtfront runs up his broad, two-dimensional body to his round, reddish head with its blue eyes and raised eyebrows; the slightly cocked position of the head lends his entire body the appearance of a question mark. The angle of his body is picked up and further emphasized by the two curved sausages on the plate and the base of the petroleum lamp. Despite their simplicity, the elements in the center attract the viewer's attention by virtue of their pure complementary colors and banish the figure of Jawlensky into a peripheral position behind the table. With its deliberately simple, avowedly representational technique, Münter's picture seems to comment ironically on Jawlensky's inability to grasp Kandinsky's complicated theories and, in addition, on Kandinsky's pictorial practice, which Münter herself found far from easy to understand.

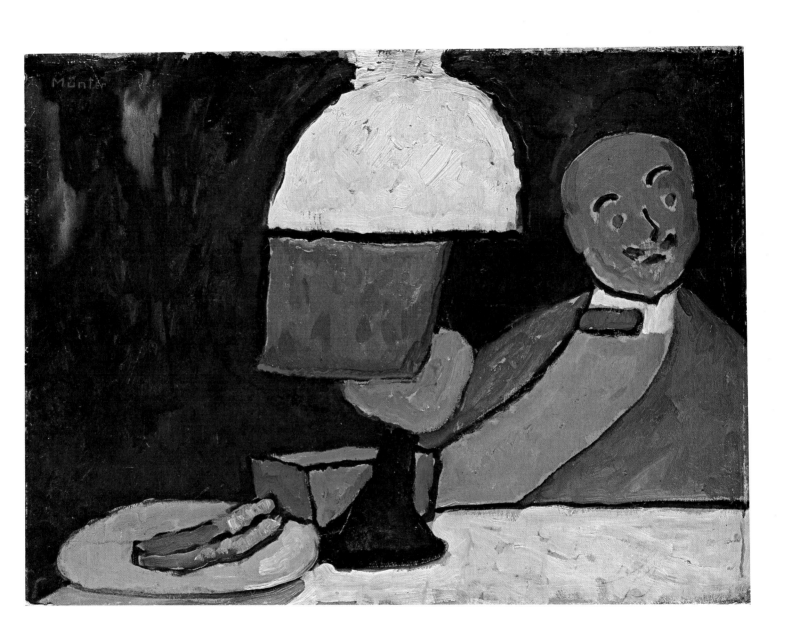

Gabriele Münter

63 STILL LIFE WITH CHAIR (*Stilleben mit Sessel*), 1909

Oil on cardboard, 28^1/$_2$ × 19^1/$_4$″ (72.5 × 49 cm)
Inscribed "Münter 09" (lower left)
On permanent loan from the Gabriele Münter and Johannes Eichner
Foundation
FH 294

Still Life with Chair offers a further demonstration of Münter's
exceptional talent for painting fascinating, highly individual
pictures of simple, everyday objects. Three small vases of flow-
ers and a pot plant stand on a small red table next to a dark
wine-red chairback. Their blues and yellows form a garland
of color around the large pot behind them, which contains a
shrub with a profusion of dark pink flowers. Together with
the intriguingly strange arrangement of the objects, the boldly
masterful combination of the various reds with the dark yellow
background and its brightly colored plate allows this little-
known still life to be ranked among Münter's major early
works. The picture was shown, alongside six other works
by Münter, at the second exhibition of the Neue Künstler-
Vereinigung München in 1910.

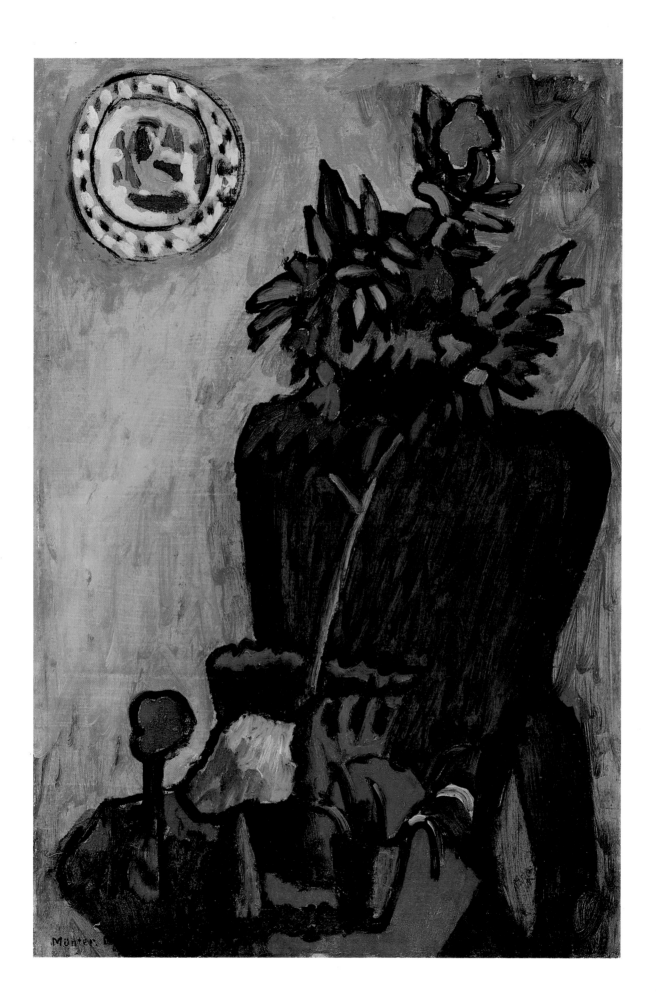

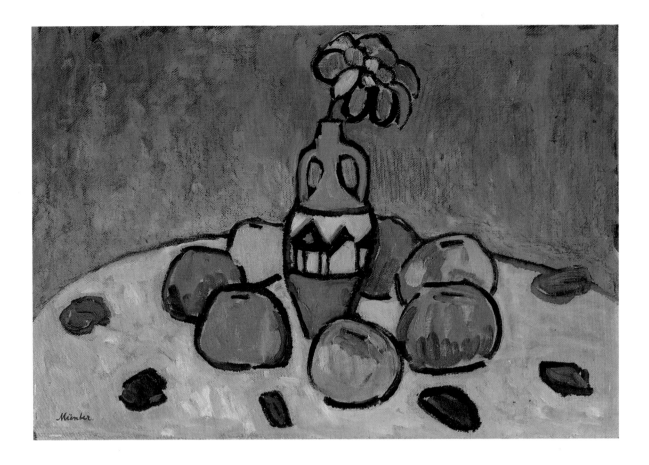

Gabriele Münter

64 STILL LIFE IN GRAY (*Stilleben grau*), 1910

Oil on cardboard, 13¹/₂ × 19³/₄″ (34.2 × 50.2 cm)
Inscribed "Münter" (lower left)
GMS 662

Still Life in Gray owes a particular debt to Jawlensky and the French tradition. In a manner similar to Jawlensky's *Still Life with Fruit* (plate 81), the picture is divided by a central line into two differently colored but corresponding zones; the upper zone is gray-blue and the bottom half of the picture light gray. The vase, the apples, and the leaves in the lower zone are thinly edged in black; they seem to derive their substance solely from the paint itself. The perspective of the picture and the deliberate symmetry of the arrangement on the table create a sense of order and harmony. In an undated note, Münter declared on one occasion: "If I had a formal model – and from 1903 to 1913 this was to some extent the case – then it was probably Van Gogh, via Jawlensky and his theories (the notion of synthesis)."

However, she went on to emphasize that the main influence on her work was Kandinsky. In order to grasp the formal antecedents of a picture such as *Still Life in Gray*, it is necessary to bear in mind not only Van Gogh but also Matisse and Cézanne, to whose work Münter was introduced by Jawlensky. These artists' manner of experimenting with the laws of form and color led, in its own way, to a "spiritualization" and dematerialization of the object. Marc pointed this out in his discussion of the second exhibition of the Neue Künstler-Vereinigung München in 1910: "This bold attempt to spiritualize the material reality to which Impressionism clings with such dogged obstinacy is a necessary reaction which began with Gauguin in Pont-Aven and has already given rise to innumerable experiments. The reason why this latest experiment by the Neue Künstler-Vereinigung seems to us so promising is that, in addition to their highly spiritualized meaning, the pictures of the group offer highly valuable examples of rhythm, composition, and color theory."

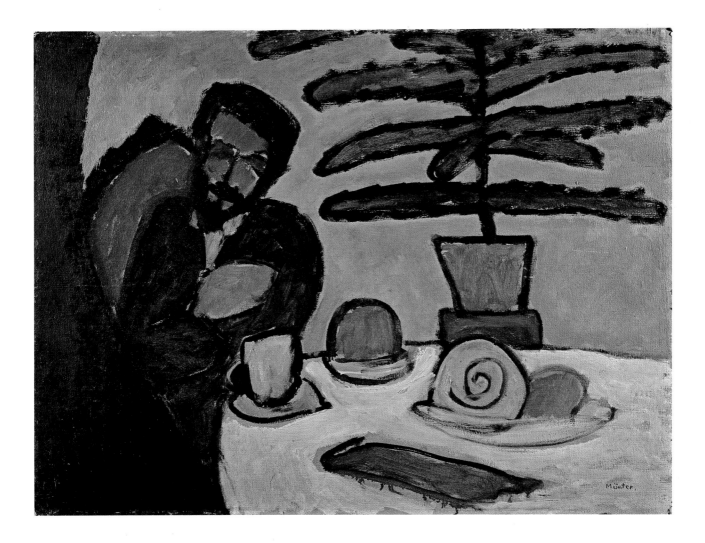

Gabriele Münter

65 MAN AT THE TABLE (KANDINSKY) (*Mann am Tisch
[Kandinsky]*), 1911

Oil on cardboard, 20¹/₄ × 27″ (51.6 × 68.5 cm)
Inscribed "Münter" (lower right), "Münter Skizze Mann am Tisch"
(reverse, in the artist's hand)
GMS 665

Man at the Table shows Kandinsky sitting at a table with his
arms folded, facing the artist as if in a sudden moment of keen
attention. In contrast to conventional portraiture, where the
prime focus is on the human subject, the slender, huddled
figure of Kandinsky is juxtaposed with the objects on the table
in a manner reminiscent of still-life painting. The muted colors
of the cup, the plate, the cake, and the flowerpot – ocher,
brown, and olive green – are complemented by the dull white
of the tablecloth and the ocher of the background. With its
aggressively stiff, stylized leaves, the tall green pot plant ex-

tends into the left-hand section of the picture and appears
almost to threaten the man at the table. The somber, dully
economical colors, whose monotony is scarcely relieved by
the orange of the fruit on the table, also convey an impression
of dissonance. Münter's manner of abstract seeing often reveals
a hidden layer of meaning behind the physical appearance of
reality: here, it seems to disclose an underlying psychological
tension between the artist and her subject, who appears to be
watching her from within the picture. Technically, the most
striking feature of the work is its graphic reduction of the
figure and the objects: it is interesting to note that Münter
herself referred to the picture as a "sketch." Kandinsky was
greatly impressed by *Man at the Table*: he commended the
"modesty" and simplicity of Münter's painting, which dis-
played "no trace of feminine or masculine coquetry," and
he included a reproduction of the picture in *The Blue Rider*
almanac.

Gabriele Münter

66 DARK STILL LIFE (SECRET) (*Dunkles Stilleben [Geheimnis]*), 1911

Oil on canvas, 30⁷/₈ × 39⁵/₈″ (78.5 × 100.5 cm)
Inscribed "13.IV.11" (upper right)
On permanent loan from the Gabriele Münter and Johannes Eichner Foundation
FH 294

In the eventful years between 1910 and 1912, when Kandinsky and Marc were putting their ambitious plans for a new art into practice, Münter was developing and refining her narrow repertoire of themes, painting mainly landscapes, still lifes, and flowers. Her still lifes in particular bear the mark of her distinctive talent. In the pictures from this period, small statuettes and carved wooden figures, taken from Münter and Kandinsky's collection of folk art, are often used to lend an added sense of animation to the selection of objects. Although the initial stimulus for the pictures came from the chance arrangement of these artifacts on a shelf or table, the figures in Münter's still lifes are caught up in a network of secret relationships.

A photograph of Münter and Kandinsky's Munich apartment enables us to identify the source of *Dark Still Life (Secret)*. In a corner of the apartment several figures stood on a small table; a number of paintings on glass can be seen hanging on the adjacent wall. With the help of the photograph it is possible to ascertain that the pair of figures at the far left-hand side of the picture was taken from a painting on glass depicting the King of Bohemia confessing his sins to St. Nepomuk. The objects on the table include an earthenware hen, an Easter egg, a handpainted drinking goblet (now in the collection of the Lenbachhaus), and a statuette of the seated Madonna. It seems likely that the picture was inspired by the experience of suddenly catching sight of these familiar objects in the evening light. However, Münter's choice of them was also motivated by their specifically religious aura. As in *Still Life in Gray* (plate 64), one is struck by the extent to which the still lifes from this period mirror the expressive power of the objects themselves, as well as the subjectivity of the artist. In a letter to Marc written in the fall of 1911, August Macke commented: "I have the feeling that she [Münter] has a penchant for the mysterious (as in the still lifes, the saints, the lilies in a corner of the garden, the sharply lit storm clouds, the lamps, and the venerable old chairs). There is something very 'German' about it all, a touch of religious and family Romanticism. I like her immensely."

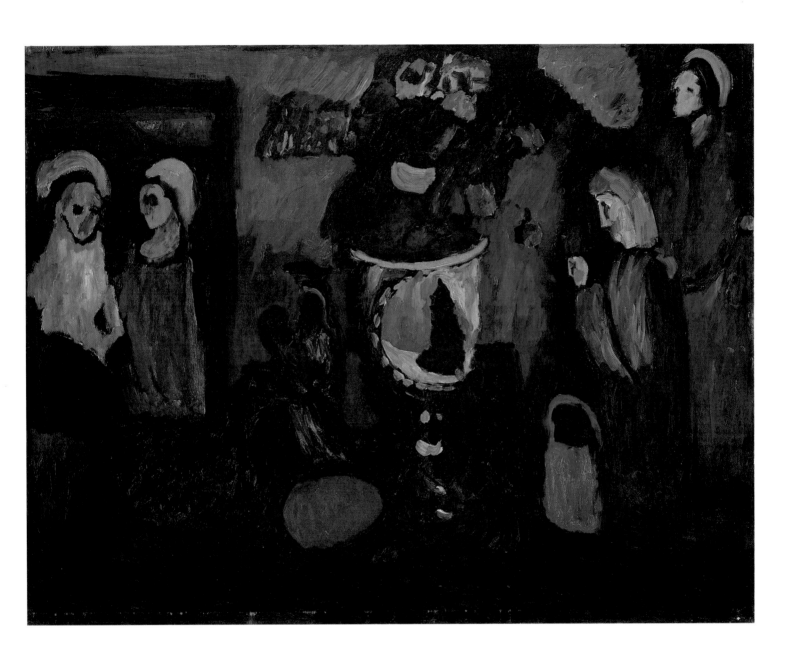

Gabriele Münter

67 MADONNA WITH WINTER FLOWERS (*Madonna mit Christsternen*), c. 1911

Oil on canvas, 36¹/₄ × 27³/₄″ (92.5 × 70.5 cm)
Inscribed "Münter" (lower right)
G 12 206

Madonna with Winter Flowers was probably painted toward the end of 1911. A statuette of the Madonna and a small figure of a shepherd stand on a pale violet surface together with a vase containing winter flowers that extend to the top of the picture. The flowers in Münter's still lifes often have an austere, almost harsh quality that did not give way to a more mellow mood until the work of her later years. A tiny doll stands at the foot of the vase. The busy colored pattern of the background creates an effect of spatial dislocation: it is not from reality, but from some other origin that the objects derive their presence. Kandinsky, the most perceptive interpreter of Münter's work, described her still lifes thus: "Münter – a world of gloomy simplicity which looks into uncertainty or suddenly reveals a pleasurable undertone in the life of the dead objects." The still lifes of this period, with their muted colors, evoke a sense of quiet melancholy: as Kandinsky said, "everything is saturated with a note of intimate feeling which sounds serious and thoughtful."

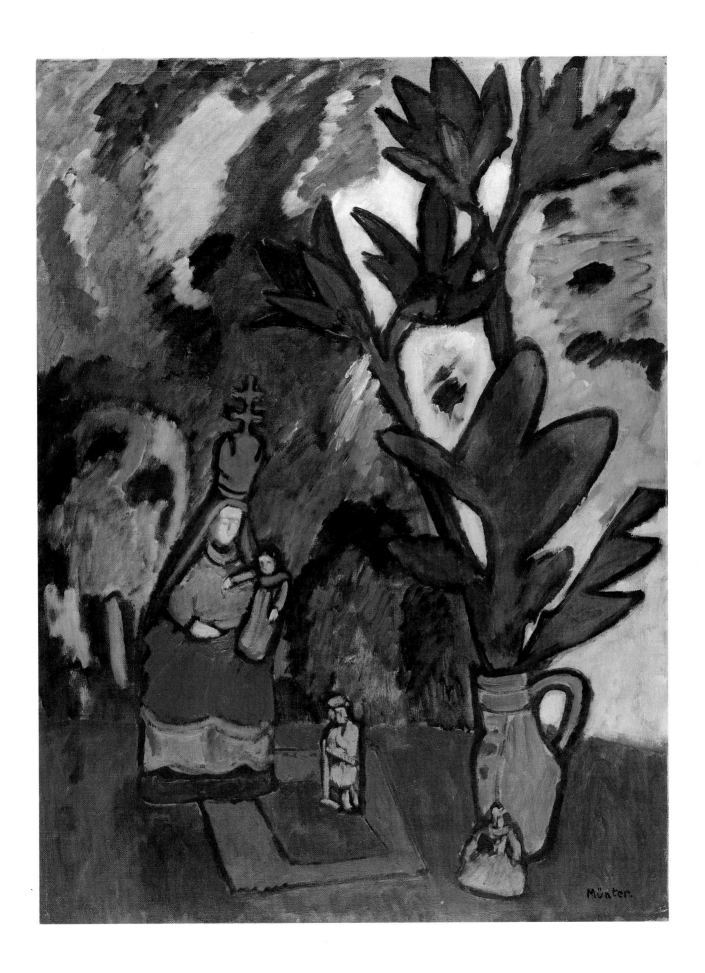

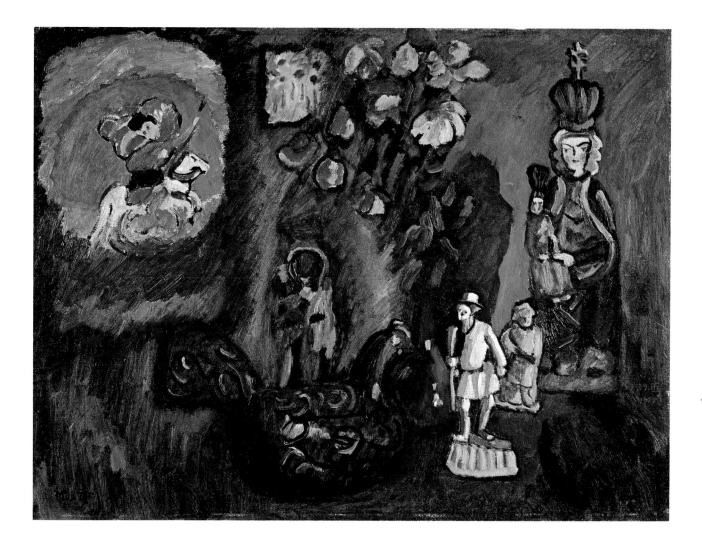

Gabriele Münter

68 STILL LIFE WITH ST. GEORGE (*Stilleben mit Heiligem Georg*), 1911

Oil on cardboard, 20^1/$_8$ × 26^3/$_4$″ (51.1 × 68 cm)
Inscribed "Münter" (lower left), "G. Münter Stilleben mit St. Georg 1911" (reverse, in the artist's hand)
GMS 666

Still Life with St. George anticipates the figure of the "Blue Rider." Standing out against the soft violet and blue-green background, the various figures in the picture appear mysteriously bound up with the two-dimensional space surrounding them. In the top left-hand corner one sees the figure of St. George mounted on a white horse and holding his lance triumphantly aloft, echoing the idea of quasi-religious revival connected with Kandinsky's Blue Rider (see plates 39, 56). The knight, surrounded by a reddish aureole, appears to float in space, thereby obscuring the fact that this section of the picture was modeled on a painting on glass which hung on the wall of Münter's apartment. The other objects in the picture include a statuette of the Madonna; a large earthenware hen; a shimmering blue vase, with a bunch of flowers painted in the same pinkish red as the aureole surrounding the figure of St. George; two carved wooden figures from a Christmas crib; and a further statuette of the Madonna, seated on a throne and

wearing a crown with a double cross. These figures were part of a collection owned by Münter and Kandinsky which is preserved in the Lenbachhaus as part of the Gabriele Münter and Johannes Eichner Foundation. The statuettes of the Madonna are copies of nineteenth-century votive images, the carved wooden figures were bought by Münter in Oberammergau, and the painting of St. George is a copy of a picture by the Murnau artist Rambold.

With its glowing colors and soft, fluid lines, *Still Life with St. George* has a quite exceptional atmospheric quality, which makes it one of Münter's most important paintings. Hans Konrad Roethel emphasizes the particular role of the colors in creating the sense of magic which permeates the work, pointing out that "the dominant color is blue, in the mysterious background, the cool patch of color which surrounds St. George, the glowing tones of the vase and the two Madonnas." *Still Life with St. George* was included in *The Blue Rider* almanac, where Kandinsky wrote: "The still life by Münter demonstrates that the different interpretation of objects to a different degree within one and the same picture is not only not harmful, but can, if correctly used, attain a powerful, complex inner sound. That concordance of sounds which produces an externally disharmonious impression is in this instance the source of the inner harmonious effect."

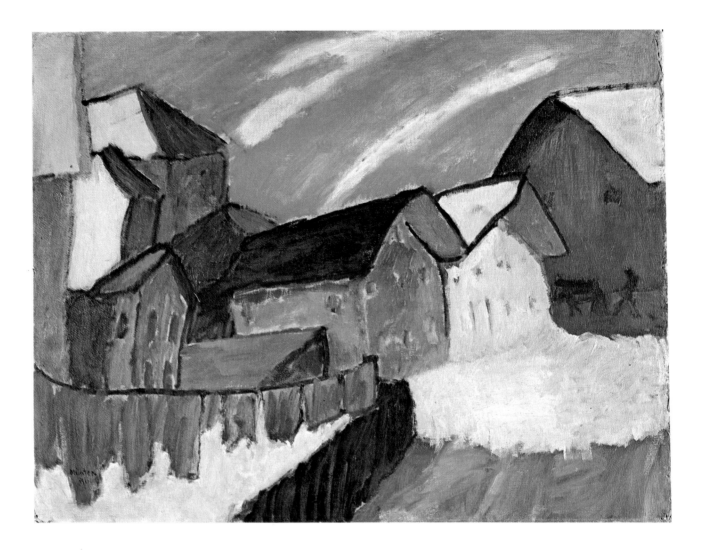

Gabriele Münter

69 VILLAGE STREET IN WINTER (*Dorfstrasse im Winter*), 1911

Oil on cardboard mounted on wood, 20⁵/₈ × 27¹/₄″ (52.4 × 69 cm)
Inscribed "Münter 1911" (lower left)
GMS 664

With its strong, bold colors, *Village Street in Winter* testifies once more to the simple, natural character of Münter's talent and, at the same time, documents her striving for radical innovation. The glowing patches of color have an unnatural appearance. Above the green, red, white, and dark blue houses which line the street, the blue-green of the sky is streaked with white and takes on a turquoise tinge. On the left, a line of violet washing hangs above a yellow background. The houses have a tilted, deliberately "deformed" appearance, which is accentuated by their dark outlines and lends the picture a sense of dynamic energy. Despite the unusual contrasts, the colors do not directly clash; the careful, clear juxtaposition of the parts welds the picture into a unified whole. As in the work of Kandinsky, the overall impression is of stylistic economy. A Swedish critic, discussing Münter's approach to new ways of seeing in connection with her 1916 exhibition in Stockholm, commented: "Frau Münter is a highly radical artist, but her temperament is such that her radicalism remains unobtrusive."

Gabriele Münter

70 KANDINSKY AND ERMA BOSSI, AFTER
DINNER (*Kandinsky und Erma Bossi am Tisch*), 1912

Oil on canvas, $37^5/8 \times 49^3/8''$ (95.5 × 125.5 cm)
Inscribed "G. Münter, Nach Tisch" (on the stretcher, in the artist's
hand)
GMS 780

This picture was painted after a spontaneous pencil sketch
which Münter made of Kandinsky and the painter Erma Bossi
engaged in after-dinner conversation. The two artists are seated
at a table in a corner of the living room of their house in
Murnau; the dark wall behind them evokes a particular sense
of intimacy. Kandinsky is holding forth, raising his hand to
emphasize a point; on the other side of the table Erma Bossi,
who had known Kandinsky for several years, since the days of
the Neue Künstler-Vereinigung München, is listening intently
to his pronouncements. The viewer's eye is drawn to the
speaker, with his bright blue jacket and light-blue spectacle
lenses, rather than to the less obtrusive figure of the listener,
whose black skirt and white blouse merge into the background.
The blues of Kandinsky's jacket and spectacles are picked up
by other elements in the picture, especially by the simple blue-
and-white crockery on the table and the deep blue of the
artifacts on the shelf above the artist's head.

Here, as in *Listening (Portrait of Jawlensky)* (plate 62), Münter
was less concerned with graphic accuracy than with the attempt
to convey the essence of a particular situation. The formal
relationships in *Kandinsky and Erma Bossi, After Dinner* are
simple but charged with tension: this is particularly apparent
in the open and closed rectangles which surround the couple
in the center. Münter demonstrates a fine sense of economy in
her depiction of the living room, with its collection of *objects
d'art,* and of the figure of Kandinsky, dressed in traditional
Bavarian costume with green calf-protectors and rough san-
dals. The painting accurately captures the atmosphere of the
often heated discussions in the Blue Rider circle and also strikes
a humorous note, gently ironizing Kandinsky's role as the
intellectual leader of the group.

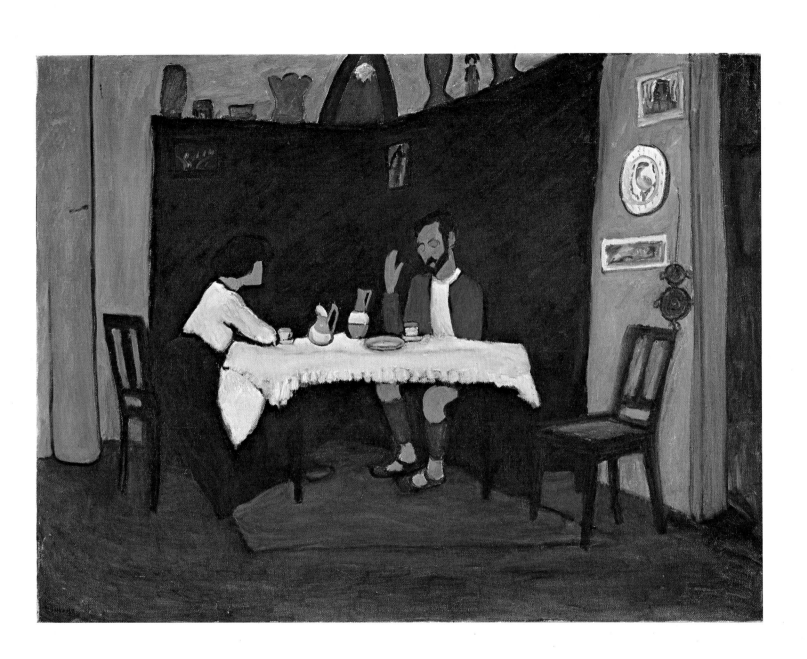

Gabriele Münter

71 THE RUSSIANS' HOUSE (*Das Russen-Haus*), 1931

Oil on canvas, $16^3/4 \times 22^1/2''$ (42.5 × 57 cm)
Inscribed "Münter 1931" (lower right)
GMS 773

Following her last meeting with Kandinsky, in Stockholm in
1916, Münter lived an unsettled, nomadic life in numerous
cities throughout Germany and northern Europe. Her creativ-
ity dried up: it was not until 1931, when she finally returned
to Murnau, that she took up painting again. *The Russians'
House* shows the house which she had shared with Kandinsky
in Murnau (fig. 29, p. 23); Münter had used the same view
from the garden in a number of other paintings, such as *Country
House* (1910; private collection). The nickname *Russen-Haus*,
conferred on the house by the local people, reflected their
attitude of amused puzzlement at the comings and goings of
the foreigner Kandinsky and his Russian friends Jawlensky and
Marianne von Werefkin. Münter's account of the purchase of
the house conveys something of the elan of the Murnau years:
"Kandinsky had fallen in love with the house at first sight, and
his love remained constant. We debated the matter, he applied
a certain amount of pressure, and in the late summer the villa
was bought by Fräulein G. Münter."

The picture depicts the attractively proportioned house,
with its friendly colors, as a place of refuge. Münter lived there
until her death in 1962.

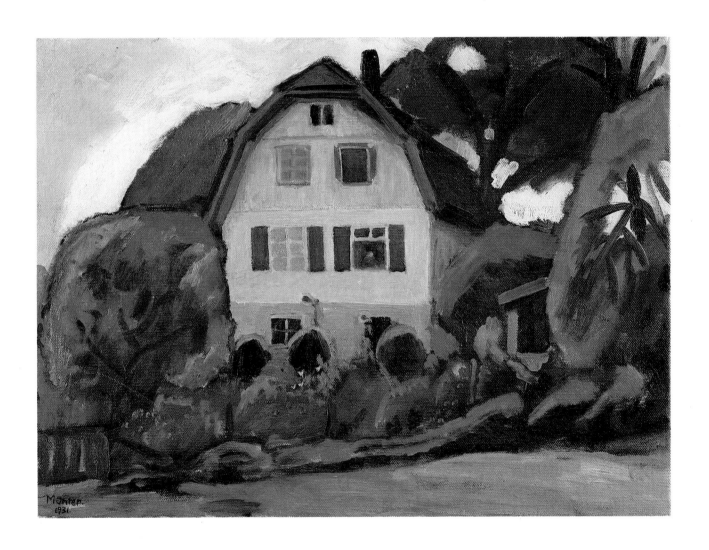

Gabriele Münter

72 THE GRAY LAKE (*Der graue See*), 1932

Oil on canvas, 21⅝ × 25⅞″ (54.8 × 65.7 cm)
Inscribed "Münter 1932" (lower right)
GMS 670

In the 1930s Münter resumed painting in a style similar to that
which she had favored before World War I. Like her early
work, the pictures from this period are characterized by a clear,
simple structure and a reductive, "synthetic" technique. She
continues to use black lines to frame the essential elements of
the picture, with little interior detail in the colored zones. Her
favored subjects are the landscape around the Staffelsee and
flowers in her house in Murnau.

The Gray Lake depicts the green meadows, the brown moor-
land, the silvery surface of the lake, the violet foothills of the
Alps, and the gray mountains in the distance in compact patches
of dense color. The contours are softer than in Münter's early
work and strike a conciliatory note; the picture also appears
to have been influenced by the static quality of much German
painting of the 1920s. Nevertheless, it demonstrates the truth
of Kandinsky's statement, concerning the Murnau years, that
"running through all [Münter's] work ... there is a common
strand."

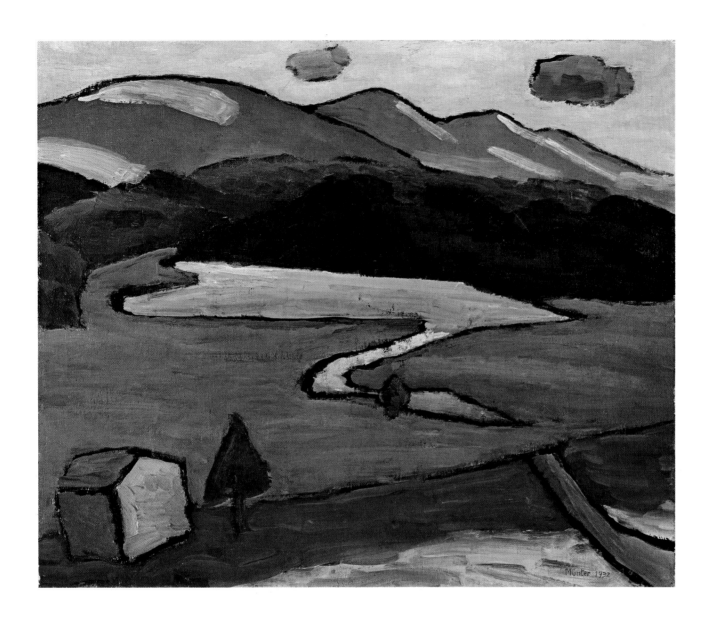

Gabriele Münter

73 MOUNTAIN VIEW (*Blick aufs Gebirge*), 1934

Oil on canvas, 18^1/$_4$ × 21^5/$_8$″ (46.5 × 55 cm)
Inscribed "Münter 1934" (lower right)
G 12 944

After World War I, and especially after her return to Murnau
in 1931, Münter did not embark on any new experiments
but stuck to the style of her earlier pictures, reducing and
simplifying natural forms. In *Mountain View* the eye is drawn
from the two large barns and the meadow in the foreground
toward the schematic blue and brown hills in the middle
distance, and is finally arrested by the tall blue mountain at the
top of the picture. The dark colors convey a certain sense of
melancholy, but at the same time the landscape has an air of
comfortable familiarity, despite the close layering of the sur-
faces. Once again, Kandinsky springs to mind, with his com-
ment that Münter's art embodied "a simple harmony, made
up of a number of wholly *serious colors,* which, through their
deep tones, form a quiet chord with the drawing." Münter
was the only member of the Blue Rider circle who remained
faithful to the Murnau landscape, where her style had first
evolved and which had been the scene of so many revolution-
ary new developments that changed the face of modern art.

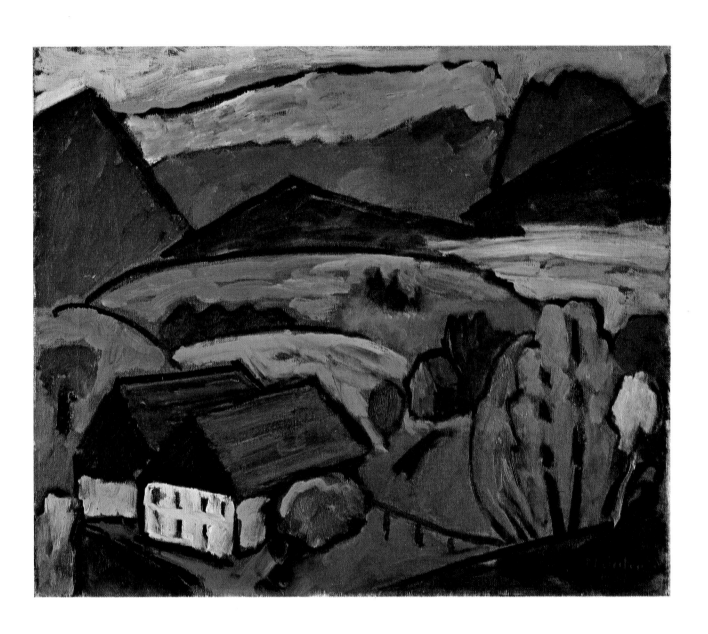

Alexei Jawlensky
b. 1864 in Torsŏk, Russia – d. 1941 in Wiesbaden

The son of a Russian colonel, Jawlensky initially embarked on a military career. In 1889 he applied for a transfer to Moscow in order to study painting at the Academy; there he met the artist Marianne von Werefkin, who for many years was his mistress and companion. Seven years later the couple moved to Munich in order to continue their studies, and soon afterward Jawlensky made the acquaintance of Kandinsky at Anton Ažbe's private art school. Between 1903 and 1907 Jawlensky spent much of his time in France, where he came under the influence of Vincent Van Gogh, Neo-Impressionism, and Fauvism; he was particularly impressed by the work of Henri Matisse. In 1908 and 1909 he lived and worked with Kandinsky, Münter, and Werefkin in Murnau in southern Bavaria, developing and refining his style in a series of landscape paintings. Subsequently, however, Jawlensky's main field of interest became the human figure and the portrait, in which the eyes are the dominant motif. Following the outbreak of World War I, Jawlensky moved to St. Prex on Lake Geneva and later to Wiesbaden, where he lived for the rest of his life, working on the representation of the human face. The formal austerity of his later, abstract pictures echoes the spiritualized, meditative character of Russian icons.

Alexei Jawlensky

74 THE HUNCHBACK (*Der Bucklige*), 1905

Oil on cardboard, 20⁵/₈ × 19¹/₂″ (52.5 × 49.5 cm)
Inscribed "A. Jawlensky" (lower left)
Purchased in 1963 with a grant from the estate of Gabriele Münter
G 13 107

The Hunchback was painted some ten years after Jawlensky's arrival in Munich in 1896. In the intervening period he had devoted a great deal of energy to studying the various styles of modern art, with particular emphasis on French painting. In 1903 he had traveled to Normandy and Paris; two years later he paid an extended visit to Brittany, where he painted a number of landscapes and character studies, sensing for the first time that his style was developing in a new direction, away from the late Impressionist manner of his early landscapes and still lifes. Most importantly, the works which he painted in Brittany exhibited a new vitality in their use of color: "the colors glowed," he later wrote, "and my inner self was satisfied." *The Hunchback* is painted with vigorous, impulsive brushstrokes whose impasto quality reminds one of Van Gogh, whom Jawlensky greatly admired at that time: in 1908 he made a considerable financial sacrifice to buy a landscape by the great Dutch master. Jawlensky used the motif of the hunchback in several other pictures, notably in *Humpback* (1911; Swiss private collection), which shows the distorted figure of a peasant woman painted in a glaring red. Together with a number of other works, the picture of the young Breton was exhibited at the Paris Salon d'Automne in 1905 and earned Jawlensky a measure of international recognition. It was on this occasion that he first made the acquaintance of Matisse.

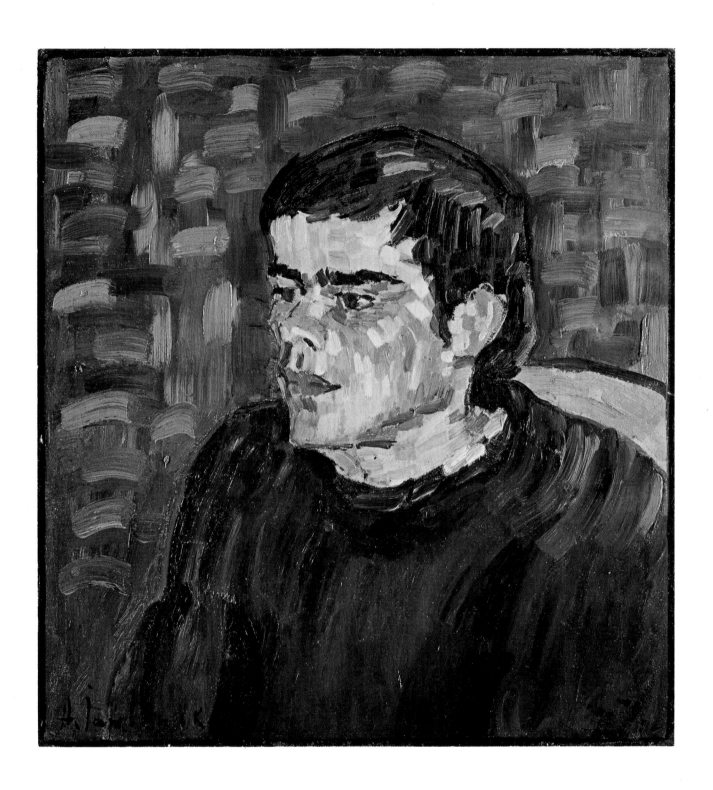

Alexei Jawlensky

75 PORTRAIT OF HEDWIG KUBIN (*Porträt Hedwig Kubin*), 1906

Oil on cardboard, 29¹/₂ × 22¹/₂″ (75 × 57 cm)

G 15670

This portrait of Alfred Kubin's wife, Hedwig, was probably painted in Jawlensky's Munich apartment at the beginning of 1906. The visionary drawings of the young, eccentric Alfred Kubin had caused a considerable stir in the Munich art world, and he had recently made the acquaintance of Jawlensky. He was a frequent guest at the salon presided over by Jawlensky and Marianne von Werefkin. In 1904, following a severe nervous breakdown, Kubin had married Hedwig Gründler, a widow considerably older than himself. Jawlensky uses broad, colored brushstrokes to portray the mature features, already marked by suffering, of the woman who, although herself chronically ill, provided Kubin with the security he so badly needed. Although the treatment of the folds of her dress and the modeling of the face betray the lingering influence of late Impressionism, the free choice of colors points in the direction of Fauvism. In May 1906 Kubin and his wife moved to the isolated village of Zwickledt in northern Austria, where Hedwig Kubin died in 1948, eleven years before her husband.

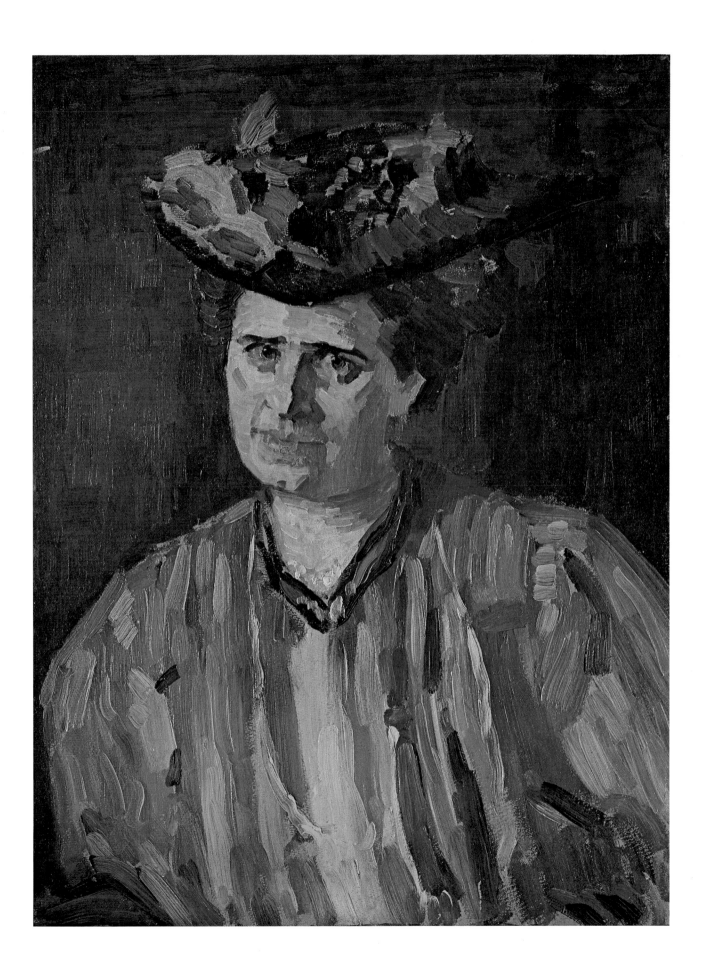

Alexei Jawlensky

76 PORTRAIT OF THE DANCER ALEXANDER
SACHAROFF (*Bildnis des Tänzers Alexander Sacharoff*), 1909
Oil on cardboard, $27^3/8 \times 26^1/8''$ (69.5 × 66.5 cm)
G 13 388

In this picture one encounters for the first time the motif of
the wide-open, piercing eyes which plays such an important
part in Jawlensky's work. The sitter faces the viewer head on,
staring out of the picture with a disarming directness that is
emphasized by the heavy stage makeup around his eyes; to-
gether with his seductive pose and the bright red of his costume,
which is echoed in his mouth, his gaze exercises a fascination
which is hard to resist. Jawlensky painted several portraits of
Sacharoff, a close friend who sat for him at least three times in
1909 alone. According to Clotilde von Derp-Sacharoff, this
picture was painted one evening on the spur of the moment,
when the dancer visited Jawlensky in his studio, in full costume
and makeup before a performance. Although the colors were
still wet, Sacharoff took the picture with him, fearing that if
he left it behind, Jawlensky would paint it over, as he had
frequently done in the past. The speed with which the work
was painted would explain why its bold sweeping lines and
the impression it conveys of an immediate personal presence
have retained their freshness. Jawlensky was particularly in-
trigued by the dancer's androgynous appearance: in his later
pictures of the human face, he eliminated all personal attributes,
including those of gender.

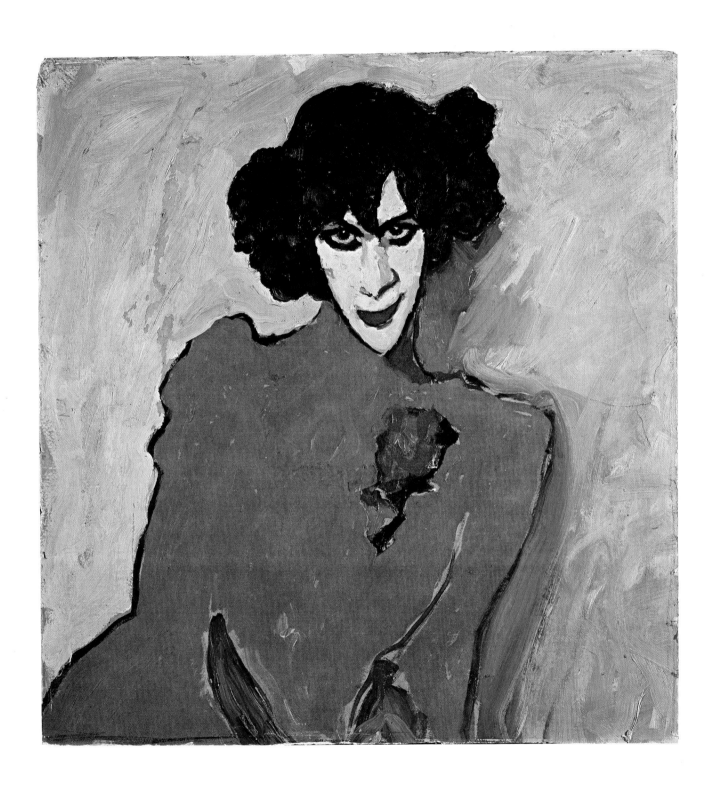

Alexei Jawlensky

77　MURNAU SKETCH (*Skizze aus Murnau*), 1908/09
Oil on cardboard, 13^1/$_8$ × 16^1/$_4$″ (33.3 × 41.3 cm)
GMS 677

In the spring of 1908 Kandinsky and Münter had discovered
the small town of Murnau in the foothills of the Alps and had
been so taken with it and the surrounding countryside that
they recommended it to Jawlensky and Werefkin, who visited
Murnau that summer and wrote to Kandinsky and Münter,
suggesting that they should come and join them. This was the
beginning of the cooperation between the four artists who
formed the nucleus of the Blue Rider circle. A particularly
close friendship grew up between Jawlensky and Münter. Jaw-
lensky, who had already gained a measure of international
recognition, initially saw himself as the "teacher" of the group
and supplied his friends with a fund of new ideas based on his
experiences in France. The small, plain *Murnau Sketch* is clearly
influenced by French street scenes, although its vivid colors
also strike a distinctly Russian note. In the facades of the houses
the ocher ground of the cardboard, which Kandinsky and
Münter also used for their landscapes, shows through the sur-
face of the picture.

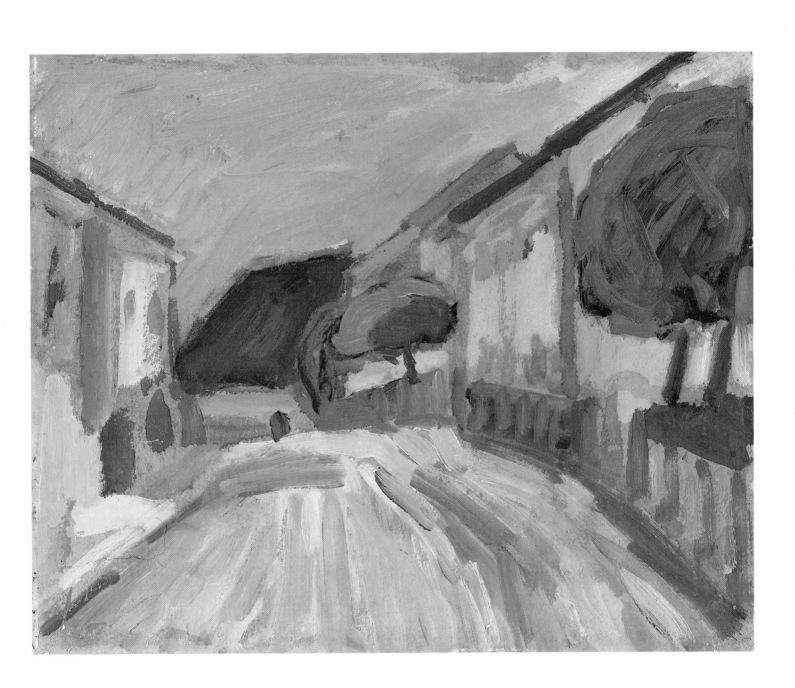

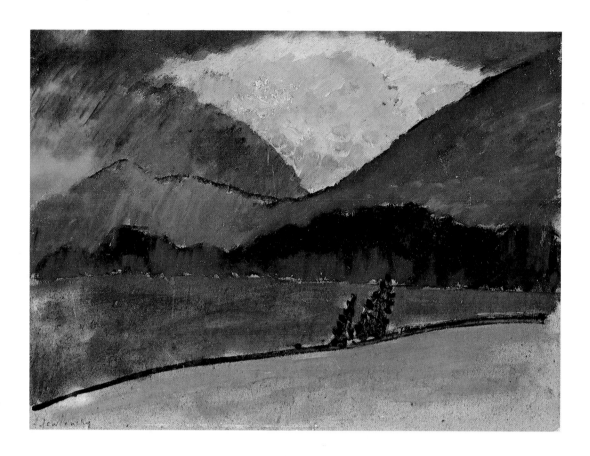

Alexei Jawlensky

78 SUMMER EVENING IN MURNAU (*Sommerabend in Murnau*), 1908/09

Oil on cardboard, 13 × 17³/₄″ (33.2 × 45.1 cm)
Donated by Gabriele Münter, 1960
G 13 109

With its graphic economy, its intense colors, and its use of dark contours, *Summer Evening in Murnau* is remarkably similar to Münter's landscapes from the same period (for example, plate 59). In accordance with his concept of "synthesis," Jawlensky reduces the landscape to a set of broad outlines, with only a few sparse details in the center. In 1907 he had met and be-friended the Benedictine friar and painter Willibrord Verkade, who introduced him to the work of the Nabis circle, a group of French artists who were followers of Gauguin. The tech-nique of *cloisonnisme,* that is, the rhythmic organization of the picture in flat areas often bounded by black contours, was one of the distinguishing features of the art of Gauguin, who strove to interpret reality in a new, subjective manner. "Art is above all a means of expression" – this was the message propagated by Paul Sérusier, the leader of the Nabis group, who visited Verkade in Munich in 1907 and also met Jawlensky. In this way the concept of synthesis, which features prominently in discussions of the theory of art at the turn of the century, was adopted by Jawlensky, who in turn passed the idea on to Kandinsky and his other Munich friends. Within the fledgling Blue Rider circle the notion of synthesis took on a new mean-ing, colored by Kandinsky's idea of "inner necessity." Kandin-sky, who was particularly inspired by the dynamic structure and the "wild" colors of a number of Jawlensky's Murnau pictures, later looked back with gratitude "to the time when you [Jawlensky] were my teacher."

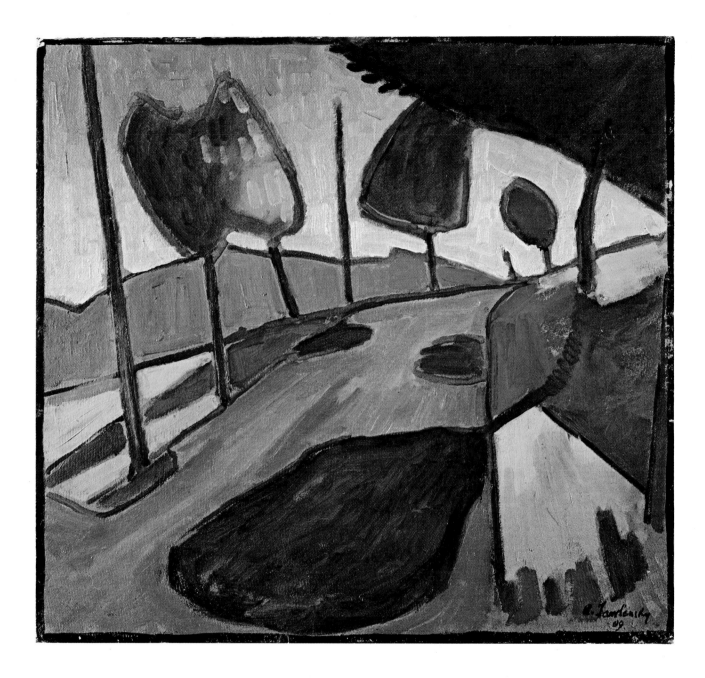

Alexei Jawlensky

79 MURNAU LANDSCAPE (*Murnauer Landschaft*), 1909

Oil on cardboard, 19⁷/₈ × 21¹/₂″ (50.5 × 54.5 cm)
Inscribed "A. Jawlensky/09" (lower right)
GMS 678

For a time at least, Jawlensky was the most "progressive" of the quartet of artists who worked together in Murnau. This is borne out by *Murnau Landscape*. Jawlensky achieves a high degree of stylization, reducing the landscape to a series of jagged geometrical forms and using deliberately unnatural colors. The distinction between objects and their shadows, between the sky and the landscape itself, has been eliminated, and the harsh contrasts between the artificially bright violet, yellow, green, and orange are heightened by the red of the tree in the background and the turquoise of the range of hills on the left. The color samples in the bottom right-hand corner emphasize the autonomous character of the picture, whose reality is located outside the world of sense-impressions.

It has been shown that the jagged, distorted forms of the picture were influenced by French Cubism, in particular by the work of Henri Le Fauconnier, whose approach to painting was in turn influenced by Gauguin and Emile Bernard. Together with Picasso, Georges Braque, André Derain, Maurice Vlaminck, Kees van Dongen, and a number of other artists, Le Fauconnier was invited to contribute to the second exhibition of the Neue Künstler-Vereinigung München. Jawlensky and Kandinsky played a leading role in the formation of this exhibiting association, and the extent to which Kandinsky was influenced by the ideas of Jawlensky, who was originally to have been its president, is demonstrated by the circular which he drafted early in 1909 to announce its founding. In it, he spoke of the search for "artistic forms that must be freed from everything incidental, in order to pronounce powerfully only that which is necessary – in short, artistic synthesis. This seems to us a solution that is once again uniting in spirit an increasing number of artists."

Alexei Jawlensky

80 SEATED FEMALE NUDE (*Sitzender weiblicher Akt*),
c. 1910

Oil on cardboard, $27^1/2 \times 16^1/2''$ (70 × 42 cm)
Inscribed "A. Jawlensky" (top left)
G 12476

Although Jawlensky made a considerable number of drawings of the female nude, especially between 1910 and 1912, he seldom used this theme in his paintings. With its precise contours and loose, colored cross-hatching, which allows the brown ground to show through the painted surface, *Seated Female Nude* is more like a colored drawing than a painting. The soft fullness of the figure, with its violet turban, is integrated into the plane of the picture by the deep blue pattern of the background. A few years previously, Henri Matisse had addressed similar formal problems in his paintings of the female nude.

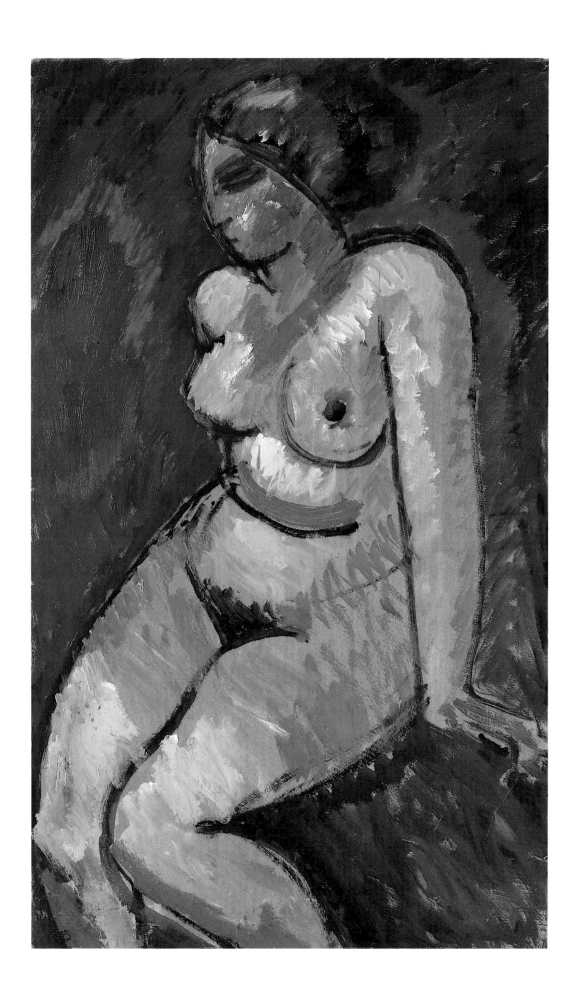

Alexei Jawlensky

81 STILL LIFE WITH FRUIT (*Stilleben mit Früchten*),
c. 1910

Oil on cardboard, 18⁷/₈ × 26⁵/₈″ (48 × 67.7 cm)
Inscribed "A. Jawlensky" (lower left)
GMS 680

In 1910 Jawlensky painted a series of still lifes which rank among his finest works from the period before World War I. From 1911 onward, he devoted himself almost exclusively to the theme of the human face; his later, obsessive concern with this subject is anticipated by these early portraits. Hence the blue still life of 1911 in the Hamburg Kunsthalle can be seen as his last major work in a genre to which he did not return until the end of his life, when he was chronically ill. All his still lifes from 1910/11 testify to the influence of Henri Matisse, whom Jawlensky unreservedly admired. After his first encounter with Matisse in 1905, he had returned to Paris in 1907 and paid several visits to the French master's studio, which at that time was a meeting place for young artists from all over Europe. In *Still Life with Fruit,* a cluster of apples, two jugs, a drinking vessel, and the heads of three dark blue stylized flowers are arranged on a blue-gray surface; these miscellaneous objects are separated from the intense bluish-green background by a thin line running across the center of the picture. The difference between Jawlensky's approach to painting and that of Matisse lies in the heaviness of the brushstrokes, which indicates a considerable expenditure of physical effort, and in the somewhat leaden seriousness of the picture. "In the still lifes," Jawlensky declared, "I was not searching for the material object; instead, I wanted to express an inner vibration by means of form and color." This comment points to a considerable disparity between the aims of Jawlensky and those of Matisse. Comparing *Still Life with Fruit* with Münter's *Still Life in Gray* (plate 64), it is possible to see how Münter used Jawlensky's work as a point of departure for her own painting.

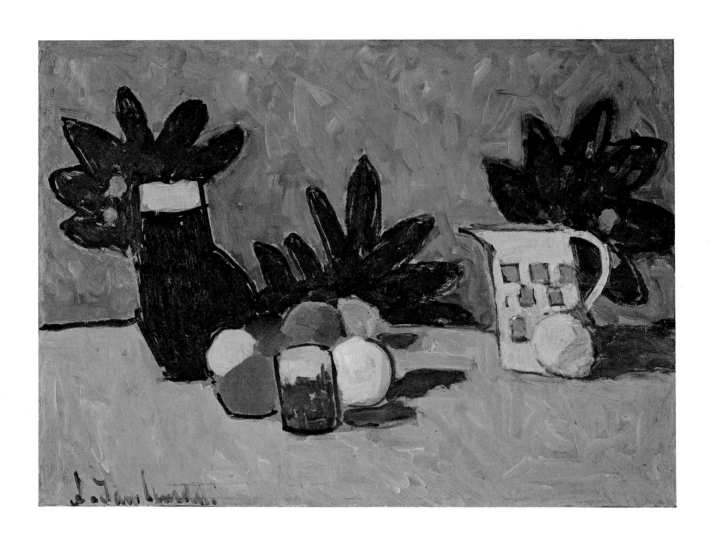

Alexei Jawlensky

82 MATURITY (*Reife*), c. 1912

Oil on cardboard, 21 × 19¹/₂″ (53.5 × 49.5 cm)
Inscribed "A. Jawlensky" (lower right)
G 13 300

Maturity marks a considerable change in Jawlensky's approach to the representation of the human face. Toward the end of his life the artist wrote to Willibrord Verkade: "In 1911 I arrived at a form and color of my own and made a name for myself by painting massive figurative heads." The figure in *Maturity* faces the viewer head on, with an imploring expression and staring eyes edged in black. The garish, unreal colors, whose "wildness" exceeds even that of the Fauves, are held in check by a solid structure of black lines. The face, from which all trace of individuality has been expunged, has the appearance of a mask. In the almost square format of the picture the figure's body is cut off below the neck; the viewer's attention is focused on the round, rudimentary form of the head and, in particular, on the green eyes, which resemble those of a pagan idol. The title *Maturity* also indicates a degree of abstraction from the reality of the sitter's face: Jawlensky uses the glowing colors of summer to create an archetypal form. The stylized, schematic appearance of the face anticipates the "mystical" portraits which Jawlensky began to paint in 1917. Jawlensky spent the summer of 1911 in the small seaside town of Prerow on the Baltic coast: it was some time after this, probably in 1912, that he painted *Maturity*. He later wrote: "That summer saw a major development in my art. In Prerow I painted my best landscapes and large studies of the human figure in very strong, glowing colors, which were absolutely non-naturalistic. I used a great deal of red, together with blue, orange, cadmium yellow, and chrome green. The bold contours of the forms were painted in Prussian blue, and the pictures were the product of an overwhelming inner ecstasy."

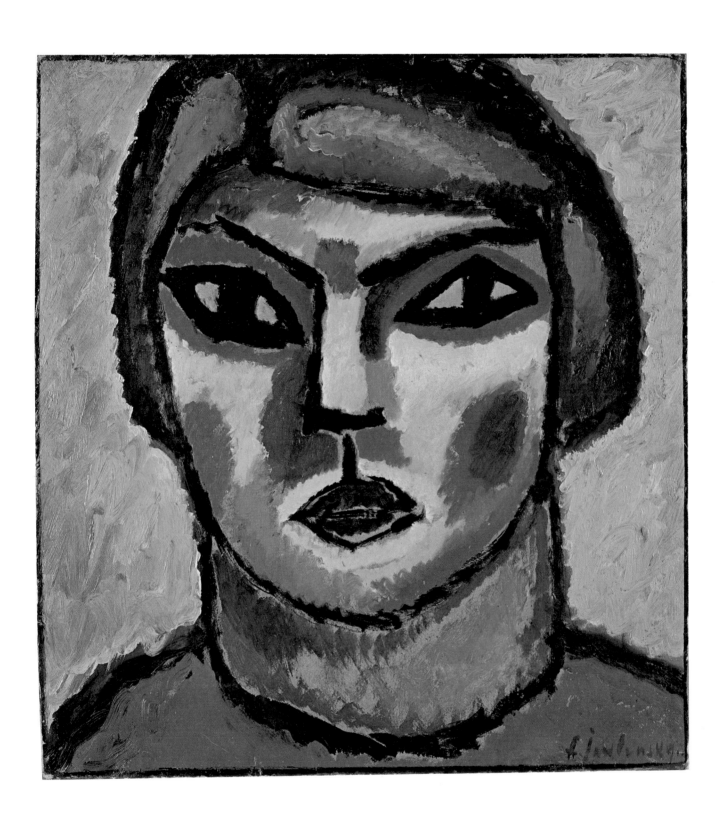

Alexei Jawlensky

83 SPANISH WOMAN (*Spanierin*), 1913

Oil on cardboard, $26^3/8 \times 19''$ (67×48.5 cm)
Inscribed "A. Jawlensky 13/" (top left), "Spanierin N. 2 A. Jawlensky"
(reverse)
G 12556

In the years immediately preceding the outbreak of World
War I Jawlensky devoted nearly all his energies to painting
women's faces with sharp black contours and dark, staring
eyes. The formal problems remain the same throughout this
series of over one hundred pictures; the eyes alone convey, in
each case, something of the individual character of the figure,
taking on the status of a highly suggestive sign, whose meaning
can only be ascertained in relation to the series as a whole. In
these pictures Jawlensky was evidently struggling to achieve a
deeper understanding of the principles underlying his own
approach to painting. In 1913 he painted a total of five pictures
entitled *Spanish Woman*. In the present work, with its tall
format, the olive-skinned face of the woman is slightly off-
center. Together with the black mantilla which falls around
her shoulders, the roses in her hair and around the neckline of
her dress form a decorative framework which, rather than
distracting the viewer's attention from her face, serves to
heighten the effect of her atavistic gaze. According to Elisabeth
Macke-Erdmann, Jawlensky used the dancer Alexander Sach-
aroff (see plate 76) as his model for the *Spanish Woman* pictures,
but the degree of formalization in the faces makes it impossible
to determine whether this was in fact the case. Pictures such as
Byzantinerin (*Byzantine Woman*), *Kreolin* (*Creole Woman*), and
Sizilianerin (*Sicilian Woman*), all painted in the same year and
now in private collections, offer further evidence of Jawlen-
sky's attempt to abstract the general from the particular.

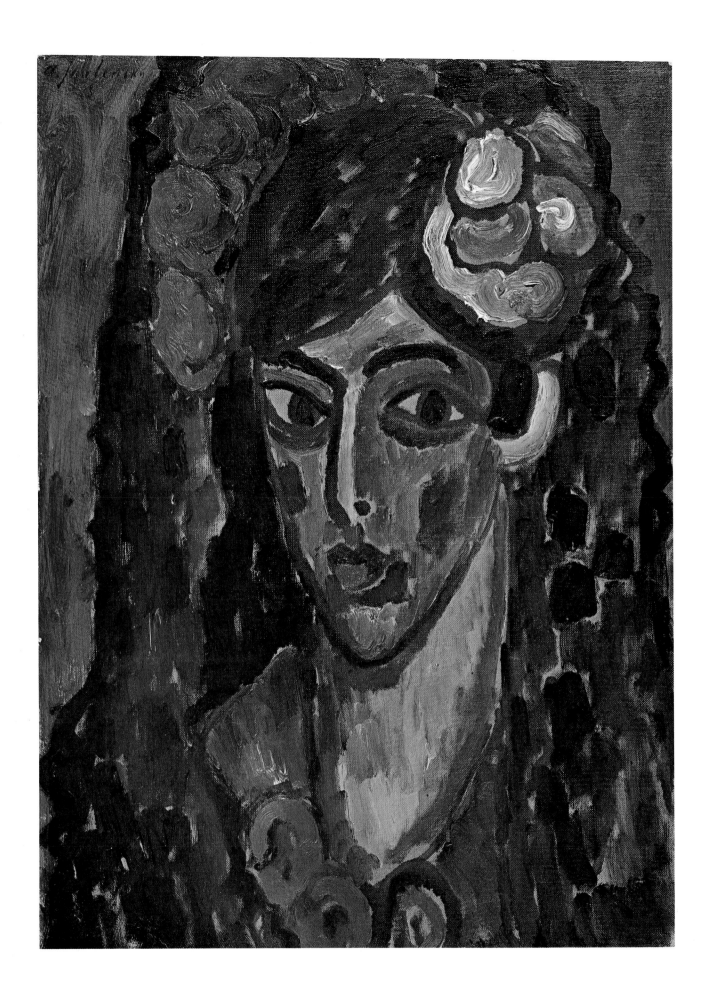

Alexei Jawlensky

84 NIGHT IN ST. PREX (*Nacht in St. Prex*), 1916

Oil on cardboard, $14 \times 10^5/8''$ (35.7×27 cm)
Inscribed (barely legible) "A. Jawlensky" (lower left)
Bernhard Koehler Donation, 1965
G 14669

At the beginning of World War I Jawlensky, as a former officer
in the Russian army, was immediately expelled from Germany
and fled to Switzerland with Marianne von Werefkin and their
maid-companion Helene Nesnakomoff. Until 1917 the trio
lived together in a house in St. Prex on Lake Geneva. In his
reminiscences Jawlensky wrote: "In our small house I had only
a tiny studio with a single window. I wanted to paint huge
pictures with strong colors, but I sensed that this was impos-
sible. My soul would not allow me to do this kind of sensual
painting, although there is much beauty in my pictures I
sat at my window. In front of me I saw a path and a few trees,
and from time to time it was possible to see a mountain in the
distance. I began to seek a new artistic approach. It was hard
work My formats grew smaller: 30×40 centimeters. I
painted a large number of pictures which I called *Variations on
a Landscape Theme*. They are songs without words."

The landscapes which Jawlensky painted of the view from
his room in St. Prex do indeed constitute a new departure in
his work. His exclusive concentration on a single theme points
to a desire for contemplative isolation, a retreat from wordly
distractions. This tendency is clearly apparent in *Night in
St. Prex*, in which the visible motifs – the trees and the shrub-
lined path leading down to the lake – allude only superficially
to reality. Jawlensky varied the theme of the view from his
window in over one hundred pictures, some of which were
painted as late as 1921, long after he had left St. Prex: "Working
very hard and with great concentration, I gradually found
the right forms and colors to express what my spiritual self
demanded. Every day I painted these colored variations, taking
my inspiration from the mood of nature and from my own
spirit. It was here that I produced a whole series of my most
beautiful variations, which to this day are unknown to all but
a few people." Jawlensky's fellow members of the Blue Rider
circle were initially taken aback by this radical shift in his
painting style. The degree of abstraction in works such as this
is determined by the function of nature as a key to the inner
life of the artist.

Alexei Jawlensky

85 MEDITATION, 1918

Oil on cardboard, 15³/₄ × 12¹/₄″ (40 × 31 cm)
Inscribed "A. Jawlensky" (lower left)
Bernhard Koehler Donation, 1965
G 13 340

In 1917 Jawlensky moved from St. Prex on Lake Geneva to
Zurich. It was at this point that he turned his full attention to
the depiction of the human face, which was to occupy him –
with a degree of obsessiveness unparalleled in modern art – for
the rest of his life. In the first group of works, painted between
1917 and 1921, Jawlensky used portraits of women and girls
as the basis for a series of so called "mystical heads" and "saints'
heads." One of these portraits was of Emmy Scheyer, herself
an artist, who had seen a selection of Jawlensky's pictures at an
exhibition in Lausanne in 1915 and promptly decided to devote
herself to the task of promoting his work. Her features are
alluded to in the narrow oval face and the stylized curls of the
woman in *Meditation*. The face, with its fine structure of col-
ored lines, seems to hover over the ocher ground; all further
details of the hair and the neck have been eliminated. The
closed eyelids and the three lopsided lines of the mouth contrib-
ute to the expression of a general, rather than individual,
experience of human life and suffering.

In the basic geometrical figure of *Meditation*, and especially
in the center of the face, with its closed eyes and the colored
flecks of the "mark of wisdom" at the root of the nose, the
elements are assembled which were to form the basis of all the
subsequent "saints' heads," "abstract heads," and "medita-
tions." Jawlensky painted literally hundreds of these faces,
which for him were far more than merely formal studies. In
his work, the human face became a medium for the experience
of transcendence; the continuous variation of the same basic
form was "a pathway to God." In a letter to his friend Father
Willibrord Verkade, written in 1938, Jawlensky spoke of the
reasons for this radical reduction of the function of art to a
means of religious self-expression, which alone explains the
limitation of his work to a single motif over a period of some
twenty years: "For a number of years I painted these variations,
and then it became necessary to find a form for the face, since
I had understood that great art can only be painted with
religious feeling. And for that, the human face was the only
vehicle. I understood that the duty of the artist is to express,
through forms and colors, that which is divine in himself.
Hence the work of art is a visible god, and art itself is 'a longing
for God'."

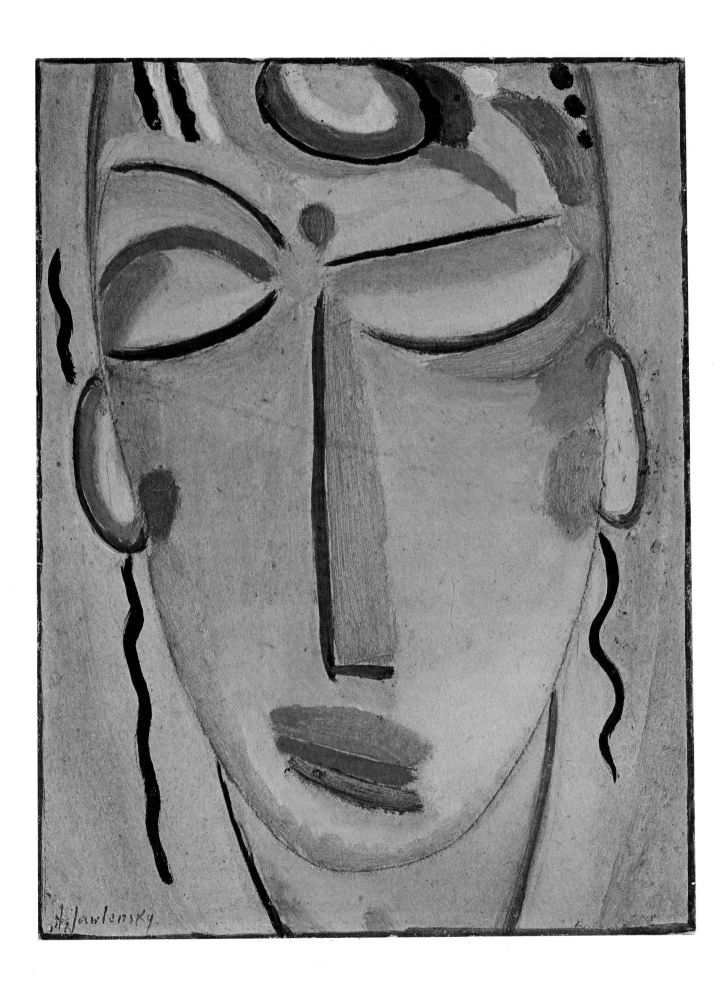

Alexei Jawlensky

86 MEDITATION "THE PRAYER" (*Meditation "Das Gebet"*), 1922

Oil on cardboard, 15³/₄ × 11³/₄" (40 × 30 cm)
Inscribed "A.J." (lower left), "A. Jawlensky Gebet 1922" (reverse)
Bernhard Koehler Donation, 1965
G 13 341

In 1921 Jawlensky put an end to his previous nomadic existence by settling in Wiesbaden, where a highly successful exhibition of his work had recently been held. It was there, in the 1920s and 1930s, that he painted his extensive series of "abstract heads," which are a logical continuation of the earlier "mystical heads" and "saints' heads." Like many of the early picures in the series, *Meditation "The Prayer"* features the light, almost transparent colors found in the works from the first phase of Jawlensky's interest in the human face. The artist reduces the shape of the face to a schematic outline and twists it slightly to one side, using subtle effects of line and color to lend it an air of meditative rapture.

Armin Zweite has described this phase of Jawlensky's development thus: "Especially in the early 1920s, the forms of Jawlensky's work take on a steadily increasing precision. The formerly shapeless patches of color metamorphose into clearly defined circles, which contrast with the orthogonal structure or lines; the color itself also becomes more homogeneous. Step by step, Jawlensky reduces the expressive content of the pictures, using a restricted vocabulary of stereotyped forms. The cheeks and the chin are indicated by a large U-shape; the thin lines of the nose and eyebrows generally meet at right angles, vaguely hinting at the form of a cross. A horizontal line marks the mouth, beneath which a semicircular colored shadow paraphrases the curve of the chin. Over the forehead there is a triangle, the tip of which points toward the crown of the head. All that remains of the eyes, the most expressive feature of the human face, is a horizontal or downward-curving line, which in some of the pictures is accentuated by blurred bands of color. The only reminder of Jawlensky's earlier work is to be found in the curling strands of hair hanging down each side of the face." Drawing on this limited repertoire of forms, Jawlensky's "abstract heads" achieve a maximum degree of spiritual concentration. Despite the deliberate elimination of individual features, the faces are by no means devoid of expression: on the contrary, they have a specifically human, animated quality, and convey the impression of, as the artist himself put it, "great spirituality."

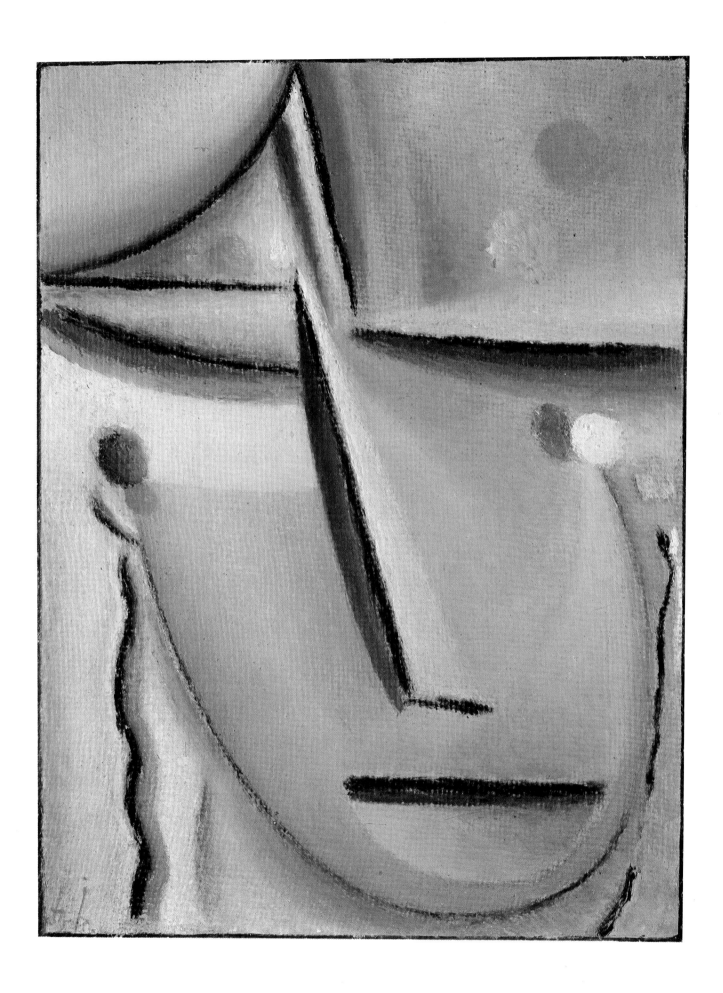

Alexei Jawlensky

87 LOVE (*Liebe*), 1925

Oil on cardboard, $23^{1}/_{4} \times 19^{1}/_{4}''$ (59×49.5 cm)
Inscribed "A.J." (lower left), "X.25" (lower right)
G 15678

The large-format painting *Love* is one of the main works in
the series of pictures of the human face which Jawlensky created
in the 1920s. Its pure forms have a geometrical clarity and
precision which call to mind the work of other contemporary
artists. The austere horizontal and vertical lines, the circles and
semicircles, and the even application of the paint, from which
all irregularity has been banished, place the picture in a general
context of experimentation with the constructive laws of form.
In the mid-1920s Jawlensky temporarily emerged from his
self-imposed isolation and joined forces with Kandinsky, Klee,
and Lyonel Feininger – who at that time were teaching at the
Bauhaus – to form the group known as *Die Blauen Vier* (The
Blue Four). Although the name of the group echoes the pro-
gram of the Blue Rider, The Blue Four was primarily con-
cerned with the practical issues of exhibiting and marketing
the pictures of its members, especially in the USA, where its
cause was energetically promoted by Emmy Scheyer. Jawlen-
sky's contacts with his three colleagues had little or no influence
on his artistic goals. Whereas in the work of Kandinsky, Klee,
and Oskar Schlemmer the use of elementary, schematic forms
was bound up with an attempt to uncover the spiritual founda-
tions of the world of appearances, Jawlensky was principally
interested in constructive form as a means of extending the
possibilities of personal religious experience. In his finest pic-
tures from this period he comes very close to capturing the
essence of a mysterious original form which embodies an arche-
typal image of human spirituality.

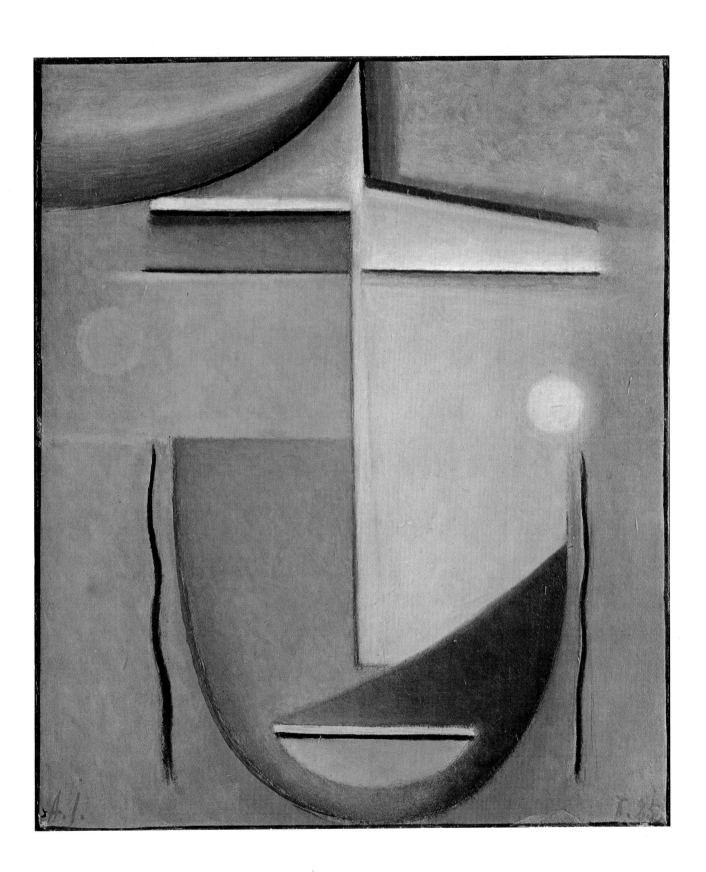

Alexei Jawlensky

88 MEDITATION ON GOLD GROUND (*Meditation auf Goldgrund*), 1936

Oil on paper mounted on cardboard, $5^1/2 \times 4^3/8''$ (14×11 cm)
Inscribed "A.J." (lower left), "36" (lower left)
Bernhard Koehler Donation, 1965
G 13339

From 1929 on, Jawlensky suffered from arthritis, which made it increasingly difficult for him to paint at an easel. In the confessional letter which he wrote in 1938 to Father Willibrord Verkade, he described how the condition finally forced him to give up painting: "Years of toil passed. And then I fell ill; although my hands got stiffer and stiffer, I was still able to work. I could no longer hold the brush in one hand; I had to use both hands, and it was always very painful. I used a very small format, and I had to find a new technique. For three years, like one possessed, I painted these small abstract heads. I sensed that I would soon have to give up work altogether. And that indeed turned out to be the case."

In the series of "meditations" painted between 1934 and 1937 a further decisive change takes place in Jawlensky's treatment of the human face: the pictures attain an extreme degree of stylization. Armin Zweite offers the following comments on these works from the final stage of Jawlensky's career: "In one picture after another thick black lines are used to create a series of variations on the form of the Greek Orthodox cross, which rests on the horizontal line of the mouth and extends up to the eyebrows at the top. The parallel brushstrokes confer an independent structure on the zones of color between the lines. The transparent lines of the brushwork overlap at the edges and frequently form narrow opaque zones of thickened color, with the result that the dark and light areas merge into a unified whole. At the root of the nose the light-colored 'mark of wisdom,' which is added as a finishing touch, emphasizes the religious, meditative character of the pictures." This character is especially apparent in the present work, which is painted on a gold ground. Jawlensky's friend, the painter Alo Altripp, had suggested the use of this traditional medieval and Greek Orthodox technique in order to underline the symbolic quality of his depiction of the human face. The experiment was rarely repeated: Jawlensky, who always worked on several pictures at once, covering them with laborious brushstrokes, painted a mere five "meditations" on a gold ground.

Alexei Jawlensky

89 MEDITATION, 1937

Oil on canvas mounted on cardboard, $9^7/_8 \times 6^7/_8''$ (25 × 17.5 cm)
Inscribed "A.J." (lower left), "37" (lower right)
Inscribed on the cardboard mount in a different hand, "IV 37" (lower left), "N. 18" (lower right); in the artist's hand, "Dem lieben, verehrten Pater Willibrord Verkade schicke ich einen Splitter von meiner Seele A. Jawlensky"
On permanent loan from the Monastery of St. Martin, Beuron
FH 234

This "meditation" is one of a large number of similar pictures which Jawlensky painted in 1937. It is one of the last works he created before his arthritis forced him to give up painting altogether. He presented it to Willibrord Verkade, who was at that time living in the Monastery of St. Martin in Beuron. On the back he wrote the following dedication: "To my dear friend Father Willibrord Verkade I send a splinter of my soul A. Jawlensky." The late "meditations" are indeed a personal confession which Jawlensky struggled obsessively to formulate while battling with the pain that ultimately put an end to his work. In this picture, only a vague trace remains of the human face, indicated by the heavy lines of the Greek Orthodox cross. From 1934, one notices a continuous darkening of the colors in the "meditations." Jawlensky himself explained: "In my last pictures I took away the magic of color in order to concentrate still further the spiritual depth." The coarse brushwork bears witness to the crippling pain suffered by the artist, who at the end of his life could only paint by holding the brush in both hands and moving the whole of his upper body. The extent to which Jawlensky was prepared to suffer for his art testifies in turn to the intense spiritual obsession that lies behind a large part of his work.

August Macke

b. 1887 in Meschede (Westphalia) – d. 1914 near Perthes-les-Hurlus, France

Macke studied painting from 1904 to 1906 at the Düsseldorf Academy. In 1907 he traveled for the first time to Paris, where he encountered the work of the Impressionists, whose use of color and emphasis on the sensual immediacy of experience exercised a fruitful influence on his artistic development. In 1907/08 he studied for six months with Lovis Corinth in Berlin. After a further stay in Paris he lived for a year by the Tegernsee lake in southern Bavaria. In 1910 he met and befriended Marc. Although Macke moved to Bonn the following year, he was one of the founding members of the Blue Rider group; he contributed to the almanac and took part in the group's exhibitions. In Bonn he became an important mediator between the Blue Rider and the Rhineland Expressionists. However, he rejected the mystical, "spiritual" emphasis of Marc and Kandinsky: for him, painting was a joyful recreation of nature by means of blocks of glowing color. This view of painting was confirmed by a visit with Marc to Robert Delaunay's Paris studio in 1912. The following year Macke spent eight months living on Lake Thun near Bern. Together with Klee and Louis Moilliet, he traveled to Tunis in the spring of 1914 and returned to Germany with a fund of new material. In August he was drafted into the army and, only a few weeks later, was killed in action in the Champagne region.

August Macke

90 PORTRAIT WITH APPLES (*Porträt mit Äpfeln*), 1909

Oil on canvas, 26 × 23³/₈″ (66 × 59.5 cm)
Inscribed "AMacke 1909" (center right), "(7) Porträt mit Äpfeln,
Macke" (reverse)
Bernhard Koehler Donation, 1965
G 13 326

Macke painted *Portrait with Apples* shortly after moving with
his young bride to Tegernsee, where he lived for over a year
from the end of October 1909. On October 5, 1909, he had
married Elisabeth Gerhardt, whom he had known since
adolescence; after a brief honeymoon in Paris, the couple
decided, on the recommendation of a friend, to settle for a
time in the rural solitude of southern Bavaria. The year in
Tegernsee saw a decisive advance in Macke's artistic develop-
ment. It was here that the basic direction of his early work
emerged and that he found the leisure to digest in full the wide
variety of influences to which he had been exposed in the
course of his brief career: he had only begun to study art in
1905. During his stay in Tegernsee he created over 150 paint-
ings, plus a large number of watercolors and drawings.

Macke's attractive young wife was one of his main sources
of artistic inspiration. She had always been his favorite model,
and in many of his pictures she is seen as a kind of female
prototype, the very incarnation of womanhood. With its
gently undulating contours, its sensitive use of color, and its
careful composition, *Portrait with Apples* is patently the work
of early masterhood. Facing the viewer head on, the pregnant
woman stands in front of a dark brown background; in her
hands she holds a bowl containing three apples. The yellow
curtain on the right, the woman's calm face, with its downcast
eyes, the dull white shawl around her shoulders, and the curve
of her breasts are gently and evenly modeled in the soft light
that falls from the front. One is reminded of the late pictures
of Paul Cézanne, to which Carl Hofer had drawn Macke's
attention on his recent trip to Paris. The bowl, in particular,
with the red and yellow apples depicted in the manner of a
still life, is clearly influenced by the work of the Frenchman.
One of the most prominent features of Macke's art is the
balanced arrangement of individual elements to create what
the artist called "total harmony," an integration of color and
form, of the figure and its surroundings. In this picture, the
sense of harmony derives to a considerable extent from the air
of contemplative calm which surrounds the central figure. In
the early years of their marriage Macke painted numerous
portraits of Elisabeth reading, sewing, or holding their child;
her head is invariably lowered, which heightens the effect of
quiet concentration. Macke was particularly proud of *Portrait
with Apples*, which was shown at the 1912 Sonderbund exhibi-
tion in Cologne and subsequently bought by his wife's uncle,
Bernhard Koehler (see plate 91).

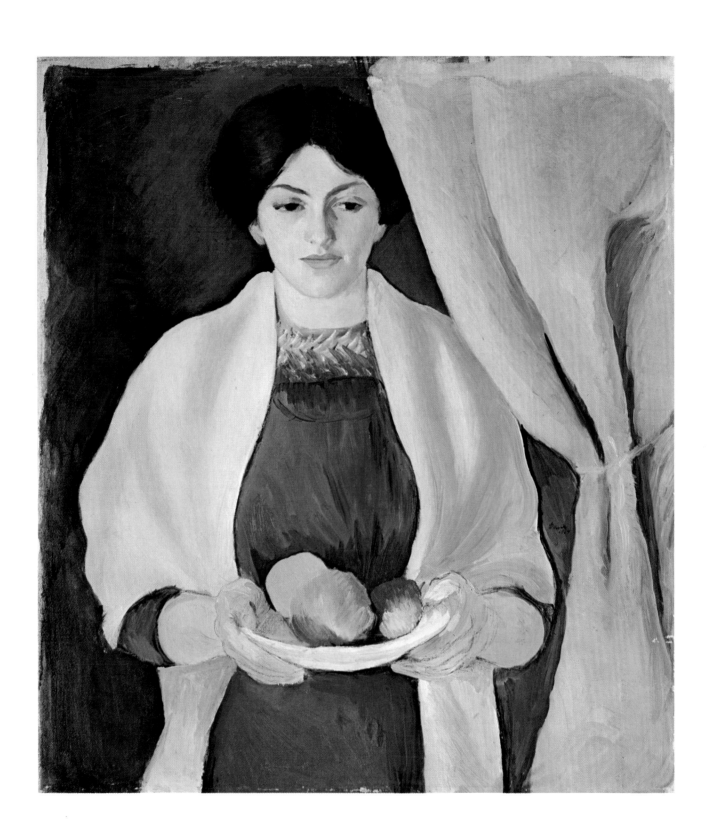

August Macke

91 PORTRAIT OF BERNHARD KOEHLER (*Bildnis Bernhard Koehler*), 1910

Oil on canvas, 25 × 16¹/₈″ (63.5 × 41 cm)
Bernhard Koehler Donation, 1965
G 13335

From the beginning of Macke's career, his wife's uncle, Bernhard Koehler, a wealthy Berlin industrialist, was a generous friend and patron. He helped to finance Macke's first trip to Paris in 1905, and later that year, when the aspiring young artist spent several months studying with Lovis Corinth in Berlin, he was warmly welcomed as a temporary member of the Koehler household: Koehler even gave him the money to buy paints and other materials. The following year Macke, his wife and her uncle traveled again to Paris, where they visited numerous galleries and Koehler, under Macke's guidance, bought a number of contemporary French paintings for his collection. Koehler was subsequently to become the major patron of the Blue Rider. He not only donated a substantial sum of money to finance the publication of the almanac in 1912 and the organization of the Erster Deutscher Herbstsalon (First German Salon d'Automne) in 1913; he also frequently helped Macke and his colleagues by buying their pictures.

With its simple, elegant forms, the present portrait, one of several that Macke painted of Koehler, conveys a sense of the artist's respect for his sitter's distinguished personality. The restraint in the use of color and the absence of detail in the neutral background point to the influence of modern French portraiture, and especially to the work of Edouard Manet, which Macke greatly admired. Koehler's face, with its blue eyes and even-tempered expression, is framed by the beard and the quiff of gray hair; his high forehead has a faintly rosy glow, suggesting a lively temperament. This picture, like *Portrait with Apples* (plate 90), comes from Koehler's private collection. Unfortunately, a large part of this valuable collection, which included works by Paul Cézanne, Claude Monet, Edgar Degas, Charles Camoin, and Robert Delaunay, as well as by the Blue Rider artists, was destroyed in Berlin in 1945.

August Macke

92 FARMBOY FROM TEGERNSEE (*Tegernseer Bauernjunge*), 1910

Oil on canvas, $34^5/_8 \times 26^1/_8''$ (88×66.5 cm)

G 12 195

During the year he spent in Tegernsee Macke worked extremely hard, experimenting with the motifs which were to form the basis of his relatively limited repertoire of subjects: landscape, still life, the human figure, and details from his house and garden. He frequently used his neighbors' children as models: in addition to the boy depicted here, he painted a *Farmgirl with Straw Hat* (also in the Lenbachhaus) and a picture of the village blacksmith's daughter clutching a doll. The new stylistic approach apparent in these portraits owes a considerable debt to the work of Henri Matisse, in which Macke had begun to take a keen interest. At the end of January 1910, he had traveled to Munich to see an exhibition of pictures by Matisse at the Thannhauser gallery. Macke was one of the first German artists to recognize the exceptional importance of the French painter, whom he rated higher than the Impressionists and Post-Impressionists and in whom he perceived something of a kindred spirit. He was particularly attracted by Matisse's vividly glowing colors, by the simplicity of his themes, and the ease with which he allowed his subjects to unfold on the canvas. In this picture, however, rather than directly imitating Matisse's highly expressive Fauvist style, Macke depicts the boy in a subdued manner reminiscent of still-life painting. Dressed in traditional Bavarian costume, with a high-necked jacket, the generously proportioned figure of the boy sits in a position which lacks a clear sense of spatial definition. The rather sullen expression on his fresh face probably reflects his resentment at having to sit still for the portrait. The face in particular, with its lively brown eyes, stands out clearly against the pale blue background. Macke had not yet abandoned the conventional shadow behind the figure, which in the work of Matisse is dissolved in the play of colors. Yet it was Matisse whom he regarded as a model for his own work. In a letter to his mother-in-law in 1910 he wrote: "I instinctively find him the most congenial of the whole bunch [the Fauves]. An altogether passionate painter, animated by a holy zeal. The fact that he is alleged to be a very simple person doesn't surprise me in the least. I never imagined him to be otherwise."

August Macke

93 TWO GIRLS IN A LANDSCAPE (*Zwei Mädchen in Landschaft*), 1911

Painting on glass, $7^5/_8 \times 10''$ (19.5 × 25.5 cm)
Inscribed in Gabriele Münter's hand "August Macke 1911. Bonn" (on the cardboard backing)
GMS 720

Macke was introduced to the Blue Rider circle by Marc (see plate 98) and attended the meetings of the committee which edited the almanac in Murnau in the fall of 1911. In the summer of that year, following the example of the other Blue Rider artists, he had begun to experiment with the traditional technique of painting on glass. In her memoirs, which display a remarkable sense of literary style, Macke's wife, Elisabeth, recalls: "When we visited the Marcs in Sindelsdorf (I believe it was in the fall of 1911), we would all sit around the table in the evenings, doing paintings on glass. The party comprised Franz and Maria [Marc], August and me, and occasionally Helmuth Macke and Campendonk, who were living in Sindelsdorf at the time. A considerable number of painters had recently taken up this somewhat primitive form of folk art:

Jawlensky had covered a whole wall of his studio in Munich with paintings on glass. Our interest in the subject had been aroused by a brewer in Murnau, who had a huge collection of them in a wide variety of styles." This is a reference to the collection of the master brewer Johann Krötz – numbering over a thousand paintings from southern Germany and Bohemia – which Jawlensky had discovered in Krötz's house in Murnau and which is now housed in the Heimatmuseum at Oberammergau.

In *Two Girls in a Landscape* Macke refrains from exploiting the primitive charm of folk art which so fascinated his colleagues. The delicate lines of the drawing and the skillful use of color remind one of a Japanese woodcut rather than a traditional German painting on glass. Macke was familiar with the formal vocabulary of Japanese art – one of his friends had a substantial collection of Oriental paintings – and his work often shows a characteristically Japanese lightness of touch. The elegance and modernity of *Two Girls in a Landscape* contrasts with the more traditional style of the paintings on glass done by Kandinsky and Münter (see plates 55-57 and figs. 20, 21, p. 21).

August Macke

94 AT THE CIRCUS (*Im Zirkus*), 1911

Painting on glass, $4^5/_8 \times 3^1/_2''$ (11.8×8.9 cm)
Inscribed in Gabriele Münter's hand "August Macke Bonn, 1911" (on the cardboard backing)
GMS 721

Like *Two Girls in a Landscape* (plate 93), this small-format painting on glass is characterized by a highly skillful use of line and contains a hint of modern exoticism. In the circus ring, which is painted a dull white and bordered by coral red, the slender figure of a female acrobat, wearing a golden leotard, balances on a gold and black horse. A man in a green tailcoat holds up a hoop for her to jump through; in the background, one sees the finely drawn outline of a clown wielding a long whip. The picture, which was probably painted in Sindelsdorf, evokes in miniature the world of the stage and the circus. This world fascinated such modern French artists as Edgar Degas and Henri Toulouse-Lautrec, as well as the German Expressionists, and formed the subject of a number of Macke's most famous paintings, including *Russisches Ballet* (*Ballet Russe*; Kunsthalle, Bremen) and *Seiltänzer* (*Tightrope Walker*; Städtisches Kunstmuseum, Bonn). The dully gleaming frame, with its spots of violet and green, strikes an additional note of playfulness.

August Macke

95 THREE GIRLS IN A BARQUE (*Drei Mädchen in einer Barke*), 1911

Painting on glass, $14^1/2 \times 22''$ (37×56 cm)
Inscribed "August Macke, Die Barke, 1912 Hinterglas" (on the cardboard backing)
G 12983

In a different way from *At the Circus* (plate 94) this picture transports the viewer into a strange, exotic world. Three naked girls are depicted sitting in an elegantly curved boat, which floats gently downstream in an indeterminate zone between the riverbank, with its luxuriant vegetation, and the shimmering waves of a river. An oarsman, wearing only a loincloth and a turban, stands at the stern with his back to the viewer. The style of this Oriental vision, which at first sight appears unique in Macke's oeuvre, was influenced by an exhibition of Islamic art which Macke saw in Munich in May 1910 and which caused a considerable stir in artistic circles: even Henri Matisse, accompanied by fellow painter Hans Purrmann, paid a special visit to the Bavarian capital in order to avail himself of this rare opportunity to see examples of Islamic art at first hand. The effect of this new stimulus can be seen in a number of Macke's drawings and paintings from the period. The motif of *Three Girls in a Barque* is not, in fact, as unique as it might seem: the theme of three naked women recurs several times in Macke's work, in such pictures as *Drei Akte mit blauem Grund* (*Three Nudes with Blue Background*, 1910; Lenbachhaus) and the later *Drei Mädchen mit Stadt im Hintergrund* (*Three Girls with Town in the Background*, 1913; Bayerische Staatsgemälde-sammlungen, Munich). Macke combines the classical ideal of harmonious physical proportion with the notion of an earthly Paradise, which played a significant part in his thinking throughout his career. His ideal of carefree existence, unencumbered by worry, determines the form and content of many of his later pictures, including *Zoological Garden I, Promenade,* and *A Stroll on the Bridge* (plates 99, 102, 103).

August Macke

96 OUR STREET IN GRAY (*Unsere Strasse in Grau*), 1911

Oil on canvas, 31^1/$_2$ × 22^5/$_8$″ (80 × 57.5 cm)
Inscribed in an unknown hand "Unsere Straße in Grau, 1913" (reverse,
on the canvas foldover)
Bernhard Koehler Donation, 1965
G 13 333

At the end of 1910 Macke and his wife returned from Tegernsee
to Bonn, where the artist finally set up a studio in February of
the following year. In *Marienkirche im Schnee* (*St. Mary's in the
Snow*; Kunsthalle, Hamburg) and *Marienkirche mit Häusern und
Schornstein* (*St. Mary's with Houses and Chimney*; Städtisches
Kunstmuseum, Bonn), the first pictures which he produced in
Bonn, he depicted one of the city's characteristic architectural
features, as seen from his studio. Shortly afterward, he painted
Our Street in Gray, a view of Bornheimer Strasse directly
beneath his window. Macke's wife, Elisabeth, recalls that
Bornheimer Strasse was "a busy street which offered a constant
source of visual stimuli: children walking to school in long
rows, soldiers marching to the barracks, hussars on horseback,
wagons and carts piled high with baskets. It was close to the
industrial quarter of the city, whose life and bustle August
always loved. The railroad line to Cologne was also nearby;
it ran under the Victoria bridge, right in front of the house.
From the studio window one could see St. Mary's church,
which, surrounded by houses, showed itself in a different mood
every day."

 Judging by the two tentatively blossoming trees, it would
seem that *Our Street in Gray* was painted in the first days of
spring, before winter had finally passed. The gray of the over-
cast sky resonates throughout the picture, mingling with the
yellow, orange, and violet in the facades of the houses and with
the greenish tint of the fence around the patch of waste ground
on the corner; the road surface and the sidewalk are also
painted a fine pearl gray. The deliberate foreshortening of the
perspective at the top edge of the picture recalls the street scenes
of the French Impressionists; one is reminded, for example, of
the work of Albert Marquet. A certain French influence is also
apparent in the black arabesques of the passersby, the delicate
lines of the street lamps on either side of the road, and the
graceful drawing of the trees. When he visited Paris in 1907
Macke sketched a number of street scenes similar to this one.
These impressions of Paris are echoed in *Our Street in Gray.*

August Macke

97 FLOWERS IN THE GARDEN – CLIVIA AND
GERANIUMS (*Blumen im Garten, Clivia und Pelargonien*),
1911

Oil on canvas, 35³/₈ × 28¹/₈" (90 × 71.5 cm)
Inscribed "Macke 1911" (lower right)
Bernhard Koehler Donation, 1965
G 14665

In the course of 1911 Macke found himself confronted with a
wide variety of influences, including that of the other Blue
Rider artists. Hence his work from this period, which evinces
several quite different approaches to painting, betrays no over-
riding stylistic unity. *Flowers in the Garden – Clivia and Gera-
niums* continues in the vein of the still lifes which Macke had
painted in Tegernsee and can be seen as the culmination of his
Fauvist, Matisse-inspired phase. The picture is dominated by
the rich greens of the stylized foliage, which soak up the light
and form a bold contrast with the reds of the flower pots and
the flowers themselves against the violet background. The
sheer intensity of the pure colors confers an almost threatening
quality on the essentially harmless motif of a corner of Macke's
garden in Bonn. Despite the decorative effects of the leaves
and flowers, the most fascinating aspect of this pictorial tribute
to Matisse is its use of color to create a sense of depth. Macke
himself spoke of his quest to release the "spatial energy" of
colors. This played a central part in his subsequent attempts to
come to terms with the challenge posed by Futurism and
Cubism, which eventually resulted in the original, prismatic
solutions to the problem of color seen in his mature work from
1913 onward.

August Macke

98 INDIANS ON HORSEBACK (*Indianer auf Pferden*), 1911

Oil on wood, 17³/₈ × 23⁵/₈" (44 × 60 cm)
Bernhard Koehler Donation, 1965
G 13327

Indians on Horseback is clearly influenced by the ideas and the "spiritualized" style of the Blue Rider artists Kandinsky and Marc. The choice of motif deviates from Macke's general policy of concentrating on the depiction of the real, perceptible world. Two delicately painted Indians with feathered head-dresses are seen riding through a brightly colored imaginary landscape; a third Indian carrying a spear walks ahead of them. The transparent, stylized forms of the mountains and the slanting trees owe an obvious debt to the work of Marc. It is possible that the picture was painted in the summer of 1911, while Marc was staying with Macke in Bonn after his honeymoon in London. On this occasion the two artists worked together in Macke's studio, as Macke had always dreamed of doing. Since his return to Bonn from Tegernsee, Macke had corresponded regularly with his friend: the artists' letters offer a wealth of insights into their respective aesthetic theories. In 1910 Marc had tried to interest Macke in the ideas of the Neue Künstler-Vereinigung München, which he himself had joined at the instigation of Kandinsky. However, Macke, whose sense of form was decidedly nontheoretical, was skeptical about the group: "The association is a very serious affair," he wrote in September 1910, shortly after visiting one of the association's exhibitions, "and I prefer its art to anything else. But it doesn't move me Kandinsky, Jawlensky, Bechtejev, and Erbslöh have tremendous artistic sensibility. But *their means of expression are too big* for what they are trying to say It seems to me that they are *struggling* too hard to find a form. There is a great deal to be learned from this struggle. But to me, Kandinsky's early pictures and a number of Jawlensky's things seem somewhat empty. And there is rather too much color in Jawlensky's heads." Nevertheless, Macke subsequently allowed himself to be drawn into the Blue Rider circle; in the fall of 1911 he joined the committee which edited the almanac. He too became interested in "primitive" art, which formed the subject of his essay "Die Masken" ("The Masks"), a poetic celebration of the expressive power of primitive art forms which was published in the almanac.

The interest in cultures untouched by civilization may have determined his choice of Indian subject matter in this and two further pictures. However, this taste for exotic narrative is only one of the many facets of his art, in which form is invariably seen as a means of exploring the essence of the material world, rather than the realm of the spirit. In *The Blue Rider* almanac he wrote: "Unfathomable ideas express themselves in comprehensible forms – comprehensible through our senses as stars, thunder, flowers, as form. Our senses are the bridge between the unfathomable and the comprehensible." The visible world remained the focus of Macke's art, and he soon began to reject what he saw as the excessive emphasis placed by the other Blue Rider artists on abstract ideas. The year 1912 saw his first encounter with Futurism and Cubism, which gave a new formal stimulus to his work.

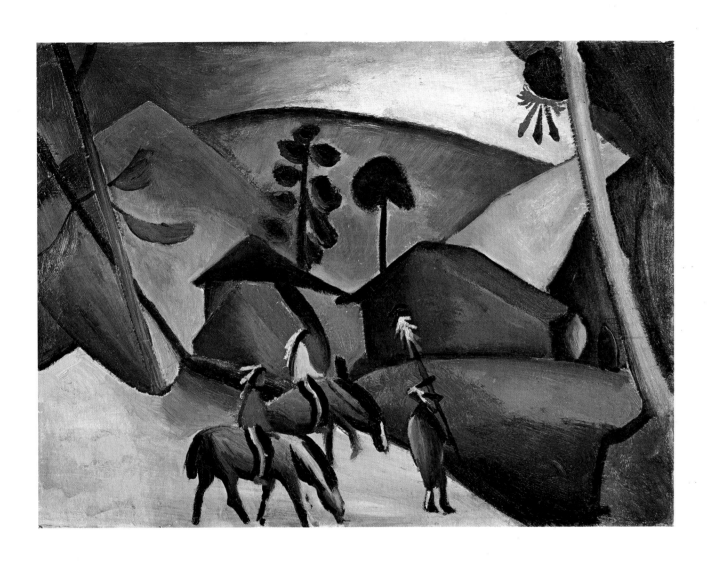

August Macke

99 ZOOLOGICAL GARDEN I (*Zoologischer Garten I*), 1912

Oil on canvas, 23 × 38⁵/₈″ (58.5 × 98 cm)
Bernhard Koehler Donation, 1965
G13329

Zoological Garden I is one of Macke's best-known pictures. The artist himself was extremely pleased with the work, whose underlying theme – the world of middle-class leisure – was to become one of his favorite subjects. He hit upon the motif of the zoo in the spring of 1912, while staying in Amsterdam, where he made a large number of preparatory sketches, including one of the parrot whose flamboyant plumage dominates the foreground of the present work. Subsequently, he set up his easel at Cologne Zoo and painted numerous studies there, which formed the basis not only of *Zoological Garden I*, but also of *Kleiner Zoologischer Garten in Gelb und Braun* (*Small Zoological Garden in Yellow and Brown*; private collection) and the triptych *Grosser Zoologischer Garten* (*Large Zoological Garden*; Museum am Ostwall, Dortmund).

The masterly composition of *Zoological Garden I* points to a new development in Macke's work. In January 1912 he had seen one of Robert Delaunay's paintings of the Eiffel Tower in an exhibition at the Gereons-Club in Cologne and had been greatly impressed by its transparent, fragmented forms. Delaunay's "Orphic" Cubism is echoed in the angular, broken forms which structure the rich colors of Macke's pictures from 1912 onward. A striking feature of *Zoological Garden I* is the even, rhythmical distribution of the stylized, bowler-hatted figures on the right, particularly noticeable in the group of three standing with their backs to the viewer. The play of light and color is heightened by the precious "trimming" of flowers and lights between the animals and the people. For Macke, the zoo was an ideal theme, a source of exotic images in a domesticated setting, dominated by the idea of leisure and offering an opportunity to experience a sense of harmony between man and nature.

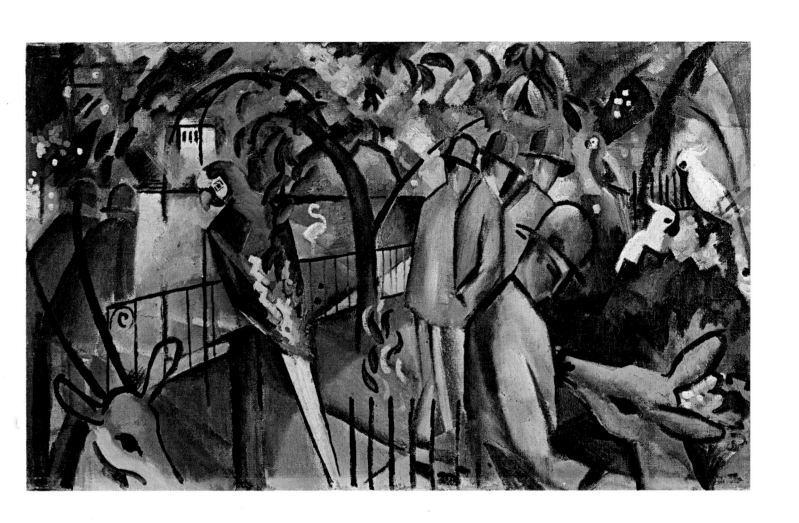

August Macke

100 CHILDREN WITH GOAT (*Kinder mit Ziege*), 1913

Oil on cardboard, $9^{1}/_{2} \times 13^{3}/_{8}''$ (24 × 34 cm)
Inscribed "Aug. Macke 1913" (lower right)
Bernhard Koehler Donation, 1965
G 13 331

In October 1913 Macke moved from Bonn to Hilterfingen, a
village on the Lake of Thun in Switzerland, where he stayed
until June the following year. This was the most productive
period of his career: it was in Hilterfingen that the mature,
relaxed style of his late pictures evolved. His range of subjects
remained limited: the majority of his pictures from this period
feature strolling couples, women standing in front of shop-
windows, or bathing girls. In her memoirs Macke's wife,
Elisabeth, recalls that *Children with Goat* was painted at the
beginning of the fall, when the weather was still warm and
summery. With her characteristic gift for observation, she
gives the following account of her husband's artistic aims:
"What most interested August Macke at that time was the
sense of dynamic energy conveyed not only by the formal
organization of space, but also by the play of colors ... for
him, color had to work, to vibrate, to live. August strove,
above all, to balance and reconcile pure colors in a picture, so
as to create a sense of harmony and unity, despite the necessary
contrasts." In *Children with Goat* the fine nuances of color in
the green of the foliage above the children's heads do indeed
have a vibrant quality, causing the eye to flicker back and
forth. Standing in a pool of light, the children appear protected
and sheltered by the surrounding trees, wrapped up in a care-
free, innocent world of their own.

The use of color to create a sense of life and movement is
one of the most prominent features of Macke's mature work.
Although he had already learned a good deal about the depic-
tion of time and movement from Futurism, the most important
influence on his style was his encounter with the work of
Robert Delaunay, whose cityscapes and pictures of the Eiffel
Tower he had seen in the first Blue Rider exhibition (see figs.
44 and 48, pp. 32 and 35). Two years later in 1913, he saw
Delaunay's series of "window" pictures in an exhibition at the
Gereons-Club in Cologne and was deeply impressed by their
prismatic, colored forms. In a note written in 1914 he spoke
of his striving "to concentrate life – and space as well – in a
single moment. We apprehend light very quickly. We take in
the individual parts of the picture very quickly. The difference
between sequentiality and simultaneous animation remains."
Whereas in Delaunay's work the materiality of the colors
themselves – their intervals, contrasts, and formal energy – is
the real subject of the picture, Macke uses color to convey the
essential unity, the "great harmony," of life.

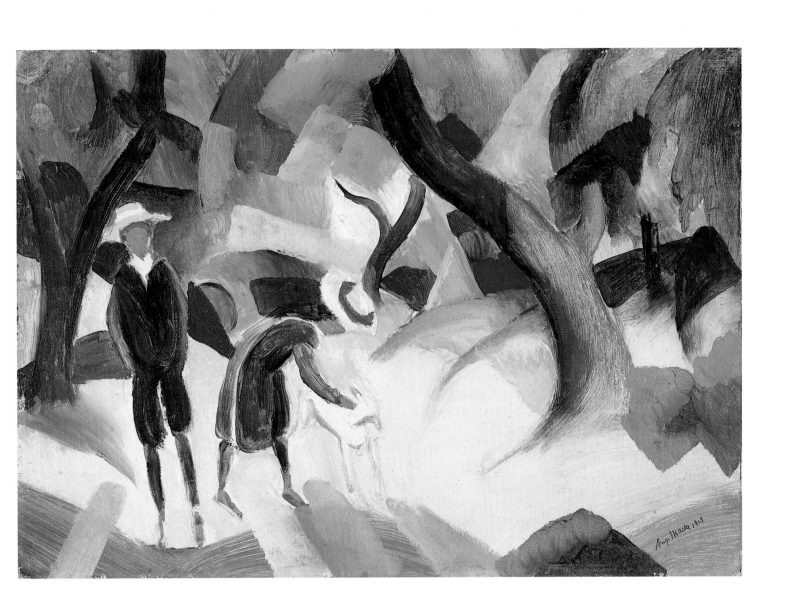

August Macke

101 MILLINER'S SHOP (*Hutladen*), 1913

Oil on canvas, 21^1/2 × 17^3/8″ (54.5 × 44 cm)
Inscribed "Macke 1913" (lower right)
Bernhard Koehler Donation, 1965
G 13 334

Macke first used the motif of the woman standing in front of a shopwindow in his seminal picture of 1912 *Grosses helles Schaufenster* (*Large Light Shopwindow*; Sprengel Museum, Hanover). This painting was influenced by Futurism – in particular, by Umberto Boccioni's *La strada entra la casa* (*The Street Invades the House*; Sprengel Museum, Hanover) – and depicts a woman standing, with her back to the viewer, in front of a shopwindow in which a street scene is mirrored: the reflection is broken up into a myriad of colored facets. A year later, Macke returned to this motif in the pictures of fashion stores and milliner's shops which he painted in Hilterfingen. In the intervening period he had encountered the art of Robert Delaunay, which was to be a major influence on his mature work. Delaunay's "window" pictures, which caused a considerable stir in the German art world – Paul Klee was also influenced by them – greatly appealed to Macke's sense of form and sensual harmony. In these works, whose subject is the image of the Eiffel Tower as reflected in a window, Macke saw the expression of "a quite heavenly reveling in the sun and in life." He wrote an enthusiastic letter to his wife's uncle, Bernhard Koehler, advising him to buy *Les Fenêtres 2*: "I have just received a reply from Delaunay. I have been thinking about it [his work] a great deal recently. Windows like mirrors, in which, on a sunny day, one sees the city and the Eiffel Tower, the deep violet reflections, on the left the wonderful orange, at the bottom the pale blue houses, from which again and again the green tower rises steeply up into the azure sky, offset by the sharp glint of the windowpane Above all, you must see for yourself how the colors take on a wonderful depth when one looks at the painting from a distance. It is all so superbly balanced."

In *Milliner's Shop* the motif has a quality of almost magical concentration. The slender figure of the woman, with her royal-blue dress, stands as if mesmerized by the window display. The hats are displayed on golden stands, like some form of precious fetish. Macke dispenses with illusionistic effects in the depiction of the windowpane, which is at once present and absent: there is no division between the two levels of reality. The richly colored, expensive hats offer themselves as objects of consumption and take on a life of their own, casting a spell on the woman. The only direct allusion to the work of Delaunay is to be seen in the angular blocks of yellow and pale violet in the center of the picture. Rather than copying the formal experiments of the French artist, Macke uses intensity of color to evoke a particular vision in an exceptionally precise manner. As Ilse Erdmann wrote to the poet Rainer Maria Rilke, "it is as if the experience of life's essential transience had revealed itself to him [Macke] in the image of a woman standing still and then walking on."

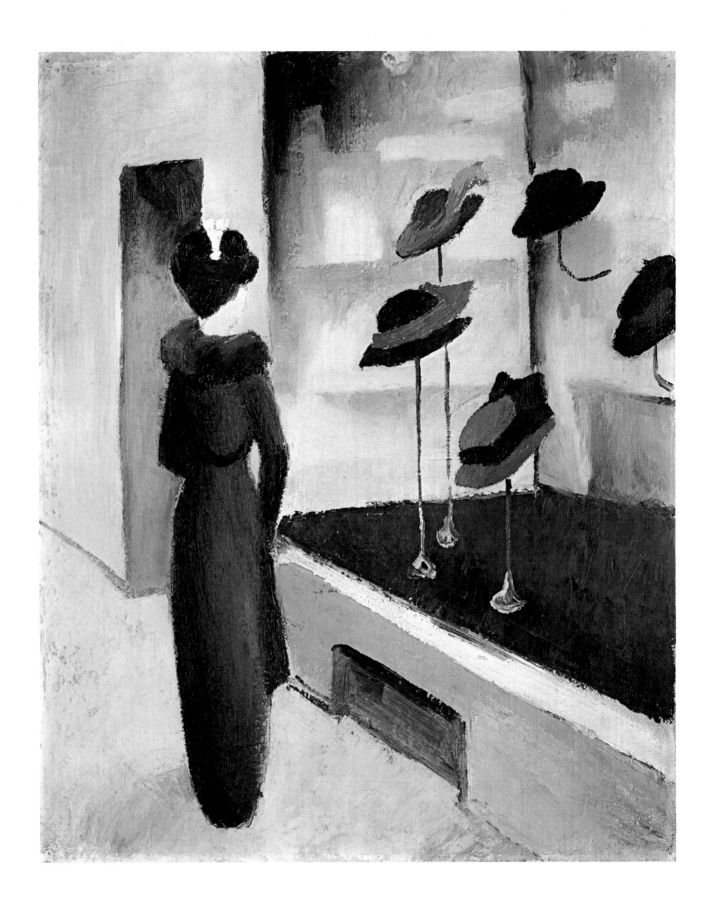

August Macke

102 PROMENADE, 1913

Oil on cardboard, $20^1/_8 \times 22^1/_2''$ (51 × 57 cm)
Inscribed "August Macke 1913" (lower left)
Bernhard Koehler Donation, 1965
G 13 328

The pictures that Macke painted in Hilterfingen of people strolling by the lake are among the finest in his entire oeuvre. These park scenes have an almost dreamlike quality and a quite exceptional charm. After Macke's death, his widow described the pictures as follows: "They are characterized by a loose, relaxed use of glowing color, especially in the greens of the trees, the blue of the sky, and the patches of sunlight on the ground, which darken from the brightest yellow to the deepest reddish brown. In this atmosphere the outlines of the figures are soft, but not without contrast; there are no longer sharp contours, everything is in a state of flux, the color is dematerialized, like melted enamel. In these small pictures, which shine like jewels, one sees an intense concentration They are truly poetic visions of everyday life painted with unabashed joy and with a deep, fervent commitment."

Macke frequently uses the motif of the bridge or the wall along the promenade, with figures leaning over the parapet and staring at the water below. In *Promenade* two identically dressed men and a schematically outlined woman with a red skirt and white blouse are depicted in this pose, seemingly lost in thought. In the foreground, etched against the curving colored forms of the trees and the path, an elegantly dressed young couple stands in intimate but silent communion. The network of relationships between the outlines of the two figures includes an element of distance: they are together yet at the same time apart. Magdalena Moeller describes *Promenade* thus: "As in many of Macke's park scenes, time appears to stand still. The picture, which shows people at leisure, is a record of a fleeting moment If one looks at the work more closely, the scene takes on an air of unreality; one notices a strange sense of stillness. Despite the dynamic element in the colors and the composition, everything seems frozen and static." Conveying a sense of the transience of the experience which it depicts, the work has a faint undertone of melancholy.

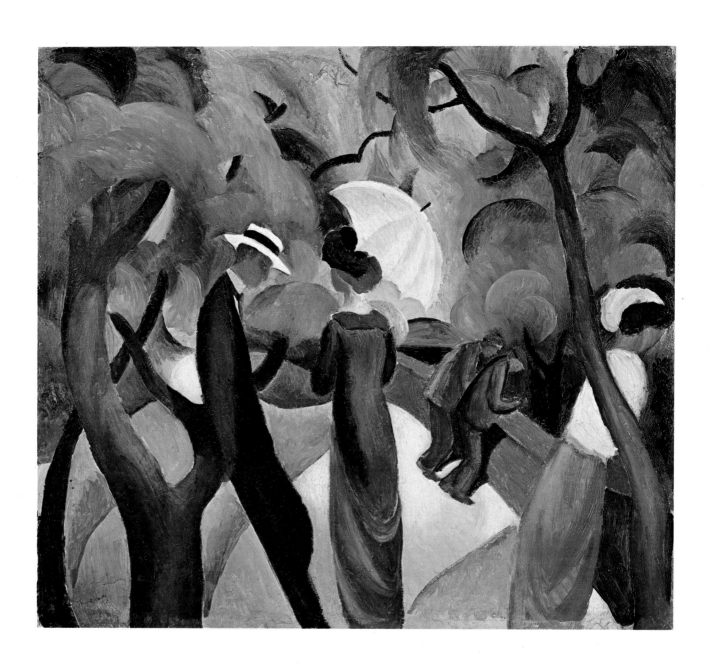

August Macke

103 A STROLL ON THE BRIDGE (*Spaziergang auf der Brücke*), 1913

Oil on cardboard, $9^3/4 \times 11^7/8''$ (24.7 × 30.2 cm)
Bernhard Koehler Donation, 1965
G 13332

The setting of *A Stroll on the Bridge* is similar to that of *Promenade* (plate 102); only the figures appear to have changed. Here too, a row of people, their backs to the viewer, are leaning over a parapet and looking down at the water; among them is the woman in the red skirt and white blouse from *Promenade*. In the foreground, two bowler-hatted men, again with their backs to the viewer, are strolling along the path, walking toward the man and woman on the far left. The small red-roofed houses and the chain of schematic blue hills on the opposite shore of the lake figure repeatedly in Macke's Hinterfingen pictures. The tree in the center, with its widely arching branches, also appears in other pictures, such as *Dame in grüner Jacke* (*Lady with Green Jacket*; Museum Ludwig, Cologne). As Macke's sketchbooks show, its form owes a good deal to the influence of French painting.

Looking at Macke's pictures of people strolling by the lake, one is struck by the fact that he does not paint directly from nature but uses stock images which he imbues with an iconic significance. The human figures – the women, with their elegant, cinched waists, and the men, with their dark suits and bowler hats – also have a stereotyped effect. This is entirely deliberate: Macke himself speaks of the bowler hat as a generally accepted sign of "male presence," while the women in his pictures have "well-formed necks and hips and carry parasols through which the sun shines." In *A Stroll on the Bridge* it is also interesting to note that the color blue is assigned to the men and red to the women, in accordance with the theory of colors which Macke expounded in one of his letters to Marc. With the contrasting yellow of the path, the green of the foliage above the figures' heads, and the patches of violet and orange, the picture contains all the basic colors of the spectrum. Like the other Hilterfingen paintings, it conveys a heightened awareness of reality and, at the same time, expresses a longing for order and harmony which can only be satisfied by art.

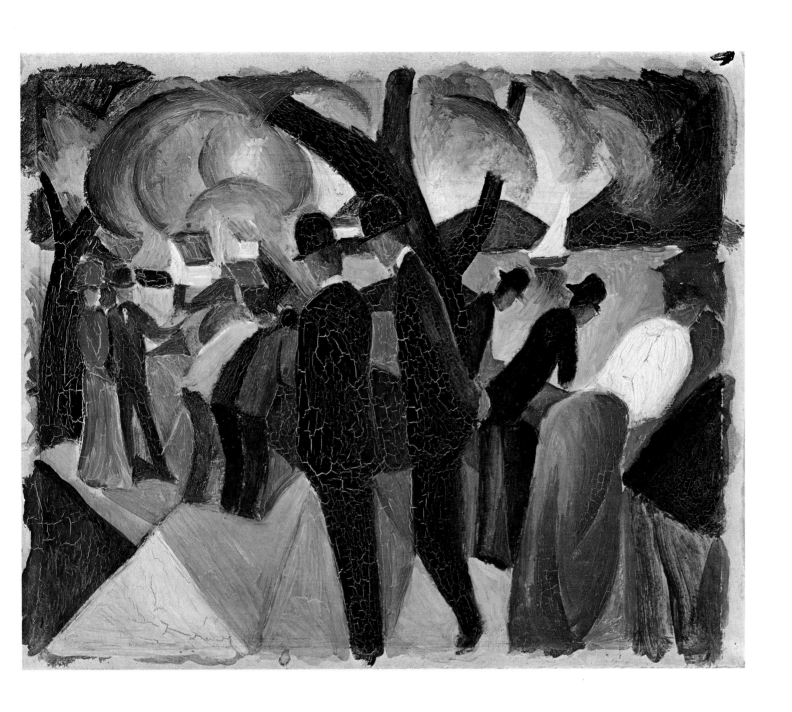

August Macke

104 TURKISH CAFÉ (*Türkisches Café*), 1914

Oil on wood, 23⅝ × 13¾″ (60 × 35 cm)
Inscribed "Aug. Macke 1914" (lower right)
Bernhard Koehler Donation, 1965
G 13325

In April 1914 Macke, Klee, and Louis Moilliet went on the
journey to Tunis which was later to acquire legendary status
as a milestone in the history of modern art. The Mediterranean
light and colors fired Macke's imagination afresh, and he re-
turned home with a bulging portfolio of watercolors and
sketches. When he arrived back in Bonn, he painted two
versions of *Turkish Café,* one of which – the present work –
he presented to Bernhard Koehler, who had helped to finance
the trip. According to Moilliet, the subject of the picture is the
covered entrance at the foot of the steps leading up to the
famous Café des Nattes in Sidi-Bou-Said. Whereas the draw-
ings in Macke's sketchbook are highly detailed, the painting is
simple and direct, relying entirely on the power of its strong,
pure colors, which have an almost abstract quality. The seated
figure of the Arab, dressed in a green robe, seems to have been
cut out of the blue wall, whose color is set off by the red of
the Arab's fez. This in turn contrasts with the orange and red
of the doorway in the center of the picture, while the yellow
of the chair and the striped awning is complemented by the
blue of the wall. In a manner different from that of Kandinsky
or Marc, Macke imbues his pictures with a sense of "inner
necessity," using a restricted range of colors and forms.

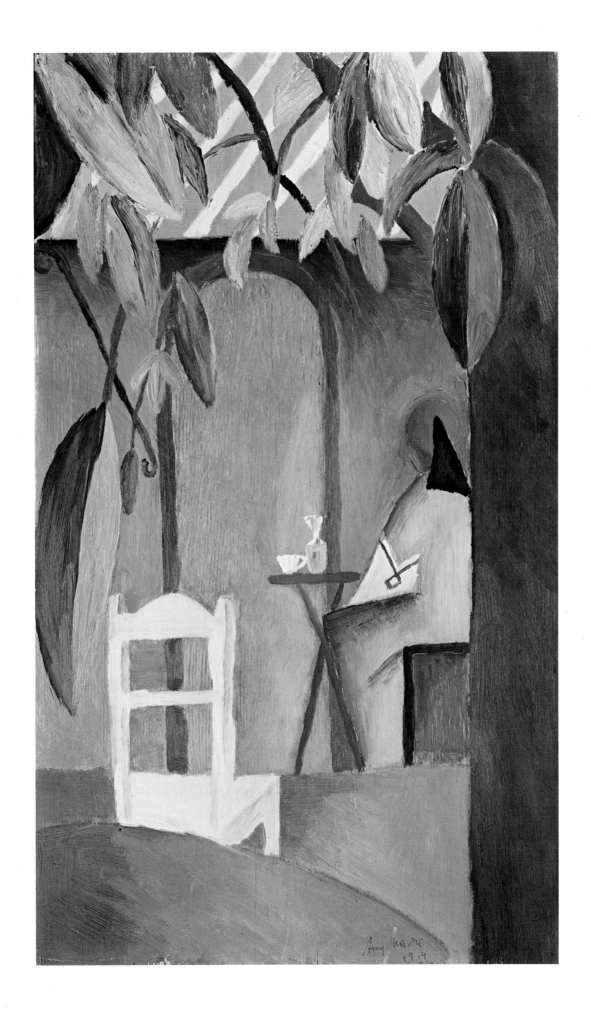

August Macke

105 GARDEN GATE (*Gartentor*), 1914

Watercolor on paper, 12$^{1}/_{4}$ × 8$^{7}/_{8}$″ (31 × 22.5 cm)
On permanent loan from the Gabriele Münter and Johannes Eichner
Foundation
FH 185

On his trip to Tunis Macke devoted all his artistic energies to
drawing and watercolor painting. The most productive period
of his two-week stay was the four days from April 10 to 13,
which the three friends, Macke, Klee, and Moilliet, spent at
the country house of Dr. Jaeggi in St. Germain near Tunis.
Klee and Macke painted several watercolors of the house and
its surroundings. On April 10 Macke wrote to his wife: "I
must have done a good fifty sketches today; yesterday it was
twenty-five. I am working like the devil and enjoying it more
than ever before." The garden gate of the country house is
painted in partly running colors over a delicate pencil drawing.
Despite the atmospheric quality of the medium, the colors are
evenly handled and succeed in conferring a lyrical form on the
motif.

August Macke

106 ST. GERMAIN NEAR TUNIS (*St. Germain bei Tunis*), 1914

Watercolor on paper, 10^1/$_4$ × 8^1/$_4$″ (26 × 21 cm)
Bernhard Koehler Donation, 1965
G 14666

St. Germain near Tunis would appear to be a picture of the view from the house of Macke's host, Dr. Jaeggi: the same motif occurs in Klee's watercolors. Here, as in *Garden Gate* (plate 105), the color is laid over a pencil sketch but liberates itself from the drawing and forms a separate, autonomous structure. Macke seldom used forms as free as those of the squares of blue in the sky, and yet he still succeeds in conveying sensitively the essence of his subject. It was with Macke's supreme confidence in the handling of color that Marc chose to conclude the deeply moving obituary which he wrote following his friend's death in action shortly after the outbreak of World War I: "We painters are well aware that, with the passing of his harmonies, color in German art will pale by several tones and will take on a duller, dryer sound. He gave color the lightest and purest sound, as clear and light as his own personality."

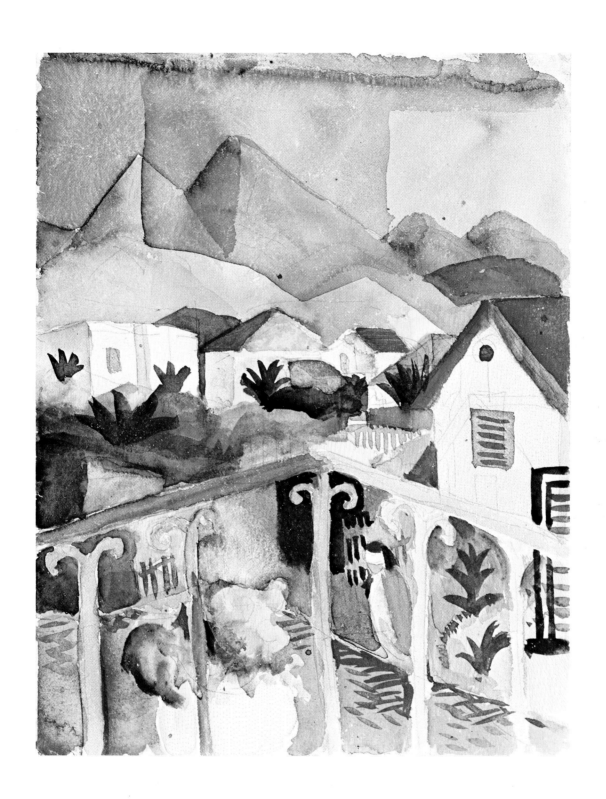

Paul Klee

b. 1879 in Münchenbuchsee near Bern – d. 1940 in Muralto
near Locarno

Klee was born into a musical family and grew up in Bern; in
1898 he decided to go to Munich to study painting. From 1900
he attended Franz von Stuck's master class at the Munich
Academy, where he briefly encountered Kandinsky. After
traveling to Italy and France, he finally settled in Munich in
1906. For several years he devoted the major part of his energies
to the production of drawings, etchings, and paintings with a
graphic structure. With their sense of rational control and
wealth of intellectual and emotional connotations, these early
works already testify to the originality of Klee's artistic ap-
proach. In 1911 Klee met Macke and Marc and renewed his
acquaintance with Kandinsky; his sense of affinity with these
three artists led him to take part in the second Blue Rider
exhibition in 1912. In the same year he traveled to Paris and
visited Robert Delaunay, whose brilliantly colored "window"
pictures particularly impressed him. Klee's own breakthrough
in the use of color followed two years later, in the course of a
stay in Tunis with Macke and Louis Moilliet in the spring of
1914.

After World War I Klee, together with Kandinsky, Lyonel
Feininger, and Oskar Schlemmer, taught at the Bauhaus in
Weimar, where he remained until 1931. He subsequently held
a further teaching post for a short time at the Academy in
Düsseldorf, but was dismissed by the Nazis in 1933, whereupon
he left Germany and returned to Switzerland.

Paul Klee

107 FÖHN IN MARC'S GARDEN (*Föhn im Marc'schen Garten*), 1915

Watercolor on paper mounted on cardboard, $7^7/8 \times 5^7/8''$ (20 × 15 cm)
Inscribed "Klee" (center right), "1915 102" (lower left), "Föhn im Marc'schen Garten" (reverse)
G 13 266

The watercolor *Föhn in Marc's Garden* bears eloquent testimony to the "conquest of color" which occurred during Klee's famous trip to Tunis with Macke and Louis Moilliet in April 1914. Until then, Klee had devoted the major part of his artistic energies to drawing and etching, advancing in slow, painful stages toward the use of color, which he saw as a highly problematical means of expressing reality. Like Macke and Marc, he was deeply impressed by the simultaneous contrasts of color in Robert Delaunay's "window" pictures, but it was the Mediterranean light of Tunis that brought about Klee's final breakthrough in the use of color. On April 16, 1914, he noted in his diary: "Color has got me. I no longer need to chase after it. It has got me for ever, I know it. That is the meaning of this happy hour: color and I are one. I am a painter."

Föhn in Marc's Garden, which was painted during a visit to Marc's house in Ried, near Kochel, while Marc was back home on leave from the front, exhibits a relaxed, confident grasp of pictorial architecture. The soft colors of the squares, triangles, and diamond shapes, which in places are almost transparent and overlap at the edges, convey a vivid impression of the *Föhn,* a warm, dry wind which frequently blows from the Bavarian Alps. The reflections of the sky and the countryside are evoked by corresponding honeycombs of color which appear to demonstrate some kind of optical principle: the rudiments of natural forms are overlaid by geometrical shapes and reduced to flat surfaces, as in the even triangle of the violet mountain or the narrow, dark triangles of the fir trees. Here, Klee follows a system first developed in his Tunis watercolors, which, however, still contained representational forms, unlike the present work, in which the motif of the landscape is dissolved into a tissue of pure colors.

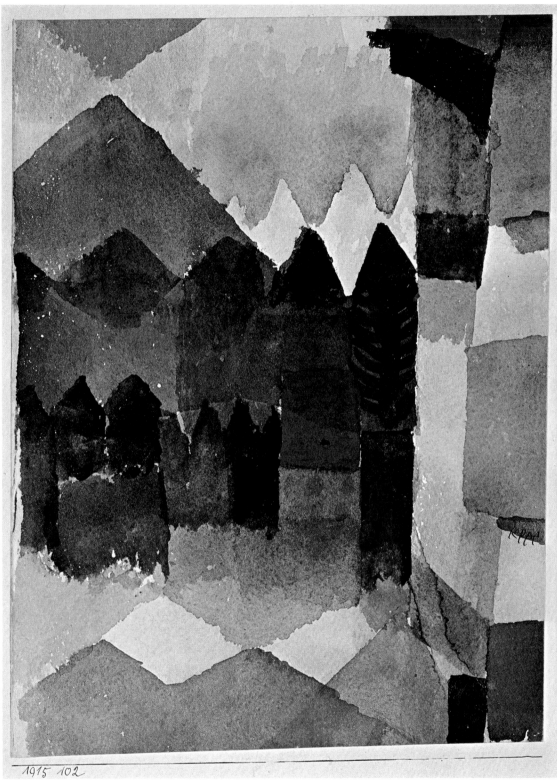

1915 102

Paul Klee

108 ROAD JUNCTION (*Strassenzweigung*), 1913

Charcoal, pen and ink, and wash on paper mounted on cardboard,
$5^{1}/_{4} \times 10^{1}/_{4}''$ (13.4 × 26 cm)
Inscribed "Klee 1913" (lower right), "Straßen Zweigung 1913 27"
(lower left, on the mount)
G 13 119

Before he created *Road Junction* Klee had experimented for a
time with painting on glass and black watercolors; in this
drawing, however, he returned to that "original area of psychic
improvisation" which corresponded most closely to his artistic
nature. After his return from Paris in the spring of 1912 he had
written to Alfred Kubin: "From Paris I have brought back all
sorts of vivid impressions. Although I have a high opinion of
the latest activities there, I have come to realize that I should
devote less time to research and work more on my personal
style. At present, my *Candide* illustrations seem to offer a
suitable basis for this." In these illustrations, on which Klee had
begun work in 1911, but which remained unpublished until
1920, the physical appearance of the figures is dissolved into a
subjective language of graphic signs which exposes the bur-
lesque, farcical dimension of human folly.

Road Junction was done at the same time as the *Candide*
illustrations. At the top edge of the narrow, oblong picture,
the tiny, antlike human figures are drawn with nervous, broken
lines; the pale, vaguely unhealthy yellow of the watercolor is
overlaid with violet, green, and red clouds of color which
reinforce the impression of flickering haste. The same sense of
weightlessness, of stumbling helplessly through space, can be
seen in the figures in a number of Klee's other drawings from
this period; the depiction of the figures in *Road Junction* reminds
one of the great Expressionist street scenes by the Brücke artists
and Lyonel Feininger. However, in the fragmentary space of
Klee's pictures there is always a narrative thread, a story line
relating to some form of adventure: Klee spoke of pictures as
experiences, as "journeys into a land of greater possibilities."

The first version of *Road Junction* was a similar pen-and-ink
drawing of two intersecting roads, to which Klee applied
watercolor wash and added the passersby. This picture was the
"construction of the pure graphic expression" of yet another
drawing, done in 1912, in which the image was broken up
into a series of Cubist surfaces. The decisive motif, the receding
lines that appear to suck the tiny figures into a kind of vortex,
was only added in the final version of the picture.

Paul Klee

109 GARDEN STILL LIFE/FLOWER STAND, WATER-
ING CAN, AND BUCKET (*Gartenstilleben/Blumensteg,
Giesskanne und Eimer*), 1910

Watercolor on paper mounted on cardboard, $5^1/2 \times 5^1/4''$
$(13.9 \times 13.3$ cm)
Inscribed "Klee" (lower left), "1910 47" (lower right, on the mount)
G 13 116

In 1910, four years before his journey to Tunis (see plate 107),
Klee made a series of small-format watercolors in which he
experimented with color, dispensing with line and traditional
chiaroscuro. The technique which he used is described in his
diary: "Summer in Bern ... watercolors wet in wet on paper
sprinkled with water. Quick, nervous work with a certain
sound whose parts are dispersed over the whole." Despite
the spontaneously intermingling colors, one is struck by the
caution with which Klee balances the light and dark sections:
he had previously conducted numerous experiments on the
distribution of light and dark in his black watercolors. The
color changes in subtle gradations between the flower stand,
the watering can, and the bucket. In the quiet economy of
Garden Still Life one also detects the influence of Cézanne and
his dematerialized colored surfaces. In the spring of 1909 Klee
had seen an exhibition which included a number of pictures
by Cézanne and which he described in his diary as "the greatest
event in painting so far! For me, he is the teacher *par excellence,*
far more so than Van Gogh." These remarks appear in the
context of a general discussion of the role of discipline and the
will in art, and of that stylistic economy which often creates a
seemingly "primitive" effect.

Paul Klee

110 LEGEND OF THE SWAMP (*Sumpflegende*), 1919

Oil on cardboard, 18¹/₂ × 16″ (47 × 40.8 cm)
Inscribed "Klee 1919.163" (lower right), "1919.163 Sumpflegende ver-
kauft Besitzer Dr. Küppers" (reverse, in the artist's hand on a slip of
paper glued to the cardboard)
G 16 399

For many years Klee confined himself to drawing, etching,
and watercolor painting; it was only after World War I that
he turned his attention to easel painting. *Legend of the Swamp*
is one of his first works in oils. A common feature of the early
oil paintings is the combination of organic and inorganic forms,
which was to become one of the central metaphors in Klee's
oeuvre. In *Legend of the Swamp* the geometrical forms of win-
dows and roofs, etched in white, stand out against the damp
brown and green vegetation of the swamp. Here and there,
one sees small white fir trees and fan-shaped plants; at the
very bottom of the picture, there is a tiny, almost transparent
matchstick figure. These pictorial elements are enmeshed in an
almost invisible network of fine black lines which binds the
forms together and assimilates them into the colored space.
The dialectic of organized and amorphous form is particularly
apparent in the building on the left, which is evidently a
church; it is distinguished from the surrounding swamp by its
structure alone, rather than by its color. Above the church, to
the right, the head of a phantasmagorical human figure, half
man and half child, stares with dead eyes into the picture.

Christian Geelhaar, Marcel Franciscono, and Jim M. Jordan
have shown that Klee's pictures from 1919/20 are based on a
modified version of Cubism. Klee was particularly fascinated
by the Cubists' dissolution of form and the possibilities which
it offered for creating new and complex relationships between
the different elements of a picture, giving equal weight to each
part. In 1912 he described the transition from Realism to the
new conception of painting which Cubism had made possible:
"Houses which are to be fitted into an interesting pictorial
structure become crooked Trees are violated, people be-
come unfit for life, there is a compulsion to render objects
unrecognizable, up to the point where the picture becomes a
puzzle. For here it is not the law of the world which applies,
but the law of art. In the picture, crooked houses do not fall
down, trees no longer need to blossom, people do not need to
breathe. Pictures are not living images." Klee's interest in the
art of children and the mentally ill is apparent in the strange,
primitive forms of *Legend of the Swamp*. This interest is illus-
trated by an entry in his diary, in which he spoke of a particu-
larly happy moment when he felt himself to be "a spectator
above this world and, in the world as a whole, a child."

Paul Klee

111 TOWN R (*Stadt R*), 1919

Watercolor and tempera on plaster, $6^1/2 \times 8^5/8''$ (16.5 × 22 cm)
Inscribed "Klee/1919 205" (lower right)
On permanent loan from the Gabriele Münter and Johannes Eichner
Foundation
FH 188/2

Architecture is one of the main themes of Klee's pictures
from the period around 1920. He evidently saw the artificial,
"constructed" character of architecture as having special rel-
evance to the laws of art. At the very beginning of his career,
during his travels in Italy in 1901/02, he had become aware
not only of the fundamentally epigonal nature of art, but also
of the close relationship between architectural and pictorial
order. The significance of this relationship for his development
as a painter is indicated by one of the entries in his diary during
his stay in Tunis: "Went to work straight away and painted
watercolor in the Arab quarter. Art/Nature/Self. Tackled the
synthesis of urban architecture and the architecture of the
picture."

In *Town R* a variety of architectural features – walls, chim-
neys, and roofs – are bound together by a complex geometrical
pattern. Some of the elements in this pattern, such as the brick
red of the walls and the blue triangle of sky, refer to reality,
while others, such as the "walled" moon on the right, have an
intermediate status. In the center there is a large black letter
"R" and a black comma with a period; it is from the "R" that
the picture, like *Villa R* (Kunstmuseum, Basel), painted in the
same year, derives its title. Marcel Franciscono describes the
Cubist formal principle underlying the picture: "From 1911
onward, and especially after the Cubists began to use collage
in 1912, their approach to painting was no longer based simply
on the fragmentation of visual perception, but on the arrange-
ment of abbreviated, two-dimensional graphic signs and dia-
grams which permitted forms and ideas to interpenetrate and
mingle in a variety of interesting ways. The foundation of a
picture – its structure, space, and motifs – were linked to a
common visual and conceptual core, so that even letters or
words could be included without disturbing the balance of
the whole." The introduction of letters was a particularly
important source of inspiration to Klee. However, whereas the
letters used by the Cubists refer to reality – for example, to
newspapers or advertising placards – the letters in Klee's work
take on a symbolic significance akin to that of other geometri-
cal or emblematic signs, such as the arrow, the heart, or the
sun. The meaning of the "R" ultimately remains a mystery,
as does the overall architecture of the picture. Meaning, in
Klee's work, can only be inferred from the picture as a whole,
since the artist himself, according to Klee, is "a creature within
the whole." In his essay "Wege des Naturstudiums" ("Ways of
Studying Nature"), published in 1923, Klee described how this
conception of the artist emerges in the gradual process by
which "a totalization occurs in the image of the natural object
– be it vegetable, animal, or human, in a domestic space or in
the space of landscape or the world – a totalization which
begins with a more spatial image of the object."

Paul Klee

112 DESTROYED PLACE (*Zerstörter Ort*), 1920

Oil on paper mounted on gray-blue cardboard mounted on plain
cardboard, with a narrow strip of tarnished silver around the image,
$8^3/_4 \times 7^5/_8''$ (22.3 × 19.5 cm)
Inscribed "Klee" (lower left), "1920/215" (lower left, on the mount),
"Zerstörter Ort" (lower right, on the mount)
G 15638

Like *Town R* (plate 111), *Destroyed Place* is based on an architec-
tural motif, but its style is quite different. Together with *Zer-
störtes Dorf* (*Destroyed Village*; private collection), it is one of
the very few pictures in which Klee directly referred to the
horrors of World War I. Klee's attitude to the war was one
of detachment, as the following, oft-quoted words indicate:
"I already had this war within myself. Hence it no longer
concerns me." In this picture the ghostly gray and violet
ruins of a village stand out against the blue-black sky, which
is lit up by the reflection of a fire. The windows, which in
many of Klee's pictures symbolize the dialectic of interior
and exterior and connote a sense of comfort and security,
are here like yawning black chasms. In the foreground, one
sees the remains of a ruined church; the pale clumps of
vegetation next to it may be interpreted as metaphors of
rebirth and renewal. However, the associations which the
small picture evokes are dominated by the absence of living
things and the emptiness of the anonymous place. Here,
Klee has succeeded in the "visualization of nonvisual
impressions and ideas," to which he referred in his essay
"Wege des Naturstudiums" ("Ways of Studying Nature")
as an essential feature of modern art. In a private obituary
of his friend Marc, Klee spoke of the particular quality of
"dispassionate fervor" in pictures such as *Destroyed Place,*
whose effect on the viewer is quite different from that
induced by the work of Kandinsky or the Brücke artists.
Comparing his own art with that of Marc, he wrote: "My
fervor is more like that of the dead or the as yet unborn
I adopt a distant, original standpoint, where I presuppose
formulas for man, animals, plants, rocks, and the elements,
for all the circulating forces at once. A thousand questions
fall silent before they are answered." However, the "silent,"
dispassionate quality of Klee's pictures owes more to their
carefully calculated gestural vocabulary and their seismo-
graphic recording of a given state of mind than to the artist's
adoption of a superior creative standpoint.

1920/215 zerstörter Ort

Paul Klee

113 ROSE GARDEN (*Rosengarten*), 1920

Oil on cardboard, 19¹/₄ × 16³/₄″ (49 × 42.5 cm)
Inscribed "klee 1920/44" (center right)
Gabriele Münter and Johannes Eichner Foundation/Städtische Galerie
im Lenbachhaus
G 16 102

In the period around 1920 Klee painted a series of pictures
in which organic and inorganic structures are fused into a
rhythmical whole. There can be no doubt that *Rose Garden* is
the most significant of these works. The idea of the garden,
which has a central place in Klee's thinking, encompasses both
the principle of artificial order and that of natural, organic
growth. In *Rose Garden* irregular narrow triangles and trape-
zoid forms, with fine black borders, give rise to a structure
that resembles a wall made up of a variety of vivid red, orange,
and pink bricks. The same reds are used for the buildings with
pointed triangular roofs, whose vertical lines contrast with the
horizontal structuring of the garden. With their long stems
and round, spiral-shaped blooms, the roses rhythmically dis-
tributed throughout the picture are reminiscent of musical
notes.

Klee did indeed see an analogy between painting and music.
In his notes on "Bildnerisches Denken" ("Pictorial Thinking"),
written while he was teaching at the Bauhaus, he spoke of
"cultural rhythms" and referred to "the structure of the beat
as an ordering rhythm in landscape." This link between music
and painting is fundamental to Klee's ideas concerning the
principles of pure artistic construction, an issue in which Kan-
dinsky was also keenly interested. Yet whereas Kandinsky
contented himself with discussing the general "inner sound"
of pictures, Klee sought to discover precise formal laws, calling
for "exact research" of the kind which had long since been
undertaken in music – although in some respects, for example
in the use of polyphony, he thought that art had already
overtaken music. In a diary entry, written in 1917, he cited
the simultaneous contrasts in Robert Delaunay's "window"
pictures, which had so impressed Marc and Macke, as an
example of "polyphonous painting" which he saw as superior
to music, since "the temporal has a more spatial quality. The
idea of simultaneity emerges in an even more complex form
.... By his choice of a particularly long format, Delaunay
endeavored to accentuate the temporal dimension of the pic-
ture, in the manner of a fugue." The melodic structure of *Rose
Garden* also expands rhythmically from the center outward. It
is known that Klee trimmed the edges of the finished picture,
as he frequently did with his early paintings and watercolors,
in order to achieve precisely the desired structural effect.

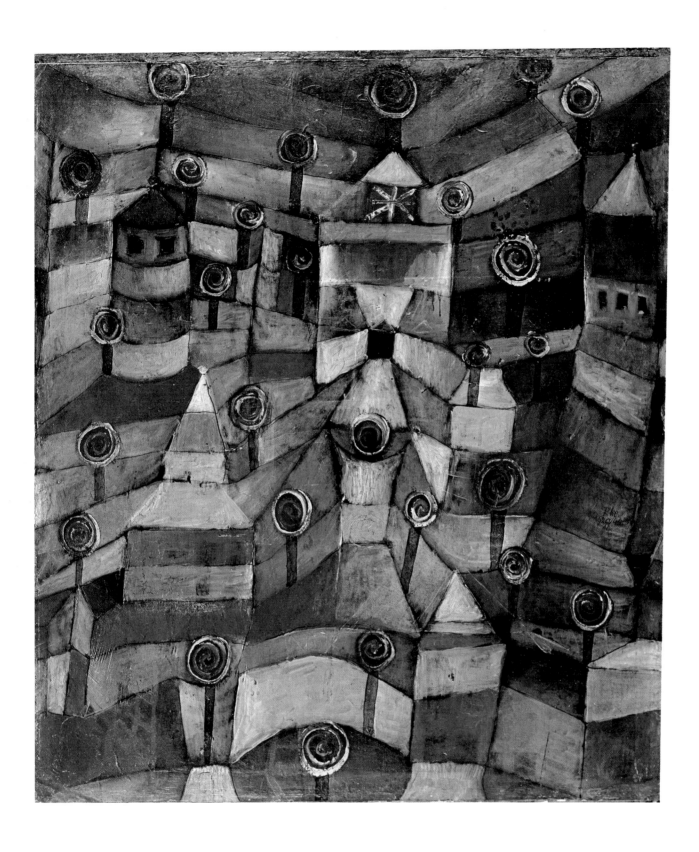

Paul Klee

114 WILD BERRY (*Waldbeere*), 1921

Watercolor on paper mounted on cardboard, with a $^1/_2''$ strip glued
on by the artist at the bottom; image $12^5/_8 \times 9^7/_8''$ (32×25.1 cm), sheet
$14 \times 10^5/_8''$ (35.7×27 cm)
Inscribed "Klee" (lower right), "1921/92 Waldbeere" (center, on the
mount)
G 15694

The world of the stage held a continuing fascination for Klee:
the theater, the circus, variety artistes, and magicians form the
subject of many of his pictures, in which bizarre imaginary
figures are seen performing some sort of act which is far
removed from reality. In *Wild Berry* a strange puppet-like
creature with an enormous head stands on a kind of stage in
the middle of a dark wood. Armin Zweite describes the picture
as follows: "The scene reminds one of a stage set. The diminu-
tive figure stands out against the dark violet background; at
its feet, there is a row of stylized plants. It seems as though the
figure is straining to lift its huge balloonlike head. Together
with the leaf forms and diamond shapes of its costume, the
semitransparent head lends the bizarre, hermaphroditic crea-
ture an air of mystery: it is seemingly part human and part
vegetable. This symbiosis confers a puzzling, quietly uncanny
quality on the picture."

The year 1920 saw the publication of several books on Klee's
art, and a major exhibition of his work was held at the Goltz
gallery in Munich. He had at last begun to secure the recogni-
tion for which he had longed. In the same year he was ap-
pointed to a teaching post at the Bauhaus in Weimar, where
he gave his first classes in January 1921; in the fall of that
year he finally moved to Weimar with his family. With its
geometrical forms, *Wild Berry* bears a certain resemblance
to the puppets of Oskar Schlemmer, who also taught at the
Bauhaus. However, the intentions which inform Klee's bizarre
poetic creature are quite different from those underlying the
work of Schlemmer, whose aim was to demonstrate the mech-
anical, functional character of the human body. Although *Wild
Berry* adumbrates the theme of the relationship between natural
and artificial, mathematical forms which preoccupied Klee
while he was working at the Bauhaus, it is emphatically a
product of the artist's own imagination, rather than of a purely
rational, mechanical approach to painting. It originates from
an anthropocentric view of the world, through which the artist
takes possession of nature. Klee describes this process in his
essay "Wege des Naturstudiums" ("Ways of Studying
Nature"), where he speaks of a "humanization of the object
... which establishes a relationship of resonance between the
self and the object which goes beyond the visual basis."

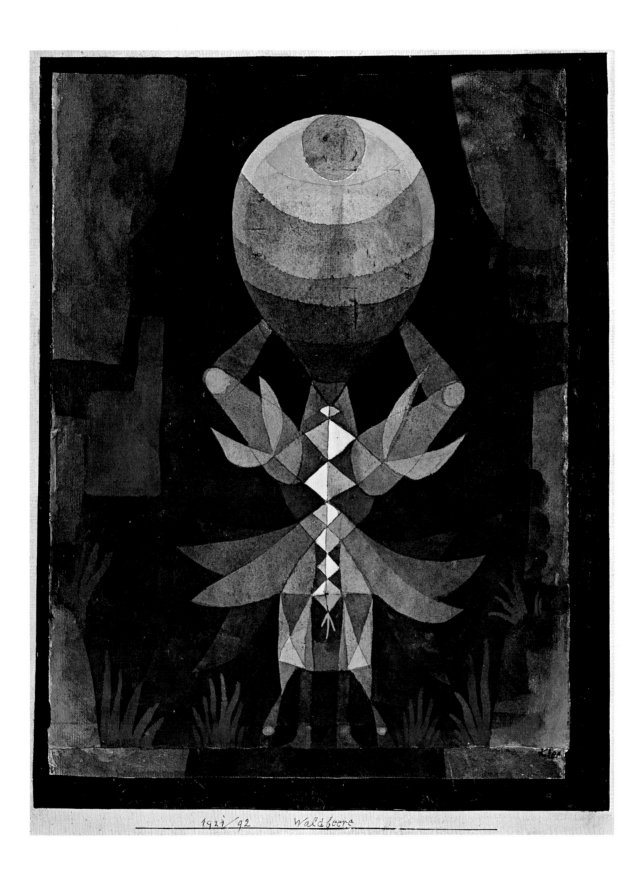

1921/92 Waldbeere

Paul Klee

115 THE WILD MAN (*Der wilde Mann*), 1922

Mixed media on chalk ground on canvas mounted on cardboard,
23 × 15¹/₄″ (58.6 × 38.8 cm)
Inscribed "Klee" (lower right), "S.Cl." "Der wilde Mann" (lower left
and center, on the mount)
FH 207

In *The Wild Man* a schematic male figure in harlequin costume
is shown as the helpless victim of conflicting drives, symbolized
by the arrows pointing in opposite directions. Against the
chalk ground, which was deliberately prepared to absorb the
paint, the figure is seen as a kind of marionette, torn this way
and that by the variety of human urges. The large brown
arrows emerging from his head, which is covered by a trans-
parent veil, would appear to signify intellectual or psychologi-
cal obsession; the smaller arrows shooting out of his staring
eyes symbolize the incompatibility of conflicting desires. In
the center of the picture, the figure's drooping chin, covered
with curly hair, resembles a pair of testicles, a sexual connota-
tion that is echoed by the red and brown arrows emerging
from his groin. As in the early *Held mit Flügeln* (*Hero with
Wings*), an etching dating from 1905, where the central figure
is trapped by his carnal "weakness," Klee depicts the eternal
conflict between the promptings of the flesh and the striving
for higher things, between id and superego.

The arrow also appears as a symbol of sexual desire and
aggression in such pictures as *Der Pfeil* (*The Arrow,* 1920;
Kunstmuseum, Bern) and *Analyse verschiedener Perversitäten*
(*Analysis of Diverse Perversities*; Musée National d'Art Mod-
erne, Paris), where Klee dissects human sexuality in the man-
ner of Max Ernst. At the same time, Klee endows the arrow
with a rich variety of other connotations: it indicates a particu-
lar direction, an increase of energy, a tendency to exceed the
given. He discusses the significance of this symbol, which is
central to his work, in his *Pädagogisches Skizzenbuch* (*Pedagogi-
cal Sketchbook*): "The father of the arrow is the question: how
do I extend my range to get there?...Man's ability in the
sphere of ideas to traverse the earthly and the celestial worlds
conflicts with his physical impotence, and this is the origin of
human tragedy. Man is half free and half prisoner." However,
the arrow also has a certain Utopian dimension: "The longer
the journey, the greater the tragedy of not already being there
.... The recognition that where there is a beginning, there can
never be infinity. Consolation: a little further than usual, than
possible?" In view of Klee's use of the principle of montage,
combining figures with abstract signs, it is hardly surprising
that the Surrealists invited him to take part in their first group
exhibition in Paris in 1925.

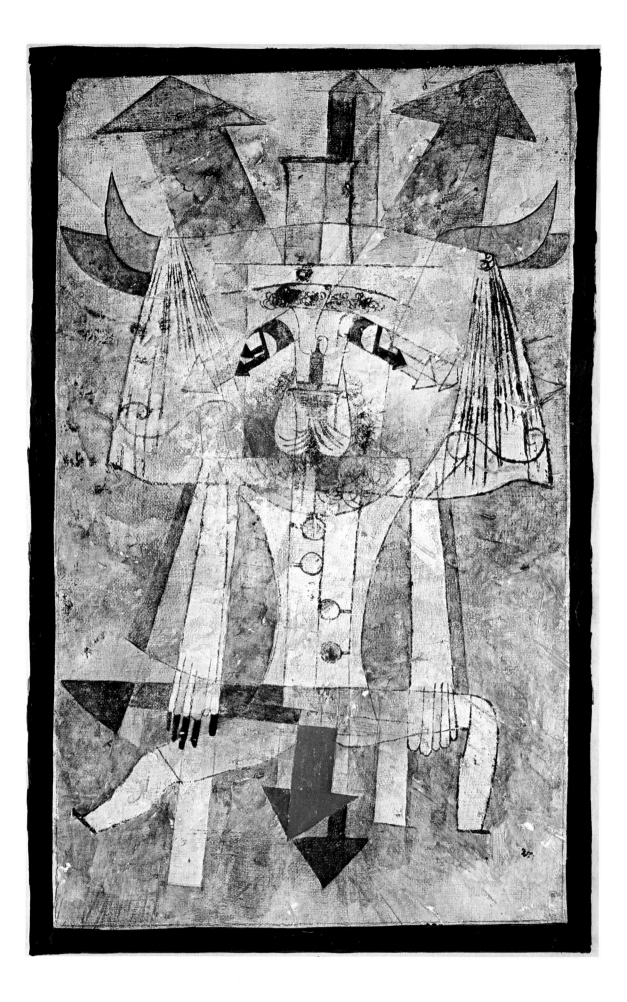

Paul Klee

116 BOTANICAL THEATER (*Botanisches Theater*), 1924
and 1934

Oil, watercolor, and ink on cardboard mounted on plywood,
19³/₄ × 26⁵/₈″ (50.2 × 67.5 cm)
Inscribed "Klee/1924/ = 1934" (top left), "1924/198" (lower right)
Gabriele Münter and Johannes Eichner Foundation/Städtische Galerie
im Lenbachhaus
G 15632

Klee painted *Botanical Theater* in 1924, reworked it in 1934,
and exhibited it the following year at his major one-man show
in Bern. With its dramatic *mise-en-scène* of the processes of
creation and growth, it offers a key to one of the main ideas
informing Klee's art. In pictures such as *Fruits on Red* (plate
117) Klee frequently addressed the theme of hidden life-forces,
of creation and metamorphosis. However, the specific reper-
toire of forms seen in *Botanical Theater* appears to have held a
special interest for him. Similar forms are to be seen in many of
his pictures from the 1920s: *Bühnenlandschaft* (*Stage Landscape*,
1922; private collection) and the watercolor *Kosmische Flora*
(*Cosmic Flora*, 1923; Kunstmuseum, Bern) exhibit a form of
order which directly anticipates Klee's first work on *Botanical
Theater*.

Despite the mysterious, pulsating energy of the work and
the bizarreness of the individual forms, order is the basic princi-
ple of the picture. The framework of twiglike forms, leaves,
seeds, and flowers resembles the proscenium arch of a stage, in
the center of which one sees a plantlike structure with a red
teardrop-shaped heart, surrounded by a profusion of strange
offshoots. Armin Zweite writes of this structure: "It is, so to
speak, the *Urpflanze,* the original plant, from which the various
species appear to evolve. The picture speaks at one and the
same time of natural laws and the mystery of organic growth."
One has the impression of looking into an alchemist's labora-
tory in which the materials and the instruments are identical:
the small, neatly ordered elements at the top and bottom of
the picture are arranged like tools for the creation of larger
forms of plant life. Using Klee's own vocabulary, Christian
Geelhaar has interpreted *Botanical Theater* as an evocation of
the workings of the *Urgesetz,* the primal law which governs
all creation. This sense of organic growth is conveyed not only
by the objects themselves, but also by the way in which they
are painted, with fur-like structures of fine lines and cross-
hatching which cover the forms. The idea of creation as a
continuing process is also emphasized by the materiality of the
picture, by the layering of the colors, the slight cracks in the
center, and the variety of media: oil, watercolor, and ink.
Addressing his pupils at the Bauhaus, Klee remarked on one
occasion that the task of the artist was to present "not form,
but the process of shaping." This analogy between natural and
artistic creation is central to Klee's aesthetic theory. With its
theme of imaginary growth, initiated by the artist, *Botanical
Theater* is without a doubt one of the finest examples of Klee's
mature work.

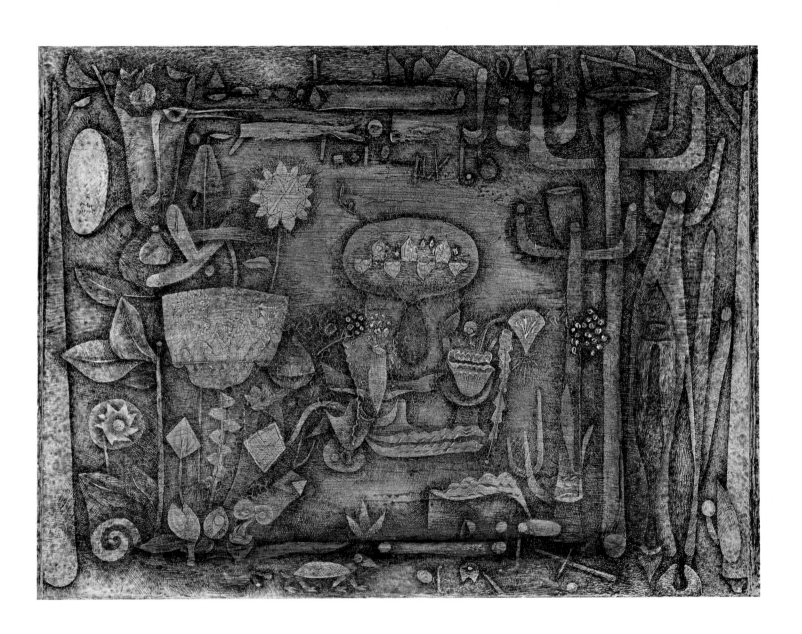

Paul Klee

117 FRUITS ON RED – THE VIOLINIST'S SWEAT-CLOTH (*Früchte auf rot – Schweisstuch des Geigers*), 1930

Watercolor on silk mounted on cardboard, 24 × 18¹/₈″ (61.2 × 46.2 cm)
Inscribed "Klee" (lower right), "S.Cl.1930 AE 3", "Fruechte auf rot"
(left and right, on the mount)
FH 222

Like *Botanical Theater* (plate 116), *Fruits on Red – The Violinist's Sweatcloth* deals with the theme of natural growth, of the development from flower to fruit. The watercolor is painted on a piece of fine copper-colored silk which is mounted on cardboard painted blue. The forms of the fruits and leaves are also cut from silk and glued to the surface; the branches, on the other hand, are painted with a fine brush or pen. Christian Geelhaar describes the picture thus: "The dominant image is one of growth: flowers and fruits shoot up from the ground and grow inward from the edges. The central structure is a tall plant or tree which resembles a candelabrum, with branches running off in several directions. In the bottom right-hand corner a number of small plants with berries and bell-shaped flowers rise up from the base. All the plants are straining upward, toward the light." Geelhaar mentions a further significant detail: the elongated triangular shape in the top left-hand corner, which suggests a theater curtain. "This motif frequently crops up in Klee's pictures from 1918 onward. Here, the curtain not only serves to round off the composition, it also conveys an idea of visionary revelation in the depiction of natural growth. Hence *Fruits on Red* is thematically aligned with the group of works which includes the painting *Botanical Theater*."

Fruits on Red – The Violinist's Sweatcloth was painted after the Bauhaus had moved from Weimar to Dessau. While working at the Bauhaus, Klee experimented with a number of new artistic techniques. In 1930 he began to paint on primed surfaces; in his late, expressive work he often used such coarse materials as jute and sackcloth. The delicate silk collage of *Fruits on Red* uses highly artificial means to observe and analyze natural processes: the organic forms appear to be seen in cross-section, with their inner structure exposed. In his essay "Wege des Naturstudiums" ("Ways of Studying Nature") Klee wrote: "Man takes the object apart and exposes its innards on cut surfaces: the nature of the object determines the number and character of the cuts. It is this visible penetration into hidden regions – sometimes with a simple sharp knife and sometimes with the help of delicate instruments – which clearly opens up the material structure or the material function. The sum of the experiences gained in this way enables us to judge the inner nature of the the object intuitively, looking only at its outer surface." The delicate architecture of *Fruits in Red* perfectly exemplifies this precision in the anatomy of objects.

The silk cloth on which the picture is painted was originally used by Klee while playing the violin, in order to avoid damage to the instrument from perspiration: hence the title *The Violinist's Sweatcloth*, which also contains an ironic illusion to the cloth with which St. Veronica wiped the sweat from Christ's brow on his way to Calvary and on which his image was miraculously preserved. Klee is thus referring here to the complex relationship between image and reality present in medieval depictions of St. Veronica with her cloth.

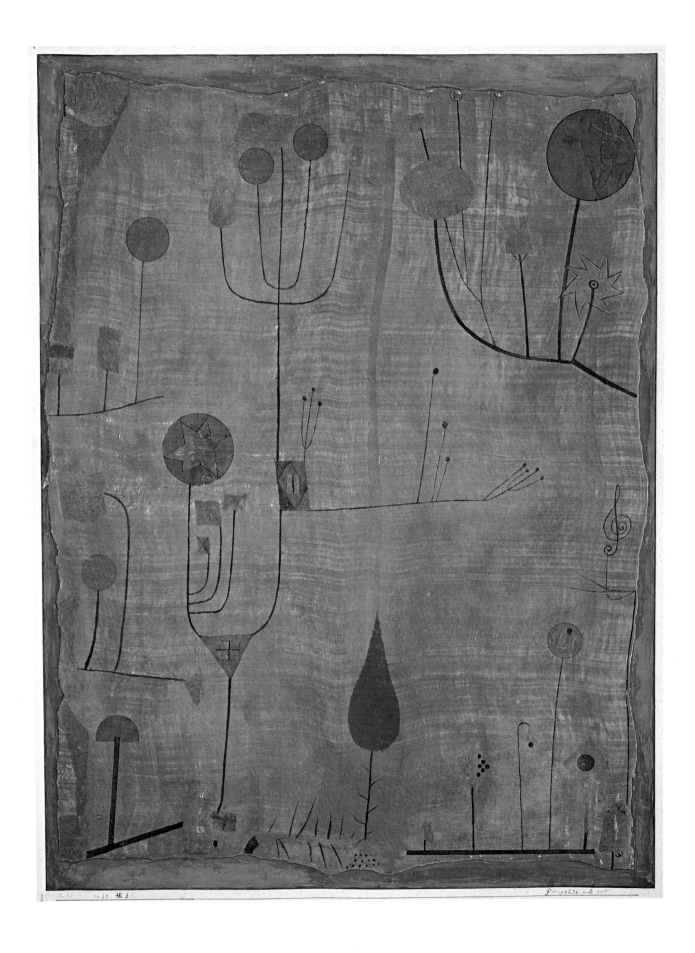

Paul Klee

118 RHYTHMICAL, MORE RIGOROUS AND
FREER (*Rhythmisches strenger und freier*), 1930

Gouache on paper mounted on cardboard, $18^1/2 \times 24^1/4''$ (47×61.5 cm)
Inscribed "Klee" (lower right), "1930 0.9", "rhythmisches strenger
und freier" (lower left and right, on the mount)
G 16155

In 1923 Klee began producing pictures based on the form of a
chessboard, and repeatedly returned to this motif throughout
the rest of his career. Although he subjected what Will
Grohmann has called his "magic squares" to intensive theoreti-
cal scrutiny during his time at the Bauhaus, their essential
character as images of balance and harmony remained un-
changed. Around 1930 he painted several pictures of this kind,
including *Rhythmical, More Rigorous and Freer.* The entry for
it in his personal catalogue of his works reads: "Large water-
color, i.e., thick, waterbased paste applied with a palette knife,
German Ingres" (the name of the paper used for the picture).
Combining squares and irregular oblongs of black, reddish
brown, blue, and gray into a large square which is set against
a pink background, Klee experiments with the alternating
rhythms of form and color, subtly varying and distorting the
shapes to produce a pattern quite unlike that of an ordinary
chessboard, whose even, symmetrical structure he found lack-
ing in "the stimulus of increase or decrease Despite the
variety, the formal result is unproductive." In his notes on
"Bildnerisches Denken" ("Pictorial Thinking") he wrote:
"Whereas in the ordinary chessboard the division follows the
eye, in the *Überschach* [superchess] it is to be viewed as a
measure and a functional basis" – in other words, a system
which may or may not be visible and whose absolute laws
enable the movement of the parts to unfold in a "more rigorous
and freer" manner.

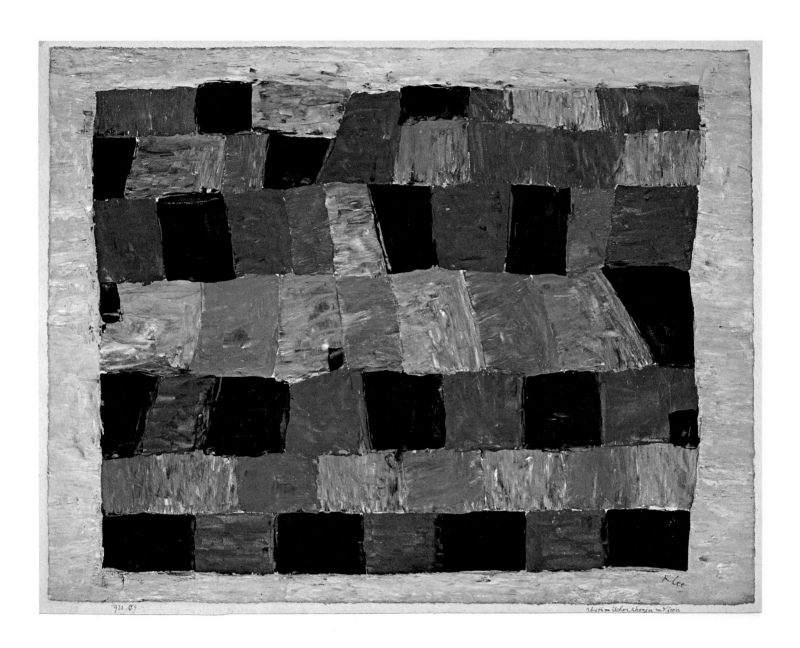

Paul Klee

119 CLIFFS BY THE SEA (*Klippen am Meer*), 1931

Oil on canvas, $17^{1}/_{2} \times 24^{3}/_{8}''$ (44.5 × 62 cm)
Inscribed "Klee" (lower right), "R.14 Klippen am Meer" (on the stretcher)
On permanent loan from the Gabriele Münter and Johannes Eichner Foundation
FH 211

In April 1931 Klee left the Bauhaus and went to teach at the Academy in Düsseldorf. It was at this point that he became particularly interested in the use of a technique which he himself termed "so-called Pointillism," in reference to the work of Georges Seurat and the Neo-Impressionists, who had dissolved the surface appearance of reality into minute dots of color. Klee's approach is somewhat different. In his "Divisionist" paintings he first seals off the surface of the picture with thick white paint, which is often applied in successive layers, and then covers this with a dense mosaic of colors. Often painted over several times, the individual particles of color create a surface relief, as in *Cliffs by the Sea*. The dots of color in this picture form an animated pattern in which one vaguely recognizes the outlines of a seaside landscape, with cliffs, the sea, and the sky. As in his famous pictures *Ad Parnassum* (Kunstmuseum, Bern) and *Das Licht und Etliches* (*Light and Various Things*; private collection), both painted in 1931, Klee experiments with the representation of light; here, he takes the experiment to its ultimate conclusion, beyond which lies total abstraction. The mosaic of colors is a logical extension of the chessboard patterns in pictures such as *Rhythmical, More Rigorous and Freer* (plate 118), whose rectangles of color have dwindled here into isolated dots. In order to recreate a visual connection between the dots of color, the viewer has to concentrate far harder on the picture than in the case of Neo-Impressionist painting, where the technique of Pointillism serves to convey an immediate sensual experience of reality.

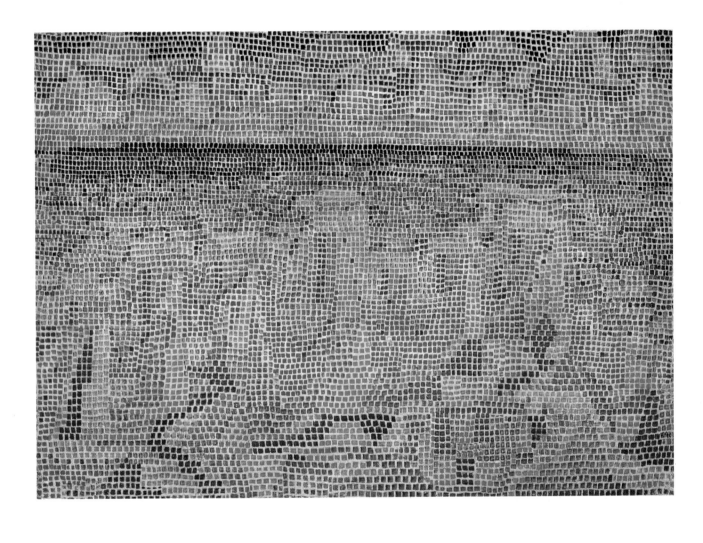

Paul Klee

120 ARCHANGEL (*Erzengel*), 1938

Oil on jute, 39³/₈ × 25⁵/₈″ (100 × 65 cm)
Inscribed "Klee" (lower right), "1938 Y Erzengel" (on the stretcher)
On permanent loan from the Gabriele Münter and Johannes Eichner
Foundation
FH 182

Klee returned to Switzerland in 1933, after being dismissed by
the Nazis from his teaching post at the Düsseldorf Academy.
Two years later he contracted sclerodermia, a fatal skin disease
from which he eventually died in 1940. In 1936 he painted
very little, but, beginning in the following year, a new burst
of creativity resulted in over two thousand pictures, an aston-
ishing figure in view of the illness that was gradually destroying
the artist. One of the main themes of these late pictures is the
figure of an angel. The motif occasionally occurs in his earlier
work, but in pictures from the late 1930s, such as *Archangel*,
the figure takes on an entirely new dimension: it is used to
convey a sense of the thin line separating life from death, of the
transience of earthly existence, beyond which lies immortality.

The heavy black lines in *Archangel* stand out boldly against
the translucent background, whose variegated colors have been
absorbed by the coarse jute and whose pale glow lends the
picture a semireligious aura. Despite the disparate character of
the formulaic signs, there is an overriding sense of hierarchical
order which welds them into an intelligible whole. The image
of the angel's face embodies an awareness of imminent death
and a longing for transcendence, and simultaneously evokes
the pessimistic mood of the time, when the world faced the
threat of Fascism and war.

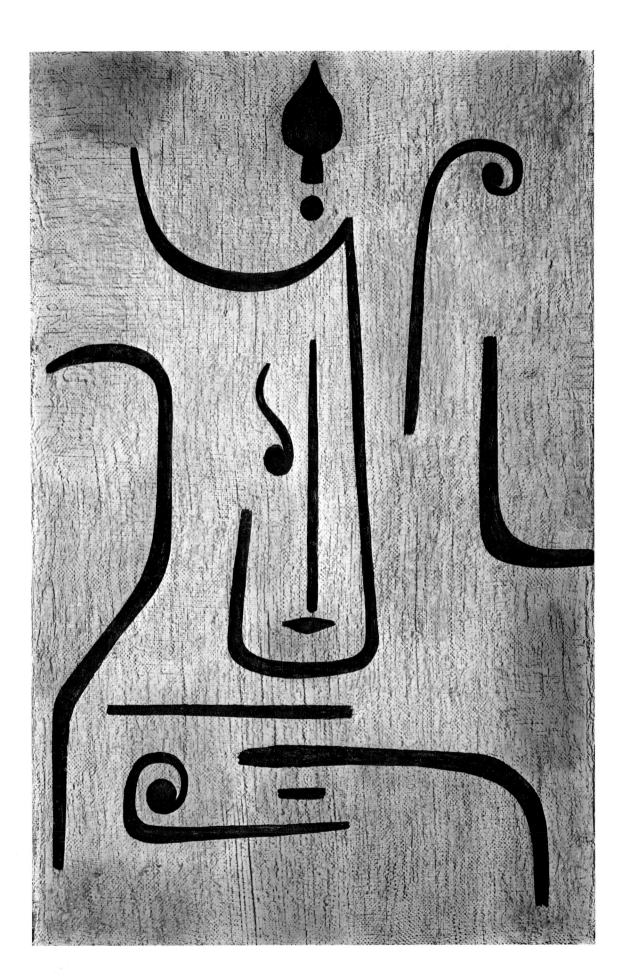

Paul Klee

121 INTOXICATION (*Rausch*), 1939

Oil and watercolor on jute, $25^5/8 \times 31^1/2''$ (65 × 80 cm)
Inscribed "Klee" (top right), "1939 Y 1 Rausch Klee" (on the stretcher)
Purchased with the help of the Gabriele Münter and Johannes Eichner
Foundation

G 15953

Toward the end of Klee's life, his painting takes a pronounced
"primitive" turn and reaches a final creative climax. The frag-
mentary figures in *Intoxication* are like hieroglyphs which, as
Rosel Gollek has pointed out, allude to "the intoxication of
eternal processes of change within nature" and which also
indicate the isolation of human, animal, and vegetable exis-
tence. The cosmos of the general concept of art formulated by
Klee in his "Schöpferische Konfession" ("Creative Confes-
sion") of 1920 has clearly fallen apart. There appears to be no
way out of the closed world of *Intoxication*, which, like *Arch-
angel* (plate 120), is painted on coarse jute. The depiction of
growth as a coherent process has given way to the presentation
of individual forms which lack any sense of inner connection.

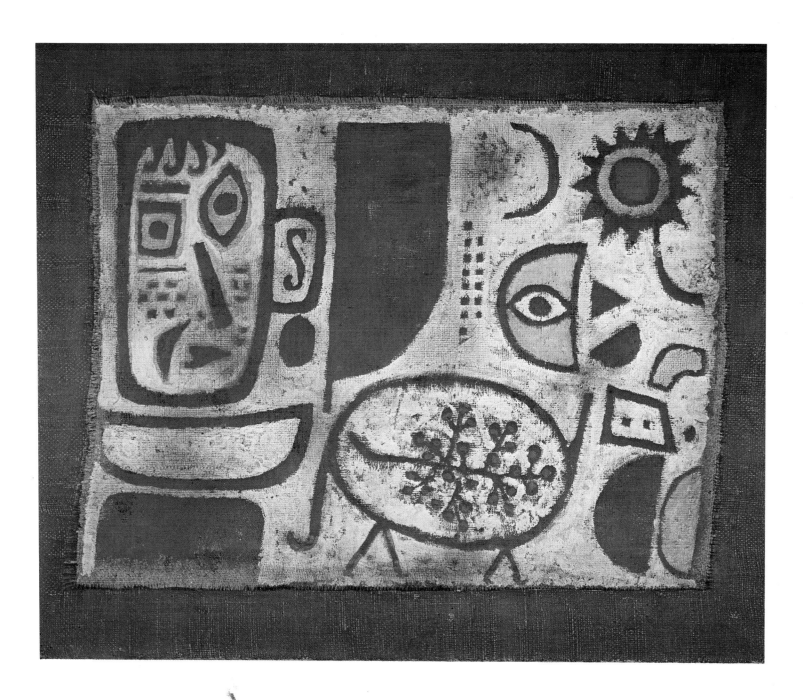

Selected Bibliography

GENERAL

Buchheim, Lothar-Günther. *Der Blaue Reiter und die "Neue Künstlervereinigung München."* Feldafing, 1959.

Der Blaue Reiter. Exhibition catalogue. Ed. Hans Christoph von Tavel, with contributions by Andreas Meier, Hans Christoph von Tavel, Felix Thürlemann, Klaus Lankheit, Jessica Boissel, Günter Krüger, and Wolfgang Kersten. Kunstmuseum, Bern, 1986.

Der Blaue Reiter: Dokumente einer geistigen Bewegung. Ed., and with an afterword by, Andreas Hüneke. Leipzig, 1986.

Glatzel, Ursula. "Zur Bedeutung der Volkskunst im Blauen Reiter." Diss., Ludwig-Maximilians-Universität, Munich, 1975.

Gollek, Rosel. *Der Blaue Reiter im Lenbachhaus München: Katalog der Sammlung in der Städtischen Galerie.* Munich, 1974. 2nd rev. and enl. ed., Munich, 1982. 3rd rev. ed., Munich, 1985.

Moeller, Magdalena M. *Der Blaue Reiter.* Cologne, 1987.

The Blaue Reiter Almanac. Ed. Vassily Kandinsky and Franz Marc. Documentary ed. by Klaus Lankheit. London and New York, 1974.

Vogt, Paul. *Der blaue Reiter: Sammelband, Ausstellungen, Künstler.* Cologne, 1977.

ALEXEI JAWLENSKY

Alexej Jawlensky. Exhibition catalogue. Musée des Beaux-Arts, Lyon, 1970.

Alexej Jawlensky. Exhibition catalogue. Städtische Galerie im Lenbachhaus, Munich, 1964.

Alexej Jawlensky 1864-1941. Exhibition catalogue. Ed. Armin Zweite, with contributions by Jelena Hahl-Koch, Armin Zweite, Bernd Fäthke, Jürgen Schultze, and Katharina Schmidt. Städtische Galerie im Lenbachhaus, Munich, and Staatliche Kunsthalle, Baden-Baden, 1983.

Alexej Jawlensky. Exhibition catalogue. Serge Sabarsky Gallery, New York, 1982.

Alexej Jawlensky: Vom Abbild zum Urbild. Exhibition catalogue. Comp. Gottlieb Leinz. Galerie im Ganserhaus, Wasserburg, in cooperation with the Bayerische Staatsgemäldesammlungen, Munich, 1979.

Demetrion, James T. "Alexei Jawlensky: Variation and Meditation." In *Alexei Jawlensky: A Centennial Exhibition.* Exhibition catalogue. The Pasadena Museum, Pasadena, California, 1964.

Jawlensky, Alexei. "Lebenserinnerungen." In Weiler, 1970.

Jawlensky, Alexei. *Meditationen.* Ed. W. A. Nagel, intro. Ewald Rathke. Hanau, 1983.

Jawlensky. Exhibition catalogue. Intro. Ewald Rathke. Kunstverein, Frankfurt, and Kunstverein, Hamburg, 1967.

Jawlensky and the Serial Image. Exhibition catalogue. Text by Shirley Hopps and John Coplans. Art Gallery, University of California at Irvine and University of California at Riverside, 1966.

Jawlensky and Major German Expressionists. Exhibition catalogue. Leonard Hutton Galleries, New York, 1980.

Paul Klee, Alexej Jawlensky. Exhibition catalogue. Städtisches Museum, Wiesbaden, 1962.

Rosenbach, Detlev. *Alexej von Jawlensky: Leben und druckgraphisches Werk.* Hanover, 1985.

Schultze, Jürgen. *Alexej Jawlensky.* Cologne, 1970.

Weiler, Clemens. *Alexej Jawlensky.* Cologne, 1959.

Weiler, Clemens. *Alexej Jawlensky: Köpfe, Gesichte, Meditationen.* Hanau, 1970.

VASSILY KANDINSKY

Barnett, Vivian Endicott. *Kandinsky at the Guggenheim.* New York, 1983.

Bowlt, John E., and Rose-Carol Washton-Long, eds. *The Life of Vasilii Kandinsky in Russian Art: A Study of "On the Spiritual in Art."* Newtonville, Massachusetts, 1980.

Eichner, Johannes. *Kandinsky and Gabriele Münter: Von Ursprüngen der modernen Kunst.* Munich, 1957.

Fineberg, Jonathan David. *Kandinsky in Paris 1906-1907.* Ann Arbor, 1984.

Gollek, Rosel, intro. *Wassily Kandinsky: Frühe Landschaften.* Munich and Zurich, 1978.

Grohmann, Will. *Wassily Kandinsky: Life and Work.* New York, 1958.

Hahl-Koch, Jelena, ed. *Arnold Schönberg, Wassily Kandinsky: Briefe, Bilder und Dokumente einer aussergewöhnlichen Begegnung.* With an essay by Hartmut Zelinsky. Salzburg and Vienna, 1980.

Hanfstaengl, Erika. *Wassily Kandinsky: Zeichnungen und Aquarelle – Katalog der Sammlung in der Städtischen Galerie im Lenbachhaus München.* Munich, 1974. 2nd ed., Munich, 1981.

Kandinsky, Vassily. *Complete Writings on Art.* Ed. Kenneth C. Lindsay and Peter Vergo. 2 vols. Boston, 1982.

Kandinsky: The Munich Years 1900-1914. Exhibition catalogue. The Scottish Arts Council Gallery, Edinburgh, and The Museum of Modern Art, Oxford, 1979.

Kandinsky: The Road to Abstraction. Exhibition catalogue. Marlborough Fine Art Limited, London, 1961.

Kandinsky and his Friends: Centenary Exhibition. Exhibition catalogue. Marlborough Fine Art Limited, London, 1966.

Kandinsky: Das druckgraphische Werk – Zum 100. Geburtstag. Exhibition catalogue. Städtische Galerie im Lenbachhaus, Munich, 1966.

Kandinsky in Munich 1896-1914. Exhibition catalogue. Text by Peg Weiss. The Solomon R. Guggenheim Museum, New York, 1982.

Kandinsky: The Russian and Bauhaus Years. Exhibition catalogue. The Solomon R. Guggenheim Museum, New York, 1983/84.

Kandinsky in Paris: 1934-1944. Exhibition catalogue. The Solomon R. Guggenheim Museum, New York, 1985.

Kandinsky: Œuvres de Vassily Kandinsky (1866-1944). Exhibition catalogue. Comp. Christian Derouet and Jessica Boissel. Musée National d'Art Moderne, Centre Pompidou, Paris, 1984.

Langner, Johannes. "Impression V: Observations sur une thème chez Kandinsky." *Revue de l'Art,* 45 (1979), pp. 53-65.

Lindsay, Kenneth C. "The Genesis and Meaning of the Cover Design for the First Blaue Reiter Exhibition Catalogue." *The Art Bulletin,* 35, no. 1 (1953), pp. 47-52.

Lindsay, Kenneth C. "Graphic Art in Kandinsky's Oeuvre." *Prints,* 12 (1962), pp. 235-52.

Overy, Paul. *Kandinsky: The Language of the Eye.* New York and Washington, D.C., 1969.

Ringbom, Sixten. "Art in 'The Epoch of the Great Spiritual': Occult Elements in the Early Theory of Abstract Painting." *Journal of the Warburg and Courtauld Institutes,* 29 (1966), pp. 368-418.

Ringbom, Sixten. *The Sounding Cosmos: A Study in the Spiritualism of Kandinsky and the Genesis of Abstract Painting.* Abo, 1970.

Robbins, Daniel. "Vasily Kandinsky: Abstraction and Image." *Art Journal*, 12 (Spring 1963), pp. 145-47.

Roethel, Hans K. "Kandinsky: Improvisation Klamm – Vorstufen einer Deutung." In *Festschrift für Eberhard Hanfstaengl*, pp. 186-92. Munich, 1962.

Roethel, Hans K. *Kandinsky: Das graphische Werk*. Cologne, 1970.

Roethel, Hans K. *Kandinsky*. Munich and Zurich, 1977.

Roethel, Hans K., with Jean K. Benjamin. *Kandinsky*. New York, 1979.

Roethel, Hans K., and Jean K. Benjamin. *Kandinsky: Catalogue Raisonné of the Oil Paintings*. Vol. 1: *1900-1915*, vol. 2: *1916-1944*. London and New York, 1982, 1984.

Roters, Eberhard. "Wassily Kandinsky und die Gestalt des Blauen Reiters." *Jahrbuch der Berliner Museen*, 5 (1963), pp. 201-26.

Thürlemann, Felix. *Kandinsky über Kandinsky: Der Künstler als Interpret eigener Werke*. Bern, 1986.

Vasily Kandinsky: Painting on Glass (Hinterglasmalerei) – Anniversary Exhibition. Exhibition catalogue. Text by Hans K. Roethel. The Solomon R. Guggenheim Museum, New York, 1966.

Washton-Long, Rose-Carol. "Kandinsky and Abstraction: The Role of the Hidden Image." *Artforum*, 10 (June 1972), pp. 42-49.

Washton-Long, Rose-Carol. "Kandinsky's Abstract Style: The Veiling of Apocalyptic Folk Imagery." *Art Journal*, 34, no. 3 (1975), pp. 217-28.

Washton-Long, Rose-Carol. *Kandinsky: The Development of an Abstract Style*. Oxford, 1980.

Wassily Kandinsky à Munich: Collection Städtische Galerie im Lenbachhaus. Exhibition catalogue. With contributions by Armin Zweite, Rosel Gollek, Hans K. Roethel, Jelena Hahl-Koch, and Michael Hoog. Galerie des Beaux-Arts, Bordeaux, 1976.

Wassily Kandinsky, 1866-1944. Exhibition catalogue. Haus der Kunst, Munich, 1976/77.

Weiss, Peg. "Kandinsky and the 'Jugendstil' Arts and Crafts Movement." *The Burlington Magazine*, 117 (May 1975), pp. 270-79.

Weiss, Peg. *Kandinsky in Munich: The Formative Jugendstil Years*. Princeton, New Jersey, 1979.

Whitford, Frank. *Kandinsky*. The Colour Library of Art. London, 1967.

Zander Rudenstine, Angelica. In *The Guggenheim Museum Collection: Paintings 1880-1945*. Vol. 1, pp. 204-391. New York, 1976.

PAUL KLEE

Geelhaar, Christian. "Paul Klee: 'Früchte auf rot.'" *Pantheon*, 30, no. 3 (1972), pp. 222-28.

Geelhaar, Christian. *Paul Klee and the Bauhaus*. Greenwich, Connecticut, New York, and Bath, England, 1973.

Geelhaar, Christian. *Paul Klee: Life and Work*. New York, 1982.

Geelhaar, Christian, ed. *Paul Klee: Schriften, Rezensionen und Aufsätze*. Cologne, 1976.

Giedion-Welcker, Carola. *Paul Klee*. New York, 1952.

Glaesemer, Jürgen. *Paul Klee: Handzeichnungen*. Vol. 1: *Kindheit bis 1920*, vol. 2: *1921-1936*, vol. 3: *1937-1940*. Bern, 1973, 1984, 1979.

Glaesemer, Jürgen. *Paul Klee: The Coloured Works in the Kunstmuseum Bern*. Bern, 1979.

Grohmann, Will. *Paul Klee*. New York, 1954.

Grohmann, Will. *Der Maler Paul Klee*. Cologne, 1966.

Haftmann, Werner. *The Mind and Work of Paul Klee*. New York, 1954.

Haxthausen, Charles Werner. *Paul Klee: The Formative Years*. New York, 1981.

Franciscono, Marcel. "Paul Klee's Italian Journey and the Classical Tradition." *Pantheon*, 32 (1974), pp. 54-64.

Jordan, Jim M. *Paul Klee and Cubism*. Princeton, New Jersey, 1984.

Klee and Kandinsky: Erinnerung an eine Künstlerfreundschaft anlässlich Klees 100. Geburtstag. Exhibition catalogue. Staatsgalerie, Stuttgart, 1979.

Klee, Felix, ed. *Paul Klee: His Life and Work in Documents*. New York, 1962.

Klee, Felix, ed. *Paul Klee: Briefe an die Familie*. Vol. 1: *1893-1906*, vol. 2: *1907-1940*. Cologne, 1979.

Klee, Paul. *Tagebücher, 1898-1918: Texte und Perspektiven*. Ed. and intro. Felix Klee. Cologne, 1957. 2nd ed., Cologne, 1968; repr. 1979.

Klee, Paul. *The Notebooks of Paul Klee*. Ed. Jürg Spiller. Vol. 1: *The Thinking Eye*, vol. 2: *The Nature of Nature*. London and New York, 1961, 1973.

Klee, Paul. *Beiträge zur bildnerischen Formenlehre*. Facsimile edition of the manuscript of Klee's first series of lectures at the Bauhaus in Weimar, 1921/22. Ed. Jürgen Glaesemer. Basel and Stuttgart, 1979.

Klee, Paul. *Tagebücher 1898-1918: Textkritische Neuedition*. Ed. Wolfgang Kersten. Stuttgart and Teuffen, 1988.

Kornfeld, Eberhard W. *Verzeichnis des graphischen Werkes von Paul Klee*. Bern, 1963.

Kornfeld, Eberhard W. *Paul Klee in Bern: Aquarelle und Zeichnungen von 1897 bis 1915*. Bern, 1973.

Mueller, Carola. "Das Zeichen in Bild und Theorie bei Paul Klee." Diss., Ludwig-Maximilians-Universität, Munich, 1979.

Paul Klee: Aquarelle, Handzeichnungen. Exhibition catalogue. Kunsthalle, Bremen, 1967.

Paul Klee: Das Werk der Jahre 1919-1933 – Gemälde, Handzeichnungen, Druckgraphik. Exhibition catalogue. With contributions by Marcel Franciscono, Christian Geelhaar, Eva-Maria Triska, Siegfried Gohr, Placido Cherchi, and Per Kirkeby. Kunsthalle, Cologne, 1979.

Paul Klee: Das graphische und plastische Werk – Mit Vorzeichnungen, Aquarellen und Gemälden. Exhibition catalogue. With contributions by Marcel Franciscono, Christian Geelhaar, Jürgen Glaesemer, and Mark Rosenthal. Wilhelm-Lehmbruck-Museum, Duisburg, 1975.

Paul Klee (1879-1940): Innere Wege. Exhibition catalogue. Wilhelm-Hack-Museum, Ludwigshafen, 1981/82.

Paul Klee: Das Frühwerk 1883-1922. Exhibition catalogue. Ed. Armin Zweite, with contributions by Rosel Gollek, Christian Geelhaar, Marcel Franciscono, Jürgen Glaesemer, Charles Werner Haxthausen, Otto K. Werckmeister, Jim M. Jordan, Magdalena Droste, and others. Städtische Galerie im Lenbachhaus, Munich, 1979/80.

Paul Klee. Exhibition catalogue. Ed. Carolyn Lanchner. The Museum of Modern Art, New York, The Cleveland Museum of Art, and Kunstmuseum, Bern, 1987/88.

Plant, Margaret. *Paul Klee: Figures and Faces*. London, 1978.

Rewald, Sabine. *Paul Klee: The Berggruen Collection in The Metropolitan Museum of Art*. New York, 1988.

Roethel, Hans K. *Paul Klee in München*. Bern, 1971.

Schmalenbach, Werner. *Paul Klee: The Düsseldorf Collection*. Munich, 1986.

Smith Pierce, James. *Paul Klee and Primitive Art*. New York and London, 1976.

Tower, Beeke Sell. *Klee and Kandinsky in Munich and at the Bauhaus*. Ann Arbor, 1981.

Verdi, Richard. *Klee and Nature*. London, 1984.

Werckmeister, Otto K. *Versuche über Paul Klee*. Frankfurt, 1981.

Zweite, Armin, ed. and intro. *Paul Klee: Zauber Theater*. Foreword by Felix Klee. Munich and Zurich, 1979.

AUGUST MACKE

August Macke: Handzeichnungen und Aquarelle. Exhibition catalogue. Kunsthalle, Bremen, 1965.

August Macke: Die Tunisreise – Aquarelle und Zeichnungen von August Macke. 2nd ed., Cologne, 1978.

August Macke: Gemälde, Aquarelle, Zeichnungen. Exhibition catalogue. Kunstverein, Hamburg, 1969.

August Macke und die Rheinischen Expressionisten aus dem Städtischen Kunstmuseum Bonn. Exhibition catalogue. Kestner-Gesellschaft, Hanover, 1978/79.

August Macke. Exhibition catalogue. Intro. Hans K. Roethel. Städtische Galerie im Lenbachhaus, Munich, 1962.

August Macke: Aquarelle und Zeichnungen. Exhibition catalogue. Westfälisches Landesmuseum für Kunst und Kulturgeschichte, Münster, Städtisches Kunstmuseum, Bonn, and Kaiser Wilhelm Museum, Krefeld, 1976/77.

August Macke: Gemälde, Aquarelle, Zeichnungen. Exhibition catalogue. Ed. Ernst-Gerhard Güse, with contributions by Ernst-Gerhard Güse, Rosel Gollek, Katharina Schmidt, Johannes Langner, Ursula Heiderich, Klaus Lankheit, and others. Westfälisches Landesmuseum für Kunst und Kulturgeschichte, Münster, Städtisches Kunstmuseum, Bonn, and Städtische Galerie im Lenbachhaus, Munich, 1987.

Die Rheinischen Expressionisten: August Macke und seine Malerfreunde. Exhibition catalogue. Städtisches Kunstmuseum, Bonn, Kaiser Wilhelm Museum, Krefeld, Von der Heydt-Museum, Wuppertal, 1979.

Erdmann-Macke, Elisabeth. *Erinnerung an August Macke*. Stuttgart, 1962.

Güse, Ernst-Gerhard, ed. *Die Gemälde von Franz Marc und August Macke im Westfälischen Landesmuseum Münster*. Münster, 1982.

Heiderich, Ursula. *August Macke: Skizzenbücher*. 2 vols. Stuttgart, 1987.

McCullagh, Janice Mary. "August Macke and the Vision of Paradise: An Iconographic Analysis." Diss., University of Texas at Austin, 1980.

Macke, August. *Briefe an Elisabeth und die Freunde*. Ed. Werner Frese and Ernst-Gerhard Güse. Munich, 1987.

Macke, Wolfgang, ed. *August Macke, Franz Marc: Briefwechsel*. Cologne, 1964.

Moeller, Magdalena M. *August Macke*. Cologne, 1988.

Vriesen, Gustav. *August Macke*. Stuttgart, 1953. 2nd, enl. ed., Stuttgart, 1957.

FRANZ MARC

Franz Marc. Exhibition catalogue. Text by Mark Rosenthal. University Art Museum, Berkeley, 1979.

Franz Marc: Gemälde, Gouachen, Zeichnungen, Skulpturen. Exhibition catalogue. Intro. Hans Platte. Kunstverein, Hamburg, 1963/64.

Franz Marc. Exhibition catalogue. Foreword by Hans K. Roethel, intro. Rudolf Probst. Städtische Galerie im Lenbachhaus, Munich, 1963.

Franz Marc 1880-1916. Exhibition catalogue. Ed. Rosel Gollek, with contributions by Rosel Gollek, Johannes Langner, Frederick S. Levine, and Carla Schulz-Hoffmann. Städtische Galerie im Lenbachhaus, Munich, 1980.

Lankheit, Klaus. *Franz Marc im Urteil seiner Zeit: Texte und Perspektiven*. Cologne, 1960.

Lankheit, Klaus. "Zur Bildtradition von Franz Marc." In *Festschrift für Herbert von Einem*, pp. 129-35. Berlin, 1965.

Lankheit, Klaus. *Franz Marc: Katalog der Werke*. Cologne, 1970.

Lankheit, Klaus. *Franz Marc: Sein Leben und seine Kunst*. Cologne, 1976.

Lankheit, Klaus. *Franz Marc: Schriften*. Cologne, 1978.

Levine, Frederick S. "The Iconography of Franz Marc's Fate of the Animals." *The Art Bulletin*, 58 (1976), pp. 269-77.

Levine, Frederick S. *The Apocalyptic Vision: The Art of Franz Marc as German Expressionism*. New York, San Francisco, and London, 1979.

Marc, Franz. *Briefe, Aufzeichnungen und Aphorismen*. 2 vols. Berlin, 1920.

Marc, Franz. *Briefe aus dem Feld*. Berlin, 1948.

Marc, Franz. *Skizzenbuch aus dem Felde*. Facsimile ed. with text vol. by Klaus Lankheit. Berlin, 1956.

März, Roland. *Franz Marc*. Berlin (GDR), 1984.

Rosenthal, Mark. *Franz Marc*. Munich, 1989.

Schuster, Peter-Klaus, ed. *Franz Marc: Postcards to Prince Jussuf*. Munich, 1988.

Wassily Kandinsky, Franz Marc: Briefwechsel — Mit Briefen von und an Gabriele Münter und Maria Marc. Ed. and intro. Klaus Lankheit. Munich and Zurich, 1983.

GABRIELE MÜNTER

An Exhibition of Unknown Work by Gabriele Münter 1877-1962: "Hinterglasmalerei" (Painting on Glass), Woodcuts in Color, Etchings, Collages. Exhibition catalogue. Intro. Alfred Werner. Leonard Hutton Galleries, New York, 1966/67.

Cole, Brigitte M. "Gabriele Muenter and the Development of her Early Murnau Style." Diss., University of Texas at Arlington, 1980.

Comini, Alessandra. "State of the Field 1980: The Women Artists of German Expressionism." *Arts Magazine* (Nov. 1980), pp. 147-53.

Eichner, Johannes. *Kandinsky und Gabriele Münter: Von Ursprüngen der modernen Kunst*. Munich, 1957.

Gabriele Münter: Aquarelle und Handzeichnungen. Exhibition catalogue. Foreword by Günther Busch. Kunsthalle, Bremen, 1972/73.

Gabriele Münter. Exhibition catalogue. Ed. Karl-Egon Vester. Kunstverein, Hamburg, Hessisches Landesmuseum, Darmstadt, and Sammlung Eisenmann, Aichtal-Aich, 1988.

Gabriele Münter 1877-1962. Exhibition catalogue. Intro. Hans K. Roethel. Städtische Galerie im Lenbachhaus, Munich, 1962.

Gabriele Münter: Das druckgraphische Werk. Städtische Galerie im Lenbachhaus München: Sammlungskatalog 2. Comp. Sabine Helms, foreword by Hans K. Roethel. Munich, 1967.

Gabriele Münter 1877-1962: Gemälde, Zeichnungen, Hinterglasbilder und Volkskunst aus ihrem Besitz. Exhibition catalogue. Comp. Rosel Gollek. Städtische Galerie im Lenbachhaus, Munich, 1977.

Gollek, Rosel. "Gabriele Münter 1877-1962." *Die Kunst*, 89, no. 2 (Feb. 1977), pp. 79-83.

Gollek, Rosel, intro. *Gabriele Münter: Hinterglasbilder*. Munich and Zurich, 1981.

Gollek, Rosel. *Das Münter-Haus in Murnau*. N.p., 1984.

Gregg, Sara. "Gabriele Münter in Sweden: Interlude and Separation." *Arts Magazine*, 55 (May 1981), pp. 116-19.

Kandinsky, Marc, Münter: Unbekannte Werke. Exhibition catalogue. Text by Hans K. Roethel, Klaus Lankheit, and Johannes Eichner. Moderne Galerie Otto Stangl, Munich, 1954/55.

Lahnstein, Peter. *Gabriele Münter*. Ettal, 1971.

Mochon, Anne. *Gabriele Münter: Between Munich and Murnau*. Cambridge, Massachusetts, 1980.

Münter, Gabriele. *Menschenbilder in Zeichnungen*. Twenty collotype plates, intro. G.F. Hartlaub and with reminiscences by the artist. Berlin, 1952.

Pfeiffer-Belli, Erich. *Gabriele Münter: Zeichnungen und Aquarelle*. With a catalogue by Sabine Helms. Berlin, 1979.

Roethel, Hans K., intro. *Gabriele Münter*. Munich, 1957.